antennae

antennae

THE JOURNAL OF NATURE IN VISUAL CULTURE
edited by Giovanni Aloi

Antennae (founded in 2006) is the international, peer reviewed, academic journal on the subject of nature in contemporary art. Its format and contents are inspired by the concepts of 'knowledge transfer' and 'widening participation'. Three times a year, the Journal brings academic knowledge within a broader arena, one including practitioners and a readership that may not regularly engage in academic discussion. Ultimately, *Antennae* encourages communication and crossovers of knowledge amongst artists, scientists, scholars, activists, curators, and students. In January 2009, the establishment of *Antennae*'s Senior Academic Board, Advisory Board, and Network of Global Contributors has affirmed the journal as an indispensable research tool for the subject of environmental and nature studies. Contact the Editor in Chief at: antennaeproject@gmail.com Visit our website for more info and past issues: www.antennae.org.uk

inter

face

contents

14

A Node within a Network of Networks: An Interview with Roger Malina

Interviewee: **Roger Malina**
Interviewer: **Andrew Yang**

Roger Malina's remarkable career spans the natural sciences, art, design, and education. In this interview with Andrew Yang, Malina discusses his exceptional role as editor of *Leonardo* and the challenges involved in working at the intersection of art andf science.

22

Eduardo Kac: From Holopo-ems to Outer Space

interviewee: **Eudardo Kac**
interviewer: **Giovanni Aloi**

Eduardo Kac is considered a pioneer of bioestetic and telematic research. He is widely recognized for his interactive installations and his Bio Art. His work deals with issues that range from the mythopoetics of online experience to the cultural impact of biotechnology, collective agency the creation of life and evolution.

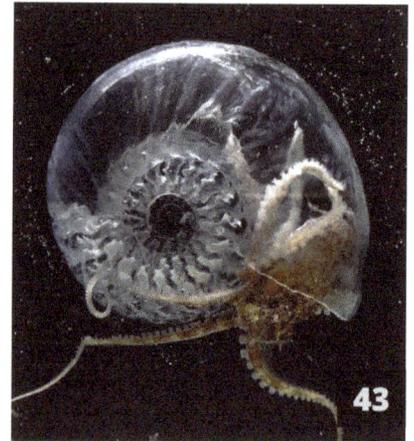

43

Aki Inomata: Think Evolution

text and images by **Aki Inomata**

Inomata's work often involves 3D printing and relies on collaborations with animals. Together, works like *Why Not Hand Over a 'Shelter' to Hermit Crabs?* and *Think Evolution* draw important considerations on notions of deep-time, mobility, temporality, and change.

52

Tomás Saraceno: Interfacing nature and culture through art and science

text by **Elizabeth Atkinson**

This essay explores the interconnecting elements at play in the practice of Tomás Saraceno, one very much studio-based and rooted in human/non-human collaboration.

72

Sam Nightingale's Para-photo-mancy

text and images by **Sam Nightingale**

Para-photo-mancy is a series of experimental photographic artworks that utilise the inherent photo(phyto) chemical capacities of plants to produce images.

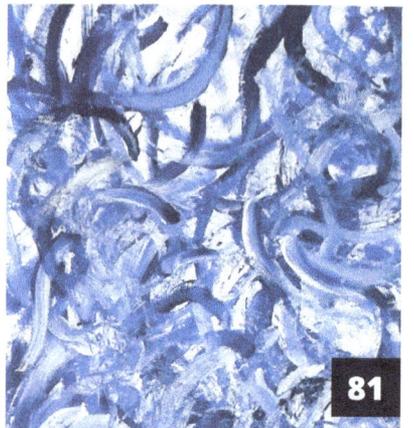

81

Sougwen Chung: Drawing Operations

text and images by **Sougwen Chung**

An artist reflects on research-based practice, the conception of a special committee Ph.D. in Interdisciplinary Arts and Science at the University of Wisconsin-Madison, and the privileges of working, learning, and teaching at the intersections of disciplines.

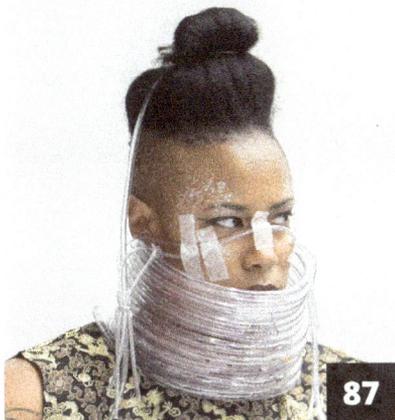

87

Engineering Spaces for Cyborgs
text and images by **Lee Blalock aka L[3]^2**

Inspired by science fiction, futurism, and technology itself, Lee Blalock's work is an exercise in body modification by way of amplified behavior or "change-of-state".

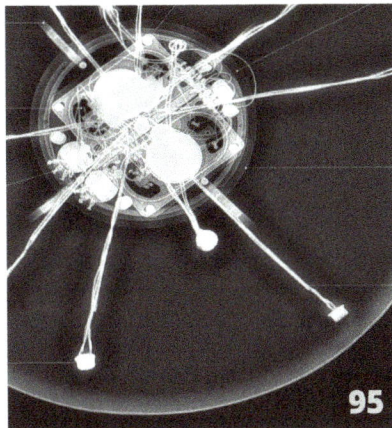

95

Parasitos Urbanos
text and images by **Gilberto Esparza**

Gilberto Esparza is a Mexican artist whose work involves electronic and robotic means to investigate the impacts of technology in everyday life, social relationships, environment and urban structure. He currently conducts research projects on alternative energies. His practice employs recycling consumer technology and biotechnology experiments.

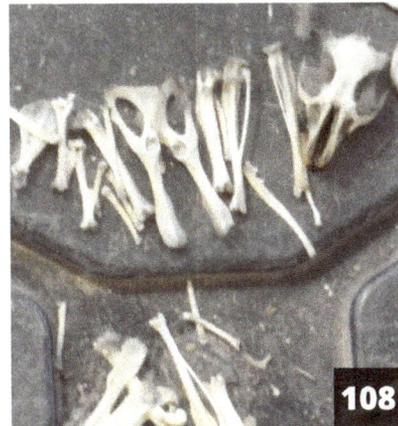

108

Art-Eco-Science. Field Collaborations
in-conversation: **Keith Armstrong and Tania Leimbach**

Art-Eco-Science practitioner Keith Armstrong and sustainability scholar Tania Leimbach explore how artists hope to radically transform our attitudes, perceptions, and modes of participation.

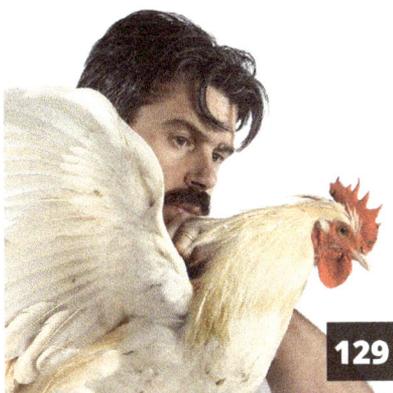

129

LABIOMISTA: Biology, Art, and Philosophy
text by **Geerdt Magiels**
images by **Koen Vanmechelen**

Biologist and philosopher of science Geerdt Magiels talked to Koen Vanmechelen about his work. Each piece tells a story in which the local and the global interact. A reflection on art, science, culture, and society.

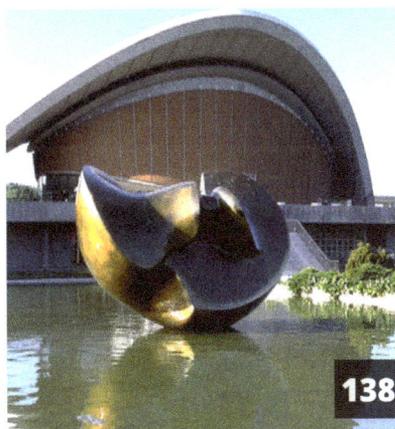

138

Bernd Scherer: Curating the Anthropocene
interviewee: **Bernd Scherer**

interviewer: **Giovanni Aloi**

Bernd Scherer, director of HKW in Berlin talks to Giovanni Aloi about the importance of engagement in the context of anthropogenic research and contemporary art.

155

Embodied Objects
text and images by **Laura Splan**

Laura Splan's *Embodied Objects* series uses biosensors to produce data-driven forms and patterns for objects and images. The project examines the potential for objects to embody human experience and to materialize the intangible.

contents

Let Yourself be a Mirror
text by **Sylvia Solakidi**

166

As consilience results from transformation through the mirror of the other, Jan Fabre takes from Giacomo Rizzolatti a model for his theatre and Rizzolatti takes from Fabre an image for brain function.

Dana Simmons: Micrographs
text by and images **Dana Simmons**

192

As a neuroscientist, Dana Simmons studied how autism affects the cerebellum, a brain region that supports our balance and posture, and helps us learn new movements. Dana used a high-powered microscope and manipulated laser light and color filters to create these intriguing neuron portraits.

Contemporary Relics: Threads Across Time in Bio Art
text by and images **Anna Dumitriu**

202

This article considers the health and safety challenges that my collaborators and I face in producing and exhibiting artworks, which take the form of sculptural objects or installations and incorporate diverse materials such as altered historical objects or textiles combined with bacteria and DNA.

Regenesis Aesthetics: Visualizing the Woolly Mammoth in De-Extinction Science
text by **Sarah Bezan**

218

Pursuing an iconographical analysis of the de-extinction of the woolly mammoth, this essay explores how the (re)production of the visual image intersects with the creative and variable processes of species revivalism.

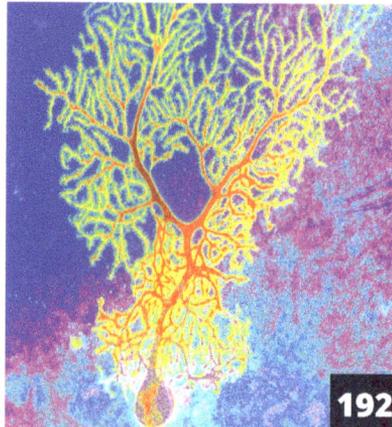

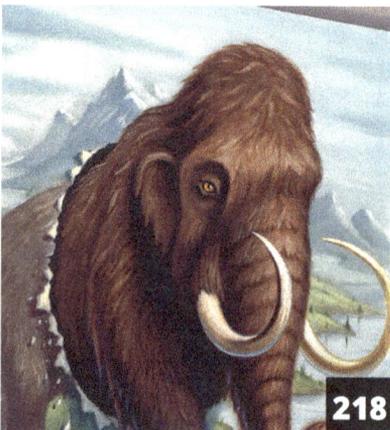

Right: detail from *Laura Splan*
Recursive Expressions (Squint #2)
2017, archival pigment print on hot press cotton rag
© Laura Splan

editorial

Giovanni Aloi

In the 1890s, playwright and artist August Strindberg spent many nights attempting to capture the cosmos on metal plates coated with emulsion. He was attempting to craft a new photographic method based on the principle of direct-impression. By the end of the nineteenth-century photography had overcome early technical limitations. From better focus to ever faster exposure times, photography captured details in seemingly faithful ways—where painting idealized, photography recorded truth. Strindberg's *Celestographs* are thoroughly anachronistic. They belong somewhere between William Henry Fox Talbot's early photograms of the 1940s and Anna Atkins's cyanotypes of seaweeds and plants. But perhaps more than the work of these pioneers, Strindberg's plates attempt the impossible: they are incarnations of the artist's fervent desire to unite the sky and the earth, not through an optical image, but by directly teasing the constellations onto a material surface. As "failed photograms", the *Celestographs* flirt with the edge of the unknowable to capture the unrepresentable. And as purely poetic plateaus, they function as tremendously evocative interfaces upon which past mythologies and modern histories of optical and existential desire become visible.

Strindberg's interest in alchemy always led him to question the nature of truth itself. Over time, it drew him to blur the boundaries of art and science. His wish to test disciplinary boundaries was a clear symptom of his awareness that knowledge is ultimately defined by the materials we use to visualize personal and institutional truths. But, the constellation-like markings imprinted upon his plates could not possibly be the faithful reflection of the universe he wished for. They most likely were the traces of dust particles suspended in the atmosphere or the ghostly fabrications of chemical reactions that occurred overnight.

From the essentially theatrical epistemic spaces of the Renaissance, such as fairs, tournaments, cabinets of curiosities, and herbaria to zoology collections, botanical gardens, and the archives of the Classical Age, the very birth of modern science was defined by the material spaces and surfaces through which knowledge was produced. In *The Order of Things,* Foucault discusses at length the importance of these spaces through which knowledge was produced. He also analyses the complexities involved in the structure of the page of natural history treaties, the relationship between text and image, and the epistemic limitations imposed by the flatness of the page and its margins upon the object of study. In so doing, Foucault emphasizes the importance materiality plays in shaping our ability to produce knowledge itself—pure thinking does not exist.

It is in this context that the interface emerges as an agentially charged field—it reveals itself as a productive material dimension through which our thinking, questions, and assumptions are formed, mapped, shaped, and tested. From this perspective, the interface manifests itself as an artistic material-surface—a creative and reactive field through which we modulate the bandwidth of a perceptual gap—the poetic and philosophical distance between us and the actants and systems we study. Because of its inherent agential potential, the interface is also prone to become an ethical battlefield. Strindberg constructed his own pinhole cameras because, in his view, lenses distorted the world. Yet, his desire to record nature as objectively as possible led to the production of images that could not be more distant from reality. Did he know it wasn't stars he had captured? And did it matter? Interfaces are sites of negotiation—they are selective. The same interface reveals very different aspects of reality when used in different disciplinary settings. From this generative condition, however, sometimes stems the mistrust that limits collaborations in art and science.

I have often argued, in recent talks and publications, that modern science has accomplished two incredible feats over a relatively short period of time. On the one hand, it has drastically improved our quality of life by controlling and defeating diseases and other afflictions. On the other, it has devoided the world of magic. It has stripped the mythologies of ancient cultures, including those of indigenous peoples (casting them as backward primitives) and replaced them with measurable, hard facts. My views have been at times misinterpreted to imply a discreditation of science, something that in the age of post-truth seems to cause considerable anguish to audiences who have forgotten that science has more than one dark side too. My comments about the cultural hegemony of science and its negative impact on our ability to empathize with ecosystems in creative ways have been partly informed by Suzi Gablik's controversial 1991 book titled *The Reenchantment of Art.* On its pages, the author diagnoses the traits of a cultural crisis essentially caused by modernism, which in the second half of the twentieth century substantially impoverished artistic discourses and art making. Gablik argues that this new relation should be employed in light of the need to overcome the hegemony of technological and materialist views that have compromised any other possibilities to form connections between humans and nature. A reenchantment of art, however, has nothing to do with a return to religious art but is instead centered on the possibility that new mythologies may help us empathize with the world around us. Paradoxically, the way to make people care about the natural work might not be to shove science in their faces all the time, but to strike the right balance between science and poetry, mythology and documentary.

It is in this context that, in art and science, the interface emerges as a site of negotiation through which we can envision alternative futures. This is one of the most important roles collaborations in art and science can play—to instill empathy and promote engagement in the conception of a world that's more than a resource and that we can engage with beyond the baseline of functionalism.

This project is co-edited in collaboration with American artist and philosopher Jonathon Keats whose bold experiments have risen important questions and put into practice his conviction that the world needs more "curious amateurs" willing to explore publicly whatever intrigues them in defiance of a culture that increasingly forecloses on wonder and silos knowledge into narrowly defined areas of expertise.

A team of scholars and artists has also helped us with the task of selecting some of the most exciting representatives of this ever-growing movement. We are thankful to Andrew Yang (Associate Professor of Liberal Arts at the School of the Art Institute of Chicago), Daniela Silvestrin (Curatorial Assistant at Leuphana Universität Lüneburg), Julie Marie Lemon (Program Director & Curator of the University-wide Arts, Science + Culture Initiative at the University of Chicago), Julia Buntaine Hoel (Conceptual Artist and Director of SciArt Magazine), Ken Rinaldo (artist and professor of robotics at The Ohio State University), and Piero Scaruffi (research on cognitive science and art) for their help and advice. As always, we would like to thank everyone involved in the making of this issue.

Giovanni Aloi
Editor in Chief of AntennaeProject

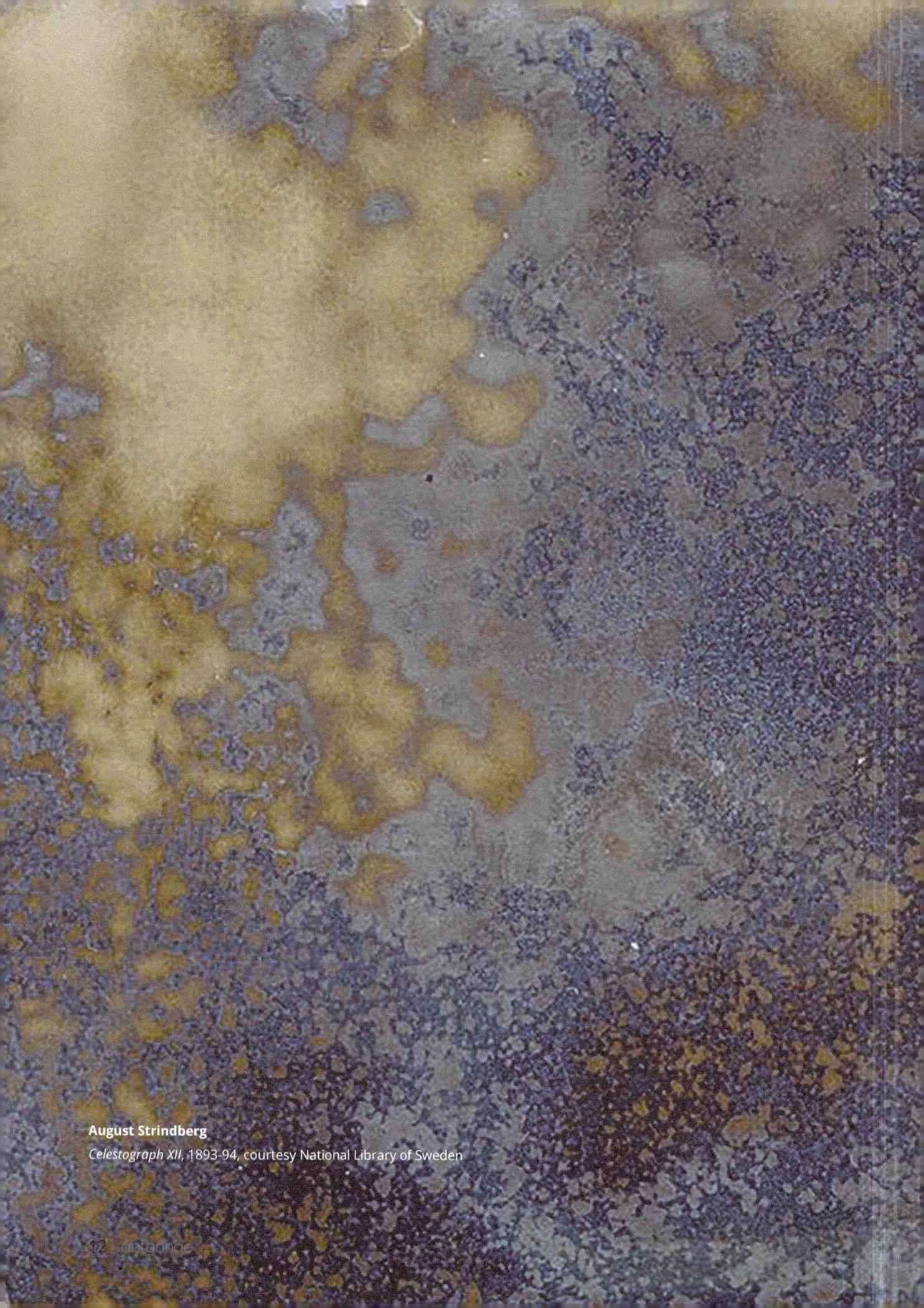

13

A Node within a Network of Networks: An Interview with Roger Malina

Roger Malina's remarkable career spans the natural sciences, art, design, and education. An astrophysicist, he is the former Director of the Observatoire Astronomique de Marseille Provence (OAMP) and was a member of its observational cosmology group which collaborated studies of dark matter and dark energy. As Executive Editor of the journal Leonardo *at MIT Press since the early 1980s, Malina has been a key and catalytic figure in the realms of new media art and art & science over the past four decades.*

Interviewee: **Roger Malina**
Interviewer: **Andrew Yang**

Andrew Yang: Your father, Frank Malina, was an aeronautical engineer, artist, and founder of the art, science, and technology journal *Leonardo*. Today you are the Executive Editor of "Leonardo publications" and a main organizer of the network's initiatives. What influence did that upbringing have in your own professional and creative trajectory? Did you assume you would follow in his footsteps?On the occasion of *Leonardo*'s 50th anniversary, Andrew Yang spoke with Roger Malina on the past, future, and dynamic present of the art & science conversation.

Roger Malina: As a child, I knew my father was an aeronautical pioneer and helped co-found JPL (the Jet Propulsion Laboratory in Pasadena, CA). The rockets that his team designed launched some of the first objects into space. But when I would come home from elementary school he would be painting. And so, from a very early age, I thought that is what engineers did! The home that my parents had in San Francisco was a hotbed of mixed-meetings between artists and scientists of various kinds, from C.P Snow to people from the Oulipo movement. The kind of things we talk about now in terms of transdisciplinarity was the everyday in my parents' house.

In retrospect, I had a fairly clear career path in physics (B.S., MIT) and astrophysics (Ph.D., Berkeley). Nobody told me that I had to be a scientist, but they did say, "You can be a scientist first and a poet second, but it is really hard to become a poet first and a scientist second."

Yang: That is uncanny, I had a drawing professor in college that told me the exact same thing, although she said it is a reference to being a visual artist more specifically.

Malina: I had a natural model in my father, although early on I was on a very narrow and somewhat blinkered career in astrophysics and instrument design. I was a postdoc on this NASA team that was trying to build a new satellite, but then my dad died in 1981 very unexpectedly. At first, I tried to sell *Leonardo,* but I quickly found that art journals

have no monetary value. I couldn't find anyone who wanted to buy it! At that time, Stephen Wilson, one of the authors publishing in the journal, suggested we'd move the journal to San Francisco State, where he was.

Soon after that, Frank Oppenheimer (of the San Francisco Exploratorium) helped us set up a non-profit, with a network of twenty volunteers supporting *Leonardo* in those early years. I was sort of the figurehead and stabilizer—meaning I would occasionally inject money). I got really excited about how *Leonardo* could advocate for artists and scientists doing cutting-edge work. And so suddenly I was an astronomer by day and working in the art & science world at night. So perhaps there was some sense of filial obligation at first, but then *Leonardo* really took off. It was the right vehicle at the right time. Around that time, we also set-up a French non-profit, because I was born in Paris and got a job in Marseilles as the director of the observatory there, which helped make *Leonardo* more international.

Yang: That geographic diversity seems like a big part of *Leonardo,* especially in light of its 50th anniversary this past year. What have been some of the key characteristics of the *Leonardo* community so far, and how do you think they will change or remain the same in the coming fifty years?

Malina: The world has really changed since *Leonardo* was founded, it is a really different environment now. It is not a matter of keeping the family business going but working with this network of people to advocate for their work and disseminate it. We've published 100 books, and perhaps over 15, 000 articles about people in our community of practice. In the 50th anniversary year, we developed this metaphor of *Leonardo* as "a node within a network of networks," although by no means a central node. Later in the year, we've started talking about it as a network of villages. There is a collective group who feels that *Leonardo* is useful to their careers and community. For example, in the beginning, there were no more than 300 on the planet interested in art and biology. *Leonardo* has helped these communities grow.

As for the 50th anniversary, like all good non-profits, we didn't have a budget to support it. Nina Czegledy, who is on *Leonardo*'s board, said: "let's have a birthday party". So we had one, but then a second one happened. And then they just kept going – from Uruguay to Bologna, from Helsinki to Colombia to Beijing, there were over thirty-seven different parties held. People talk about things going viral, but it was another case of the right thing at the right time. It was all very de-centralized, we had no unified strategy.

Yang: Even with this decentralized character of the community, clearly *Leonardo* as a publication has continued to play an important role.

Malina: I always compare the editor of a journal to an astronomer observing the universe: suddenly you notice, "Oh, that star just changed

One of the things that artist do is make science intimate in a way that scientists don't know how to do.

Roger Malina

A selection of front *Leonardo* front covers.

> *We are not building a new discipline; interdisciplinarity is not a new discipline.*

brightness!" and you point a telescope at it. That is something we reflected on in the 50th anniversary. For example, In the late 1980s, we put together two amazing issues on holography because at the time that was something new – there were only 20-30 artists really involved in that area initially, but eventually, holography has ended up on every credit card. Many people hoped digital holography would take over from the roots holography started to set, but for various reasons it never did. There was also a period when we published computer graphics because there were no computer graphic journals at the time, but once computer graphics journals did start to appear, we stopped publishing that kind of work.

And so, it is almost like *Leonardo* has been a kind of early detection system for things that are going on. I think of early work by Christa Sommerer when she was in Japan and the interesting project that she started with Laurent Mignonneau on plants and interactive computer visualization (*Interactive Plant Growing,* 1992), it just came out of nowhere. As a parenthesis, there are a lot of couples in our community of practice; perhaps with this risky work sometimes couples were able to succeed where individual artists didn't.

But let me give you an example on something on my particular editorial telescope at the moment: the intersection of cognitive science, medical science, and the art & technology community, an example being the *Your Brain on Art* project. Through these kinds of initiatives,

I think the field of art therapy might be in the process of being totally reinvented. Obviously, art therapy has a 150-year history, but now with the discoveries in cognitive and brain science, we have a much better idea of how art transforms the brain. In some circles, this might be called "embodied cognition," which Simon Penny wrote an excellent book on. I don't know if I am right, but I am on the hunt for people who might bring articles into *Leonardo* about this reinvention of art therapy.

Now we get contacted by undergraduate students, who ask "I want to combine being a doctor and musician, how do I do that formally, not accidentally?" And so, we are in a sea change in the STEM to STEAM movement, or what Carol LaFayette, Carol Strohecker, and I can SEAD (Science, Engineering, Art, and Design).

Yang: What do you see as the main issues or challenges facing a publication like *Leonardo* now and into the near future?

Malina: Certainly, the community that we've advocated for is bubbling and expanding, going in different directions. I think the main challenge we have is adapting to the way people are documenting and communicating their work, which is changing so rapidly. For example, I don't know how to do a "selfie" journal yet. But with a little bit if AI, maybe this would be possible. If Andy Warhol were alive, he would probably do an AI selfie journal of his art-making and different

stages of his work. Artists are so good about documenting what they see with their smartphone cameras. My guess is that in 20 or 30 years that we are going to see have "selfie" publications with AI underneath that structures the material narratively, that can be commented upon, and through which the content of an article can change as new material is uploaded.

It is an interesting time with the transitions going on in publishing. A thing we are struggling with, like so many others, is the question of the Open Access movement— the problem being that the implicit bias of Open Access movement is that, yes, everyone can read it for free, but only rich people can publish. And so, if you are an AI scientist with a big government grant, you have no problem paying page charges, but if you are an independent artist, it is either pay the rent or pay the page charges…

Yang: Does this relate at all to questions around print and digital publication platforms?

But I don't like the print/digital dichotomy, sometimes a sound file is better than any other format.

Malina: You know, Stelarc told me to hate false dichotomies (probably because he had three hands at one point). It is not "print" or "digital." I teach a seminar here at the University of Texas Dallas on experimental publishing, and the term I like is "multimodal." God damn it, when it makes sense to write and publish an article in print format, do it. If you want to do a 12-minute video abstract that captures your work and publish it on YouTube, do it. With multimodal publishing, maybe some formats like physical books one publishes because they are meant to be archival and last for the next 500 years. But many things are also going to disappear and not have longevity, like YouTube videos, and that is fine too. But I don't like the print/digital dichotomy, sometimes a sound file is better than any other format.

Another thing that I am pushing for is multi-lingual publishing. On the podcast platform (The Creative Disturbance podcast), I think we are up to 15 languages, including podcasts in indigenous languages. The idea behind this is that you should be able to publish in the language you think in. One's maternal language is often much more expressive. It is a historical accident that English has had this 50-year run as a "world language," but in 500 years I think English might seem as obscure as some Aboriginal Australian language is now — who knows what people will be speaking then, though given the amount of publishing in Mandarin, certainly, that will be an important language. Right now, Google Translate is still a bit of a joke, but I also think that in 50 years we will have much better translation engines materials with better fidelity into other languages.

Yang: And so, rather than the modernist notion of unifying and standardizing through common or global language, you see the trend as inter-translatable diversity?

Malina: Yes, it the idea of a global language is flawed. Although I use

emojis all the time and I bet in 50 years we will be able to express things in that form we can't yet imagine.

Yang: That makes me think of Xu Bing's work with emojis and his *Book from the Ground: From Point to Point* (MIT Press, 2014). On a related note, do you see any differences in the nature or character of the art & science conversation in different parts of the world right now? If so, what do you think might be driving them?

Malina: Yes, for sure. These thirty-seven birthday parties for *Leonardo* that I mentioned were kind of a snapshot of that in terms of what people chose to feature. One thing that struck me was the degree to which there is all kinds of work going on that I had no idea was going on, despite the internet supposedly "connecting everybody." Colombia is embedded in such a different conversation about art & science and art & technology. That country as an amazing ecology that is under threat, and they have been through this devastating war. Oslom has an amazing Bio Art lab, in Durbin street art is a big thing, perhaps partly because they don't have the same kind of museum or gallery infrastructure as in the US or Europe. Even a global topic like climate change will mean something very different wherever you go — the impacts are unique and the responses will have to be unique.

Yang: What about the role of institutions like universities that often act as key centers or nodes for much of the art & science research the world over, what roles do they play and how does that relate to the distinct cultures of art & science that you've observed?

People like tidy disciplines, but we are dealing with problems that require transdisciplinary bridging of things that no school has a department of.

Malina: It is interesting because generally, universities don't know how to organize themselves as a network structure, they only know how to organizing in a tree structure.[1] At university, you usually have biochemistry, literature, geology... while in many art schools, the medium still defines the organization: departments of ceramics, painting, photography, and now digital art. But that kind of organization has very little to do with how individual arts and creators go about their work – artists typically don't worry about what name is on something in a way that keeps them for using it. People like tidy disciplines, but we are dealing with problems that require transdisciplinary bridging of things that no school has a department of. As a matter of example, Ionat Zurr and Oron Catts did us all a great service by creating their truly transdisciplinary lab, SymbioticA.

On the matter of heterogeneity, one of the literature strands that I have been following is the "team science" literature. It turns out, with some caveats (correlation is not causation) that a heterogeneous groups will come up with ideas that homogeneous groups never will. For example, if you look at the United States Presidential Cabinet with all these 70-years old white men, it is no surprise they would separate children from their parents at the US-Mexico border. If you had at minimum 50% men and 50% women, that idea would have never have

had traction. Similarly, what's interesting it the art & science community is the very flexible nature of how these groups form. I think an important transition is from these solo artists in their studio to small groups of people working collaboratively on a project. So, heterogeneity is part of the territory we are talking about.

Yang: You describe the art & science a framework for doing something that can't be done otherwise. Does that terminology and our reliance on the anchor terms of "art "and "science" have the potential to simply re-affirm those disciplinary boundaries? Or is there are way of art & science to be post-disciplinary?

Malina: There was a conference that the Exploratorium did about 10 years back funded by the National Endowment for the Arts. There, the discussion was about "ways of knowing." And yes, there are different ways of knowing. If you want to convey something amazing you just experienced, perhaps the scientific method isn't going to be the best way to do that. There are real differences. That said, I think "art & science" is a catch-all term and we will use a different one in twenty years. We've gone through "electronic arts," "interactive arts," "new media arts, and now it is "art & science." The kind of work we are doing is not about building a new discipline. I always like to say, "we are not building a new discipline; interdisciplinarity is not a new discipline."

Yang: I've met many people in the arts that feel skeptical of the "STEM to STEAM" movement in education because there is a sense that the arts end up getting instrumentalized as a medium for science & technology to be communicated to the public, rather than art as a creative end in itself. What do you make of those concerns? [2]

Malina: There are times art should be in service of science, and other times in which science should be in service of art. But there are other times where there is a kind of middle ground of interaction in which both the science is modified and the art is modified. Yes, scientists should be much better educated about how to use contemporary media to express their ideas. But again, the part of the problem is an institutional problem.

One thing artists do is shift their attention from one thing to another. Suddenly the artist is going to start asking questions that are only at the periphery of what scientists think. Some of the practices clearly involve mutual influence. The artist Joe Davis has a desk in George Church's lab at Harvard using CRISPR technology to encode artworks. I have no doubt that George Church is hosting Joe Davis because he thinks Davis could change the direction that CRISPR research is currently going. The question is a false dichotomy. Again, to invoke the spirit of Stelarc: Is it either "science in the service of art" or "art in the service of science"? No, fortunately, it is much more interesting than that.

A point I always make is that one of the things artist do is

I don't know how to do a 'selfie' journal yet. But with a little bit if AI, maybe this would be possible. If Andy Warhol were alive, he would probably do an AI selfie journal of his art-making and different stages of his work.

to make science intimate in a way that scientists don't know how to. How do you just play with atoms? You can go to a quantum mechanic lab, but good luck. But if you want to play with atoms at home, do it in a computer game and suddenly you'll discover that atoms don't have edges, or that you can fuse them together. How does one form their intuition with things one has no experience with? I think it is one of the important roles that artists play — they make certain scientific ideas intimate.

References

[1] Gilles Deleuze and Félix Guattari discuss the "tree" organization model versus the "rhizomatic" organization in *A Thousand Plateaus: Capitalism and Schizophrenia* (University of Minnesota Press, 1987)

[2] The educational movement "STEM" is an acronym for "Science, Technology, Engineering, & Math". "STEAM" is the insertion of "Art," with the idea that arts are an important component for students in the learning and understanding of STEM topics.

Roger Malina currently holds dual appointments as Professor of Arts and Technology and Professor of Physics at the University of Texas Dallas, where his research group explores multiple lines of inquiry across the intersection of art and emerging technologies.

Andrew Yang is a transdisciplinary artist and writer working across flux of the naturalcultural. His projects have been exhibited from Oklahoma to Yokohama, including the 14th Istanbul Biennial (2015), a solo exhibition at the MCA Chicago (2016), and the Spencer Museum of Art (2019). His writings appear in *Leonardo, Biological Theory, Art Journal,* and many other publications. His holds a PhD from Duke University and MFA from Lesley University School of Art and Design, and is Associate Professor at the School of the Art Institute of Chicago. www.andrewyang.net

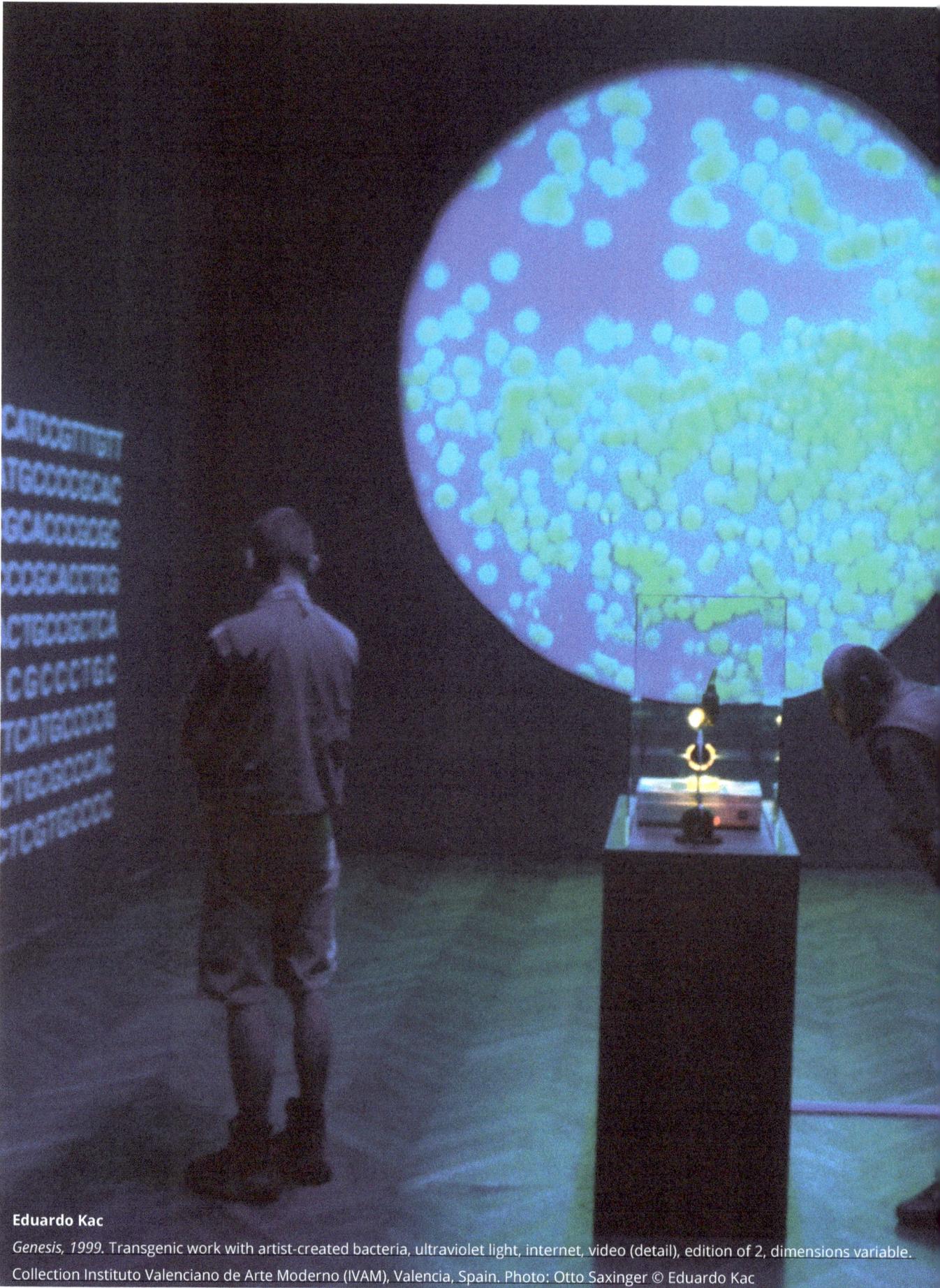

Eduardo Kac

Genesis, 1999. Transgenic work with artist-created bacteria, ultraviolet light, internet, video (detail), edition of 2, dimensions variable. Collection Instituto Valenciano de Arte Moderno (IVAM), Valencia, Spain. Photo: Otto Saxinger © Eduardo Kac

Eduardo Kac:
From Holopoems
to Outer Space

Eduardo Kac is considered a pioneer of bioestetic and telematic research. He is widely recognized for his interactive installations and his Bio aArt. An early experimentator of telecommunication-art in the pre-Web '80s, Eduardo Kac emerged in the early '90s with his telepresence and biotelematic works. His visionary combination of robotics and networking explores the fluidity of subject positions in the post-digital world. His work deals with issues that range from the mythopoetics of online experience to the cultural impact of biotechnology; from the changing condition of memory in the digital age to distributed collective agency; from the problematic notion of the "exotic" to the creation of life and evolution.

interviewee: **Eudardo Kac**
interviewer: **Giovanni Aloi**

Eduardo Kac's practice investigates the philosophical and political dimensions of communication processes. Equally interested in the aesthetic and social aspects of verbal and non-verbal interaction, in his work Kac examines linguistic systems, dialogic exchanges, and communication between species. His works, which often connect virtual spaces and physical spaces, propose alternative ways to understanding the role of communication phenomena in the formation / construction of consensual realities.

In the 1980s Kac became internationally known as a pioneer of Holopoetry and Telepresence Art. In the 1990s Kac created the new categories of Biotelematics (art in which the biological process is intrinsically connected to digital networks) and Transgenic Art. Kac combines multiple media and biological processes in order to create hybrids through the conventional operations of current communication systems. He first used telerobotics driven by the desire to convert electronic space from a representation tool to a tool for remote agency. He has created works in which the actions conducted by the participants via the Internet have a direct physical manifestation in the remote gallery space. Often resting on the indefinite suspension of the closure and on the intervention of the participant, his work encourages dialogic interaction and addresses complex issues concerning the notion of identity, agency, responsibility, and the possibility of communication itself.

In his work also Kac deals with topics ranging from the mythopoiesis of online experience (*Uirapuru*) to the cultural impact of biotechnology (*Genesis*); from the changed condition of memory in the digital age (*Time Capsule*) to the distributed collective agency (*Teleporting an Unknown State*); from the problematic notion of "exotic" (*Rara Avis*) to the creation of life and evolution (*GFP Bunny*).

His work has been exhibited extensively in the United States, Europe, and South America, in institutions like Exit Art, New York, Ars Electronica, Linz, Austria, InterCommunication Center (ICC), Tokyo, Saint Petersburg Biennial, Russia, Huntington Art Gallery , Austin, and Nexus Contemporary Art Center, Atlanta, Centre Pompidou, Paris. Kac's works belong to the permanent collections of the Museum of Modern Art in New York, Joan Flasch Artists' Book Collection, Chicago, and the Museum of Modern Art in Rio de Janeiro, Brazil, among others.

Our term at the time was pansexual, *meaning that we wanted to embrace the multiplicity of what is now called "gender expression." Instead of focusing on a specific form of identity, we wanted to advocate for all forms of identity simultaneously.*

* * *

Giovanni Aloi: One of the most fascinating aspects of your career is how over time you have focused on different conceptions of 'art and science'. However, following your creative trajectory, it is possible to identify persistent connecting threads. At the very beginning, for instance, in the 1980s we can already identify a clear interest in performance, language, and technology, and how these interfaces can mingle to ask important questions. Much of your early work seemed to pioneer ideas that have become more relevant today thanks to the work of Donna Haraway and Bruno Latour among others. I am more specifically thinking of the cyborg and the interconnectedness and anti-anthropocentric approaches of posthumanism.

How has the perception of your early works shifted over time in light of the non-human turn and the prominence that scientific and technological interfaces have gained over the past twenty years?

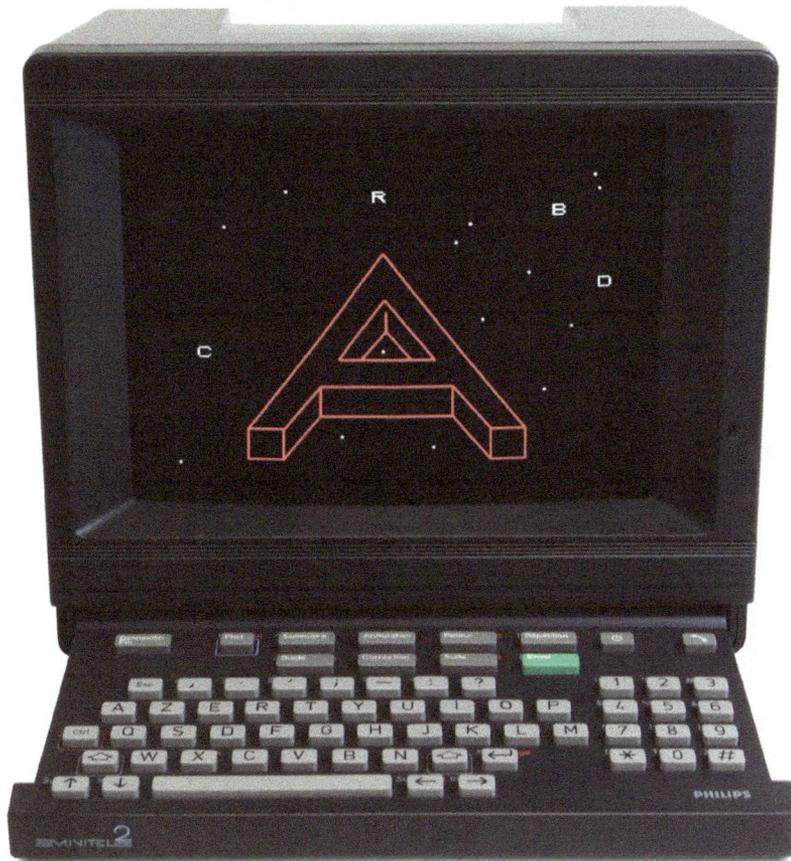

Eduardo Kac

Reabracadabra, 1985. Minitel terminal, digital poem transferred to video (color, silent; 35 sec.). Museum of Modern Art, New York

© Eduardo Kac

Eduardo Kac: One interesting case that illustrates this shift in perception is my series of "Minitel works" from 1985-86. At that time, I produced four works for the French Minitel system, a digital network that predates the web. In 2012, the French government ended the Minitel network. Starting in 2000, I spent 15 years researching and working on the restoration of these works. The restoration was completed in December 2015, and in January 2016 they premiered at the exhibition "Electronic Superhighway (2016-1966)," at the Whitechapel Gallery, London, where they were featured as pioneering works in online art. Likewise, one of the Minitel pieces was featured in the 2019 show *The Art Happens Here: Net Art's Archival Poetics,* at the New Museum, New York, which was focused on preserving online art. Many of my subsequent works from the 1980s and 1990s explored interconnectedness and anti-anthropocentrism. At this point it is a trajectory of nearly 40 years.

Aloi: How did your career start?

Kac: I started in 1980 and I leaped into the scene from a place of

Eduardo Kac

Porn Art Movement (1980–1982), Movimiento de arte pornô (1980–1982), archive at MoMA.

© Eduardo Kac

thought and research, of reading and thinking. I started with The Porn Art Movement. In 1980, "art" and "porn" were not compatible ideas. This phrase, "porn art," produced cognitive dissonance. The idea was to subvert the semiotics of porn to produce work that was imaginative. But at the same time, we wanted to produce work that would offer new forms of political resistance.

The Porn Art Movement was a genuine avant-garde project

with manifestos, journals and magazines, and programmatic organized interventions. That was meant as a new way of producing work that did not align with received ideas of self-ascribed universal normative subject positions.

The Porn Art Movement was rejected by both the political left and the right. It was rejected by the right for obvious reasons, and by the left for less obvious reasons, perhaps. But the left was still, by and large, stuck with old Marxist paradigms. We were also rejected by experimental artists and poets because something that worked with queerness and gender was not, at that time, seen as a legitimate cultural space of practice.

Our term at the time was *pansexual*, meaning that we wanted to embrace the multiplicity of what is now called "gender expression." Instead of focusing on a specific form of identity, we wanted to advocate for all forms of identity simultaneously.

For several decades, The Porn Art Movement was not of interest to most. It fell into absolute oblivion, until 2012 when a young group of scholars rediscovered it. They curated an exhibition about the '80s at the Reina Sofia Museum in Madrid and brought that work back to life. As a result, the work is being reconsidered in light of current practices that are focused on this mode of thinking and this type of practice. That was one early disruption that I pursued in a very different space, in a very different time. Not to mention the fact that, in Brazil, where I then worked, there was still a military dictatorship in place. All that complicated matters in different ways. But in any case, by 1982, when I had already completed that project, I felt that I had done what I wanted to do.

Aloi: How did you transition from your early work to technology-based art?

Kac: At that point, I came to realize that everything that I had done, and as a matter of fact, everything that had been done in art up to that point could fall under one rubric: analog.

What I'm trying to say is this: the history of art is marked by different types of "generational conflicts" between different movements that sought to push the accomplishments of the previous generation in entirely new directions or to oppose them flat out. Consider, for example, the classic opposition between figurative and abstract painting. Or, the antagonism between linear and visual poetry. These dynamics and conflicts, which lie at the core of literary and art-historical structures, appeared to be subsumed under the same rubric: analog. It seemed to me that the true paradigm shift moving forward in 1982 was digital. Digital was a wholly new dimension–a clear intellectual and material turn.

In 1986, I wrote an article for a newspaper in which I said that, if from the '60s and '70s we inherited the notion of dematerialization, we now produced works that were directly immaterial. Oscar Masotta first articulated the notion of dematerialization in 1967, in Buenos Aires, borrowing from (and quoting) Lissitzky. In the '20s telegraphy, the telephone, and radio, had introduced dematerialization. Masotta updated that concept with television and satellite and other technologies of the late '60s. In 1982, I created my first digital work. And in 1985 I produced my first online work with the Minitel.

Aloi: What brought you to work with the idea of communication,

> *I came to realize that everything that I had done, and as a matter of fact, everything that had been done in art up to that point could fall under one rubric: analog.*

Eduardo Kac

Accident, e-poetry, 1994 © Eduardo Kac

telepresence, and the challenges that it entails in the first place? I am thinking about technological as well as philosophical challenges. Where did this interest come from and why did you establish that this was the right direction for your research?

Kac: With *Digital Poetry* and *I Holopoetry,* I undermined the stability of language, creating works that were fluid, dynamic, transformative, interactive. This led to me to work with modes of communication that were not language-based, which then led me to work with non-human communication. I made my first telepresence work in 1986, and I continued to develop telepresence throughout the 1990s. It's important to not confuse telecommunications (the exchange of text, sound and images at a distance) with telepresence (the coupling of telecommunications and physicality, such as my telerobots). As I invented it, telepresence art was not about simulating presence but inventing new modalities of presence.

Aloi: Poetry has a special place in your practice, right?

Kac: I have a dual practice in contemporary art and poetry. Even though I go to museums and I look at paintings, I do not paint. Even

though I read poetry books, I do not produce poetry for books. There's a difference in the kind of practice that I engage with versus my personal appreciation of art and poetry in their multiple forms. Already in the early 1980s, I produced poetry that was presented in the form of graffiti or performance or stickers or different kinds of objects.

I've always been interested in what we might call "Expanded Poetry", to borrow Gene Youngblood's notion of "Expanded Cinema." Expanded Poetry is a serious engagement with the literary form of poetry, with the difference that it is not written for the book.

Aloi: This all sounds very contemporary.

Kac: Yes. This is happening now. Poetry is experiencing an expansion beyond the book and that's something that I've always been interested in from the very beginning, since 1980. When I shifted to digital and subsequently to these other forms like holographic poetry, starting in 1983, my interest was to continue to develop new types of poetry. While doing this, I was not interested in reproducing existing syntaxes that were conceived for the book. I was interested in inventing new syntaxes.

What's really unique about poetry is not necessarily the theme. Poets are humans and humans are always interested in the same themes; love, death, anxiety, aspirations, et cetera... Mallarmé, for example, or Rimbaud, Whitman, it's in the syntax that they convey a worldview.

The syntax of my holopoems is often metamorphic, interactive, surprising, literally changing according to the point of view. I seek to create poems that have this destabilizing factor so that we can gain a lived experience of language not as something that is static and capable of being domesticated. The problem with the book is that it conveys what I understand to be a fallacy by presenting language as a physically stable mark on a surface. It gives the impression that there's something graspable about language. In my practice, I seek to do the opposite by giving up the book and working with media that allow me to give the reader a lived experience of language as fluid, not graspable, something that you cannot grasp, that you cannot control.

Aloi: What you say brings to mind the emphasis on materiality that we see in contemporary art right now. It makes me wonder if there might be a new question about materiality and language emerging. The idea that traditionally the materiality of language is associated with the page of the book, which gives it a material presence that impacts meaning. This impacts how we engage with syntax. Instead, the dematerialization you are interested in, is not a negation of materiality, right? It's a transformation into different material dimensions. Do you perceive the dematerialization of information and images or text as a transformation from a material to another, a kind of transubstantiation, or is there something else at stake?

Kac: In a sense, the book is considered the norm and the reference for language. It would be the same as saying the piano would be the norm and the universal instrument so that when you think music, you think piano. The book has taken on the place of the cisgendered white male as the norm, as the universal value of reference. But moving forward, poetry as a serious engagement with the craft of literary writing, and has been, and will continue to be pushed be-

Poetry has traditionally seen itself as a serious writing form. That has to do with another normative prejudice. Intellectual pursuits have, in the course of time, as we know, separated themselves from the lived body, from the urges of the lived body, from the metabolism, from the desires of the lived body. The pursuit of language is a "higher" endeavor.

yond the normativity dictated by the book. Even when language is not visually present, my work aims at undermining its centrality in human experience.

Aloi: The primacy of language, and your desire to subvert its normative ability, brings to mind your latest artwork: *Inner Telescope*. How did the idea come develope?

Kac: It's been my dream since the '80s to create a work in outer space, i.e., outside of the planet Earth. An early effort in that direction was my development of holographic poetry because by writing with light — and given the fact that light is made of photons and photons do not have mass — I was able to write in space and time without the perceivable constraints of gravity.

Let's be clear. We're not ridding ourselves entirely of gravity, we are on Earth. The Earth moves because of gravity, the moon orbits the Earth because of gravity. But conditions of low gravity or zero gravity are very specific phenomena that are experienced under specific conditions. Gravity acts in one direction. It pushes us towards the center of the Earth and as a result, keeps us attached to the ground.

In other conditions we experience isotropic forces, the forces are acting upon us from all directions at the same time. So, you're not being pushed down, you're not attached. The whole history of human culture is predicated on gravity. Think about the antinomy, for example, of intellect versus the body. Your feet will be the dirtiest because they touch the ground and your brain is elevated, has conquered gravity, is the highest element, physically speaking, in your body. These facts lead to misperceptions. The notion of north and south, there's the expression, "Oh, things went south," meaning they went bad. Well, there's no north or south in space. Why is the north at the top of the map and the south at the bottom? The bottom is where your feet are, where animals live. Snakes crawl. Hierarchies of value have been created because of gravity. Language is gravitropic, language follows gravity. Consider every writing system that has ever been created. Written English goes from left to right and then down. Hebrew and Arabic go right to left and then down. Ideographic systems are vertical, but they begin at the top and they go down. The written word is gravitropic. What happens if we don't have that condition anymore? A whole new culture can be created. This is the key.

When I started to work with digital, I understood that it was not just another medium in my repertoire. This is why I said earlier that digital made me understand that all the aesthetic disputes of the past would be considered as belonging to the rubric of analog because digital introduced a paradigm shift—the beginning of a new culture.

Outer space is not just a medium or a tool that you employ. To free myself from gravity in the creation of Inner Telescope also bears a key symbolic dimension. Inner Telescope is the first poem written for zero gravity. But it is also the first artwork literally, physically made outside of the Earth.

We will spend more time in space in the decades that will come. In the near future, we're going to go back to the moon, both with an orbiting station and a habitat. This will also help us prepare for Mars. Space tourism will grow. Moving forward, we will begin to spend more time outside of Earth and non-professionals will begin

to have access to space as well.

Virgin Galactic has recently crossed the threshold of the atmosphere into outer space, meaning that space tourism will slowly begin to be a reality and that prices will progressively go down as they did with airplane flights.

You can't be the same once you experience this completely different environment in which everything you know does not apply. There's no up and down, no left and right, no front or back. So, a new culture has to be created and *Inner Telescope* is the first artwork that was literally made outside of Earth as a marker of this new era.

Aloi: What challenges did you encounter in actually making *Inner Telescope?*

Kac: I was an artist in residence at the French Space Agency for 10 years. The first three years, the French Space Agency did not have an astronaut. Thomas Pesquet was selected when I was already three years into the residence at the French Space Agency. Then, Thomas spent the next seven years training to become an astronaut until the day of the flight. At that point, I just had to wait for him to become an astronaut. The main challenge was time. The flight was delayed and there were issues with the rocket, but the main challenge was waiting for 10 years.

Working with the Observatoire de l'Espace, which is directed by Gérard Azoulay, was fantastic. The Observatoire de l'Espace is the cultural lab of the French Space Agency. It was the first time that they had been involved in a project like this. Working with him and Thomas, and the European Space Agency, was fabulous.

Aloi: I wanted to ask you about one of my favorite works of yours from the early period which is *Essay Concerning Human Understanding* (1994). I remember that after human-animal studies emerged at the beginning of the millennium, one of the big waves of interest between 2005 and 2010 was interspecies communication. I see *Essay Concerning Human Understanding* as a precursor of all that. This artwork was a live, bi-directional, interactive, telematic, interspecies sonic installation you produced with Ikuo Nakamura between Lexington (Kentucky), and New York. In this work, a canary dialogued over a regular phone line with a plant (Philodendron) 600 miles away. Can you tell us a little bit more about how you entered that sphere? What interested you about multispecies communication and how did you arrive at *Essay Concerning Human Understanding*?

Kac: *Essay Concerning Human Understanding* is the result of my interest in expanded poetry, telepresence, and undermining the centrality of language. Most people think of communications in terms of human interaction, especially human transmission of information, which is a very limited and very specific subset of the communications phenomenon. For example, when somebody says, "Do you know what I mean?" It's an attempt to receive feedback to see if the message has been transmitted successfully. If what I want you to understand has come across, right?

To me, that is persuasive communication. It's a subset of a wide array of communication practices. I'm interested in communication processes that do not necessarily involve human-based lan-

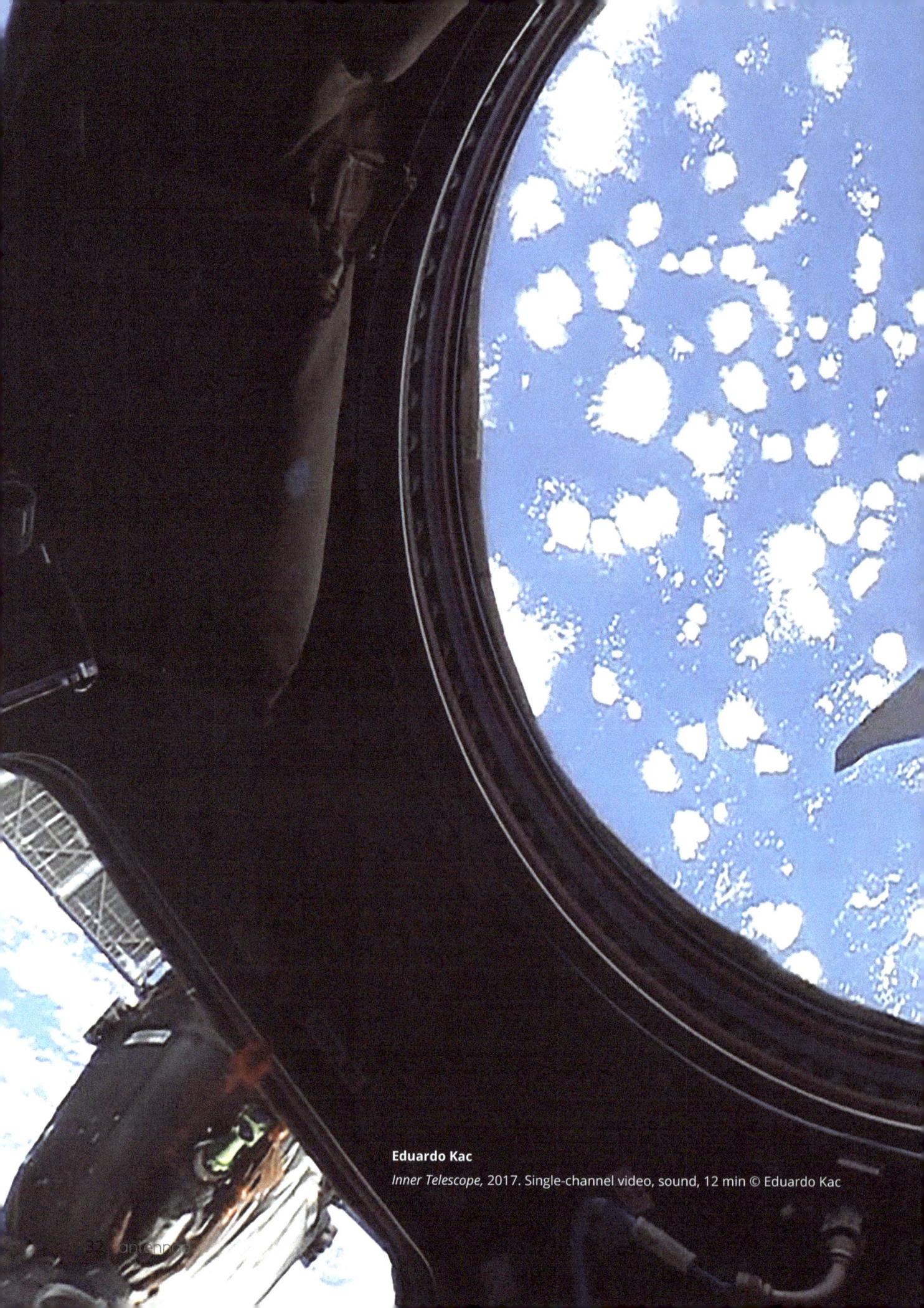

Eduardo Kac
Inner Telescope, 2017. Single-channel video, sound, 12 min © Eduardo Kac

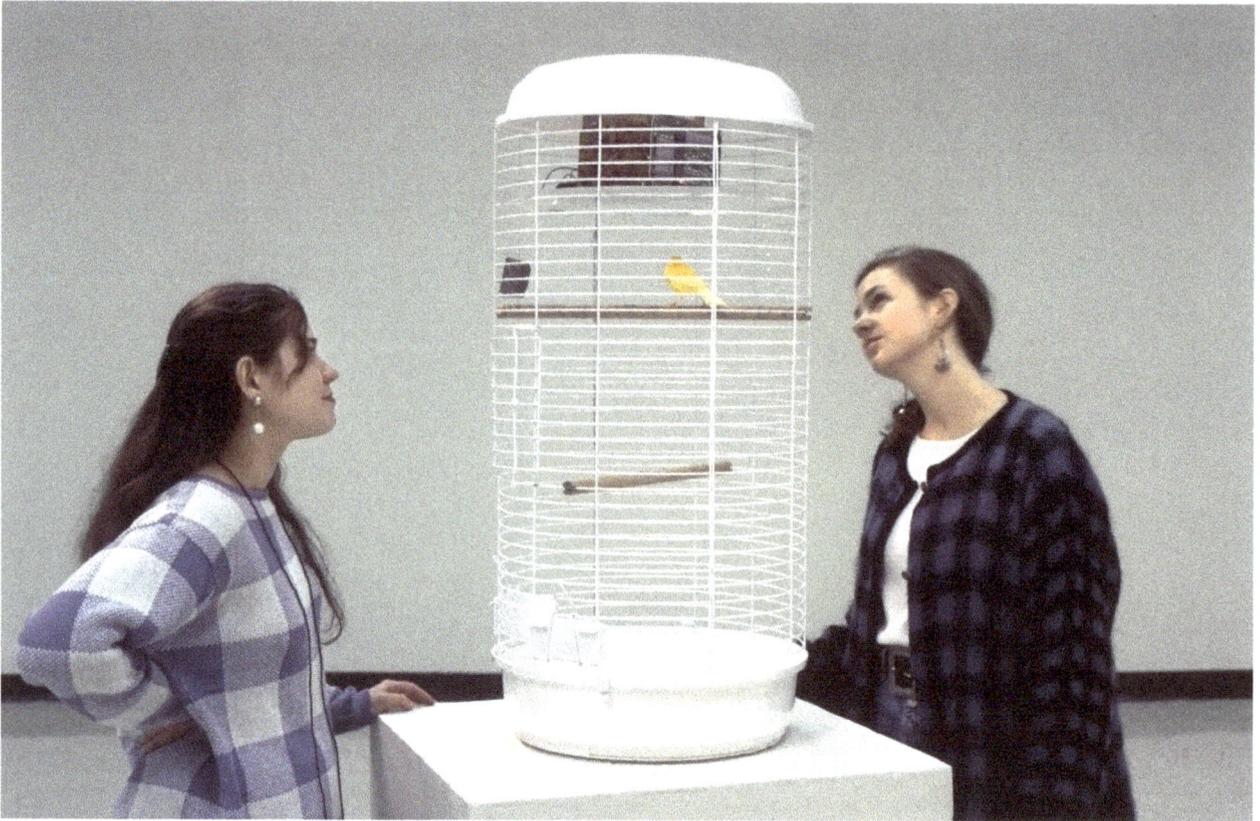

Eduardo Kac

Essay Concerning Human Understanding, 1994 © Eduardo Kac

guage. I'm also interested in non-semiological communication processes. For example, when we open a window and the cold air from outside communicates towards the inside, changing it because of its transformative properties.

I was interested in the possibility of expanding human perception beyond our limited spectrum. At the same time, I was interested in the possibility of creating work for beings that see the world, experience the world, in different ways. I already stated in the early 1990s that this and other artworks of mine were works of interspecies communication, as you can see in my articles published at the time.

Aloi: What you're saying reminds me of your 1999 artwork titled *Darker Than Night,* which involved bats. Notably, the work entailed the possibility of machine/animal communication through the use of a robotic bat.

Kac: Absolutely. And also, human/non-human communication. The idea was to remove the question of the human entirely and create work of direct interspecies communication. I must say that most people laughed at these early works of interspecies communication. It was challenging. It was difficult because most people did not understand the philosophical underpinning of the work. People found it funny. I said, "No. I mean it in earnest. This is not meant to be humorous."

Aloi: Humor also seems to be an important factor in your work,

I'm interested in communication processes that do not necessarily involve human-based language. I'm also interested in non-semiological communication processes. For example, when we open a window and the cold air from outside communicates towards the inside, changing it because of its transformative properties.

Eduardo Kac

Essay Concerning Human Understanding, 1994 © Eduardo Kac

especially earlier on in your career. There is something interesting about the daring proposals your put across in your practice. At times, I detect a sense of playfulness, for instance.

Kac: When I developed *The Porn Art Movement,* humor was central for a number of reasons. The project was extremely disruptive in a way. It was meant to really shift conversations and invent new forms.

Poetry has traditionally seen itself as a serious writing form. That has to do with another normative prejudice. Intellectual pur-

suits have, in the course of time, as we know, separated themselves from the lived body, from the urges of the lived body, from the metabolism, from the desires of the lived body. The pursuit of language is a "higher" endeavor. Everything that has to do with the body is perceived as being closer to the animal and therefore less dignified.

Humor goes directly to some fundamental, visceral process that short-circuits the logical chain of thought. Most importantly, produces a spasm which for us was analogue to an orgasm. We performed the poem and we produced the spasm in our listener. It was remarkable. We subverted in the poems expected relationships between notions of gender and power, and those unexpected reversals produced this bodily reaction, laughter.

I realize that when I coined the name, "Edunia", in 2009, it has caused people to chuckle. The name emerged as part of the central work in my Natural History of the Enigma and it is a plantimal, a new life form I created and that I called "Edunia", a genetically engineered flower that is a hybrid of myself and Petunia. The Edunia expresses my DNA exclusively in its red veins.

Aloi: Yes, there's some humor there, I agree. Something about the name Edunia, that's sweet. There's a sense of ownership and care in it that distances itself from the cold, institutional approach of science with its Latin nomenclature.

Since we're talking about *Edunia*, can you tell us about your relationship with scientists? Because so many of your important works entail multidisciplinary collaborations with individuals who usually work in institutions that are not accessible to the general public. Let's say if you were to give advice to an up and coming bioartist who was willing to engage with the scientific interface like you have, what would you tell them about working with scientists?

Kac: Collaboration means to co-labor. It means to work with others. We always work with others. Without the countless people that were involved in designing, creating, producing these objects, for example, this telephone and this recording software, what we're doing right now would be impossible. Directly or indirectly, you're always working with others. That's one aspect to consider.

Another aspect to consider is that working with others is nothing new. In history, countless painters if not every painter has worked with others. Rembrandt, Rafael, you name it. Countless people in the studio participated in the production of the work that left the studio. That is co-laboring. Filmmakers do it all the time. Orson Welles was brilliant but without the casting director, or the costume director, he couldn't do what he has done.

I don't think there is anything too specific to my practice in regard to working with others that would deserve to be singled out. Rafael Lozano-Hemmer, Olafur Eliasson, and others have studios in which many people labor. So, they co-labor. Co-laboring is different from shared authorship. The director is responsible for the film, independently of who wrote the script.

Aloi: One of your more controversial works has certainly been *GFP Bunny* (2000), in which was born Alba, the genetically manipulated fluorescent bunny which generated heated discussiuon at the dawn of the new millennium. Almost twenty years after the unveiling

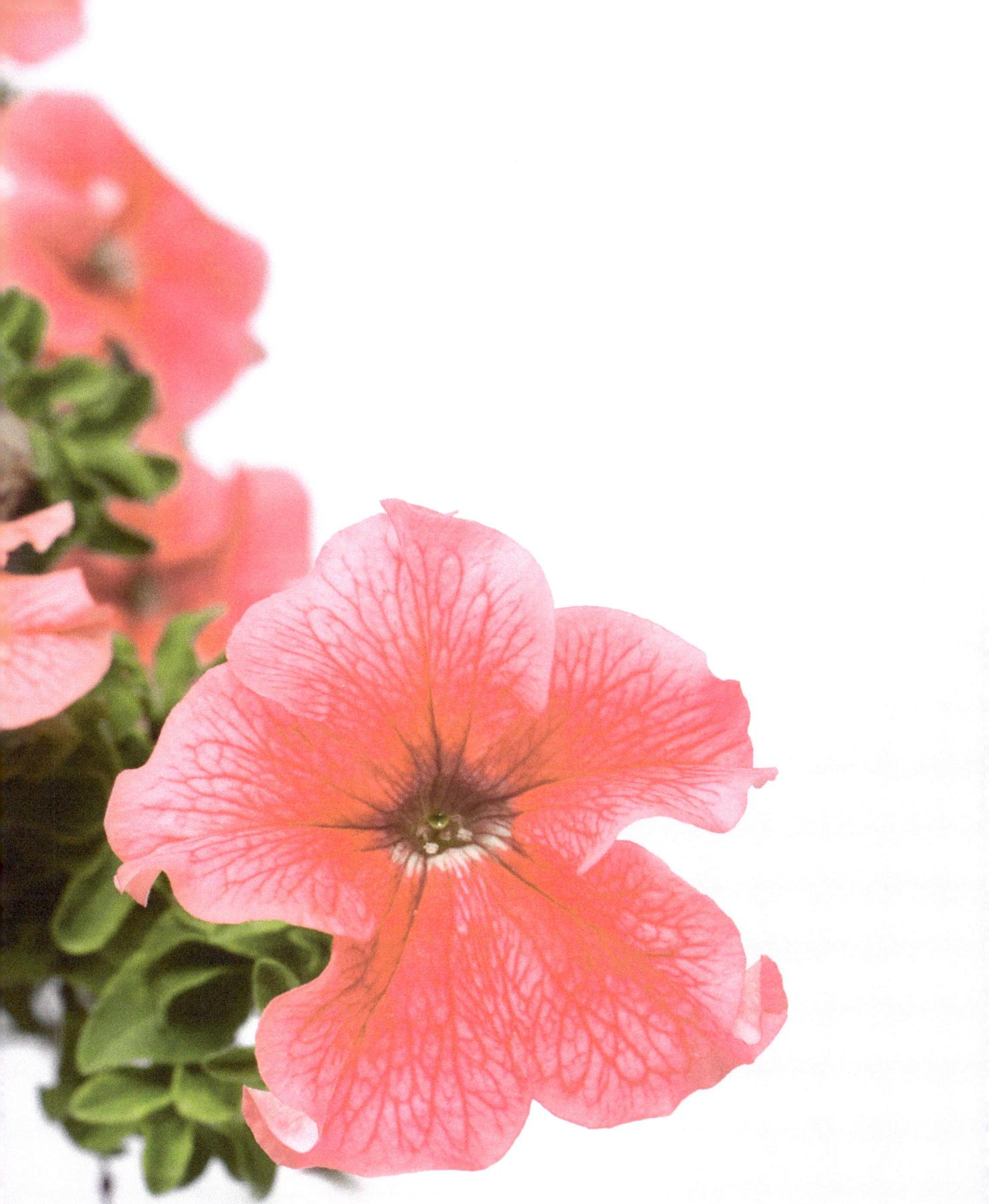

Eduardo Kac

Natural History of the Enigma, transgenic work, 2003/08. "Edunia", a plantimal with the artist's DNA expressed only in the red veins of the flower. Photo Rik Sferra © Eduardo Kac

that project, *GFP Bunny* has found its firm place in the history of art and continues to influence popular culture, most recently with an appearance in the blockbuster Smurfs: The Lost Village. There still is a lot of mystery around what really happened with Alba, why it was not allowed to follow you home here in Chicago. *GFP Bunny* has its own mythology, which is also what, I think, makes the work really interesting. How do you feel about that work in the context of your career?

Kac: It's possibly my best known work, and as such ends up serving as an entry point for many people. However, my trajectory spans four decades and, I believe, it's more interesting to consider my Bio Art in relation to my poetry, my telepresence pieces, my olfactory works, in sum, my career as a whole.

Aloi: Why wasn't she allowed to leave the laboratory?

I don't really see genetic engineering or CRISPR as an operation against nature. It's more about the impact? The cascading impact of what we do now to the future and again, because I don't really think that DNA manipulation is as powerful as it's being portrayed.

Kac: Initially we agreed she was going to come home. But then the laboratory's director changed his mind. Initially, I tried very hard to reverse the lab director's position, which was censorship. He was probably afraid that the worldwide attention might have negative consequences for the business side of the lab, but this we'll never know for sure. I first tried to free Alba discreetly, asking common acquaintances to intervene, and that wasn't going anywhere. Then, I tried a very public campaign in Paris, with posters, television interventions, radio interventions. I gave a lecture at the Sorbonne. Louis Bec and I wrote a manifesto complaining about the censorship. It was sent out to people via email. All this did not result in freeing Alba from the lab. As I realized that the likelihood of her leaving was decreasing by the day, after all these efforts, I also realized that she had captured the public's imagination.

Aloi: If Alba had been allowed to come to you in Chicago, how do you think U.S. customs would have handled it? I am referring to the legal controversy generated by Brancusi's *Bird in Space* arrival the United States in 1926. Although the law permitted artworks, including sculpture, to enter the U.S. free from import taxes, when Bird arrived, officials refused to let it enter as art. To qualify as "sculpture," works had to be "reproductions by carving or casting, imitations of natural objects, chiefly the human form". Since *Bird in Space* was substantially abstract and did not look like a bird at all, officials classified it as "kitchen utensils and hospital supplies" and levied against it 40% of the work's value. Were you counting on a similar situation to arise in the context of Bio Art?

Kac: I don't think we would have had that problem. At the time Carol Becker was still the Dean at SAIC. She put me in contact with the school's lawyer, and I put the school's lawyer in contact with the lab's lawyer. Transgenic animals move around the world all the time. There's a protocol for this; if you follow the protocol, there should be no problem. So, a lot of the mythology around *GFP Bunny* results from a lack of familiarity with simple facts like this.

Aloi: And the lab?

Kac: The lab did not invent transgenic animals; the lab did not invent

Eduardo Kac
GFP Bunny, 2000, transgenic artwork. Alba, the fluorescent rabbit © Eduardo Kac

transgenic rabbits. The first transgenic rabbit was created in 1985, but of course was not fluorescent. Alba did not exist before my work and was created as art. In any case, I'm not a scientist, I'm not competing with scientists, I'm making art. Picasso did not invent oil painting.

Aloi: Good analogy, I would say. [laughs].

Kac: As artists, we're not inventing materials, we're inventing perceivable form. Right?

Aloi: ...or applications of form, perhaps?

Kac: I create form that is given to the senses for cognitive and emotional experience. That's what artists do, in one way or another. I'm making art and I am not in competition with scientists, even though some scientists have claimed that my work *Genesis* (1999) was the first time in history that text was encoded into DNA. *Genesis* is a transgenic artwork that explores the intricate relationship between biology, belief systems, information technology, dialogical interac-

Sony Pictures

Smurfs Hefty on Bucky Figure, 2017, toy © Sony

tion, ethics, and the Internet. The key element of the work is an "artist's gene", a synthetic gene that I created by translating a sentence from the biblical book of Genesis into Morse Code and converting the Morse Code into DNA base pairs according to a conversion principle I specially developed for this work. But back to Alba...

Transgenic rabbits have existed since 1985. But a transgenic rabbit is not a synonym of a green glowing rabbit, that's something I created. Transgenic rodents, transgenic pigs, and other transgenic life forms from the '80s were created by the introduction of a foreign gene. That is often done in science for the study of disease. These animals were created as what they call in science *disease models.* That's what the lab did on a regular basis, the lab created models for scientists around the world. They were accustomed

to shipping these models to labs all over the world, to the United States as well. That would not have been a new thing for them to do. What they had not done before was to create an animal that had no value for science whatsoever and to do so for an artist. But sending a transgenic animal out of their lab is something they regularly do.

GFP is a visualization tool that is only of interest if used locally in an organism. You attach GFP, let's say, to a sequence that will generate a tumor. GFP makes it possible to track tumor growth. That technology is only scientifically worth something if it is localized—scientists say *targeted.* Instead, I expressed that ubiquitously in Alba's body because I wanted to invent, not a new art object, but a new art subject which is a new category of art.

Aloi: Years ago, while researching Alba for my first book *Art & Animals,* I came across one of your rather thought-provoking quote. You said, "With at least one endangered species becoming extinct every day, I suggest that artists can contribute to increasing global biodiversity by inventing new life forms". How do you feel about this statement today as evidence that a sixth extinction is well underway?

Kac: Culturally we operate with the false premise that somehow evolution has come to a close, that the evolution's work is done and we, humans, represent the apotheosis of that process. That's completely false. We have come to learn that neurons are malleable, DNA is malleable, as well as other biological elements which we once believed were fixed once they achieve a certain level of development and maturity. Likewise, life is malleable. When people ask, "What right do you have to create this being?" I ask back, "What right do you have to prevent this being from living?"

The question is not whether or not we bring new beings into the world. The question is under what condition we do that. This is why I insisted from the beginning that responsibility is key in the double sense of the word; to me "being responsible" for Alba was key because I was the one who initiated the chain of events that led her to come into the world. But also, in the sense of the possibility of response, so that Alba would live in an environment where she could be free and that I would get to know this individual. Because not all rabbits are the same. Every single living being is an individual. I wanted to highlight that.

I see how the destruction of species continues at an accelerated pace. Life on this planet is being deeply affected by human actions. My statement does not posit the creation of species as a solution to the elimination of species. I'm an artist, I'm not a scientist, I don't work in law or conservation, I work in a very specific realm of cultural practice. Within that realm, the emergence of new life does counter the destruction of life but that's not a solution. Conservation and preservation of natural habitats, and new laws that protect endangered species—these are the solutions to natural disasters and destructive human actions.

Aloi: Bio Art has become much more prominent over the past twenty years. Institutions are more prone to expand their curatorial as well as conservation parameters in order to represent it in their collections. What, in your opinion, are Bio Art's biggest accomplishments and where do you see the field going?

Kac: Bio Art has already some classics. Beyond my own contribution, Martha de Menezes's butterflies are exemplary works. George Gessert's irises also are a hallmark of Bio Art. Art Orienté Objet's *Let the Horse Live in Me* is also a paradigm-shifting work. Paul Vanouse's work with gel electrophoresis is emblematic. Some of these works have defined Bio Art. But there is so much more happening today. Different approaches that all contribute, in their own way, to make BioArt richer, more diverse, formally speaking.

Aloi: Perhaps the latest frontier in Bio Art is CRISPR technology. What is your take on that?

Kac: It's just another tool. The question is not oil, but the painting that the artist made. We can't get fixated on tools.

Aloi: Is it something that you might be interested in working with?

Kac: If what I want to do requires me to use CRISPR, then I will. It's not a question of technology, it's a question of my aesthetic idiom, my vision. What I'm working on now can't be done with CRISPR.

Aloi: As I am sure you're aware that CRISPR has raised quite a few ethical questions. I was wondering if there's an ethical aspect that you'd be concerned with in using CRISPR rather than the transgenic processes that you have already employed.

Kac: No, it's just a different way of editing DNA. With CRISPR you're basically editing what's there and transgenic technology implies either cloning DNA that is found in nature or designing your own and then inserting foreign DNA into an organism. CRISPR is trans-genic in the sense that you are editing DNA with RNA and proteins adapted from bacteria and archaea. It's trans-genic also in the sense that the DNA configuration of an organism was X and now it's Y. It has shifted. Before CRIPR, transgenic procedures required you to bring a gene from the outside in, but you are bringing something from the outside in which is CRISPR technology itself to do the editing.

Aloi: What are you currently working on?

Kac: It's too early to discuss it.

Eduardo Kac is internationally recognized for his groundbreaking and influential contributions to the development of contemporary art and poetry. In 2017, the New York Times published a full-page article about Kac's Inner Telescope, a work he conceived for and realized in outer space with the cooperation of French astronaut Thomas Pesquet. His work is part of the permanent collection of the Museum of Modern Art in New York; Tate Modern, London; Victoria & Albert Museum, London; the Institute of Modern Art of Valencia, Spain; the ZKM Museum, Karlsruhe, Germany; and the Museum of Contemporary Art of São Paulo, among others. <ekac.org>

Aki Inomata: Think Evolution

Born in Tokyo, artist Aki Inomata has been exhibiting her work since 2002. She received an MFA in Intermedia Art from Tokyo University of the Arts in 2008 and is a recipient of the 2014 YouFab Global Creative Awards Grand Prize. Inomata's work often involves 3D printing and relies on collaborations with animals. Together, Why Not Hand Over a 'Shelter' to Hermit Crabs? *and* Think Evolution *draw important considerations on notions of deep-time, mobility, temporality, and change.*

text and images by **Aki Inomata**

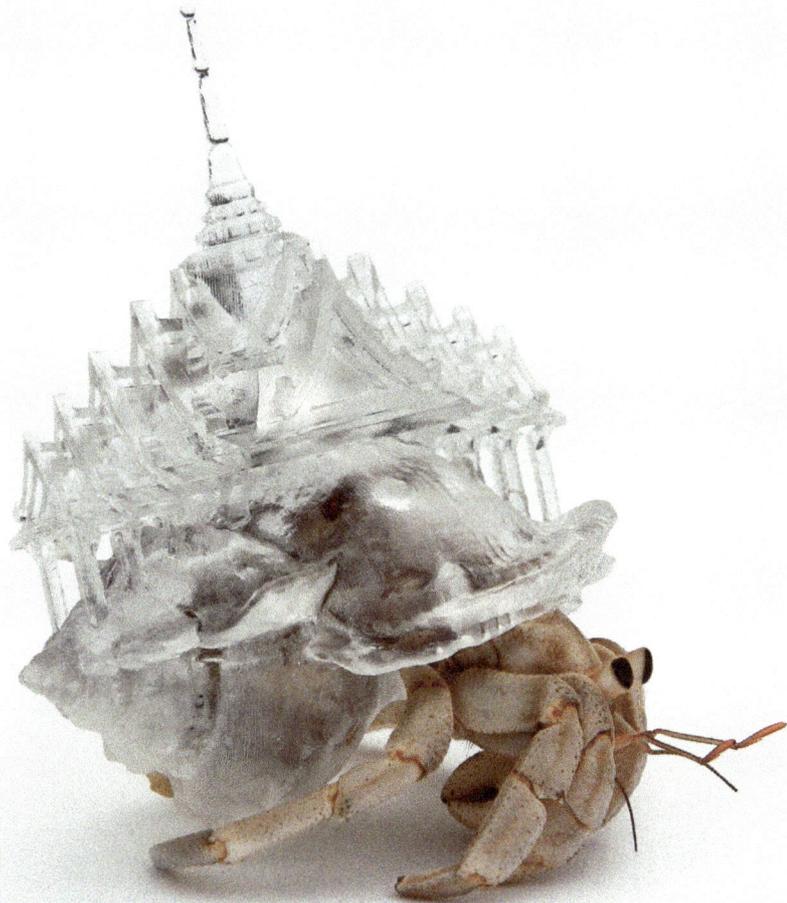

Aki Inomata

Why Not Hand Over a 'Shelter' to Hermit Crabs? - Border (Bangkok), 2009-ongoing. Courtesy of Moho Kubota Gallery © Aki Inomata

Aki Inomata
Why Not Hand Over a 'Shelter' to Hermit Crabs? - Border (New York City),
2019. Courtesy of Moho Kubota Gallery © Aki Inomata

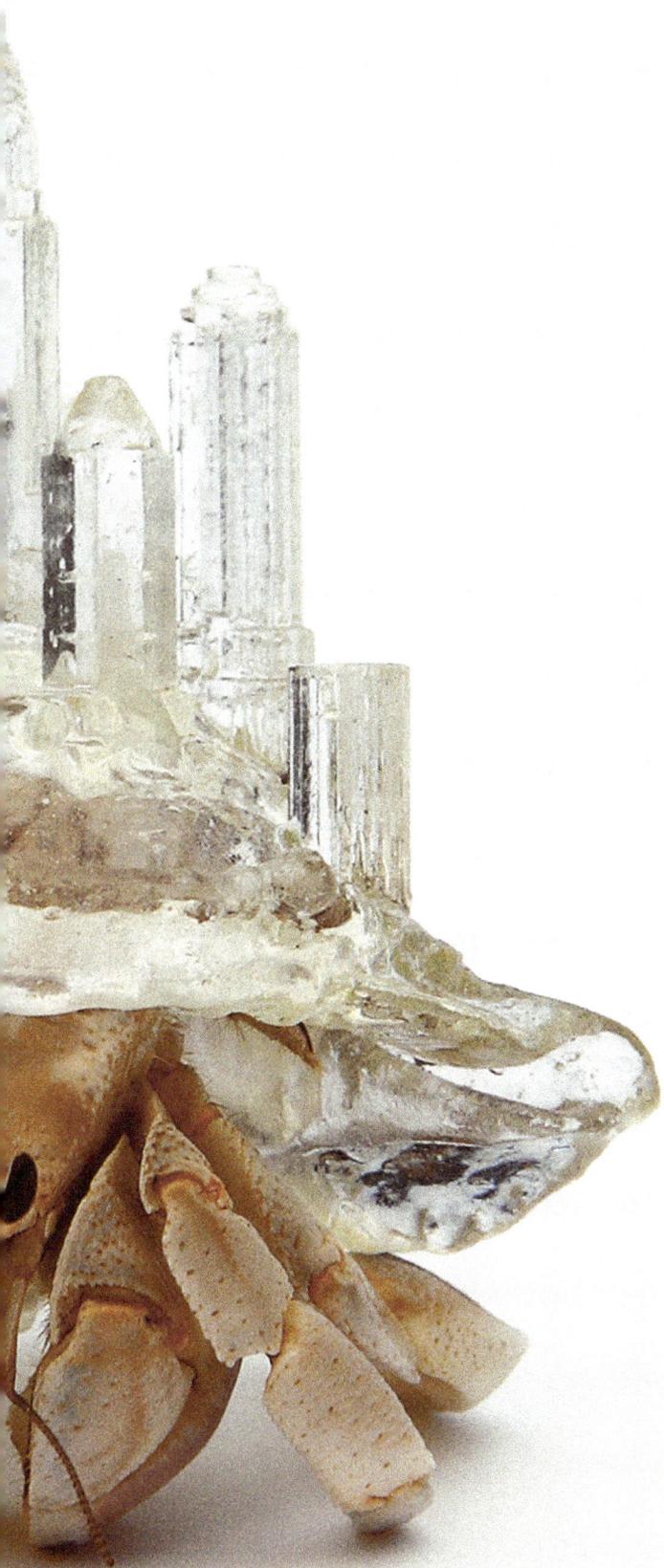

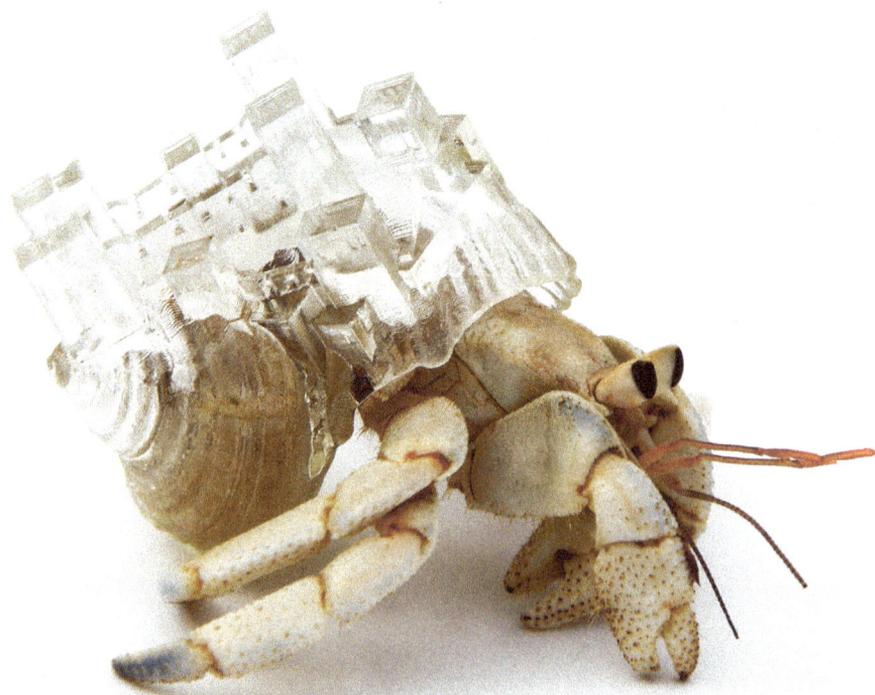

Aki Inomata

Why Not Hand Over a 'Shelter' to Hermit Crabs? - Border (Marocco), 2019. Courtesy of Moho Kubota Gallery © Aki Inomata

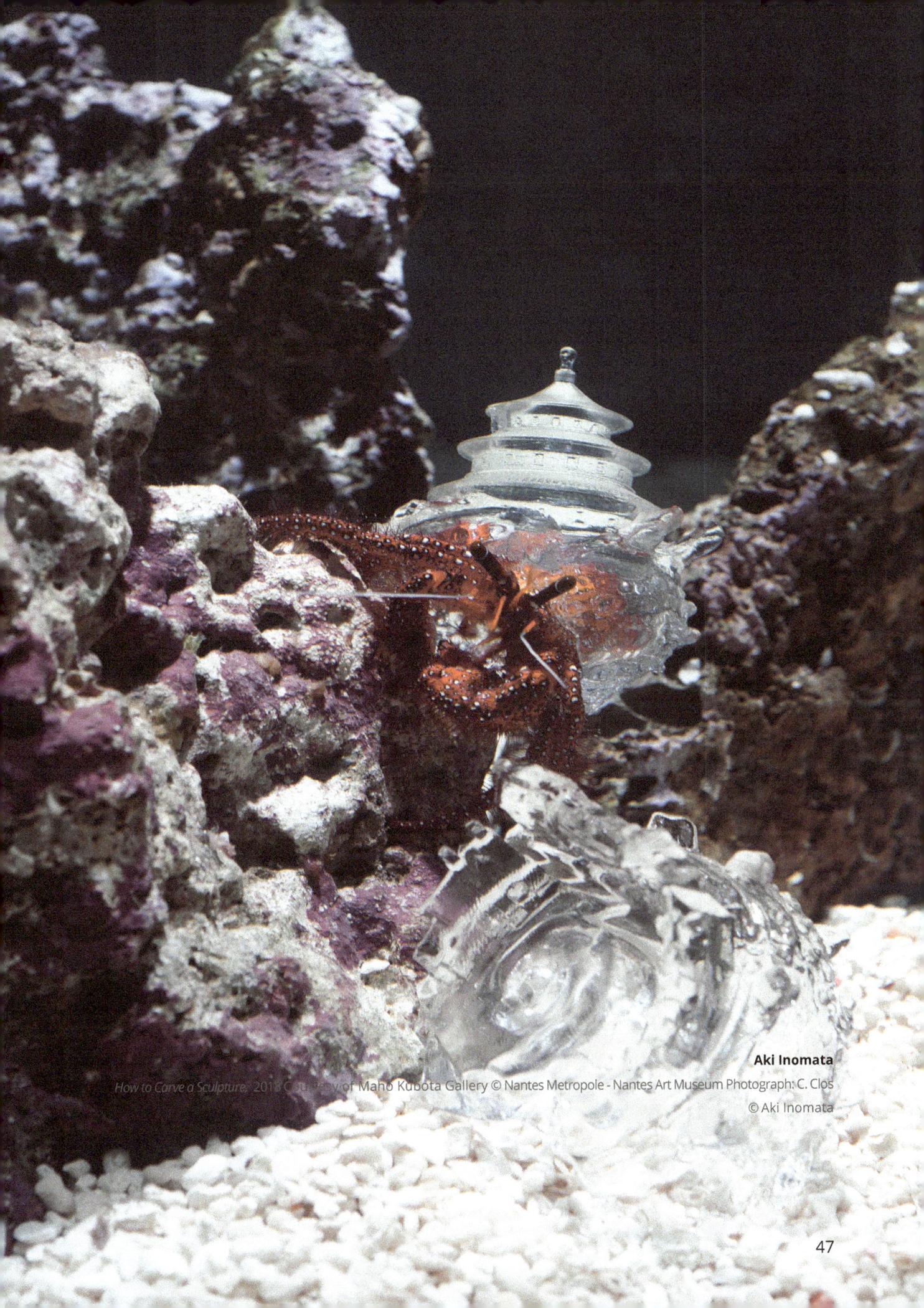

Over the last couple years, Aki Inomata's *Why Not Hand Over a 'Shelter' to Hermit Crabs?* series has received recognition in Japan and abroad. The Japanese term for hermit crab is *yadokari* which means a tenant or someone renting a home. Inomata's project deliberately leverages upon the meaning of the Japanese word to draw similarities with the ways in which we relate to notions of identity determined by geographical coordinates. In 2009, Inomata studied the natural shape of hermit crab shells using a CT scanner and used this data with a 3D printer to reproduce the crustacean domiciles. She then proceeded to craft elaborate crab shells ornate with the landmarks of important cities from around the world.

Why Not Hand Over a 'Shelter' to Hermit Crabs? was inspired from a simple real-estate transaction involving the embassies of France and Japan which led Inomata to question notions of ownership, nationality, and migration into the artist's mind. Furthermore, ermit crabs are known for scavenging shells that they use as temporary shelters. As they grow, the crabs periodically look for a larger replacement shell, thus acquiring a new look, and perhaps a new identity to its peers and predators.

Think Evolution reverts the evolutional journey that has rendered octopi shell-less. After prospering for 300 million years, the ammonites disappeared at the same time dinosaurs went extinct 66 million years ago. From shell structure and fossils, it is assumed that the ammonite is closely related to the squid and octopus. The octopus has discarded its shell through the course of evolution, but it is known to use tools such as coconut shells and bivalves to protect its soft body. Inspired by this evolutionary story, Inomata restored the shape of an excavated ammonite shell and arranged an encounter with octopus. In a mesmerizing video work, viewers can experience the innate curiosity of an octopus for Inomata's 3D printed shell and its seemingly spontaneous desire to insert itself in the structure as an ammonite would have.

Born in Tokyo in 1983, the Japanese artist **Aki Inomata** studied at MFA Inter Media Art, Tokyo University of Art. Her artistic project explore different concepts : adaptation, change, protection and architecture; all of them are inspired by natural resources.

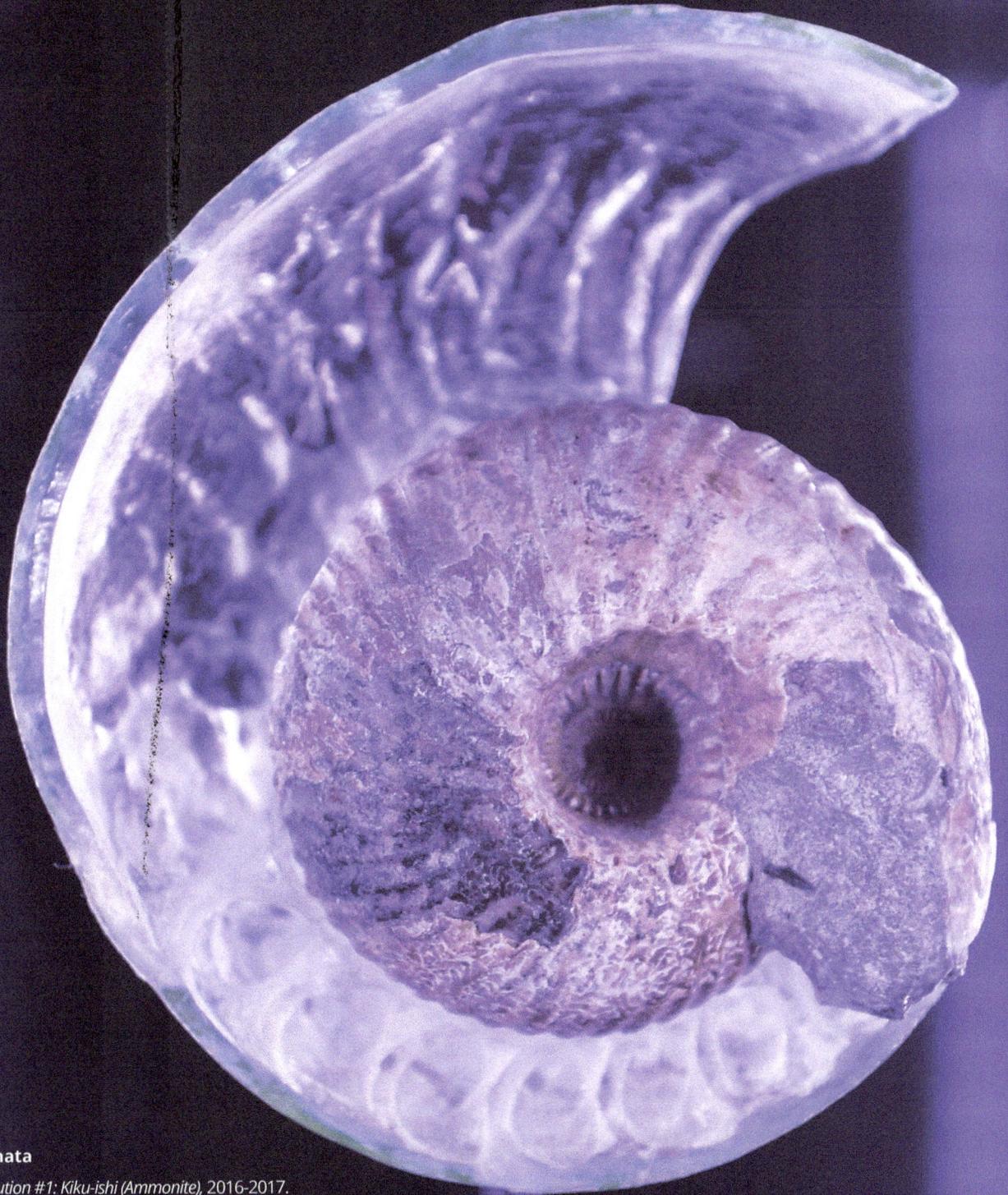

Aki Inomata
Think Evolution #1: Kiku-ishi (Ammonite), 2016-2017.
Photo Koki Nagahama. Courtesy of Moho Kubota Gallery © Aki Inomata

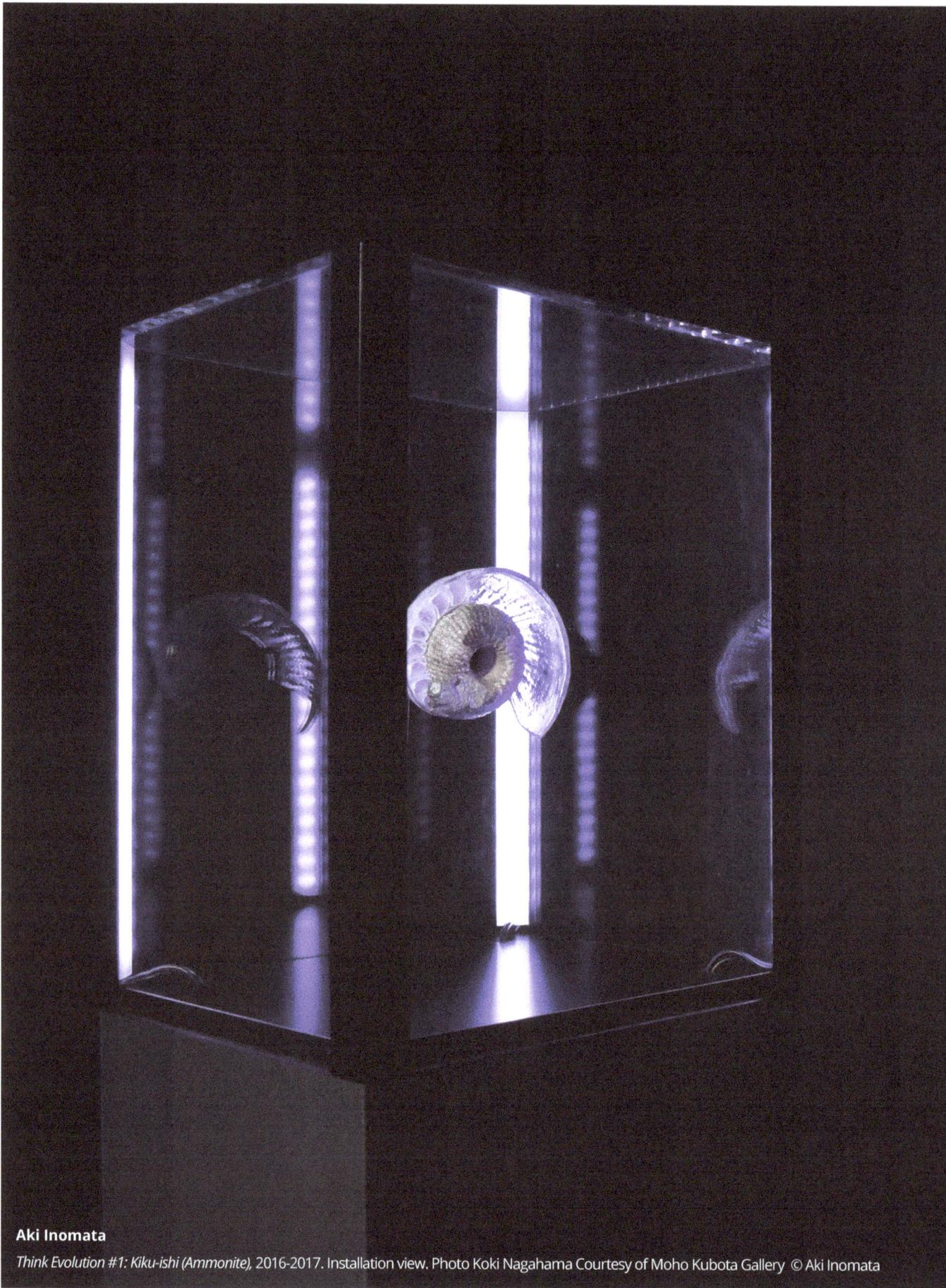

Aki Inomata

Think Evolution #1: Kiku-ishi (Ammonite), 2016-2017. Installation view. Photo Koki Nagahama Courtesy of Moho Kubota Gallery © Aki Inomata

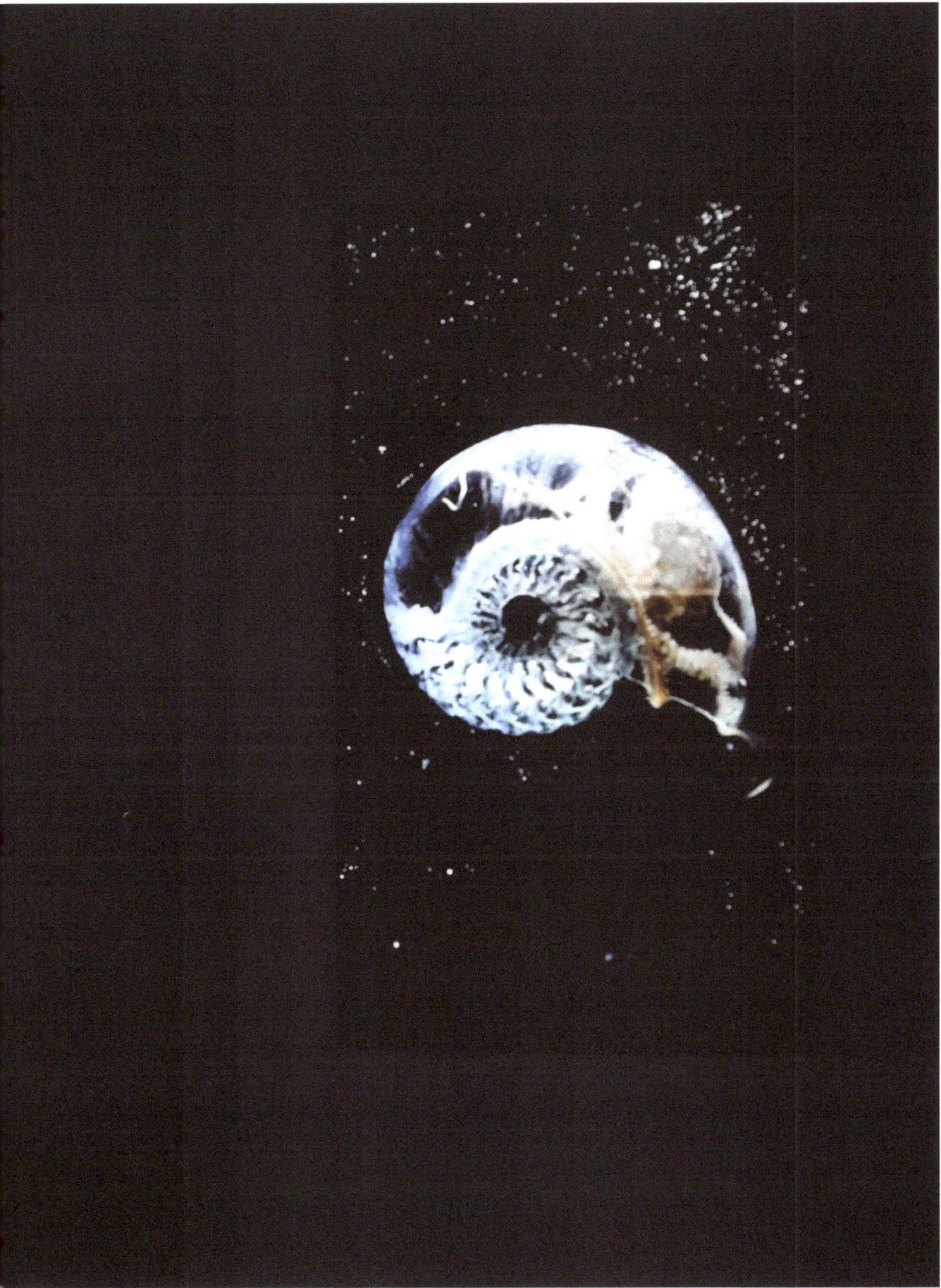

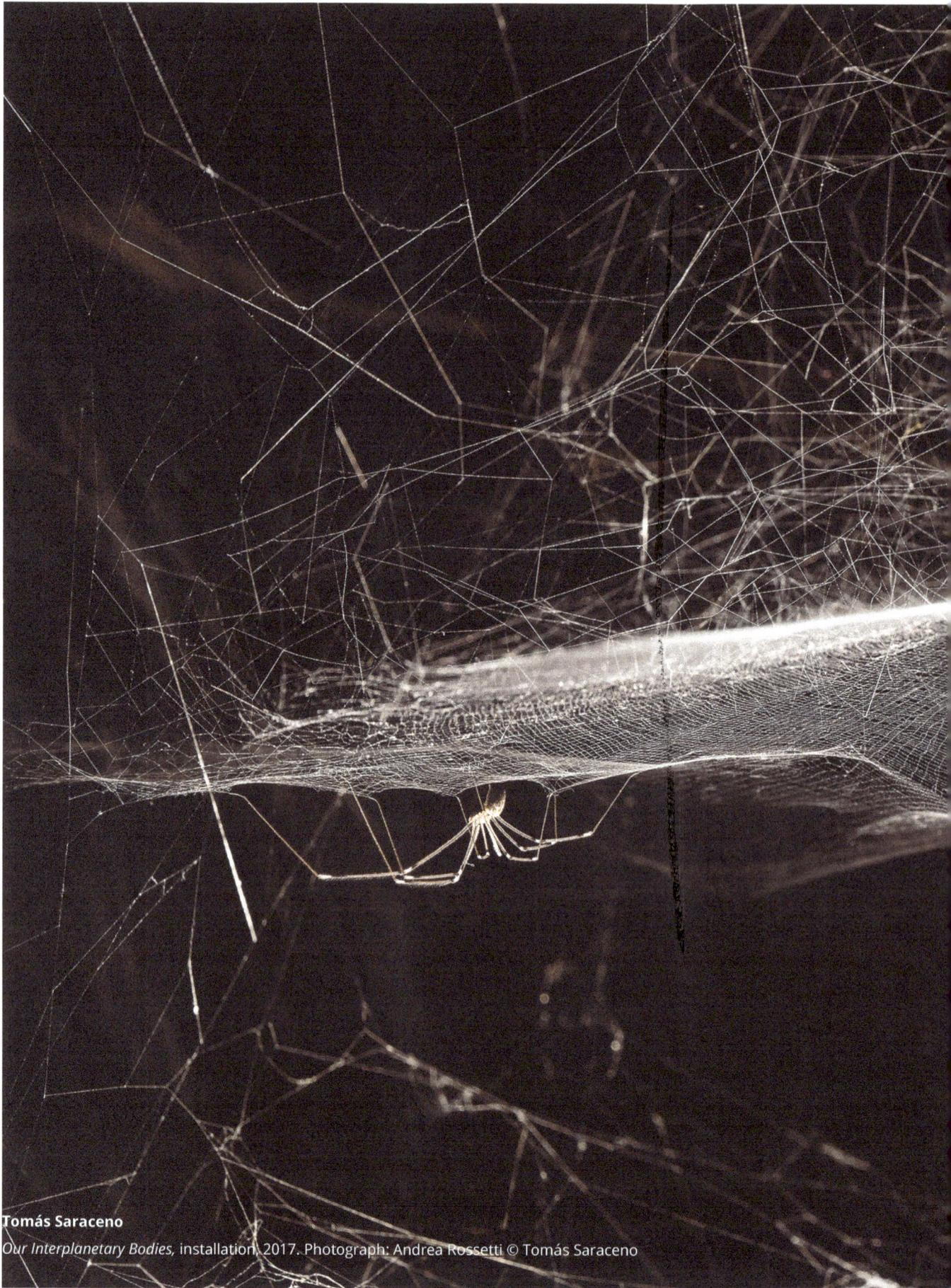

Tomás Saraceno
Our Interplanetary Bodies, installation, 2017. Photograph: Andrea Rossetti © Tomás Saraceno

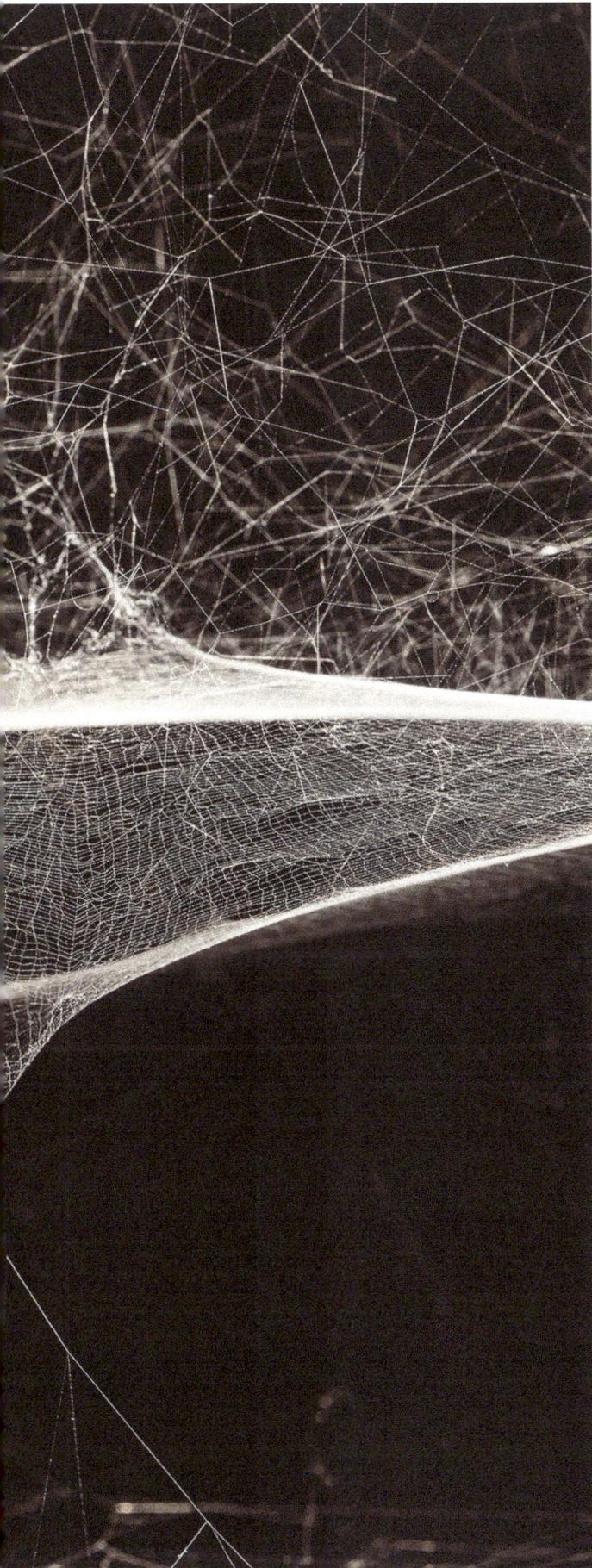

Tomás Saraceno: Interfacing nature and culture through art and science

This essay explores the interconnecting elements at play in the practice of Tomás Saraceno, one very much studio-based and rooted in collaboration. These elements are all linked by the silky threads of spider webs, woven into a mesh-like membrane, which entice viewers. The paper considers Saraceno's 2017-18 solo exhibition Our interplanetary Bodies *at the Asia Culture Centre in Gwangju, South Korea, to outline how his collaborations with spiders construct a platform of possibility for human understanding, one grounded in resonance and sensibility of the world and cosmos.*

text by **Elizabeth Atkinson**

Architect come artist Tomás Saraceno constructs immersive art installations which weave his human viewers into material webs, provoking consideration of their terrestrial position. One simultaneously enters the microcosmic world of the spider in its web, and the macrocosmic world of our galactic universe. Two webs whose patterns we still lack the language to fully explicate, Saraceno invites humans to consider what could be learnt from exploring these worlds in parallel. The artist collaborates with spiders in innovative ways, enhancing their capacities as a genus, allowing them to conduct his practice as a whole, thus provoking human reflection on our own abilities when we encounter his artwork. A typically solitary animal, certain species of spiders do in rare instances come together socially. Whether collaborating as they build their webs or manipulating the earth's electromagnetic fields to lift them in "ballooning" flight, these instances of collectivity display degrees of sensibility and resonance, an attunement[1] and hence proximity to the forces of others within their environment. I suggest that Saraceno's artworks enable the forces of nonhumans, in parallel with the more-than-human cosmos, to permeate his human viewers. Entities from different times and scales are entangled within a collaborative web where bodies and minds become congruent, forging new connections and enabling the emergence of imagined possibilities.

Becoming multi-temporal and/or multi-societal, the physically durable and resilient webbed habitats of spiders provide tangible, yet fragile models against our own more mysterious phenomena of social functioning. In our moment of ecological crisis widely named the Anthropocene, leading critical thinker on the animal question, Donna Haraway, emphasises the need for us to re-entangle ourselves with nature. She calls for a theoretical move into what she names the Chthulucene. Inspired by the spidery *Pimoa cthulhu*, this is a tentacular moment entangling "myriad temporalities and spatialities and myriad intra-active entities-in-assemblages including the more-than-human, other-than-human, inhuman and human-as-humus." (Haraway 2016, 101) "Making kin" in Haraway's Chthulucene is about recognising and embracing one's coexistence with even the most different of others. Saraceno's practice explores such coexistence. By imitating but also developing spider examples of social functioning within his practice as a whole, he suggests possibilities as to how humans might change their relationship to the environment and to each other. Spiders and their webs become an interface interconnecting humans and animals, nature and culture, biology and technology, the terrestrial and cosmological, and art and science. Saraceno uses the natural model of spiders to develop and advance artistic and scientific explorations and propositions in parallel, to weave together possibilities for interspecies futures.

In her 1987 call for a "feminist version of objectivity", Haraway asserts the need for *"situated knowledges."* In the chapter of the same name, she describes how in contemporary life, "partial, locatable, critical knowledges sustaining the possibilities of webs of connections called solidarity in politics and shared conversations in epistemology" are what is needed to allow for the acceptance, and acknowledgement, of all perspectives on earth. Such critical positioning stands in contrast to the relativism often observed in global systems of the day. (Haraway 1991, 186-8)

Spiders weave their webs anew nocturnally, capturing both the air and other lifeforms in the tensions of their resilient threads.

They often eat these fragile structures, recycling the threads to generate sustenance to repair or recast the webs. The almost blind spider's dependence on physical sensations – its tendrils reaching across time and space sensitive to tremors in the atmosphere and vibrations in its web – shows how its "knowledge [is] tuned to resonance, not to dichotomy." (Haraway 1991, 194-5) In his exploration of the material ecologies of spiders, Saraceno provides his viewers with the chance to learn from these creatures and to imagine how we might live if we were to model their behaviour. Now humans and our actions have become directly implicated in planetary crisis, such lessons seem paramount if we, and the species with whom we share the planet, are to sustain our lives into the future. By pushing art to its limits, advancing spider science into new realms and developing new models for human earth dwelling and air travel, Saraceno opens up a new conversation, suggestive of the capacity for humans to learn from our nonhuman companions.

Embodying Spiders

Spiders are familiar creatures, sharing our homes and weaving their webs to adorn our walls. As nineteenth century historian Jules Michelet writes in his 1875 study *The Insect*, "they seem to observe us" with their eight panoramic eyes. (Michelet 2012, 46) But arachno-human relationships have become fraught with fear. Arachnophobia is a trait many of us share. Their eight-limbed forms astound us with the capacity to defy gravity, crawling both vertically and horizontally, and their flying capabilities remain a mysterious phenomenon. A typically solitary spider, the black widow (*Latrodectus mactans*) perhaps exemplifies the human-spider stereotype. Famed for mercilessly eating the male after fertilisation of her eggs, the female has come to represent to us that most fiercely independent "other". However, this reputation is one skewed with human projections, the instances of sexual cannibalism in fact remaining rare. The black widow with her anthropomorphic name, indicates our need to universalise all animals beneath human categories.[2] However, this species is but one of an estimated 43,000 spider families, within which there exists only a few species poisonous to humans and around 40 social types. Spiders remain masked beneath human projections of fear and disgust, when in fact these tiny yet complex arachnids should intrigue us with their more resourceful capacities of living and moving in the atmosphere.

The eyesight of spiders, despite their octocular vision, remains partial. Their eyes resting on the lower side of their body make them unable to see what looms above. Yet in the weaving of their webs, sight becomes irrelevant. Mostly weaving at night, spiders depend on their capacity to feel and to sense, rather than to see. They measure atmospheric pressure, wind currents, the forces of gravity, and light orientation (most often from the moon and stars) and use their own body weight or an internal clock to position themselves in relation to these cues.[3] Spiders situate themselves and their web-weaving knowledge *with* the knowledges of their surroundings, mediating and responding to what they feel so as to immerse themselves and become one with the natural world, rather than objectifying and positioning themselves outside and against it.

Situating Spider Knowledges

In her 1987 chapter 'Situated Knowledges: The Science Question in Feminism and the Privilege of Partial Perspective', Donna Haraway investigates "the curious and inescapable term 'objectivity.'" She cri-

The eyesight of spiders, despite their octocular vision, remains partial. Their eyes resting on the lower side of their body make them unable to see what looms above. Yet in the weaving of their webs, sight becomes irrelevant. Mostly weaving at night, spiders depend on their capacity to feel and to sense, rather than to see.

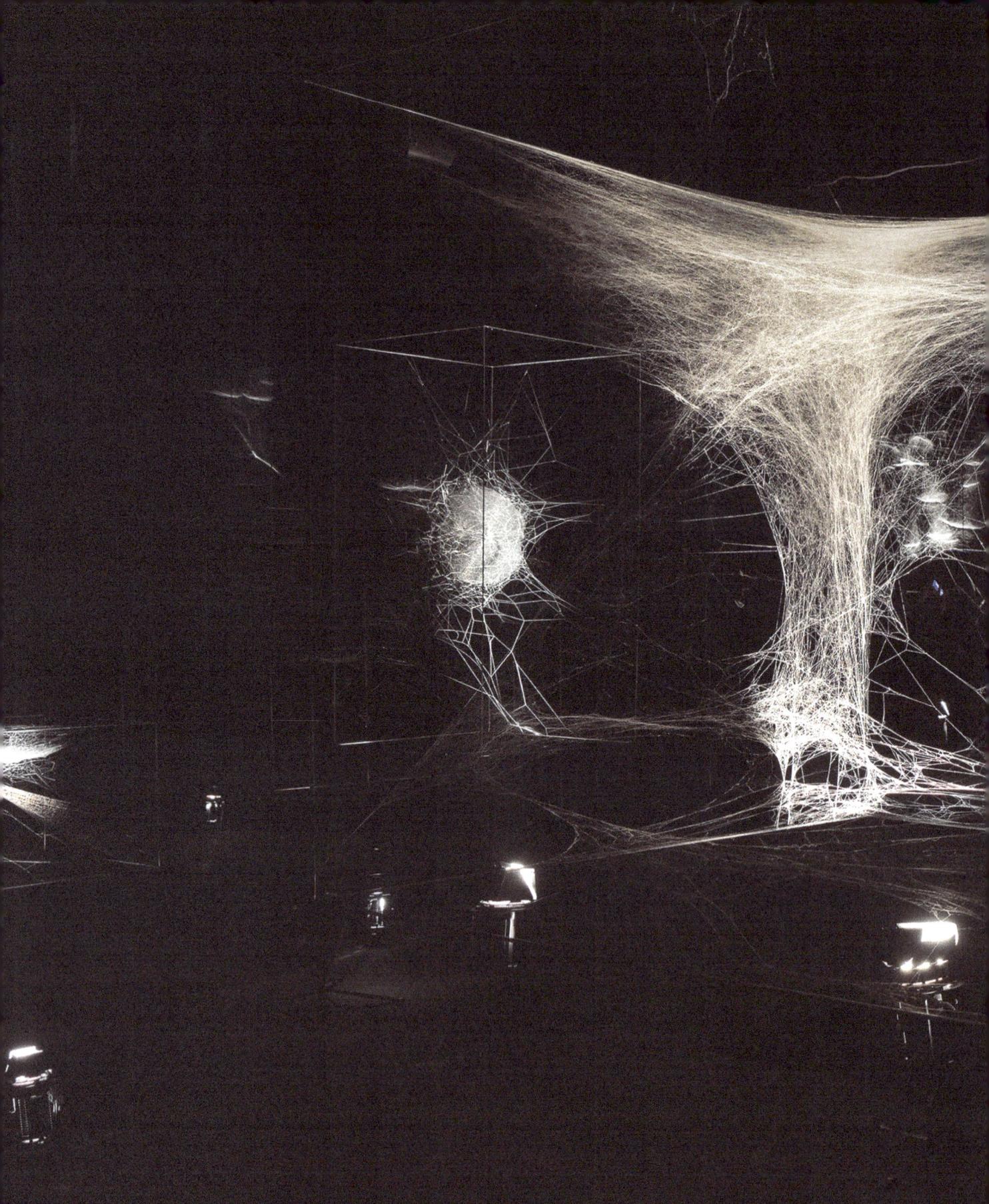

Tomás Saraceno

Webs of At-ten(sion), 2018. Made up of 76 hybrid spider web sculptures interwoven by different spider species
Exhibition view: On Air: Carte Blanche, Palais de Tokyo, Paris, 2018. Photography: Andrea Rossetti © Tomás Saraceno

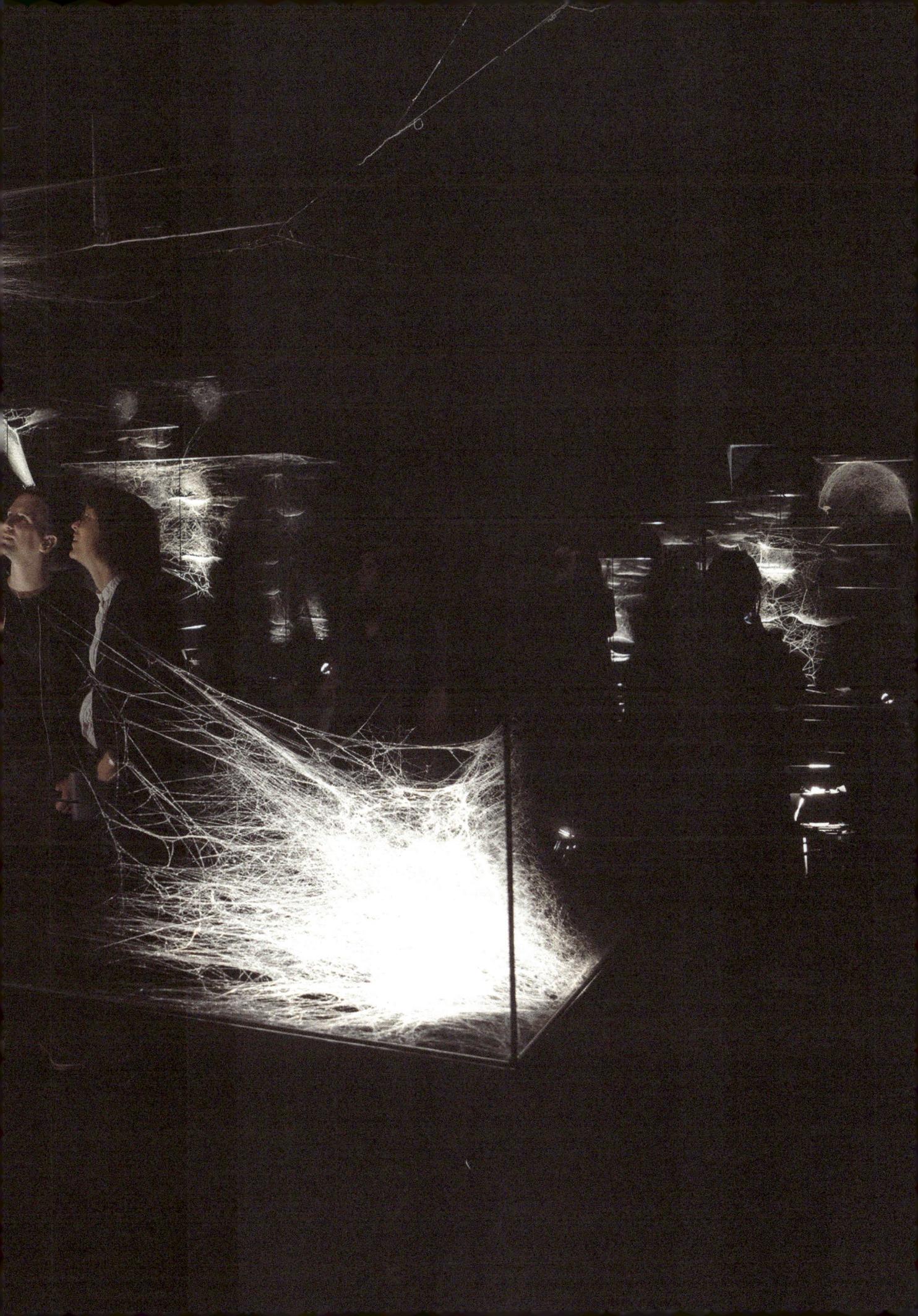

tiques traditional notions of universal objectivity, claiming these to have been established by an "imagined 'they' [of] masculinist scientists and philosophers" who align themselves against the "imagined 'we' [...] the embodied others, who are not allowed *not* to have a body, a finite point of view." Through the implementation of what she names "disembodied scientific objectivity", Haraway describes how "all truths [including those of gender, race, even the world itself] become warp-speed effects in a hyper-real place of simulations" in a "play of signifiers in a cosmic force field." Haraway instead promotes social constructionist arguments "for *all* forms of knowledge claims" where "no insider's perspective is privileged", "inside-outside boundaries" collapse, and binary distinctions are revealed as toxic "power moves, not moves towards truth." (Haraway 1991, 183-4) Through collaboration with spiders in his artistic practice, Saraceno explores and promotes spider knowledges, combining these with human knowledges to develop innovative works which challenge human dominion over the planet.

Haraway's feminism allows for fragmented histories to sit together within webs woven from tendrils tuned to the resonances of others. Despite being muddled amongst one another, these fragments of identity are grounded in specificity and difference. Constantly attuned to their surroundings, spiders retain their own specificity whilst simultaneously becoming one with their atmosphere and prey. Spiders merge their own knowledge each night with the knowledge of their specific habitat in that specific moment. They demonstrate a degree of openness and flexibility to change with others, and critically position themselves as moments of situated knowledges. Unlike the relativism inherent to totalising claims of vision most frequent amongst *Homo sapiens*, Haraway's alternative is "partial, locatable, critical knowledges sustaining the possibility of webs of connection called solidarity in politics and shared conversations in epistemology." With Haraway's knowledges comes an inherent mobility, "feminist embodiment resists fixation and is insatiably curious about the webs of differential positioning." Her version of objectivity "privileges contestation, deconstruction, passionate construction, webbed connections, and hope for transformation of systems of knowledge and ways of seeing." (Haraway 1991, 190-2) As partially blind spiders continuously recast, repair and re-ingest their fragile webs of silk, they demonstrate the capacities of transformation Haraway calls for.

"A commitment to mobile positioning and to passionate detachment" means not trying to recognise oneself as a concrete, impermeable, identified self, but rather contingent and open to others, a split self, claims Haraway. (Haraway 1991, 192) This creates a multidimensional topography of subjectivity, one with multidimensional vision. With their eight eyes, eight limbs, and capacity to extend their bodies across time and space into three-dimensional webs, spiders embody such subjectivity. Their "imperfect stitching together of selfhood" makes the knowing self "*therefore* able to join with another to see together without claiming to be another." Spiders cast themselves through the atmosphere, never claiming space as their own, but momentarily inhabiting and adapting themselves to it. They negotiate change and sense fluctuations within specific situations. As in Haraway's description of critical positioning, the situation depends upon mediation and implies responsibility for enabling practices. (Haraway 1991, 193) The natural sensibilities of

spiders allow them to inhabit themselves with nature rather than position themselves outside as disembodied observers.

According to philosopher Henri Lefebvre, the spider's web is not an "abstract space", not composed of such "separate objects as its body, its secretory glands and its legs, the things to which it attaches its webs, the strands of silk making up that web, the flies that serve as its prey." (quoted in Engelmann 2016, 171) These are instead, carefully calculated, totalisable architectures, woven as one *Umwelt*.[4] Never products of "blind instinct" or "nature", spiderwebs are cast from individual threads each in tune to their surroundings and needs. Within these webs lies a rationality we cannot understand nor predict. We might observe the regularity of the web, but we can never understand its regulations. In his anthropological study of *How Forests Think* towards an "anthropocentrism beyond the human", Eduardo Kohn emphasises the need to appreciate the patterns found in nature which do "not stem from the structures we humans impose on the world." These indeterminable forms, emerging from a "lower order", may in fact prove useful if we endeavour to understand them. (Kohn 2013, 182-3, 186) Saraceno attempts such understanding in his practice. Through imitation of spiderwebs (a method not typically applied by biologists), Saraceno demystifies the workings of this micro form and applies its patterns to solve macro problems.

Haraway's feminism allows for fragmented histories to sit together within webs woven from tendrils tuned to the resonances of others. Despite being muddled amongst one another, these fragments of identity are grounded in specificity and difference. Constantly attuned to their surroundings, spiders retain their own specificity whilst simultaneously becoming one with their atmosphere and prey.

We cannot discern where the body of the spider ends and where the web begins. Their sprawling intelligence weaves an elaborate material structure, a sensory mesh of perceptive tendrils reaching across time and space, gathering and knotting entities together, connecting the spider to the rest of the world. These iridescent, resonant, dynamic architectures become examples of extended and embodied cognition. The spiderweb is thus considered not only as a laborious creation and shelter, but as an extension of the spider *self*: web density, colour and pattern all being unique and dependent upon the specific environment and species of spider in the moment of weaving. This web, woven by itself, for itself, from itself and into itself, lives and vibrates. It encircles the spider whilst also forming a part of its being.

Both the sensory capacities of their bodies, and the interpretative abilities of their intelligence, extend and project outside spiders' physical bodies to respond to and incorporate the world in which they dwell. Threads almost invisible to our eyes, measuring but 0.001 millimetres in thickness, are at once "dynamic" and "tensile", "resilient" and "fragile" writes Sasha Engelmann in her doctoral thesis *The Cosmological Aesthetics of Tomas Saraceno's Atmospheric Experiments*. These threads intermittently connect with their environmental surroundings, forming strong yet fleeting connections with and within space. These are not networks of predefined relations, but webs of entanglement attuned to a specific time and place. "The web is a pattern, a mesh, a platform of possibility" continues Engelmann. (Engelmann 2016, 172, 181)[5] The spider's web creates opportunities for the spider to connect with the world, catching its prey or lifting itself in flight. And when displayed as artworks by Saraceno, the webs propose possibilities for future human dwelling. Viewers enter webbed worlds where traditional human binary divisions dissolve and webbed connections tuned to *resonance* are woven. Interspecies relationships are formed, the Earth and the Universe align. In so doing, this platform of possibility becomes an interface.

In her most recent book, Haraway states how "both inheriting and also reweaving ongoing webs of affective and material relationships are the stakes; such webs [being] necessary for *staying with the trouble.*" (Haraway 2016, 216) For multispecies futures, Haraway does not call for the overthrowal of human culture in favour of nature, but rather for humans to reconstruct their ways of life, carefully weaving themselves into the lives of other species to create more sustainable material ecologies of coexistence.[6] By demonstrating Arachnid feats of situated knowledges in his artworks, entangling humans and spiders in his exhibitions to coexist and learn together, Saraceno combines spider science with artistic practice, astrophysics and human cloud dwelling.

Spiderwebs in Studio Tomás Saraceno

Despite being the strongest material on earth, able to hold the weight of a fully loaded Airbus, spider silk is extremely thin, measuring 0.001 millimetres in thickness. Spider threads in their multitudes are present everywhere while (almost) not being seen anywhere.[7] They have been spotted in altitudes of 10,000 metres from airplanes and it is known that they are transferred with the winds over the Himalayan mountains. Stronger than steel and stretchier than nylon, and having evolved over 400 million years, present-day spiderwebs are structures efficiently engineered by nature.[8] Spiders use their silk to weave their webs, mummify their prey, as a jumping escape route, to transfer semen, as drag lines marked with pheromones and as a shelter into which they can retreat. The webs themselves act as temporary homes where spiders can feed and mate, and maybe even play music through the rapid vibrations of the strings.[9]

The silk is produced in silk-glands in the form of a liquid with a molecular weight of 30,000, but the molecular composition of silk varies from species to species. It is released from spinnerets; the liquid having polymerised into a more solid thread. Webs are fragile, easily damaged or destroyed by bad weather or the catching of prey. The old web is eaten and recycled, digested to produce more liquid silk and a new web is constructed once more. The cutting of the web is done by special digestive juices that contain enzymes rather than by any mechanical cutting. These juices also form the glue which holds the strands of silk together. (Brunetta and Craig 2010) This reciprocal exchange of internal fluids for external functionality, recycling an exterior to nourish the interior, constructing and deconstructing their bodies and homes and insides and outsides, demonstrates a natural resourcefulness. Spiders turn inside out our beliefs about physical boundaries, their self-individuated forms demonstrating an admirable resourcefulness in constructing intricate new worlds.

Tomás Saraceno began actively collaborating with spiders in 2008. This work was initially an investigation into the comparison made by scientists between the structure of the Universe and that of an organic web. Like the rationality inherent to the spiderweb, our cosmos is another web of patterns to which we do not understand the regulations. Astronomers propose the comparison between our universe and a complex spiderweb in which groups of stars and other matter are strung like shining bodies of water along invisible strands.[10] Furthermore, in 2006, the New Hubble telescope provided images showing a large massive galaxy under assembly as a result of smaller

Spiders turn inside out our beliefs about physical boundaries, their self-individuated forms demonstrating an admirable resourcefulness in constructing intricate new worlds.

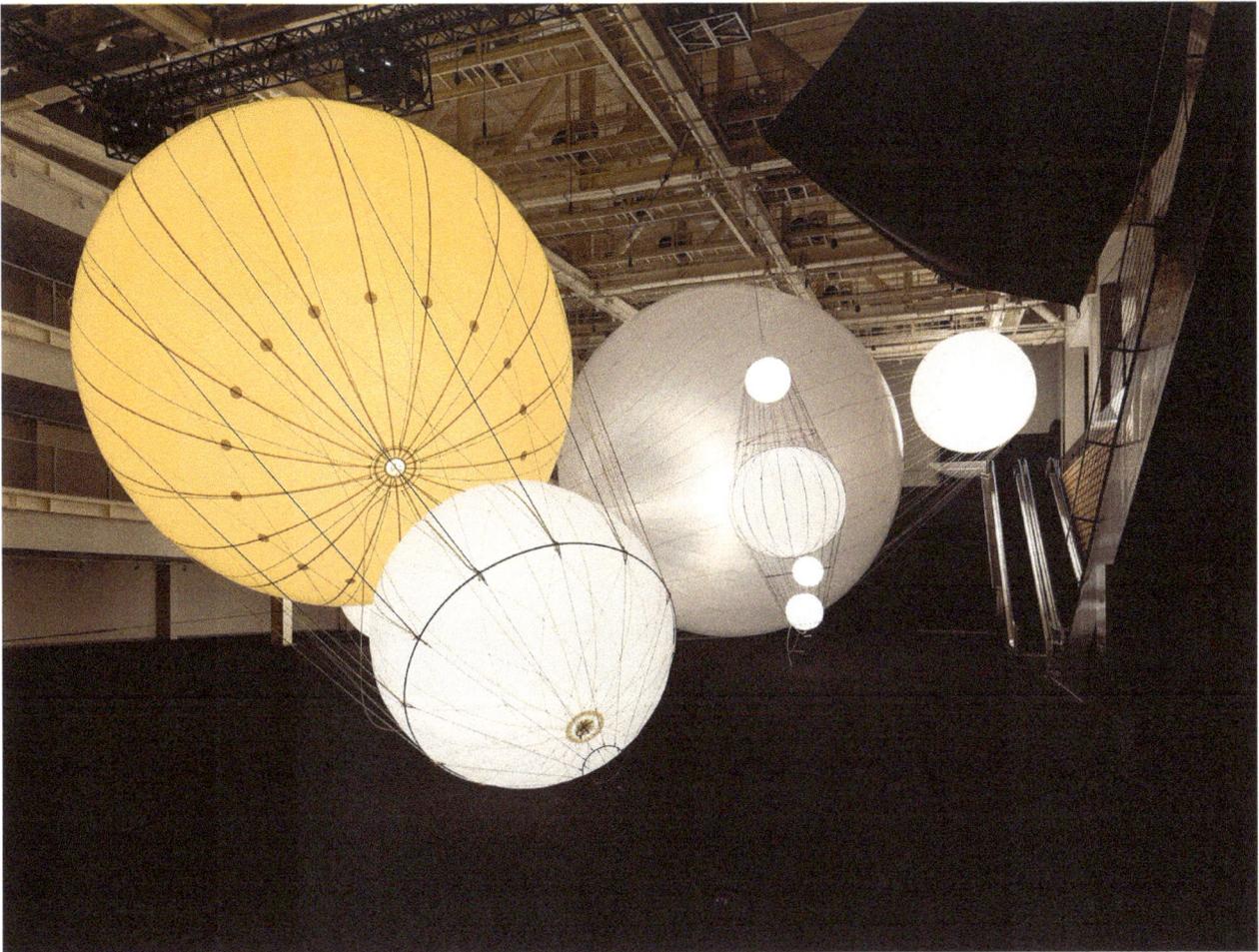

Tomás Saraceno

Our Interplanetary Bodies, Asia Culture Centre, Gwangju, 2017. Photograph: Andrea Rossetti © Tomás Saraceno

galaxies merging. Nicknamed the "Spiderweb Galaxy", it is located in the Southern Constellation of Hydra (the water snake) and is one of the most massive galaxies known. Like a spider who spins her web to weave a trap for her prey, this large galaxy appears to be "stuffing itself with smaller galaxies caught like flies in a web of gravity." (Martin 2001, 29) The telescope has observed how larger galaxies act as webs, sucking smaller galaxies along threads of dark matter into cavernous black holes within, at speeds of several hundred kilometres per second, from a distance of more than a hundred light years.[11]

Saraceno incorporates elements of physics, engineering, and aeronautics into his interactive and evolving art structures. Taking and translating web geometries the artist positions spiders as an interface between art and science. He provides structures for both his artworks and advancements in scientific fields; specifically, for the artist, developments in human habitation and travel on Planet Earth. In his efforts to understand the patterns lying within the dark matter of the universe, Saraceno contributes to advances in twenty first century technologies of sensing and communication. (Engelmann 2016, 11) In the catalogue for his 2016 Exhibition *Reset Modernity!,* Bruno Latour writes: "Rare are the artists who have pub-

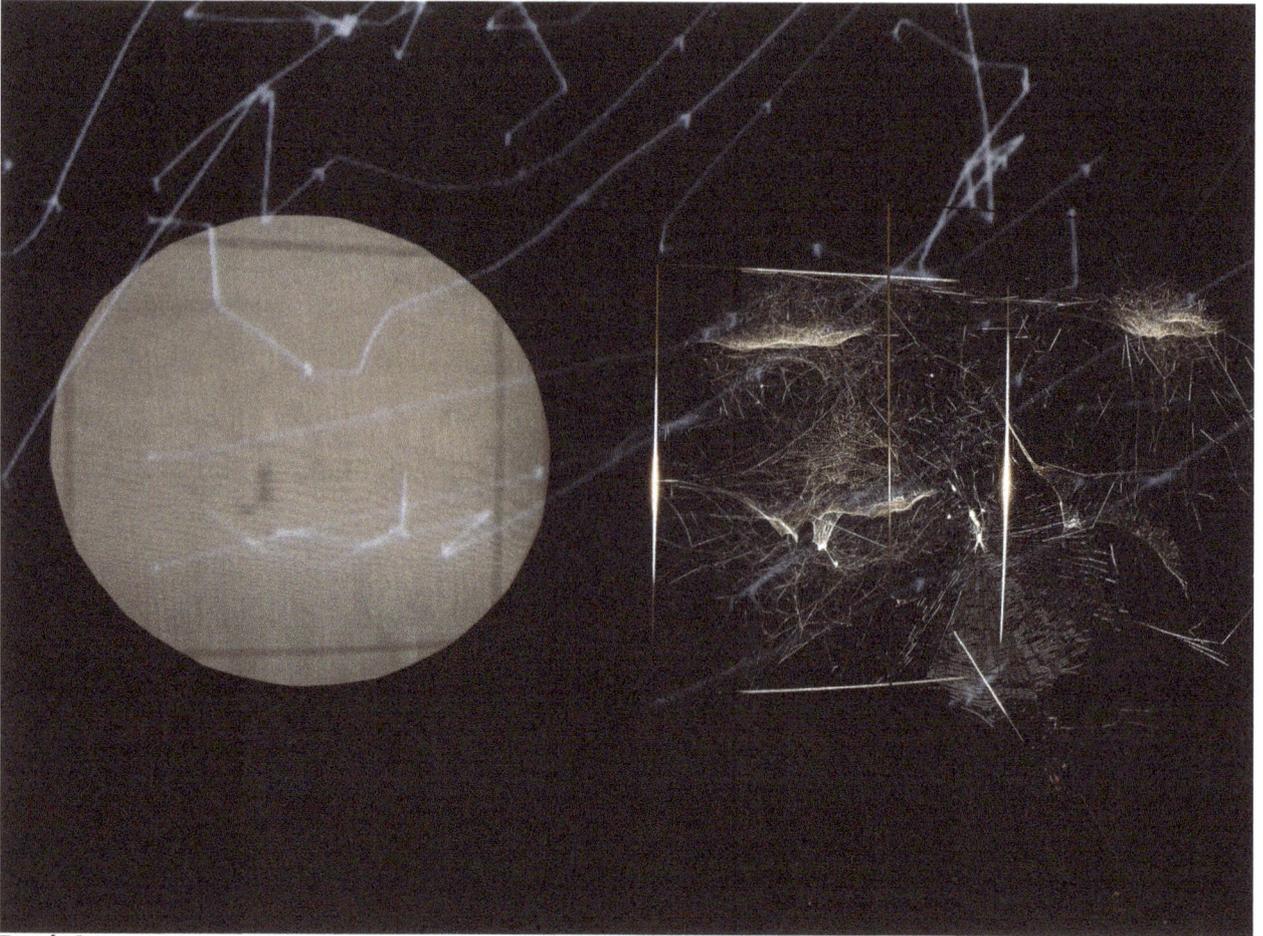

Tomás Saraceno

Our Interplanetary Bodies, Asia Culture Centre, Gwangju, 2017. Photograph: Andrea Rossetti © Tomás Saraceno

lished papers with scientists because the science they had to feed on was too limited! To extend the frontier of art, Tomás first had to push the frontier of spider science." Through his investigations into spiders and their webs, "what makes the spider move and how the web reacts to its environment", Saraceno "render[s] visually discernible – what it is for any entity to have – no, I should say, to *be* its environment." (Latour 2016, 205-6)

His studio in east Berlin devotes 600 square metres to web-spinning spiders and houses the largest (and only) collection of three-dimensional spiderwebs.[12] Saraceno works with a wide range of species but is most often drawn towards social types. Spread across three floors, each "spider room" receives an acute and careful degree of observation. As described by Engelmann in her thesis, which she completed whilst working at Studio Tomás Saraceno and on a number of their projects, Saraceno and his collaborator Adrian Krell "invited" the first spiders into the studio back in 2008. She goes on, "It took significant research with spider scientists like Dr. Peter Jäger to develop the conditions in which the spiders would weave." (Engelmann 2016, 168) Saraceno sought to advance his own (and his studio's) capacities of interspecies attunement in this process, developing their sensibilities to become more spider-like.

Engelmann elaborates on this nature of human and nonhu-

man collaboration, emphasising the fact that the spiders "ultimately did begin to weave" as a result of efforts made by Saraceno and his team. The spiders become participants in the collaborative network of Saraceno's practice. As the studio members learnt more about the spiders and their specific life-requirements so as to develop the optimal weaving environment, the spiders reciprocally habituated themselves to the studio and its conditions. (Engelmann 2016, 170) This lead to the creation of several "micro-climates", with carefully adjusted humidity and lighting according to the specific needs of the spiders, as well as the education of studio members who collaborate with the spiders. The studio now houses "both multiple species and a multitude of spiders whose expressiveness is the primary medium of artistic production" states Engelmann. (Engelmann 2017, 164)

As the studio and the spiders become habituated to one another, Saraceno's practice itself explores cohabitation between humans and animals. Saraceno's studio reverses the stereotype of spiders as alien others invading our homes, *inviting* spiders to work *with* him and share his professional space. His close sensitivity to their needs and observation of their ways of life, enacts the "specificity and difference and the loving care people might take to learn how to see faithfully from another's point of view" that Haraway longs for. (Haraway 1991, 190) Saraceno's studio recognises the specific needs of the spiders, as differentiated species and as individuals in their own rights.[13] In this regard, his practice is learning to see, or more accurately, to *feel* from the spiders' points of view. And in so doing, Saraceno emphasises the rewards humans might reap if we were to collaborate with spiders too, becoming resonant to them as atmospheric artists in themselves.

Spider inspiration in Saraceno's Practice

As described on the Studio Saraceno's website, *Hybrid Webs* are "unique architectures" that "originate from inter-specific encounters between unrelated solitary, social and semi-social spider species." (Studio Tomas Saraceno, n.d.) These are multi-generational, multi-species, multi-dimensional structures that would not occur in the natural world. Within the spider rooms, assistants allow spiders to weave their webs in the same space. Suspended in plexiglass frames, one spider will weave its web, the frame being periodically rotated so as to reorient the forces of gravity. After a recorded period of time, the first spider will be removed, and another introduced to the same frame. Saraceno takes specific examples of spider sociability, and mixes these with examples of spider independence. The results are iridescent, aesthetic forms, materialising tensions across difference, but also radical acceptance of others. His unique methods not only advance the limits of spider biology, but present models from which humans might learn to improve their own methods of social organisation. As the different species "bridg[e] the architecture of each other's webs" each web-sculpture becomes its own discrete universe, telling its own "story of hybrid relationships, entangling not only different arachnid webbed ecosystems, but also human and more-than-human worlds." (Studio Tomas Saraceno, n.d.)

Never complete and never totally itself, these structures remain flexible, changing and adapting over time as new circumstances and new species, present themselves. (Engelmann 2016, 170) Timothy Morton's *Ecological Thought* (2010) proposes the image of a *"mesh"* to assert how nothing exists by itself, so nothing

As the studio members learnt more about the spiders and their specific life-requirements so as to develop the optimal weaving environment, the spiders reciprocally habituated themselves to the studio and its conditions.

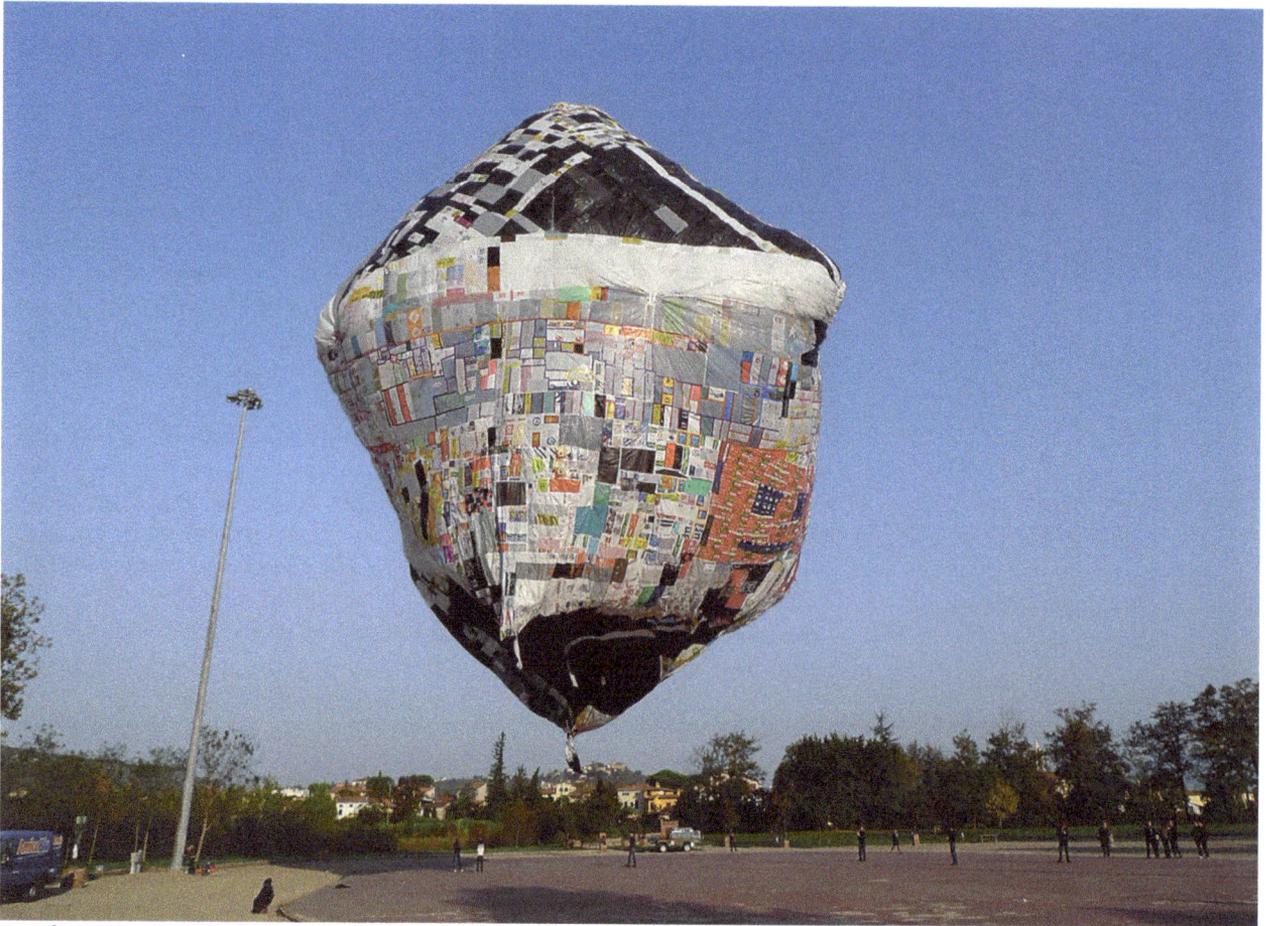

Tomás Saraceno

On Air: Carte Blanche, Palais de Tokyo, Paris, 2018, recycled plastic bags © Tomás Saraceno

is fully "itself." Morton's mesh imagines a multitude of entangled "strange strangers". However, unlike a network (or web), Morton's "mesh implies the hole in a network, the threading between them." Within Morton's mesh, each point is simultaneously both centre and edge, leaving no absolute centre nor edge. Instead the mesh consists of infinite connections and infinitesimal differences and being non-static, becomes a non-totalisable, open-ended concatenation of interrelations that blur and confound boundaries at practically any level. (Morton 2010a 15, 28-30, 2010b, 275) However, spiderwebs do not confound boundaries on every level. Their forms do possess an individual discreteness, positing them as unique entities. They entangle forms within infinite connections, but these connections remain tenuous and fragile. They weave new possibilities onto old ones, defamiliarising and transforming old structures by accommodating new ones. Instead I suggest spiderwebs to be more like Helen Hester's xeno-hospitality.

Xenofeminism is a critical position that defends rationalist claims whilst also proposing "the opening up of currently curtailed choices" to create "ideological and material infrastructures reworked to synthesise new desires as accessible, feasible choices." "Xeno-hospitality" writes Helen Hester, is thus a "form of counter-social reproduction – *social reproduction against the reproduction of*

the social as it stands." I read xeno-hospitality as a process of weaving the unfamiliar, the foreign and the strange into already existing constructions of knowledge. Its aim is not deconstruction, but a process of "defamiliarisation" by "familiarising alternative networks of solidarity and intimacy in such a way that they can become generalisable and maximally accessible." (Hester 2018, 64, 66) These are compositions that weave the foreign and strange into pre-existing structures creating instances of intimacy and tension, both attraction and repulsion, so that each *Hybrid Web* possesses an individual specificity lacking from Morton's mesh.

As an extension of the spiders' sensorial and cognitive systems, the threads of the *Hybrid Webs* allow lines of communication to merge and connect. When displayed, the open frames allow viewers to reach and touch the iridescent webs, this tentative connection allowing curiosity to emerge. These webs are not only physical extensions of the spiders' sensory perceptions but enable humans to also extend their own parameters of perception, becoming closer to spider/webs, and allowing us to learn from them. *Hybrid Webs* become aesthetic representations of the possibility for interspecies living. Saraceno presents a model for humans to imagine how the situated knowledges of others could be woven into their own. Even a partial glimpse from the perspective of another might provide opportunity for new degrees of acceptance and care to emerge. The multi-dimensional webs are multi-temporal, weaving together points in time, fragments of history and constructing traces and memories of lived moments across bodies. The collective construction of the webs denotes a sense of collaboration and community, however ultimately their construction is rooted in nature. A very "interesting" web might be produced under specific conditions in the studio but ultimately the superposition of structures remains unpredictable. (Engelmann 2016, 174) However, this is not about a forced sense of solidarity. Rather, within the webs we see the spiders adapting their weaving to the webbed form already present. "Weaving […] is *sensible*" writes Haraway. "It performs and manifests the meaningful lived connections for sustaining kinship, behaviour and relational action." (Haraway 2016, 96) Spider threads merge and accommodate others, sometimes overlapping, sometimes creating space, but always sustaining the threads of past others. Haraway does not argue for a fluid and universalising sense of identity. She emphasises the specificity of difference not its dissolution. Rather we must accept and accommodate differences in their own right, allowing ourselves to become entangled with others, even if tensions remain. *Hybrid Webs* aesthetically enact such a feat. Saraceno brings together spider species which in turn meet with human viewers, the spiders themselves enable artworks to be produced but also human futures to be imagined.

Saraceno brings together spider species which in turn meet with human viewers, the spiders themselves enable artworks to be produced but also human futures to be imagined.

Our Interplanetary Bodies

The Asia Culture Centre in Gwangju, South Korea, commissioned Saraceno to create an exhibition especially for their 16-metre-high "space one". Running from July 15th, 2017 through to March 25th, 2018, *Our Interplanetary Bodies* incorporated and developed multiple threads from Saraceno's *oeuvre.* The artist combined macro and micro perspectives collaborating with humans, nonhumans and the more-than-human, installing works in close proximity, each one connected to the others both physically with radial threads and through a larger algorithmic system. The exhibition modelled how

the world might be if Saraceno were to design it. The artist propos-es floating cities, bodies moving through galaxies, multiple perspec-tives and nonhuman collaborators to compose one whole network of future possibility. Plunging you into the microcosmic worlds of spiders whilst simultaneously making you a macrocosmic explorer, Saraceno makes possible experiences, at best, normally confined to the imagination and often resistant to thought.

The large space contained nine, interdependent, floating spheres, gently glowing with varying hues of light. These gigantic sculptures recollected cosmic constellations, strung together in threes by iri-descent threads. As visitors moved around and beneath these looming forms and across their shadows, an abstract moving image projected onto a wall formed a backdrop to the scene. The projec-tion was a live broadcast of cosmic dust particles spontaneously moving throughout the space, captured by an intricate machine developed by Saraceno to apprehend the velocity and size of the individual particles.[14] In the context of the galactic sculptures, these microscopic particles acquired new dimensions of meaning; plum-meting meteorites, shooting comets and orbiting planets burst into the imagination. This data was then converted into musical notes through an algorithm, which could be heard echoing across the gallery. The notes were accompanied by a lower frequency sound, emitting from the web of a spider. Saraceno amplified the vibrations of the spider plucking her web – a sound not normally perceivable to human ears – into acoustic rhythms which resonated with the trajectories of cosmic dust floating around the space. As the spider moved and vibrated in its *Umwelt,* these tremors echoed across the gallery, merging with the cosmic bodies on view to create a human, nonhuman and more-than-human symphony.

Saraceno started the exhibition with the weavings of a black widow spider, leaving the initial task of creation to the animal. Af-ter one week of weaving within the gallery, Saraceno "invited" her to move out of her web. Once she had left behind a living trace of her home and her movements in space, other species were "invited" to inhabit and weave new webs on top and around of the existing struc-ture. Similar to the foundations laid by the black widow herself, within this exhibition as a whole, this *Hybrid Web* generates the composi-tion of other artworks and bodies in the larger cosmological display. Miniscule conductor to this galactic orchestra, the spider spins and tends to its web in a performance dramatically lit up in a plexiglass box, making every movement visible as it floats between iridescent threads. As viewers became privy to a microscopic spider spinning at work, "hanging upside down – almost floating within their web – [the spider could] inspire new kinds of thinking about living on or even outside the planet, with other resources as the *Aerocene* is doing" hopes Saraceno. (Saraceno 2018) Different times, scales, species and perspectives abound and intermingle within the web itself, which for-ever extends out into and across the large exhibition hall.

The exhibition has been described as an extension of Saraceno's vision of the *Aerocene,* borrowing its shapes and premises.[15] Taking inspiration from the social cartography of "ballooning" spiders – who patiently await a breath of air to propel them across the empty skies in flight as their thousands of threads become entangled like a "magic carpet" (Engelmann 2016, 28) – Saraceno has developed a form of flying that is independent from fossil fuels and is instead sensitive to the elements and the atmosphere.[16] The membrane-

Miniscule conductor to this galactic orchestra, the spider spins and tends to its web in a performance dramati-cally lit up in a plexiglass box, making every movement visible as it floats between iridescent threads.

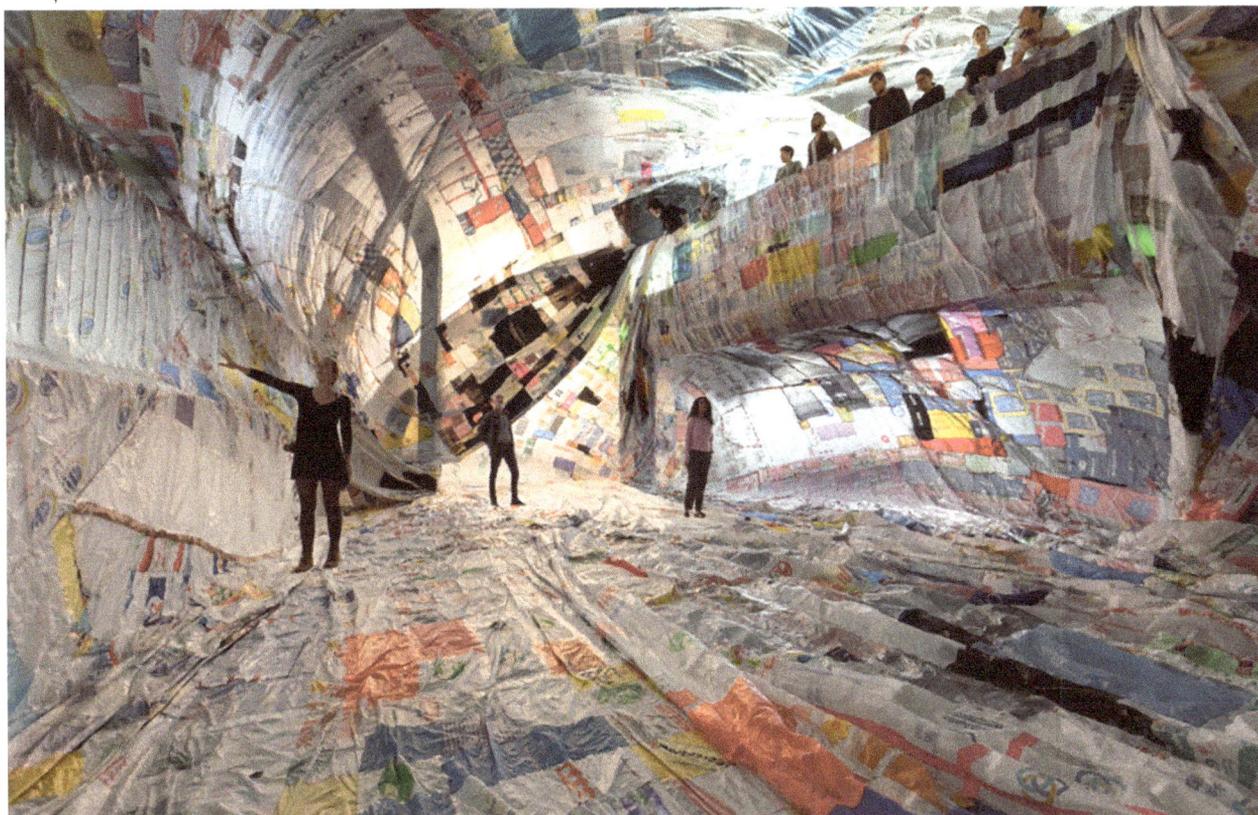

Tomás Saraceno
Our Interplanetary Bodies , Asia Culture Centre, Gwangju , 2017 © Tomás Saraceno

structure of the *Museo Aero Solar* (launched first in 2007 and now having travelled to 21 cities) is composed entirely of recycled plastic bags. Constructed over time as an open source project, it encourages us to explore new, sustainable ways of inhabiting the environment. For the solitary ballooning spiders, it is the air that makes them social and the atmosphere weaves this web. "Sensing and socialising become practically the same thing" and what would be impossible alone becomes possible together emphasises Engelmann. (Engelmann 2016, 28) In *Our Interplanetary Bodies,* Saraceno subtly moves his viewers through a process of recognising this, as they interact with nonhuman beings and learn how to sense in new ways.

As the *Aerocene* project becomes sensible to, and harnesses, thermodynamic energies of the Sun and Earth, floating freely by way of jet streams in the upper stratosphere, *Our Interplanetary Bodies* makes phenomena of the mysterious universe sensible through an organic and poetic consilience of contemporary art and different disciplines. By placing the traditionally negligible, fearsome but misunderstood insect alongside structures meant to replicate our infinitely unknowable cosmos, Saraceno seems to suggest how we all form part of the same web, where each body is awarded a degree of responsibility and nobody can be overlooked. As visitors audibly collaborate with the spider, contributing to the larger interplanetary system and its rhythms, recognition of and respect for other beings and their perspectives and contributions are enhanced. Saraceno invites viewers to appreciate the sensory capacities of the spider, whose gentle vibrations are amplified to create an audible echo resonating across the space. The exhibition allows viewers to familiarise

themselves with the spider and her web in a new way. A way normally inaccessible despite them sharing our homes. She becomes an artist, a musician, a conductor, and a being in her own right, whilst contributing to the larger artistic vision of Saraceno but on a greater level, to the more-than-human cosmos made metaphor in this installation. Humans and nonhumans both play the role of active agent in this space, joined together in cosmic harmony.

As visitors emerge from the cosmic web within the Asia Culture Centre they are able to experiment with an *Aerocene* sculpture themselves. A ballooning backpack was left in the museum courtyard for any visitor to try if they desired, with the assistance of trained attendants. What Saraceno's exhibition achieves is a poetic consilience of different artworks, species, times, places and elements. The spider as conductor creates the platform or interface where the cosmic relations between a cluster of webs and a cluster of galaxies can really be felt, and from which new ideas can unfold. The conclusion of the exhibition returned visitors to Earth to be able to realistically experiment with manifestations of future change to our ways of life, briefly floating into the air having encountered radically different ways of sensing in the world of spiderwebs.

Conclusion

A prevailing characteristic among spiders is the ability to "hear", not through a timbal-like organ as in humans, but rather through trichobothria, thin hairs emerging from their legs. These individual hairs once exposed to air currents act as movement detectors and respond to air-borne stimuli. So-called slit-sensilla, tiny slits in the exoskeleton inform the spider about vibrations through the substrate.[17] Eva Hayward describes how sense organs are portals or channels open to external and intra-(in)organic worlds, through which enormous streams of impulses are constantly flowing into the body." She concludes that beings are shaped by their sensations, going on to describe how her "lived body is always also mediated by [its] engagement with other bodies and things. Thus [one's] experiences are always mediated by historical and cultural systems that constrain [one's] perception and [one's] world." (Hayward 2006, 15, 31) Finding meaning in matter, Hayward demonstrates how sensuality can make possible (futuristic) structures and meanings that instruct experience and make it potentially inhabitable for others (who might not necessarily have a say).

Tomás Saraceno achieves such a feat working with spiders and their webs. In becoming attuned to their capacities for resonance, Saraceno creates models where humans too can experience such degrees of sensuality. His viewers are invited to feel more sensibly in the way spiders do and to hear phenomena normally out of earshot. Placing his viewers in macro-cosmological displays, the human too can experience life like the microscopic spider who scurries in the cracks between our floorboards. In this paper, I explore why the capacity to *feel* others, their movements and their positioning, and to *resonate* with them is so important in our current moment of the Anthropocene. Spiderwebs, for Saraceno, spark inquiry into possible methods to redefine relationships both within humanity itself and between humans and animals and our shared environment. Both Haraway's 'Situated Knowledges' and Hester's *Xenofeminism* emphasise that humans must learn to weave their communities within and across natural systems, in mutual reciprocation.

Although tensions and fragility might arise, the key requirement is that each node of the web, each connection and moment of synthesis, must be in resonance with all other parts of the system. Partial vision and situated knowledges are key, alongside an openness and attunement, a willingness to defamiliarise one's position to accommodate and mediate and join with, even if only fleetingly, the needs and perspectives of others. Imbricating art and science, Saraceno's spiderwebs become the most sensible way to imagine future modes of life where all situated knowledges have a place, where all strangers and outlying others are allowed, and felt, to resonate with their own perspective and voice.

In our current moment of ecological crisis, what one witnesses across a lot of humanity is a keen interest in learning ever more about more-than-human technologies and spaces. Scientists are now virtually weaving together telescopes around the world in order to look deep into the eye of a black hole or to encounter other forms of "intelligent" life "out there" for example. Saraceno instead reminds us that there are things here on Earth that merit a closer look. He provokes his viewers to enhance their connection to life here on terrestrial Earth and suggests that only once we come to terms with the other species with whom we share the planet, might we have the capacity to inhabit the universe at large. Through his close attention to arachnid ecologies, Saraceno imagines possible interspecies webs of relations that in fact lie right under our noses. His artworks show what we might learn and how we might develop if we situate our perspectives with those normally considered strangers, *xenos* such as the spider weaving its web in the corner of our window frame.

In becoming attuned to their capacities for resonance, Saraceno creates models where humans too can experience such degrees of sensuality. His viewers are invited to feel more sensibly in the way spiders do and to hear phenomena normally out of earshot.

Endnotes

[1] Here I use Tim Morton's explanation of "attunement", this "being precisely how the mind becomes congruent with an object." See Morton 2013, 171.

[2] This naming also conveys certain human racist and sexist connotations.

[3] Saraceno specifically manipulates their orientation via gravity in the periodic rotation of his *Hybrid Webs* and plans to send several species of spiders into space to investigate how they adapt to their web spinning to a weightless world.

[4] This being the world as it is experienced by a particular organism. Biologist Jakob von Uexküll goes as far as to describe the spider's web as "fly-like", the spider and its web being so attuned in anticipation of its prey. Even if the spider and fly cannot communicate with one another, the web is built so as to intercept its trajectory with exact precision. See Jakob von Uexküll, 'The Theory of Meaning' in *Semiotica, 42* (1). (1982), 66.

[5] Here Engelmann uses Tim Ingold's elucidation of the differences between networks and webs in *Being alive: Essays on movement, knowledge and description,* (Abingdon, Oxon: Routledge, 2011) 85.

[6] See Haraway's final chapter 'The Camille Stories: Children of Compost' in *Staying with the Trouble.*

[7] Spiderwebs leave no trace in the fossil record cementing their truly ephemeral quality.

[8] Spider silk has a strength five times higher than steel, and only breaks at between 2-4 times its length.

[9] Saraceno has worked specifically with the sonic vibrations of spiderwebs, devising instruments to amplify their notes and inviting musicians to play with them in jam sessions. See Tomás Saraceno, *Arachnid Orchestra. Jam Sessions.* (NTU CCA Singapore, 2016)

[10] In 2008 Saraceno constructed an installation at Tanya Banakdor gallery, New York, entitled 'Galaxies Forming Along Filaments, Like Droplets Along the Strands of a Spider's Web' a clear acknowledgement to the comparison between our cosmological structure and the organic spider's web. See the exhibition catalogue for *14 Billions (Working Title)* for various in depth discussions and evidence about the spider/cosmic

web comparison and for Saraceno's own materialisation of this analogy.

[11] "The galaxy is so far away that astronomers are seeing it as it looked in the early formative years of the universe, only 2 thousand million years after the Big Bang." Martin 2011, 29.

[12] See my earlier discussion of the 2009 project *14 Billions (Working Title)* to place spiders in scale model of the Venice biennale room – from there one would hope to see the relation between the spider web and the millennium simulation. Web woven in gallery, scanned and enlarged in 3D space so as to be accessed by humans and compared to the "cosmic webs" of the Millennium Simulation. The project was about rendering explicit a shared cosmological quality between the spider's dwelling and that of our galaxy. Crucially, the "between: that eventually brought these entities into relation was not a melting-together of the cosmic and the creaturely, but a mobilisation of their differences" "as that which relates the two as different." Engelmann 2016, 151

[13] See Engelmann's interview with Hanna Barranowska who works in the spider room at Studio Tomás Saraceno in Engelmann 2017, 164-5.

[14] Between five and 300 tonnes of cosmic dust falls through the atmosphere to earth every day, and sometimes a speck might be as old as the known Universe. These particles are therefore both past and present, cosmic and earthy.

[15] In addition to the spherical spheres interspersed within the gallery, their ballooning shapes borrowed from *Aerocene*, an *Aerocene* backpack was left in the museum's courtyard for any visitor to try if they desired, with the assistance of trained attendants.

[16] Ballooning spiders, *Stegodyphus dumicola* are normally a solitary species. However, they come together to collectively send out long sticky threads into the wind. As the wind mixes the threads, a meshed sail is produced that can lift all the spiders at once.

[17] Wolf spiders for example do not weave webs. They live on the edges of ponds and use visible landmarks or astronomical cues such as the pattern of the sky to run across water and return to firm ground. The species travels at night capturing prey. If a male spider encounters a female, he drums his abdomen on a surface and uses his legs to produce micro-turbulences in the air that the female can detect. The threads woven and sensed by the spider are not silken ones, but spirals and waves extending in air. This creature is feeling toward quasi-invisible impression in a dense milieu and is sending information back. It is both solitary and social at the same time. Engelmann, 2016, 72.

Bibliography

Brunetta, Leslie, and Craig, Catherine L., *Spider Silk: Evolution and 100 Million Years of Spinning, Waiting, Snagging and Mating*, (London: Yale University Press, 2010)

Engelmann, Sasha Hildegaard, 'Social spiders and hybrid webs at Studio Tomás Saraceno' in *Cultural Geographies* vol. 24 (1), (2017), 161-9

------------'The Cosmological Aesthetics of Tomás Saraceno's Atmospheric Experiments', (PhD diss., University of Oxford, 2016)

Haraway, Donna J., *Staying with the Trouble*, (Durham: Duke University Press, 2016)

------------'Situated Knowledges: The Science Question in Feminism and the Privilege of Partial Perspective' in *Simians, Cyborgs, and Women, The Reinvention of Nature*, (London: Free Association Books, 1991), 183-201

Hayward, Eva, 'Envisioning Invertebrates and other Aquatic Encounters' (PhD diss., University of Santa Cruz, 2007)

Hester, Helen, *Xenofeminism*, (London: Polity Press, 2018)

Jäger, Peter, in conversation with Saraceno, Tomás and Krell, Adrian, printed in *14 Billions, (Working Title)*, (Milan: Skira Editore, 2011), 30-1

------------'Crazy Threads or How Art and Science Worked Together', *14 Billions, (Working Title)*, (Milan: Skira Editore, 2011), 204-7

Kohn, Eduardo, *How Forests Think*, (Berkeley: University of California Press, 2013)

Latour, Bruno, 'Saraceno's Monads and Spiders', *Reset! Modernity*, Bruno Latour (ed.), (Cambridge Ma., MIT Press, 2016) 205-6

Martin, Davide de, and ACS Science Team, 'Flies in a Spider's Web: Galaxy Caught in the Making' in *Astrophysical Journal Letters*, (October, 2006), printed in *14 Billions (Working Title)*, (Milan: Skira Editore, 2011), 29

Michelet, Jules, *The Insect*, (Milton Keynes: Lightning Source UK Ltd., 2012)

Morton, Timothy, *Hyperobjects* (Minneapolis: University of Minnesota Press, 2013)

------------*The Ecological Thought*, (Cambridge Ma., University of Harvard Press, 2010a)

------------'Guest Column: Queer Ecology' *PMLA*, vol. 125, no. 2, (March 2010b), 273-282

Nieuwenhuys, Ed, in *14 Billions, (Working Title)*, (Milan: Skira Editore, 2011), 6

Saraceno, Tomás, 'Interview: Tomás Saraceno Our Interplanetary Bodies' *YouTube*, 11 Jan. 2018, Video, 6:59. https://www.youtube.com/watch?v=MMvGxGCkSpE

------------'How to Entangle the Universe in a Spider's Web', *Esther Schipper*, 2017. https://www.estherschipper.com/exhibitions/473/

------------'Would you live in a floating city in the sky?', TED talk, 2017, Video, 11:03. https://www.ted.com/talks/tomas_saraceno_would_you_live_in_a_floating_city_in_the_sky#t-651342

------------'Hybrid Webs', Projects, *Studio Tomás Saraceno*, accessed 28th August 2018, https://studiotomassaraceno.org/

------------Tomás Saraceno: Building "future flying cities" with spiders', *SFMOMA*, accessed 28tH August 2018. https://www.sfmoma.org/tomas-saraceno-building-future-flying-cities-spiders/

------------Uexküll, 'Jakob von, The Theory of Meaning', *Semiotica, 42* (1), (1982), 25-82

Elizabeth Atkinson is an AHRC funded PhD candidate at the Royal College of Art. She researches artists who use animals in their work to investigate how other species relate to one another and their environment. She considers what humans might learn from these animals, countering the separation of species grounded upon the anthropocentric conceit of human capacities for language and rationality (amongst others). In our current moment of ecological crisis, it seems imperative humans adopt new ways of living and Elizabeth suggests how animals might provide critical examples. This paper is taken from her thesis, 'Animals and their Artists: Challenging human anthropocentrism through nonhuman representations of self'.

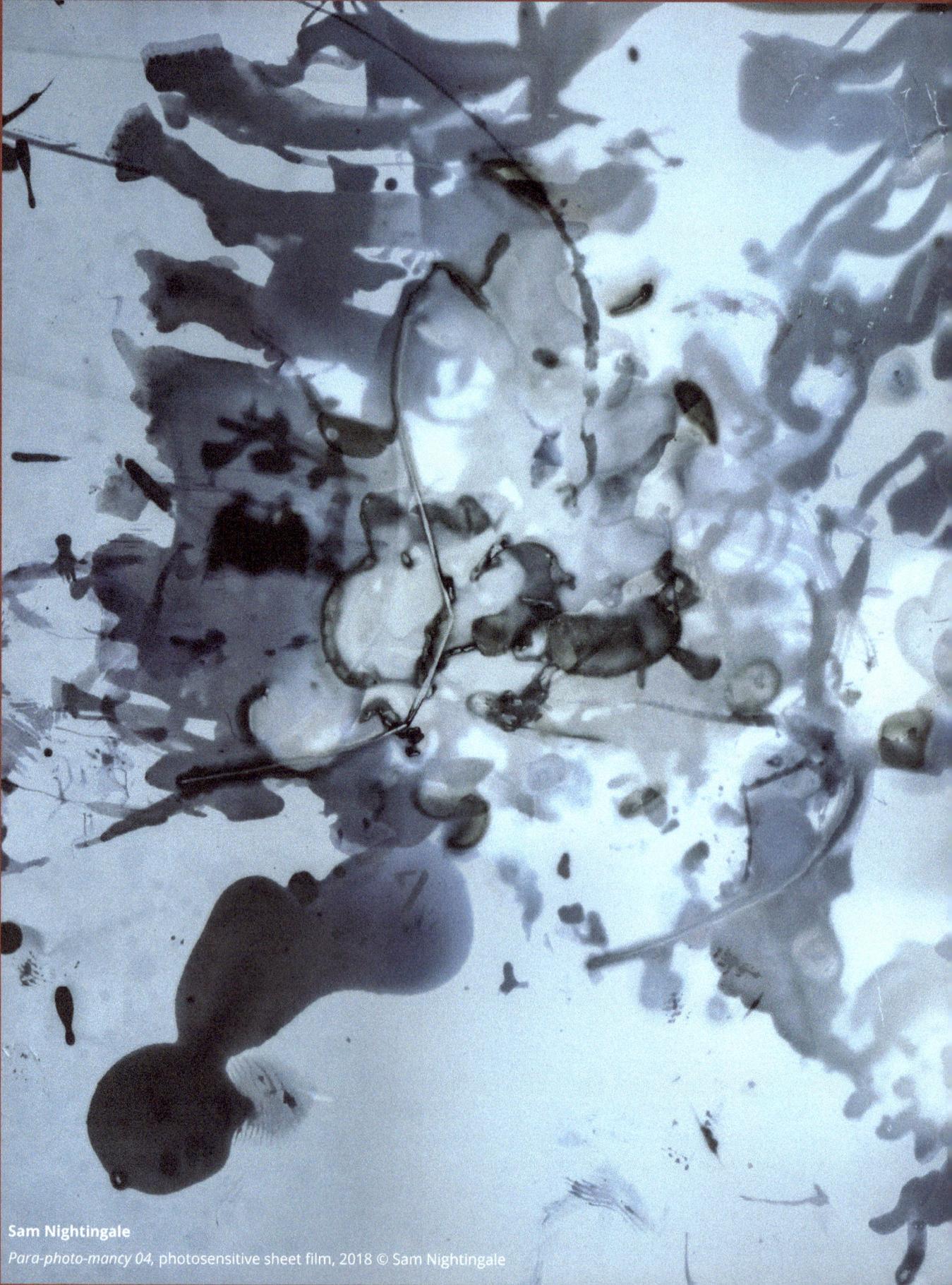

Sam Nightingale
Para-photo-mancy 04, photosensitive sheet film, 2018 © Sam Nightingale

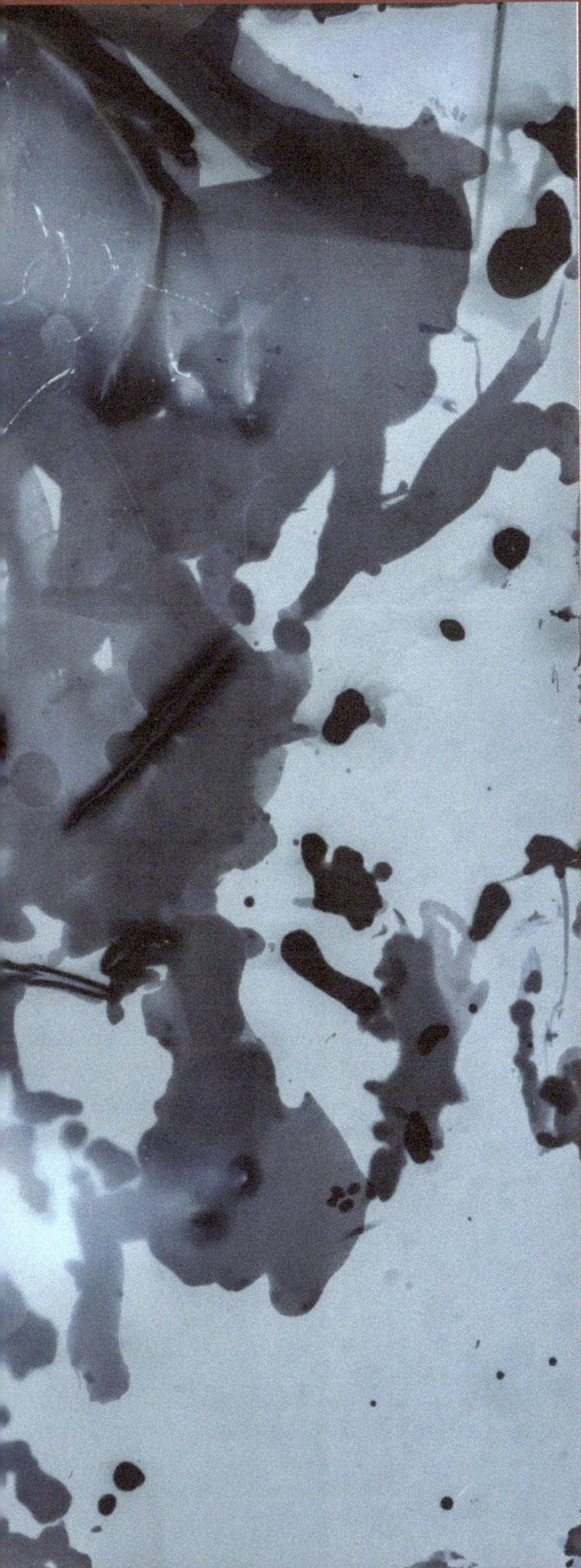

Sam Nightingale's Para-Photo-Mancy

Para-photo-mancy is a series of experimental photographic artworks that utilise the inherent photo(phyto)chemical capacities of plants to produce images. It is a process of image-making that both reconfigures technologies of representation concerning 'nature', while suggesting the existence of different material durations (human and non-human) expressed in the staticity of the images. Artist Sam Nightingale describes these works as "biochemical images", a method he has developed to explore the potential for plants to self-represent; a method that enfolds vegetal matter into the image as a means of production.

text and images by **Sam Nightingale**

*P*ara-photo-mancy is a series of experimental photographic artworks that utilise the inherent photo(phyto)chemical capacities of plants to produce images. It is a process informed by knowledge drawn from science and photography devested to reconfigure technologies of representation concerning 'nature', while alluding to different material durations (human and non-human) expressed in the images. I describe the works in the series *Para-photo-mancy* as "biochemical images", an experimental method that explores the potential for plants and minerals to produce their own image when they are brought into direct contact with photosensitive film. Instead of a representational image depicting 'nature', *Para-photo-mancy* facilitate an image in which 'nature' writes itself into the photographic object as a chemical process and interaction, recording the material durations of various agents: human, mineral, plant, chemical that are a part of its production.

The works comprised in the portfolio *Para-photo-mancy* resemble photographic images, however, these are biochemical images. They are different from traditional conceptions of photography in the sense that they are created without lenses or light; instead, these images are produced by a camera-less technique that utilises the internal energy of plants to generate a *para-photographic* image.[1] *Para-photo-mancy* could be mistaken for a series of photograms; however, such creations, also originate from 'photo-', from the Greek *phōs*, the ability of light to create images. The images in *Para-photo-mancy* instead emerge on sensitised sheets of photographic film as a result of phytochemistry.[2]

The distinct appearance of each biochemical image is dependent on a number of factors. The uniqueness of each image is contingent on the chemical reactions taking place between phenols contained within the vegetal matter and the silver halide crystals in the photographic emulsion. Phenols are a class of molecules found in plants and other micro-organisms with variations taking place between species. Through experiment, the pH of the vegetal matter used to produce the biochemical images can be modified in such a way that when brought into contact with the film emulsion it acts as like a photochemical developing agent. After leaving the vegetal matter and the film material into contact for some time, the individual molecular properties of lichen, fungi, berries, etc., imprint a strange para-photographic image on the film.

Para-photo-mancy is an experimental and collaborative artistic practice, one that unfolds between the human and non-human worlds, that foregrounds the creative agency of matter to conjure images that surpass human perception and human experience of time. In Donna Haraway's words this process can be described as a practice of 'making -with' or 'sympoiesis', a term she borrows from M. Beth Dempster to suggest that 'sympoiesis' relate to "collectively-producing systems that do not have self-defined spatial or temporal boundaries [where] [i]nformation and control are distributed among components."[3] *Para-photo-mancy* enables a way to conceive of the biochemical images as emerging through co-production or as the result of a collective system: distributed across different temporalities, between myself, the environment, the organic matter, and other chemical elements.

These images, which enfold the materiality of the site into the image-making process, also function as containers for many different temporalities (mine, the organic matter, the chemistry, the photographic substrate, to name just a few). As an experimental artistic practice, *Para-photo-mancy* draws on biochemical energy agential forces producing images that elicit other sensibilities and lines of communication. The images grant time a visible texture in a way that communicates the co-presence of the different temporalities of these other living organisms and ecosystems: of moss, fungi, lichen, agricultural, industrial, human, etc. It is a process that takes into account, as Karen Barad's would have it, the "superposition of different times", in other words, that multiple co-existing "temporalities are specifically entangled and threaded through one another".[4] Organisms that synthesise phenols do so in response to various ecological effects, such as increased in soil salinity, climate change and pathogens, for example. The expression of different time-scales, of historical action upon nature, of various ecological events that have impacted the biology of plants over time is also inscribed into the image as the mark of different material durations conjured in the photographic emulsion.

Imprinted within the biochemical images that make up *Para-photo-mancy* is something akin to a genetic fingerprint generated from the location of their germination. However, this is not one produced through purely scientific or photographic means, but through the material, expressive and creative quality of the environment itself.

Para-photo-mancy was produced during Field Notes, an art and science field laboratory that takes place at the Kilpisjärvi Biological Station in sub-Arctic Finland, organised by The Finnish Bioart Society.

Sam Nightingale

p.75 -top: *Para-photo-mancy 01*, photosensitive sheet film, 2018

below: *Para-photo-mancy 02*, photosensitive sheet film, 2018

Right: *Para-photo-mancy 05*, photosensitive sheet film, 2018

© Sam Nightingale

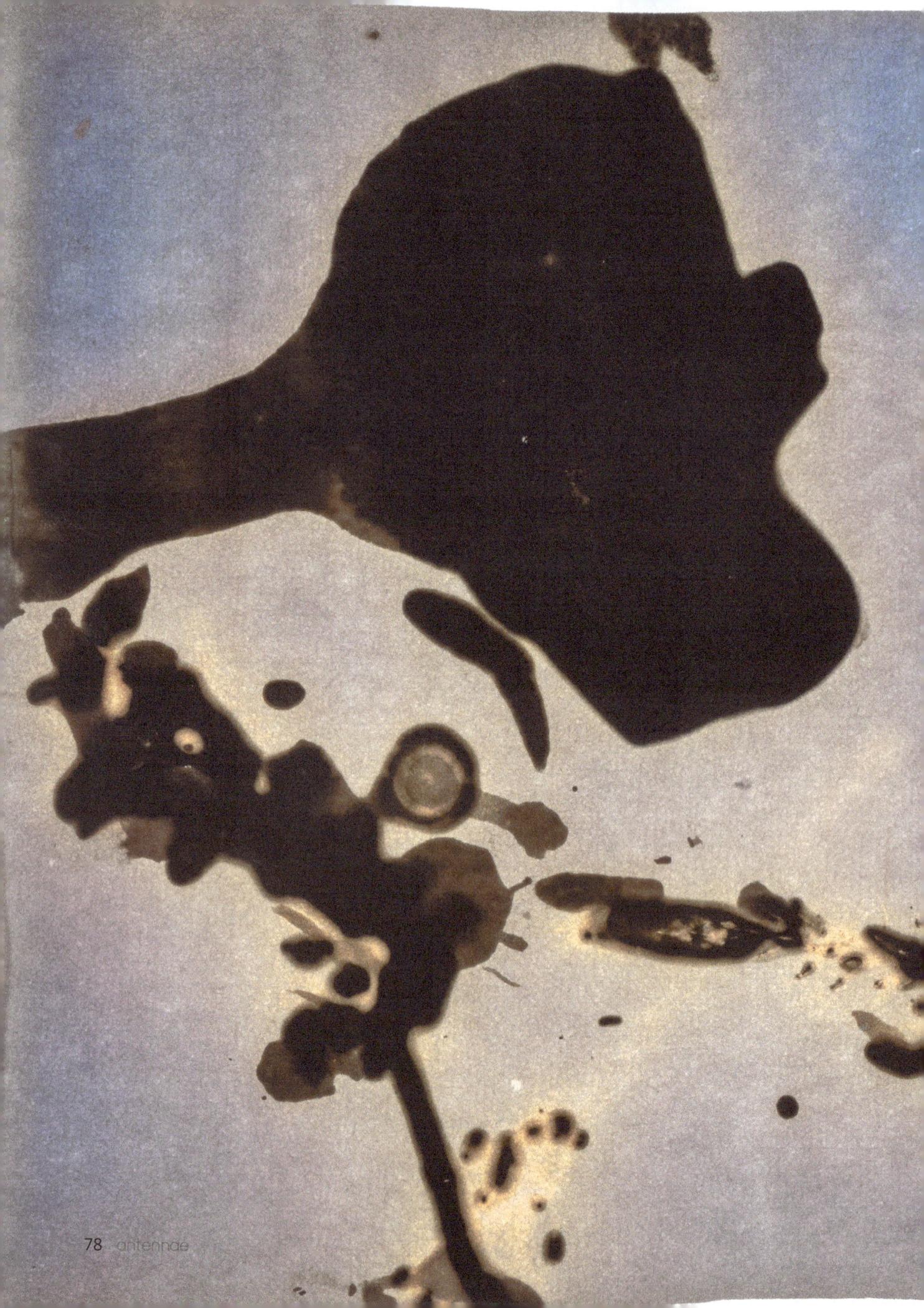

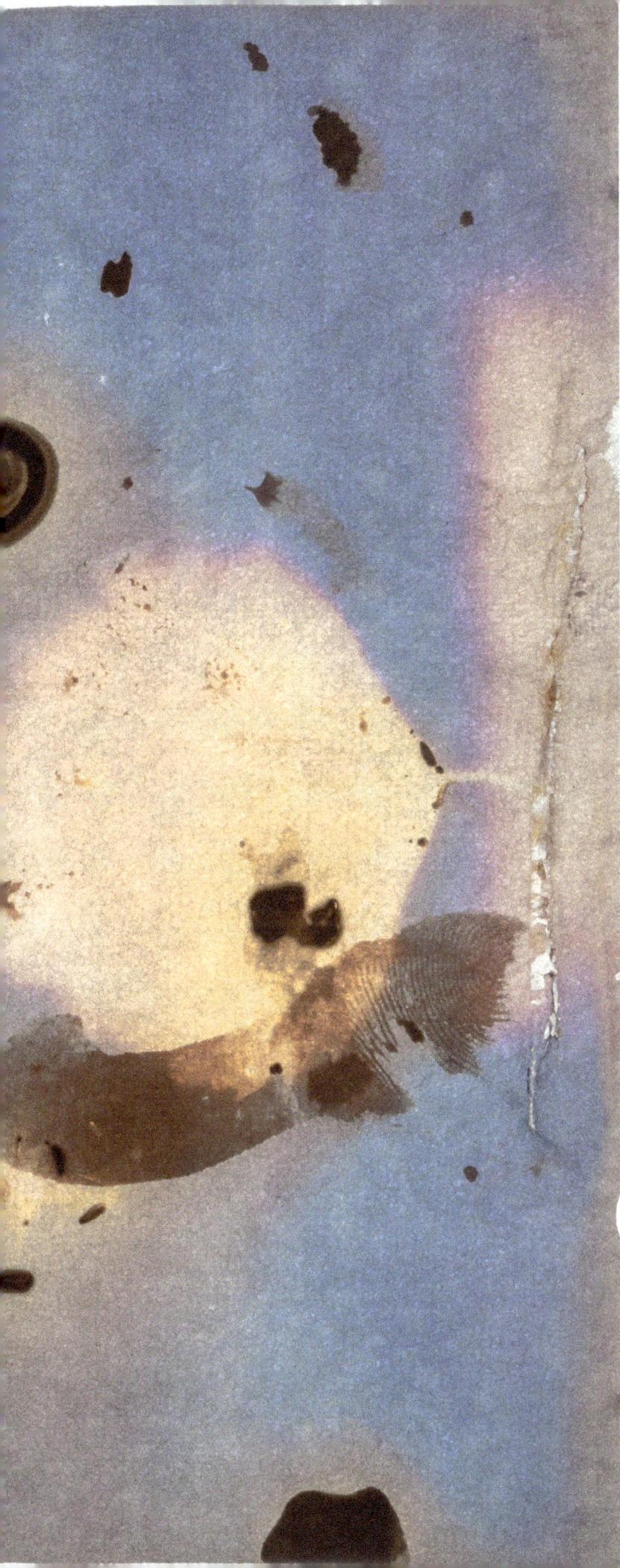

Sam Nightingale

Para-photo-mancy 06, photosensitive sheet film, 2018 © Sam Nightingale

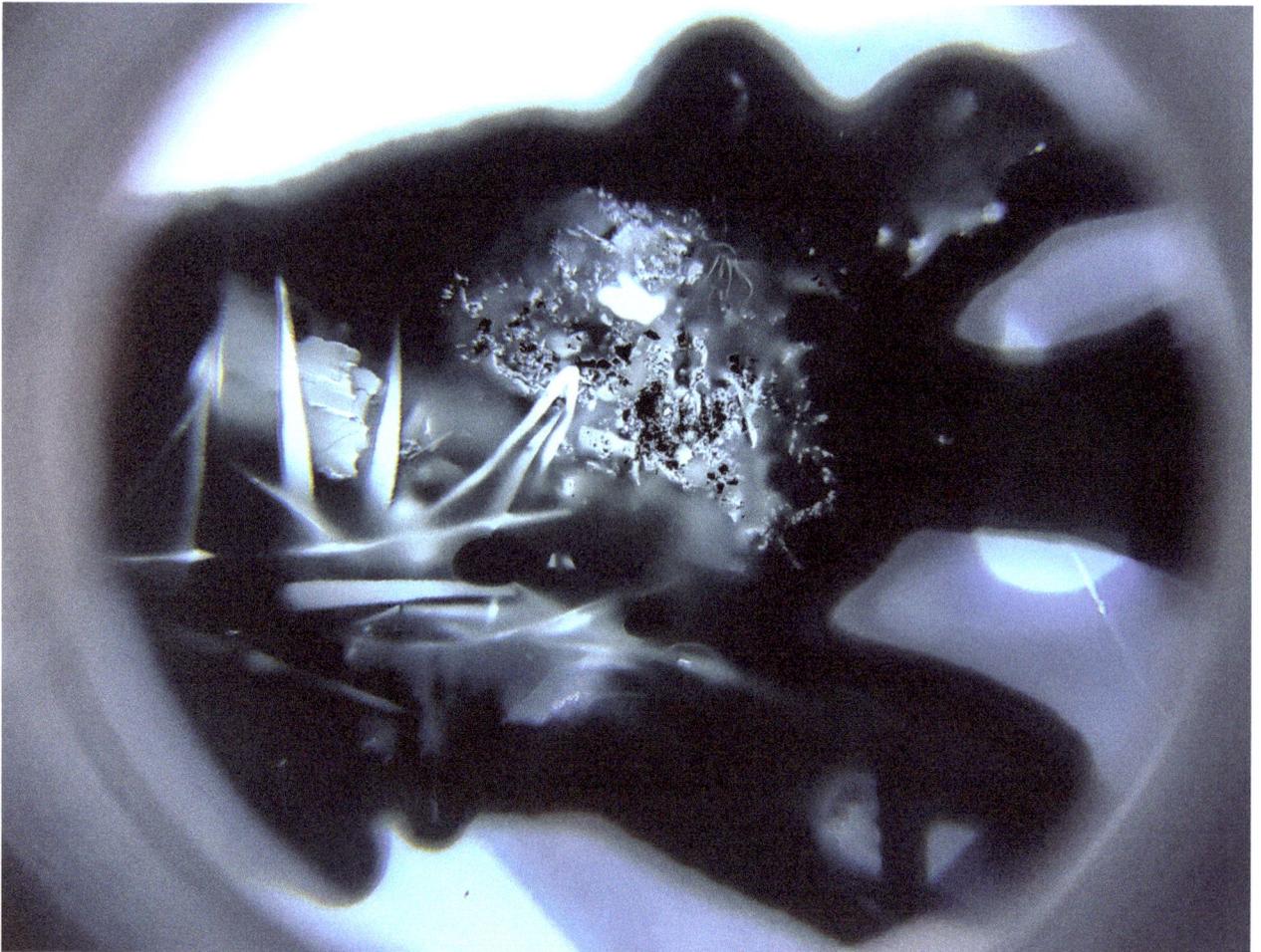

Sam Nightingale

Para-photo-mancy 07, duratran digital transparency, 2018 © Sam Nightingale

Notes

[1] The term 'para-photographic' is used here to describe a process that is related to photography, but equally is distinct from it, such that it can be considered as sitting beside or adjacent to the photographic medium. This is different from 'proto-photographic', which Geoffrey Batchen categorises as the various attempts that were made to record something photographically before the actual invention of photography in 1839. Batchen, Geoffrey. (1999) *Burning with Desire: Conception of Photography.* (Cambridge, Mass.: MIT Press).

[2] In visual culture, there is an abundance of artists and filmmakers whose practices engage organic material to produce different types of images. For example, the UK-based filmmaker Karel Doing produces 16mm films and expanded cinema, using a similar process, which he refers to as producing 'phytograms'. Many thanks to Karel for introducing me to his method of making photochemical images using phytochemistry.

[3] Haraway, Donna. (2016) *Staying with the Trouble: Making Kin in the Chthulucene.* (Durham: Duke Unversity Press) p.33

[4] Barad, Karen. "Troubling Time/s and Ecologies of Nothingness: Re-Turning, Re-Membering, and Facing the Incalculable." *New Formations* 92, no. 92 (September 1, 2017): 67. https://doi.org/10.3898/NEWF.92.05.2017

Bibliography

Barad, Karen. "Troubling Time/s and Ecologies of Nothingness: Re-Turning, Re-Membering, and Facing the Incalculable." *New Formations* no. 92 (September 2017): 56–86. https://doi.org/10.3898/NEWF.92.05.2017.

Batchen, Geoffrey. *Burning with Desire: Conception of Photography.* Cambridge, Mass.: MIT Press, 1999.

Haraway, Donna. *Staying with the Trouble: Making Kin in the Chthulucene.* Durham & London: Duke University Press, 2016.

Sam Nightingale is a visual artist based in the UK. He uses experimental modes of photographic image production and speculative fieldwork to make sensible the temporalities and spatialities of environments that we are a part but that also persist beyond the limits of human experience. His work draws as much on human media technologies as it does on a biophysical environment's capacity to act as elemental media.

He exhibits internationally, his work has been included in exhibitions and film festivals in America, Australia and Europe, including: Mildura Arts Centre, Australia (2017); Four Corners, London UK (2017); Photofusion, London, UK (2016) Deutsche Bank, London (2014). Residencies include Ecology of Sense (The Finnish Society of Bioart); Practicing Deep Time (TimeSpan Scotland); Dark Ecology (Sonic Acts - Arctic Circle). He is a PhD Candidate at Goldsmiths, University of London.

Sougwen Chung:
Drawing Operations

Sougwen Chung is a Chinese-born, Canadian-raised artist residing in New York City. Chung's critical practices are based on performance, drawing, still image, sculpture and installation. Chung's work investigates mark-made-by machine and mark-made-by-hand for understanding the encounter of computers and humans.

text and images by **Sougwen Chung**

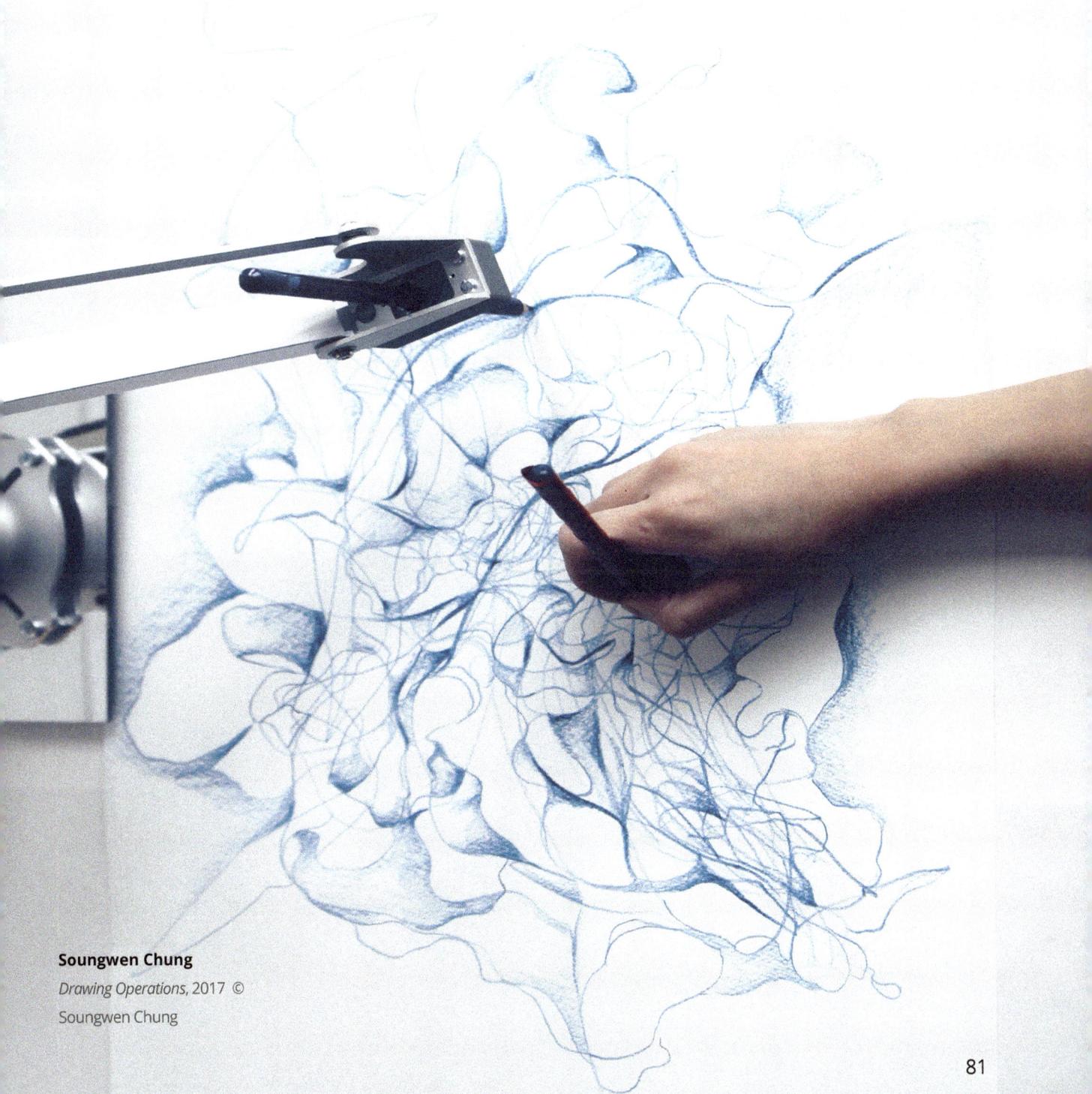

Soungwen Chung
Drawing Operations, 2017 ©
Soungwen Chung

"What is ownership? What is work?... How can we move from a production system in which human labor is merely a disposable means ...to a process that depends on and expands connective relationships, mutual respect, the dignity of work, the fullest possible development of the human subject?"

- Adrienne Rich

The projects by Sougwen Chung explore various processes, possibilities, and anxieties that define the time in which the works are produced. In part, they are inspired by Krebs's 'Cycle of Creativity', which conceives of the creativity act as a process of interrelated disciplines: an ecosystem.

Her projects explore the human-made mark and the machine-made mark as an approach to understanding the interaction between humans, computers, and the environment. They encompass installation, robotics, sculpture, drawing, and performance.

Drawing Operations 1&2 and *Omnia per Omnia,* featured in this portfolio, trace an evolving process of making with robotic units and AI technologies. This evolution forms the basis of human and machine collaboration. By working with machines as collaborators, the drawing and painting of artefacts exists as both works of art and research. In Drawing Operations, the robotic arm's behaviour is programmed by neural nets trained from the artist's drawing gestures. In a sense, the robotic arm learns from the artist's drawings style and delivers a machine-interpreted rendition during the human / robot real time, drawing collaboration.

Chung is a former researcher at MIT's Media Lab and an inaugural member of NEW INC, the first museum-led technology and art in collaboration with The New Museum. According to the World Science Festival 2018, she is an Artist-In-Residence at Bell Labs exploring new forms of drawing in virtual reality, with biometrics, machine learning, and robotics.

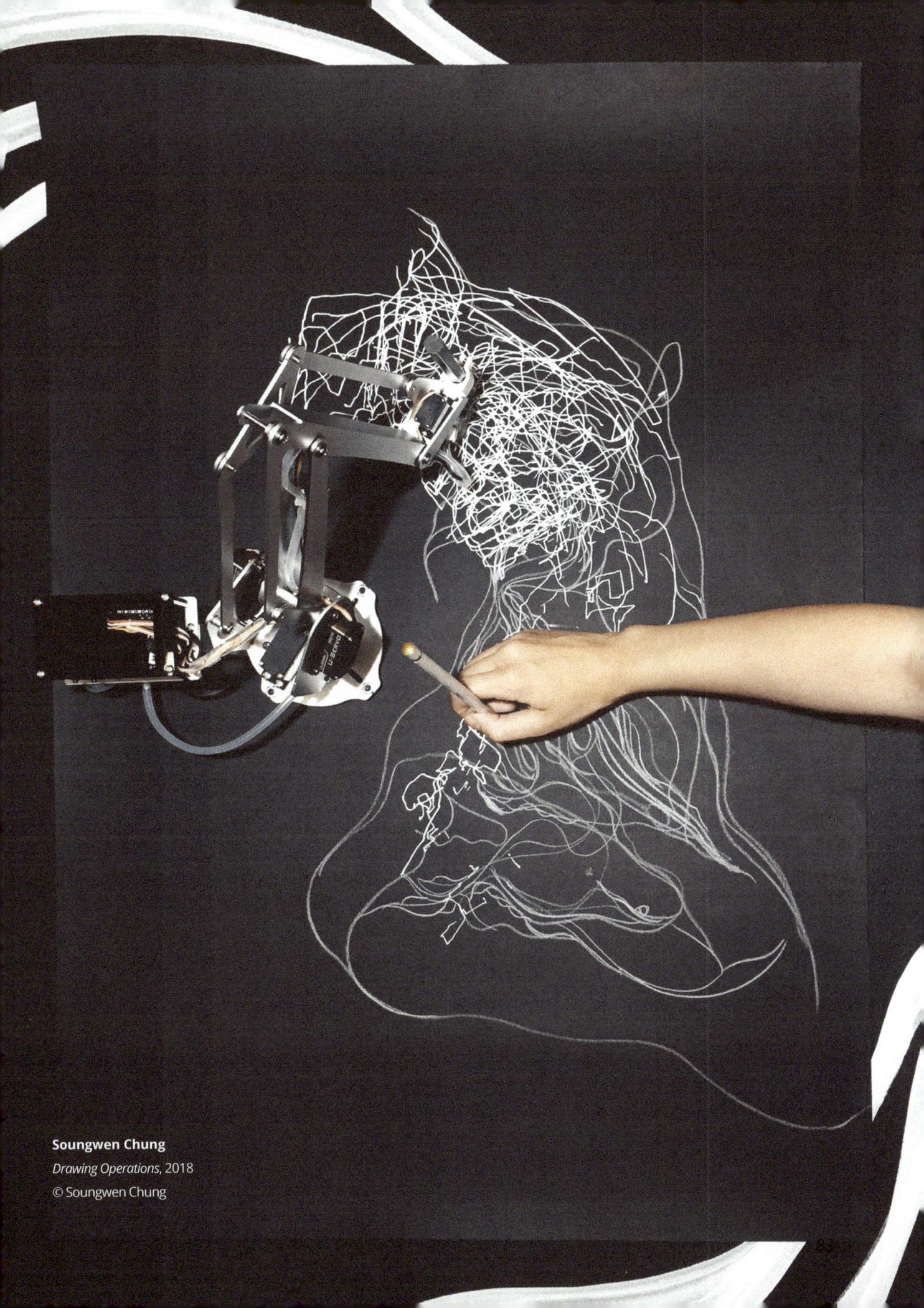

Soungwen Chung
Drawing Operations, 2018
© Soungwen Chung

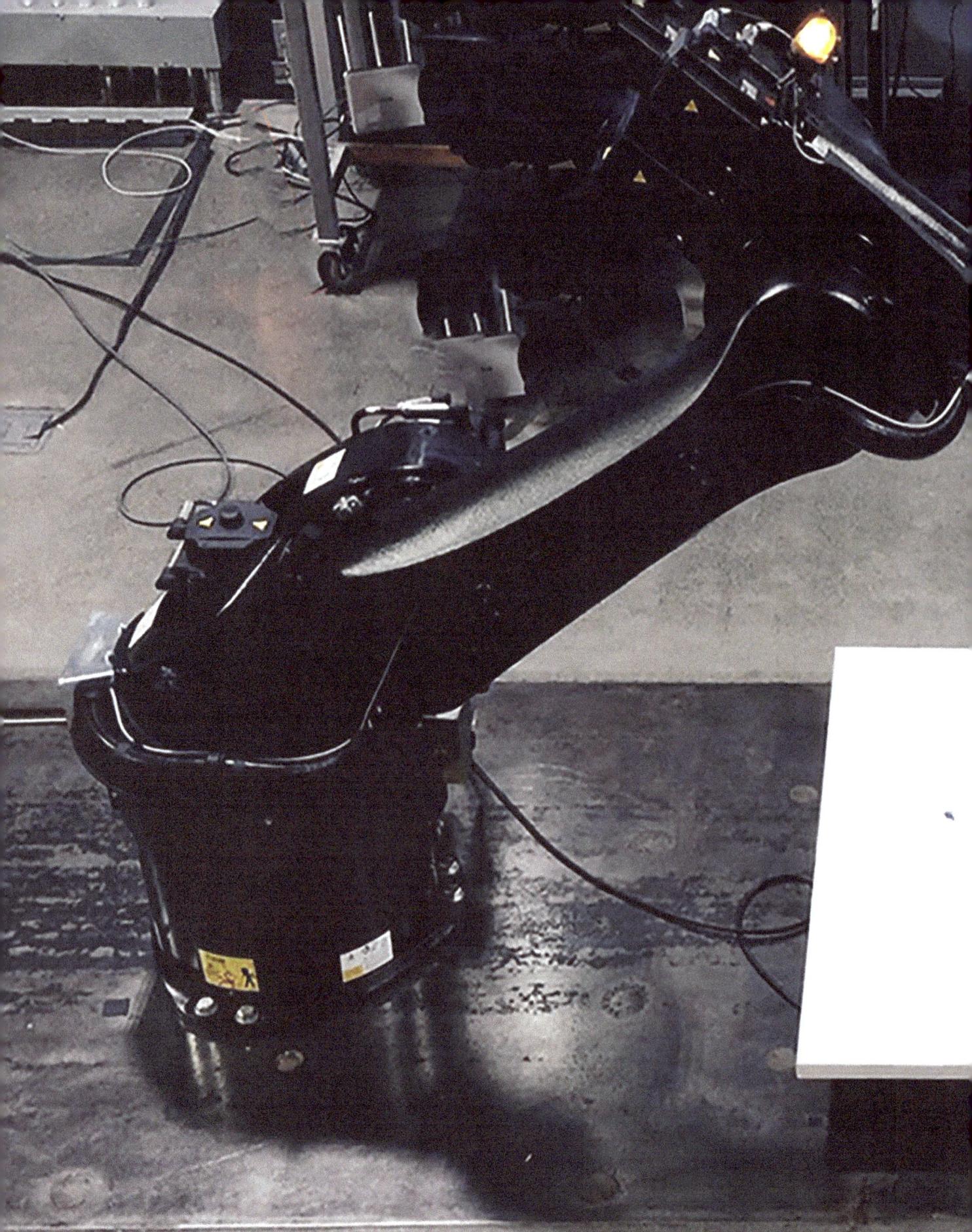

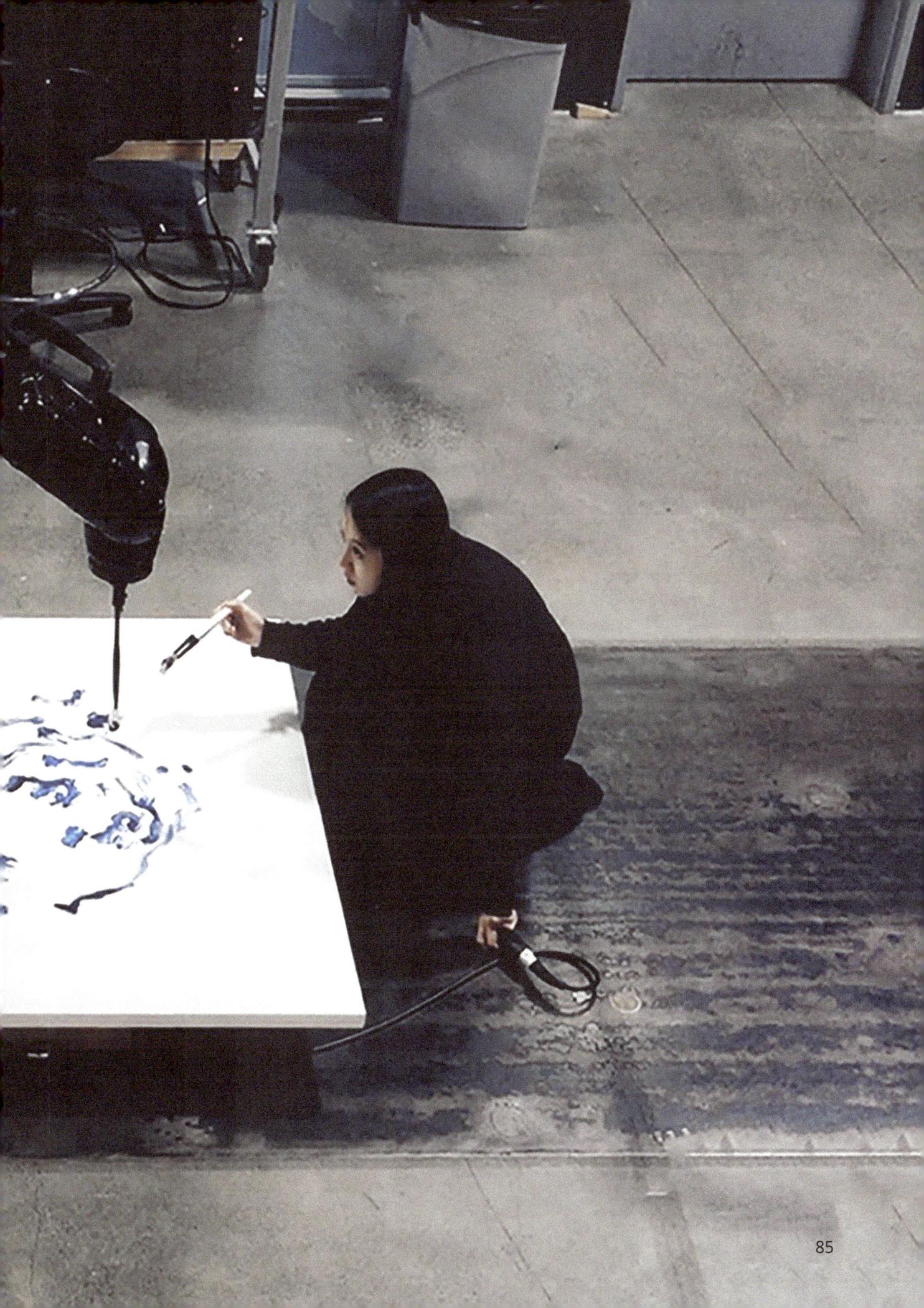

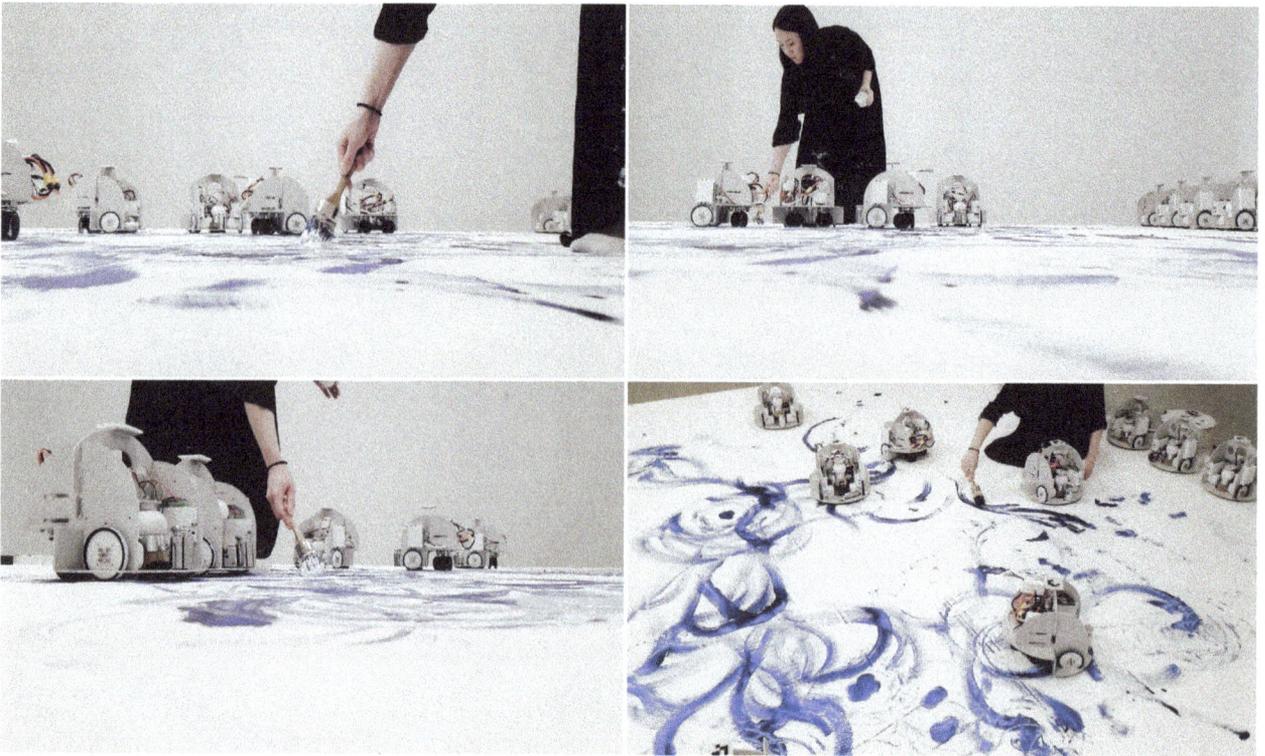

Soungwen Chung
Omnia per Omnia, 2018 © Soungwen Chung

Sougwen Chung grew up in Toronto, Canada, and Hong Kong (where her parents are from). Her father, an opera singer, made sure that his children learned a musical instrument since a very young age, so Chung grew up playing violin and piano. She moved to the States as a teenager and received her BFA from Indiana University before obtaining her Masters Degree in Interactive Art from Hyper Island in Sweden. Chung's work has been shown at galleries and museums across the world, including MAMCO in Geneva, Switzerland and Istanbul's Akbank Sanat. Chung has spoken globally at conferences including Tribeca Film, New York; The Hospital Club, London; MUTEK Festival, Montreal & Mexico City; Sonar Festival, Barcelona.The Art Directors Club, New York; Stockholm; SXSW, Austin; Tokyo; Internet Dargana, Barcelona: FITC; New York; OFFF, Barcelona. Her work has also been featured in multiple international press outlets including The New Yorker, Art F City, Dazed and Confused, The Creators Project, MASHABLE, Engadget, Business Insider, Fast Company and USA Today.

Engineering Spaces for Cyborgs

In 2015, my collective persona found itself building a human-sized box in the middle of my studio. This new habitat was a 4-foot cube made of plywood and MDF, sweat, and the tiniest bit of blood. It had a 2-ft opening on one side so that I could enter without sacrificing the feeling of confinement. The walls weren't designed to meet at the corners, so there were narrow slits of space no more than a half inch wide where I could peer into the surrounding environment. I'd built my own space station (a station for a human seeking more space).

text and images by
Lee Blalock aka L[3]^2

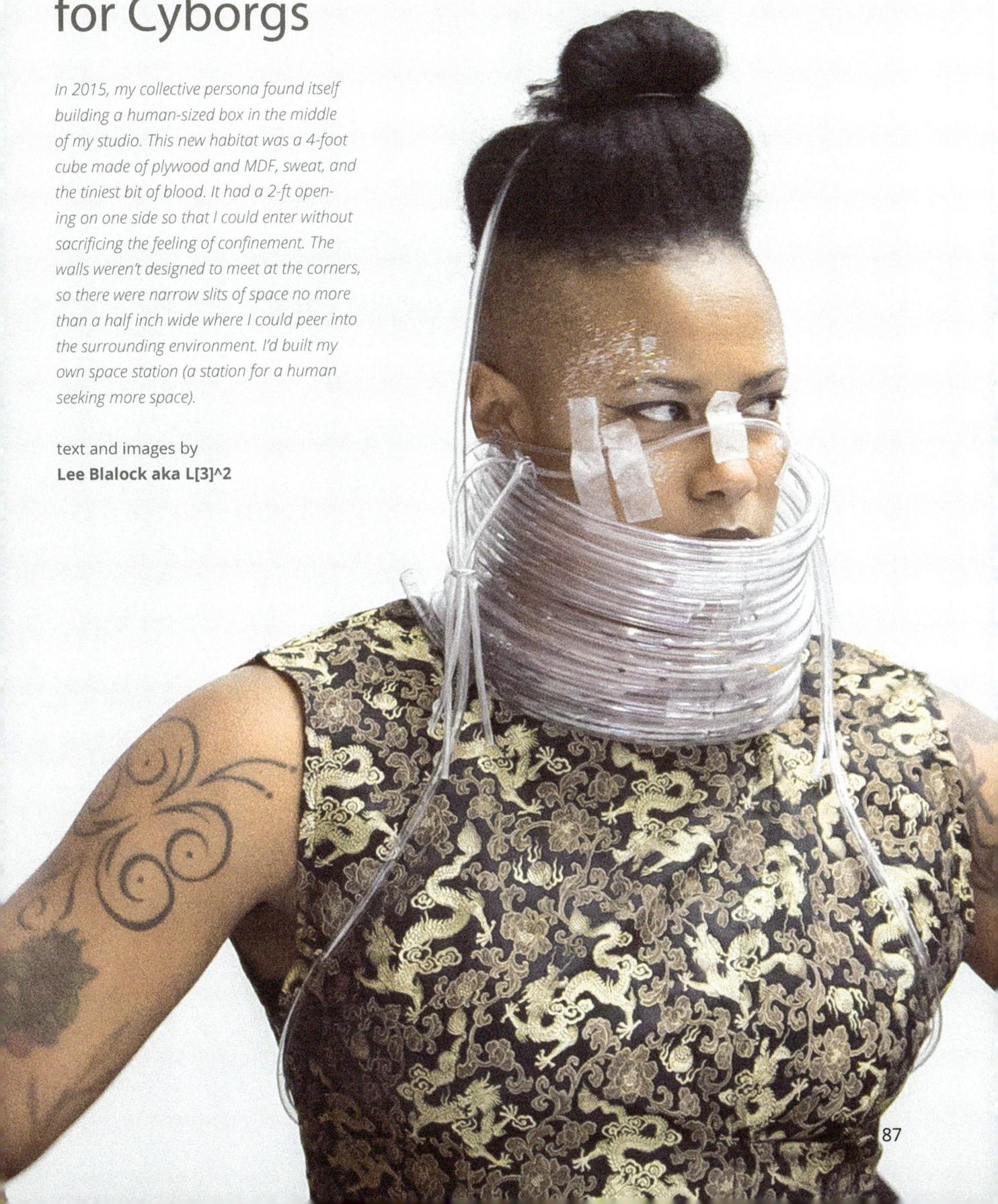

The *n3w_b0d1es Study* is a study of agency and self-regulation through processes of behavior modification and performance. This is a study in 3 phases, the data for which is ongoing.

Phase I - Design

In 2015, my collective persona found itself building a human-sized box in the middle of the studio. This new habitat was a 4-foot cube made of plywood and MDF, sweat, and the tiniest bit of blood. It had a 2-ft opening on one side so that I could enter without sacrificing the feeling of confinement. The walls weren't designed to meet at the corners, so there were narrow slits of space no more than a half inch wide where I could peer into the surrounding environment. I'd built my own space station (a station for a human seeking more space). Perhaps I was driven by a need for less noise, both visible and audible. This cube (or capsule) was not built for comfort, so it was a way to force a physical reconfiguration onto the body. Sound was filtered, sight was hindered, blood flow in my legs was restricted, and yet the newness was comfortable. The necessary adaptation incited an internal dynamic that was inspiring.

I'd gotten the capsule idea from following the Instagram feed of astronaut Scott Kelly who was, at that time, spending a year aboard the International Space Station. Though the cosmic images he'd been posting were breathtaking, I wondered about the artificial systems keeping him alive. I'd read the Clynes & Kline paper "Cyborgs and Space", first published in Astronautics in 1960. The second half of this paper is a list of psycho-physiological problems and their proposed cyborgian solutions - a manual for astronauts and their support teams. The paper was based on the idea that re-engineering the body to function automatically in a new environment was preferable to bringing our natural bodies into an environment for which they are not designed. Here on Earth, I was inspired to change my own body to survive my day-to-day.

Phase II - Environmental Testing

Patricia Cowings trained astronauts by monitoring their physiology in stressful conditions, and then taught those same astronauts to control their automatic responses via biofeedback in order to adapt. My capsule represented the second part of Cowing's cycle. The capsule was built as a response to stress and served as my control center. I crouched and listened to sounds on the other side of my door, muffled by the close walls. I sat cross-legged and played electronic music to no one. I wrote a short piece of text that couldn't have been conceived in any other place. I performed from the station remotely for a gallery that would only take 20 mins to get to physically. I wrote a web piece called "TheLongestScream" after recording my own screams in the cube, a liberating answer to the question: If a cyborg screams in space and no one is around to hear it, does it make a sound?

Phase III - Images from Space

There's little value in going to space if you don't change your perspective. (If anyone believes in a simulated universe, it must be the human floating above its terrestrial home.) The new restrictions placed on my ability to position the camera would stifle my natural inclination to compose an image. I placed the lens up against the wood and I captured whatever was visible through the narrow slit in the corners. The lens would not clarify my sight, but it would broaden my perspective. I don't know the subject in these images. I'm satisfied to know that I couldn't create them consciously. They are images of a thing that is nowhere, from a space that is no longer - a space too small to allow for anything but clear signal.

Images: Lee Blalock

p. 87, Lee Blalock photographed by Michael E. Smith.

In order of apperance from p. 88: *ii(LU)Blade, iii(RU)Clk,* and *ii(LD)Bt,* Archival pigment print, 2015 © Lee Blalock

Lee Blalock is a Chicago based artist and educator presenting alternative and hyphenated states of being through technology-mediated processes. Inspired by science fiction, futurism, and technology itself, the work is an exercise in body modification by way of amplified behavior or "change-of-state". Blalock also works under the moniker of L[3]^2, whose most recent live work embraces noise and fissure as a natural state of being for bodies living in the information age. Blalock is an Assistant Professor in the Art and Technology Studies Department at the School of the Art Institute of Chicago. She holds an Master of Fine Arts from SAIC, and a Bachelor of Science from Spelman College.

Gilberto Esparza:

Parasitos Urbanos

Gilberto Esparza is a Mexican artist whose work involves electronic and robotic means to investigate the impacts of technology in everyday life, social relationships, environment and urban structure. He currently conducts research projects on alternative energies. His practice employs recycling consumer technology and biotechnology experiments.

text and images by **Gilberto Esparza**

● SISTEMA DE ESTRUCTURA Y LOCOMOTOR
■ SISTEMA METABÓLICO Y DE ENERGÍA

MSC
MOSCA *(Helicopterulis inductus)*
RADIOGRAFÍA DIGITAL DIRECTA
5.0 kV / 0.12 MAS
DISTANCIA: 1 METRO
EQUIPO: MINI X RAY H.F 80/15+ ULTRA LIGHT
RADIÓLOGO: JOSÉ LUIS VELÁZQUEZ RAMÍREZ

FILAMENTOS DE ALIMENTACIÓN

ALAS

EJE DE NÚCLEO GIRATORIO

BOBINA

TÓRAX

| 1cm | 5cm | 10cm | 15cm | 20cm | 25cm | 30cm |

AUTÓTROFO INORGÁNICO | INORGANIC AUTOTROPH *(Luxalo sono)*, 2007

Motor and recycled pieces, servomotor, abandoned closure for fiber optic cable, Acrylic spheres with electronic circuits extracted from toys | 30 Ø

ETYMOLOGY. From the Latin lux (light) + alo (eat), and sono (sound). Refers to the effect of the variation of light levels on the sounds produced by this species.

ANATOMY. Exoskeleton formed by a translucent acrylic sphere, 30 cm in diameter, enabling light to penetrate and reach its photosensitive organs, which are made up of photo-resistors, electronic circuits from toys and musical devices, and computer speakers.

HABITAT. Found in urban parks.

BEHAVIOR. This species produces a variety of songs based on variations in ambient light levels resulting from shade from trees, clouds, and municipal lighting systems.

TTRF-S NRGNC-S
Autótrofos inorgánicos *(Luxalo sono)*
RADIOGRAFÍA DIGITAL DIRECTA
5.0 KV / 0.12 MAS
DISTANCIA: 1 METRO
EQUIPO: MINI X RAY H.F SR/15+ ULTRA LIGHT
RADIÓLOGO: JOSE LUIS VELAZQUEZ RAMÍREZ

CONECTOR DE ALIMENTACIÓN

BOBINAS

EXOESQUELETO

AMPLIFICADOR DE AUDIO

PATAS

DE SONIDO MODIFICADO

NÚCLEO

G DE SENSIBILIDAD LUMÍNICA

SISTEMA NERVIOSO

FOTORRESISTENCIA

1cm 5cm 10cm 15cm 20cm 25cm 30cm

Gilberto Esparza

Above: *Inorganic Autotroph*, 2015 © Gilberto Esparza

Below: *Hanger*, 2015 © Gilberto Esparza

Right: *Hanger X-Ray*, 2015 © Gilberto Esparza

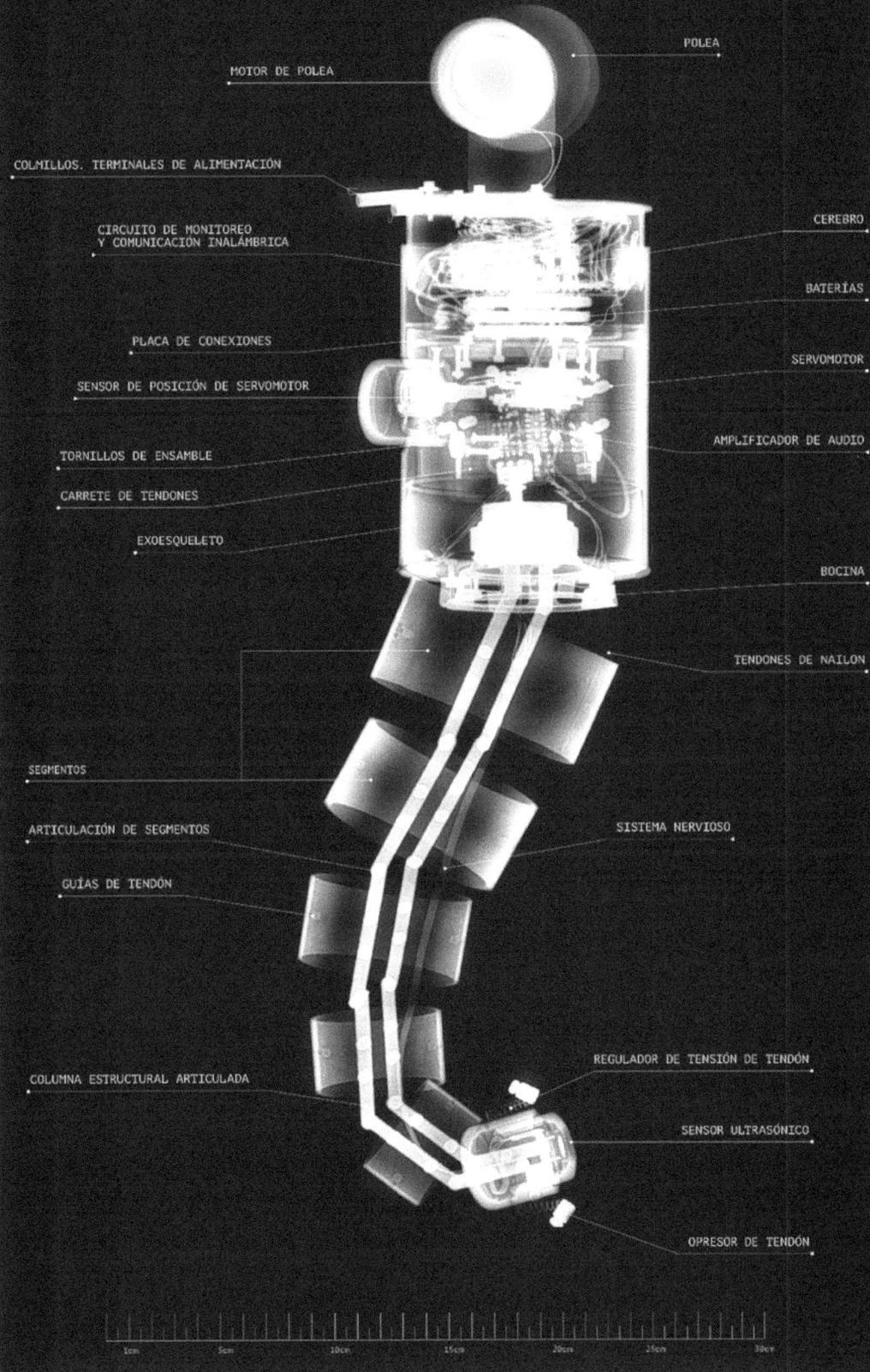

● SISTEMA DE ESTRUCTURA Y LOCOMOTOR
■ SISTEMA METABÓLICO Y DE ENERGÍA
▲ CEREBRO Y SISTEMA NERVIOSO

CLGD
COLGADO (Furtum electricus sinuatum)
RADIOGRAFÍA DIGITAL DIRECTA
5.0 kV / 0.12 MAS
DISTANCIA: 1 METRO
EQUIPO: MINI X RAY H.F 80/15- ULTRA LIGHT
RADIÓLOGO: JOSE LUIS VELÁZQUEZ RAMÍREZ

MOTOR DE POLEA

POLEA

COLMILLOS. TERMINALES DE ALIMENTACIÓN

CIRCUITO DE MONITOREO
Y COMUNICACIÓN INALÁMBRICA

CEREBRO

BATERÍAS

PLACA DE CONEXIONES

SERVOMOTOR

SENSOR DE POSICIÓN DE SERVOMOTOR

AMPLIFICADOR DE AUDIO

TORNILLOS DE ENSAMBLE

CARRETE DE TENDONES

EXOESQUELETO

BOCINA

TENDONES DE NAILON

SEGMENTOS

ARTICULACIÓN DE SEGMENTOS

SISTEMA NERVIOSO

GUÍAS DE TENDÓN

REGULADOR DE TENSIÓN DE TENDÓN

COLUMNA ESTRUCTURAL ARTICULADA

SENSOR ULTRASÓNICO

OPRESOR DE TENDÓN

1cm 5cm 10cm 15cm 20cm 25cm 30cm

99

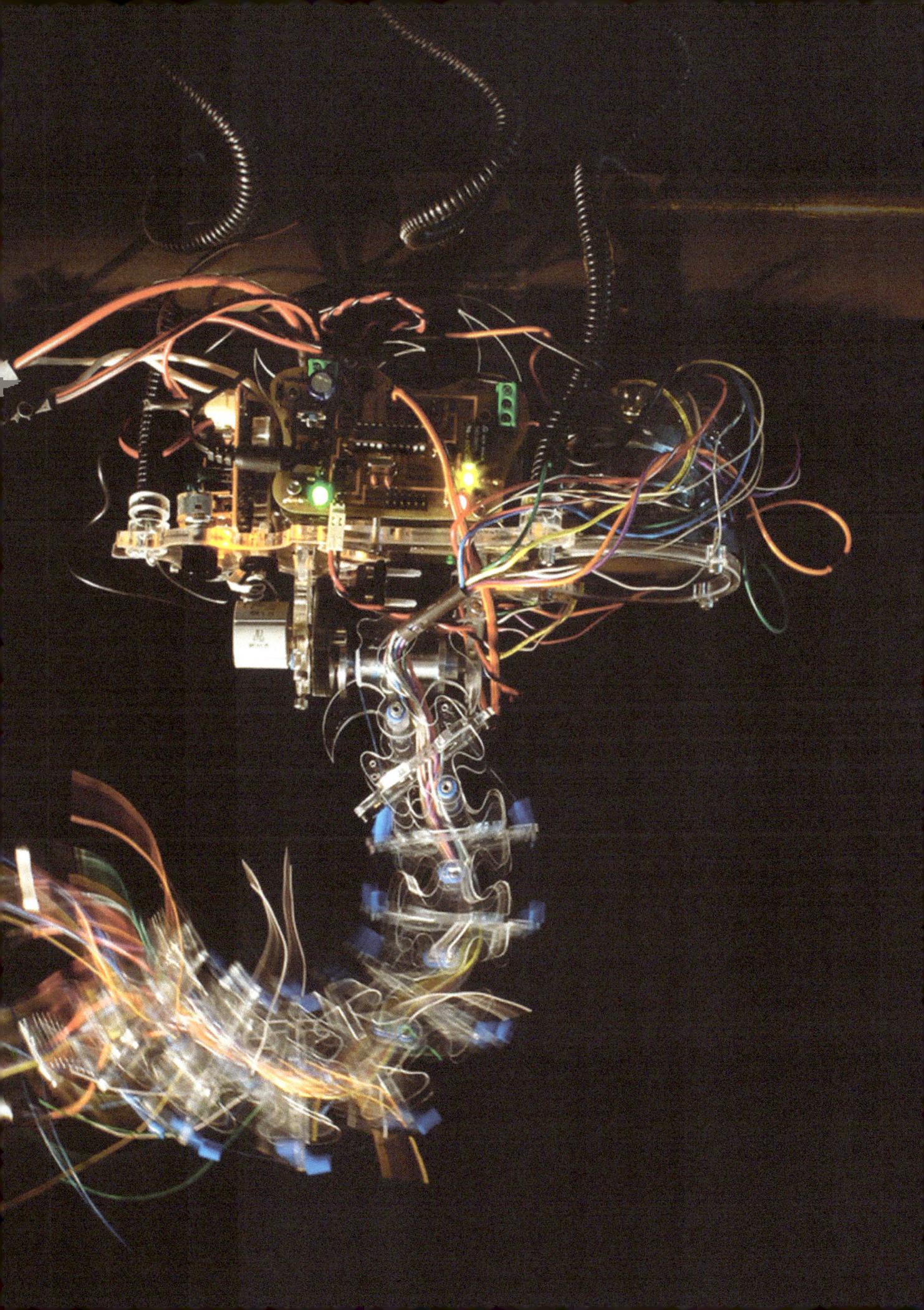

MARAÑA | TANGLE *(Capulum nervi),* 2007

Motor, nylon thread, computer speakers, and acrylic micro-controller | Variable dimensions

ETYMOLOGY. From the Latin capulum (tangle) and nervi (nerves). Refers to the chaotic pattern of its nervous system.

ANATOMY. Skeleton formed by segments of transparent acrylic. Its nervous system is visible through the acrylic and consists of differently colored cables that are tangled together, driving the vital organs in the dorsal region.

HABITAT. Its hosts are the cables or municipal lampposts from which it steals electric energy.

BEHAVIOR. Like Luxalo sono, it is sensitive to changes in ambient light that result from its movements, which it then translates into a large repertoire of sound compositions.

Gilberto Esparza

Right: *Tangle*, 2015 © Gilberto Esparza

STEMA DE ESTRUCTURA Y LOCOMOTOR
STEMA METABÓLICO Y DE ENERGÍA
REBRO Y SISTEMA NERVIOSO

MRÑ
MARAÑA *(Copulum nervi)*
RADIOGRAFÍA DIGITAL DIRECTA
5.0 kV / MAS 0.12
DISTANCIA: 1 METRO
EQUIPO: MINI X RAY H.F 80/15+ ULTRA LIGHT
RADIÓLOGO: JOSÉ LUIS VELÁZQUEZ RAMÍREZ

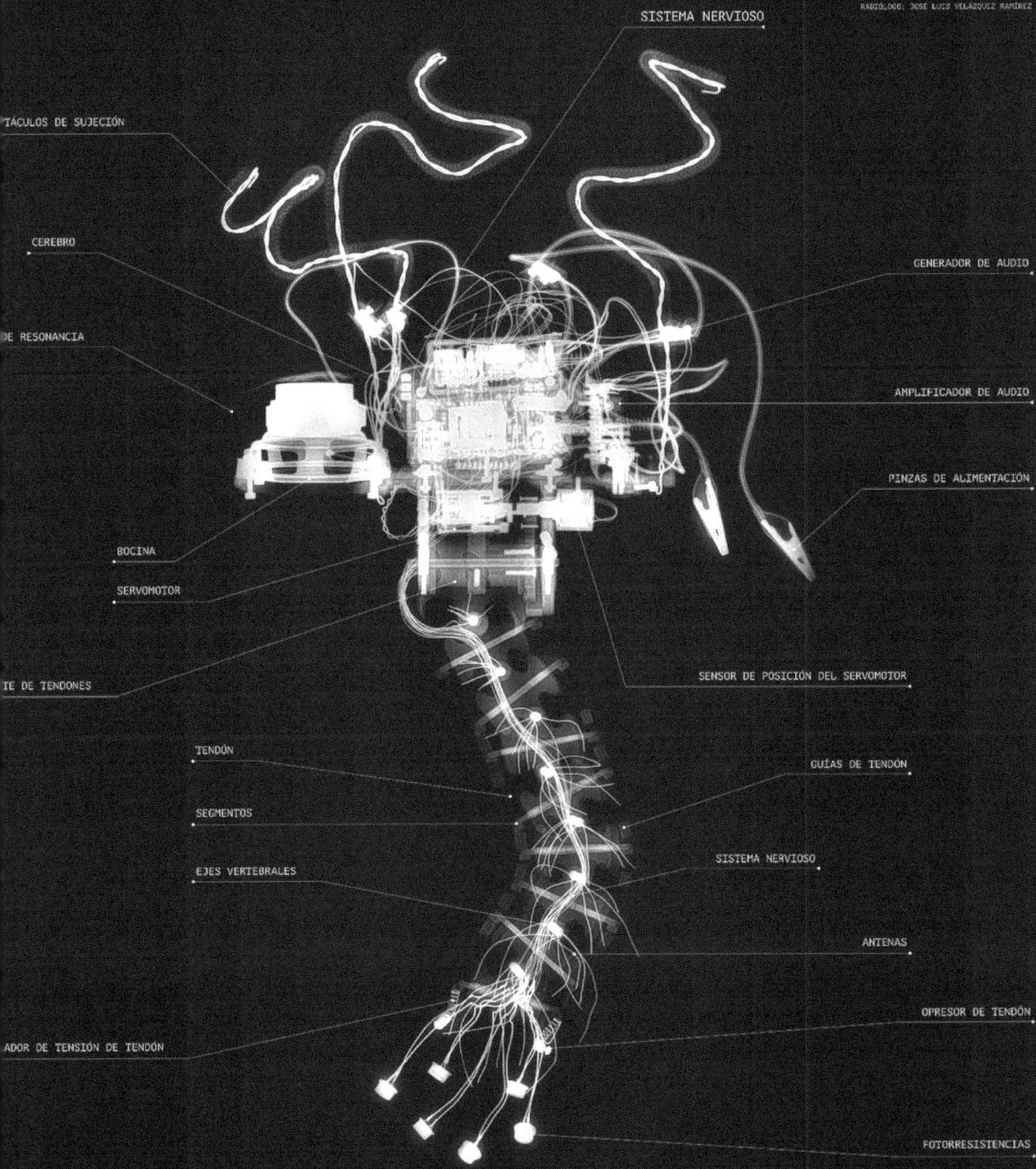

SISTEMA NERVIOSO

TÁCULOS DE SUJECIÓN

CEREBRO

GENERADOR DE AUDIO

DE RESONANCIA

AMPLIFICADOR DE AUDIO

PINZAS DE ALIMENTACIÓN

BOCINA

SERVOMOTOR

SENSOR DE POSICIÓN DEL SERVOMOTOR

TE DE TENDONES

TENDÓN

GUÍAS DE TENDÓN

SEGMENTOS

EJES VERTEBRALES

SISTEMA NERVIOSO

ANTENAS

OPRESOR DE TENDÓN

ADOR DE TENSIÓN DE TENDÓN

FOTORRESISTENCIAS

1cm 5cm 10cm 15cm 20cm 25cm 30cm

Gilberto Esparza

Little Devil, 2015 © Gilberto Esparza

DIABLITO | LITTLE DEVIL *(Furtum electricus imitor)*, 2007

Motor and recycled pieces, servomotor, abandoned closure for fiber optic cable, aluminum, stainless steel, microprocessors, sensors | 45 x 30 x 10 cm.

ETYMOLOGY. From the Latin *furtum* (steal), *electricus* (electron) and *imitor* (mimic or imitation). Its genus name denotes its survival habits, since it furtively absorbs electricity from its environment. Its species name refers to its ability to mimic its visual and sonic surroundings.

ANATOMY. AIts metal skeleton comes from plasma monitors and houses the gear system that drives the movement of its four extremities. This parasite developed the ability to inhabit empty, abandoned closures for fiber optic cables in order to protect itself from the elements and to mimic its environment, in a manner similar to hermit crabs. In this case, however, its shell is considered to be part of its body since it is attached to the mechanical system of its extremities, as well as to its nervous system and its ultrasonic sensory system.

HABITAT. Its range consists principally of a municipal electric grid.

BEHAVIOR. It moves slowly along cables, and stops to record ambient sounds in order to reproduce them later and thereby become a part of the surrounding soundscape.

*U*rban Parasites is a project about speculative life forms that could subsist at the cost of energy sources generated by the human species, and that might be found in the urban environment. The project contemplates the creation of several species of robot parasites that inhabit certain areas of the city, and that essentially are hybrid compounds of technological waste. The parasites are inserted in the urban context of the daily landscape and intervene with their surroundings.

The electronic design which is essential to two of the parasitic forms (CLGD and DBLT) has been made possible by the involvement of Medialabmx. CLGD (hanging) is a species of parasite that belongs to the chain of the polepopod helminths. Its body comprises a set of leftovers of PVC tubes articulated with each other. This parasite lives suspended among telephone wires and emits sounds to interact with the surrounding aural-environment. It simultaneously draws life-supporting energy from the cable poles in which it harbours.

DBLT (diablito), on the other hand, is a kind of mechatropod that lives in the electrical wiring of cities, to feed on the energy that runs through the grid. This species samples sounds from its surroundings and reproduces them intermittently according to their mood.

With *Urban Parasites*, the Mexican artist Gilberto Esparza has created an extraordinary symbiosis between art, design, science and technology. The project began in 2006, and it remain contemporary relevant because of the constant fascination of popular culture with the agency of new technology.

In 2015, Esparza released the preview of a documentary, filmed by Dalia Huerta Cano, which shows how these robotic organisms lead their independent lives. Both the project and the film are part of the exhibition *New Territories: Laboratories for Design, Craft and Art in Latin America*, which was presented until April 2015 at the Museum of Arts and Design in New York.

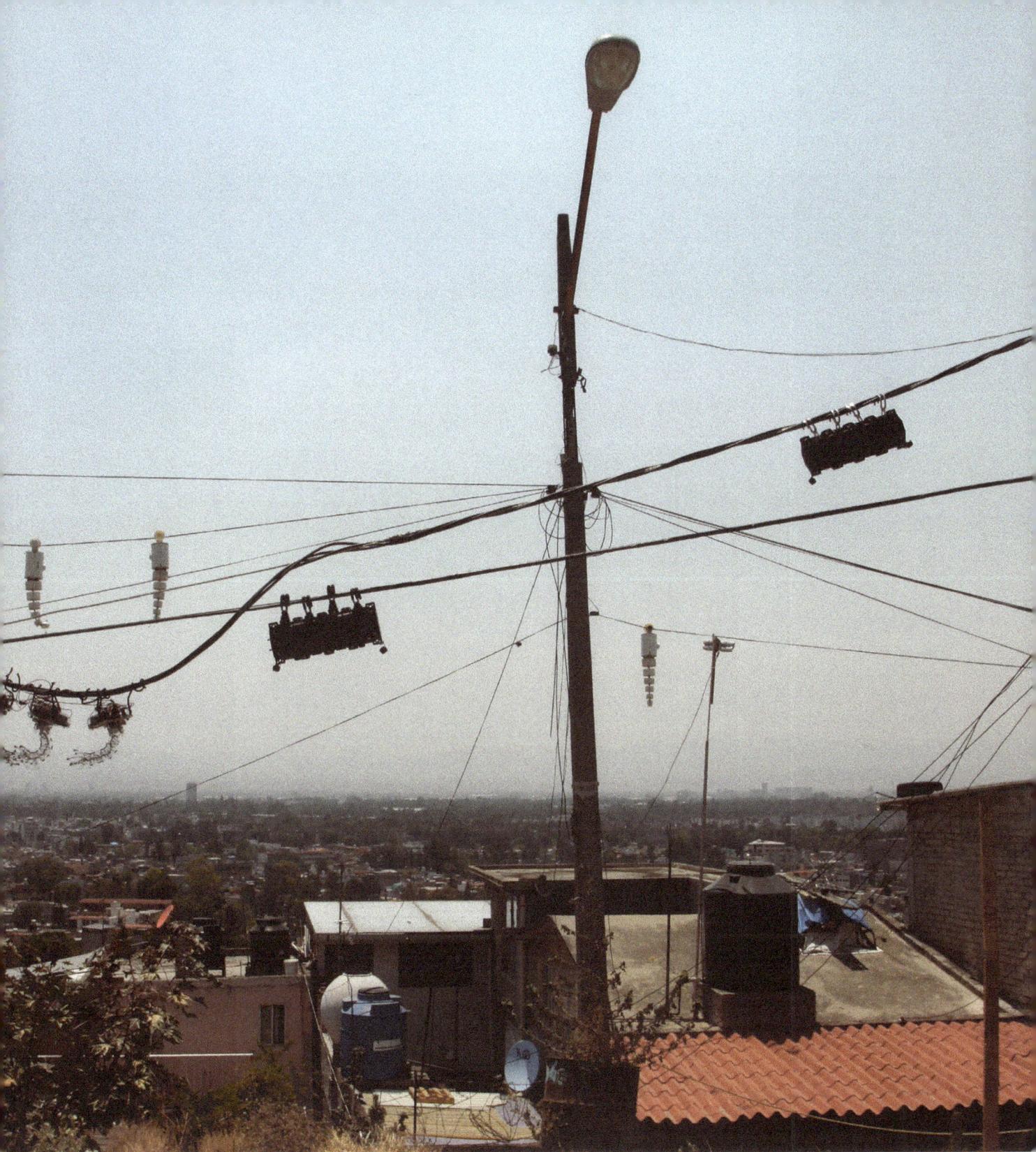

Gilberto Esparza is a Mexican artist whose work involves electronic and robotic means to investigate the impacts of technology in everyday life, social relationships, environment and urban structure. He currently conducts research projects on alternative energies. His practice employs recycling consumer technology and biotechnology experiments. In his projects he has collaborated research centers such as the Research Group in Chemical and Process Engineering at the University of Cartagena, Spain; Mechatronics Area of Cinvestav; Institute of Engineering, Juriquilla, UNAM; Digital Arts, University National Polytechnic Institute Guanajuato, Salamanca. Gilberto Esparza, graduated from the School of Fine Arts at the University of Guanajuato, Mexico and spent one year on exchange at the Faculty of Fine Arts of San Carlos in Valencia, Spain. As an artist he has participated in solo and group exhibitions in Mexico, the US, Canada, Brazil, Colombia, Peru, Ecuador, Argentina, Spain, Holland, Belgium, Slovenia and Dhoa. He received the award for Latin American Production at Life 09 and second prize at Life 13 Fundación Telefónica of Spain and a Honorary Mention at the Prix Ars Electronica. He currently is a member of the National System of Art Creators in Mexico.

Keith Armstrong (with Luke Lickfold and Matt Davis)

Eremocene (Age of Loneliness), Ars Electronica Festival, 2017, Austria, Mixed media, 2017 © Keith Armstrong

Art-Eco-Science. Field Collaborations

Art-eco-science practitioner Keith Armstrong is committed to a hybrid practice. He collaborates in the field with ecological scientists recording biodiversity, species loss and extinction and creates works that play a role in redesigning social relations to natural systems. Currently working closely with aerial robots (aka drones or UAVs), Armstrong wants to understand how 'we' might better use drones, away from societal preoccupations with surveillance, privacy, AI and remote warfare, and our apparent drive to create bleak 'new natures'. In this conversation, Armstrong and sustainability scholar Tania Leimbach explore the potential of arts-science collaborations to radically transform attitudes, perceptions and modes of participation.

in-conversation: **Keith Armstrong and Tania Leimbach**

Together, Keith Armstrong and Tania Leimbach explore insights generated through a sustained media-based collaborative arts-science practice led by artist Keith Armstrong and scientists working in the field of conservation biology and ecology. In this conversation we pay close attention to ideas and concerns emerging from Armstrong's new body of work that utilises drone technology in order to invert its associations with surveillance and warfare into something much more life-affirming, seeing these aerial robots as tools for transforming our sense of ourselves within interdependent planetary ecologies.

Tania Leimbach: With the realities of climate change, species extinction and environmental decline presenting as complex systemic problems, the capacity of creative artists for critical analysis, deep investigation and nonlinear insight are called into action. Contemporary theorists, such as the late Beatriz da Costa and Kavita Philip, suggest that the political challenges at the intersection of life, science, and art are best addressed through a combination of artistic intervention, critical theorising, and reflective practice.[1] It seems a kind of fusing of activist practices with an effective and affective poetics is really needed; something that can shine a light on our deep cultural and environmental crisis. In your own practice, you explore tensions between the interests of (certain) humans and the interests of other-than-human life and the broader environment, informed by the philosophical idea 'ecosophy'. How has the notion of ecosophy influenced your critical thinking and creative interventions over the past two decades?

Keith Armstrong: My longstanding project as an experimental media artist has been to frame my work within the realm of political ecology, in the understanding that biological, economic, social and political factors are deeply entangled and co-dependent. I have then sought to understand what capacities my practice might have to affect perceptual and philosophical shifts in the public's imagination, an approach that I understand as necessary in modelling pathways towards sustaining futures. I have pursued this hybrid practice in many guises over the past two decades, with a particular focus on art & ecological science, and art & social science projects.

This began initially with framing the practices of *Ecosophy*, a series of ecologically oriented principles, or a form of personal practice, to which one adheres. I built a case in my doctorate (written 25 years ago), as a means for framing 'embodied media' installations; in essence, interactive spaces that were a big focus at that time in the electronic arts. Ecosophy is a word coined by Norwegian philosopher Arne Naess and subsequently developed by George Sessions in particular. Michael Heim describes how ecosophy is derived from the Greek words *oikos* and *sophia,* meaning 'wisdom of the dwelling'. Founder of 'deep ecology' Arne Naess described his own personal ecosophy, which he called 'Ecosophy-T', as being a form of self-realisation, born both out of his development of, and identification with the philosophical ideals of deep ecology and his evolving engagements with the world.[2] He laid out a series of characteristics to which an ecosophical practitioner might subscribe while acknowledging that it is contextual, personal and therefore its definitions must always remain open and fluid. These included the respect for intrinsic value, the crucial importance of diversity, the need to decentre ourselves (resonating with the thinking of Timothy Morton and the broader

Object Oriented Ontology movement); all of which should be underpinned by radically redefined economic, technological, and ideological structures. Hence ecosophy was a form of political ecology that called upon its supporters to directly or indirectly attempt to implement necessary changes. This was my own call to action in the early 1980s.

Leimbach: Words such as environment, wilderness, wild, natural, organic and place have shifted in meaning over time. The cultural theorist Raymond Williams famously said that 'nature' is "perhaps the most complex word in the English language"; there is an "extraordinary amount of human history" embedded in this term.[3] Today's artists and theorists typically eschew notions of the environment and nature as something 'out there', separate to the makings of culture in light of contemporary understandings of ecological systems, and the recognition that the environment cannot be disassociated from 'us'. However the art historian T.J. Demos notes that ecology has received relatively little systematic attention within art history; whilst its visibility and significance has grown dramatically in relation to the threats of climate change and environmental destruction. His recent book, *Decolonizing Nature: Contemporary Art and the Politics of Ecology,* explores the intersecting fields of art history, ecology, visual culture, geography, and environmental politics, presenting artists' widespread aesthetic and political engagement with environmental conditions and processes around the globe. Can you talk about the conceptual challenges you have faced in defining the 'environment' and by extension 'environmental art' and describe your efforts over time to develop work at the intersection of art, science, and ecology?

My longstanding project as an experimental media artist has been to frame my work within the realm of political ecology, in the understanding that biological, economic, social and political factors are deeply entangled and co-dependent.

Armstrong: Can I answer this by first saying that experimental artists have long worked with practices and methods drawn from other disciplines as the imperatives arise. Not unexpectedly the natural sciences have been of particular interest for those seeking to conserve and protect other than human worlds. Based upon the longstanding *ecocidal* nature of our capitalist systems of governance and commerce, our new epoch is now characterised by dangerous climate change as only one of numerous worsening indicators. Faced with such risks and challenges, on scales never before encountered, and with global responses clearly inadequate, many artists like myself have felt the need to transform their practices in ways that render them viable as modes of civic engagement. Choosing to locate my work within political ecologies stresses deep interpenetration of biological, economic, social and political factors, and assists my work to remain speculative and experimental in ways that better assist the public to imagine radical and alternative sustaining futures. I consider such an ecopolitical focus a much more activated space than say 'environmental art', which tends to get caught either exclusively in the biophysical, or within particular places or causes that centre upon perceived human needs. My interest lies in engaging systemic forces and currents, understanding the imperative to acknowledge enmeshing of culture, manufacture and biology. Examples such as *SymbioticA's Tissue Culture Project* come to mind here as something similarly on the front-foot of ecopolitics.

I also understand that the innately relational sensibility of ecology suggests the importance of working with other disciplinary practitioners committed towards similar goals, in ways that draw upon the strengths and differences of each approach. Not unexpect-

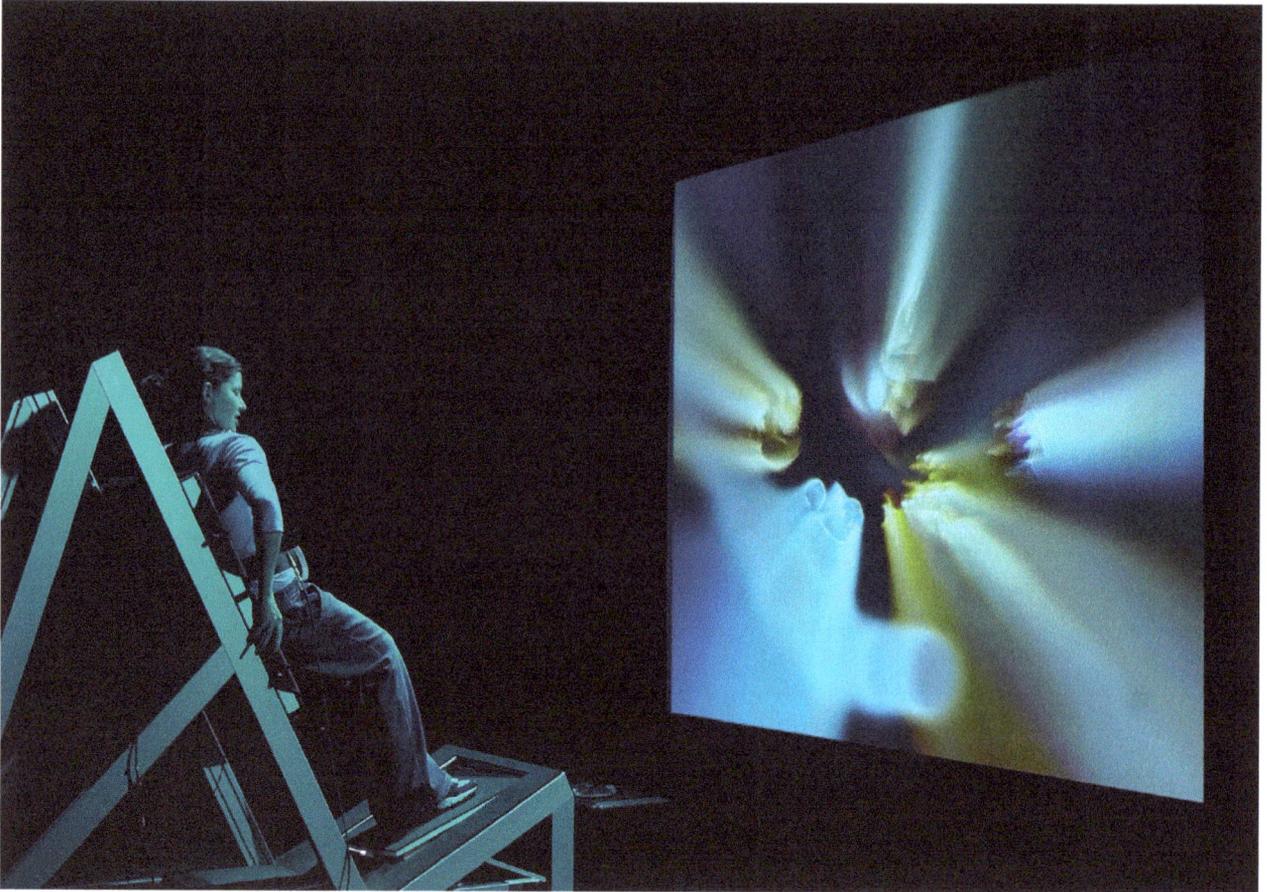

Keith Armstrong/ The Transmute Collective

The Body Shelf, 'Intimate Transactions' from the exhibition, *Media Art China,* National Gallery of China, Photo Document, 2008
© *Keith Armstrong*

edly the ecological sciences have been of particular interest to me given their work is most often dedicated to conserving and protecting other than human worlds, and I see my practice not as one based upon 'solutions', but rather an interactive modality that encourages reflexive circling around complex questions, hinting at new ways to understand how things could and might be. The goals of this speculative practice can therefore be seen to complement, but not necessarily mimic, the tactics of mainstream environmental campaigners and activists, ensuring differently valuable contributions towards proposing or building radical and alternative models for sustaining futures.

Leimbach: Artists and scientists have historically worked together. Currently, we are in an interesting moment where collaborative activities occur in increasingly diverse contexts, facilitated by high-level funding support in several countries, and broader, more systematic investigations of knowledge structures. This suggests an increasing focus and interest upon the underlying conceptual similarities (as well as the differences) that the arts and sciences share, as well as a greater interest in understanding what emerges in the hybrid space between diverse practitioners. Cultural Geographer, Leah Gibbs suggests that arts-science collaboration have the potential to engage di-

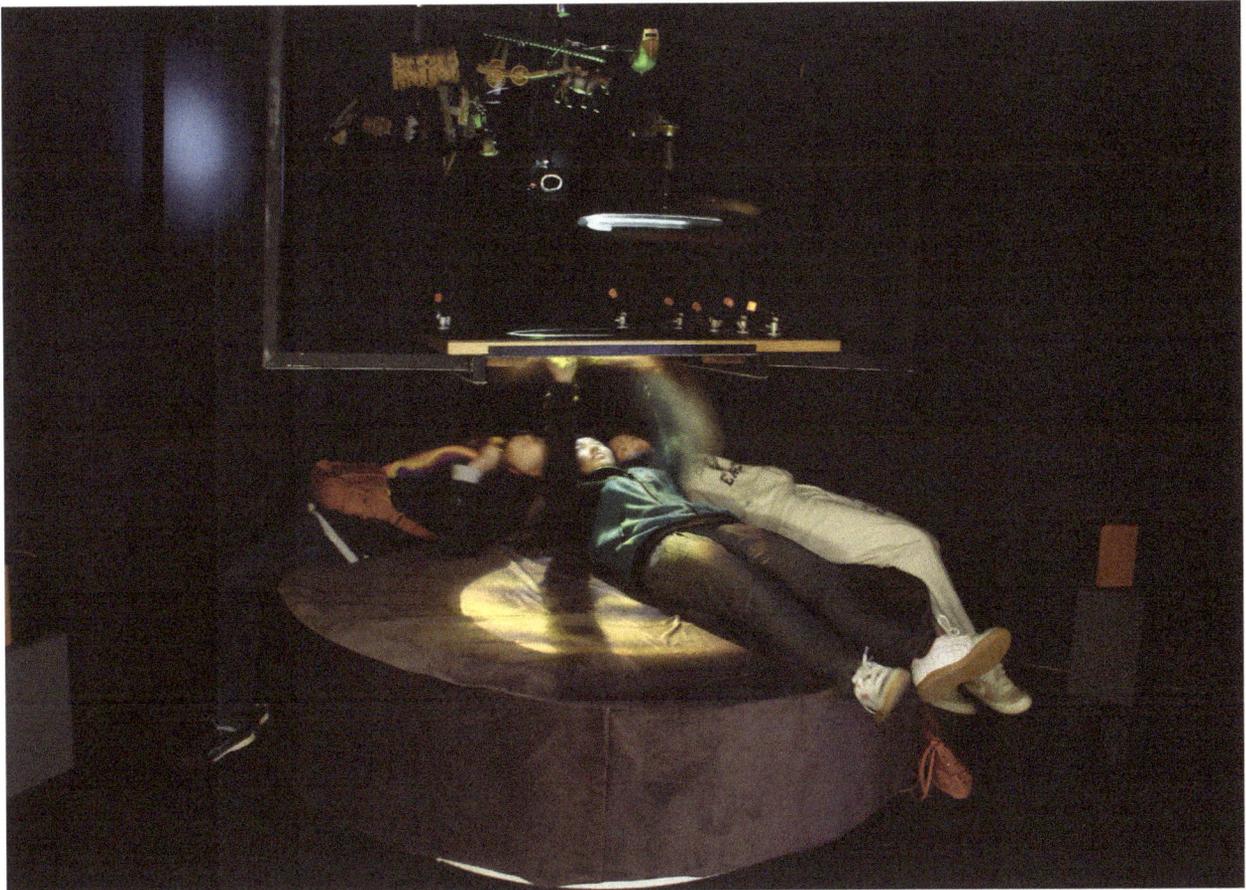

Keith Armstrong with Roger Dean, Stuart Lawson and Darren Pack

Finitude, from the exhibition, *Information, Ecology & Wisdom,* 3rd Art and Science International Exhibition and Symposium, National Science Museum, Beijing, China, Mixed media, 2012 © Keith Armstrong

verse publics and for new projects to 'do' a kind of social, cultural and political work. Certainly powerful alliances and allegiances appear possible through this process, when partners wonder together about shared politico-scientific challenges, working — if only briefly — beyond individual areas of specialisation and expertise, maybe not knowing initially what they are doing or where they are going. This is a critical potential for art-science interactions that Bruno Latour speaks to directly. Such dialogic collaborations can open up a rich space for discovery with the potential to render the pairing sensitive and sensible to unexpected kinds of phenomena, undetectable by the conventional instruments of science or art. These fusions, freed temporarily from conventional or habitual approaches seem to promise the possibility of renewed ways of thinking or seeing, about deeply entangled systems of cultures and natures; as Bruno Latour and Peter Weibel in *Making Things Public* suggest, perhaps they even offer the potential to imagine alternative modes of natural-cultural democratic assemblies.[4] By working and re-working through these findings, it seems that some collaborators are trying to advance the radical creative, perceptual and philosophical shifts necessary for imagining alternative collective futures. What are your views on the strengths and limits of scientific knowledge systems and how does that inform your approach to collaboration as a practicing artist?

Armstrong: In my view, the collaboration can only be successful if creative practitioners develop a tenable position and purpose in propelling arts-science engagements, based upon their understanding of dominant trends in scientific epistemology, in order to take a meaningful and politicised position. The world is full of powerful techno-scientific invention, and yet something that so often gets forgotten in that rush for progress is that design goes on designing. The rolling implications of scientific discoveries when released into the world have very often had severe environmental consequences that were both undesirable and unintended. Regardless, many natural scientists and policymakers continue to insist that applying further technological solutions remains the best approach. The sociologists Richard York and Brett Clark note this concurs with the broadly Modernist project of favouring science and rationality, whilst minimising consideration of the powerful political and social drivers that propel environmental demise.[5]

Collectively these observations have led me to adopt a position that I have come to understand as 'Eco-critical materialism' (or alternatively 'Eco-critical realism'). I see this epistemologically-located position as one that both stresses the crucial nature of the natural sciences in combating environmental decline, and yet remains skeptical of any science that refuses to acknowledge or act with regards to its innate societal embeddedness. Such a position is supportive of fundamental empirical, rational and realist approaches that allow us to comprehend both science and society, whilst refusing reductionisms that fails to understand how profoundly science and technology interact with, and are immersed within specific historical ecological and social relationships. It is within this space that I see the work of creative artists having real agency to affect critical reflection, given how our work has long sought to draw political heat upon the failings of each era.

I sat there with the ecologist in the heat of the afternoon watching her patiently pulling at the pellets, constructing lines of femurs, tibias, pelvis' and parts of skulls, all set in between clumps of fur and other fluid detritus, painstakingly assembling a numerical picture of what those birds of prey had consumed.

Leimbach: As you say, science has traditionally put the idea of objectivity at the heart of its practice, suggesting it can operate free of value judgements and thus can retain a political neutrality and claims of truth. However, scholars such as Haraway, Harding, Latour, and Woolgar have written widely about how social values actually both influence the types of questions being asked and then how that information is interpreted. Your alignment with an eco-critical materialist position also suggests a rejection of reductionism, concurrent with its intensive critique in recent decades. As a mode of scientific thinking, reductionism has long assumed that if complex structures are broken down into their constituent elements, and if the laws governing those elements can be discovered, then by extension the properties of the larger world can be grasped, such that the larger world becomes the sum of its many parts. In recent decades it has been shown how ecosystems are governed by emergent behaviours, ensuring that processes are in reality inseparable and that reductionism cannot provide successful explanations for levels of complexity that arise due to emergence and contingency within complex systems.

While many arts-science collaborations have occurred in laboratories (and there are numerous precedents for this kind of work), the wider located 'field' as a site for collaboration is a distinctly different context. Currently, we are seeing interdisciplinary efforts to engage in the 'field' discursively through new forms of 'worlding' and writing in the environmental humanities, but not so much arts-science collaboration in response to the field as a space for generating

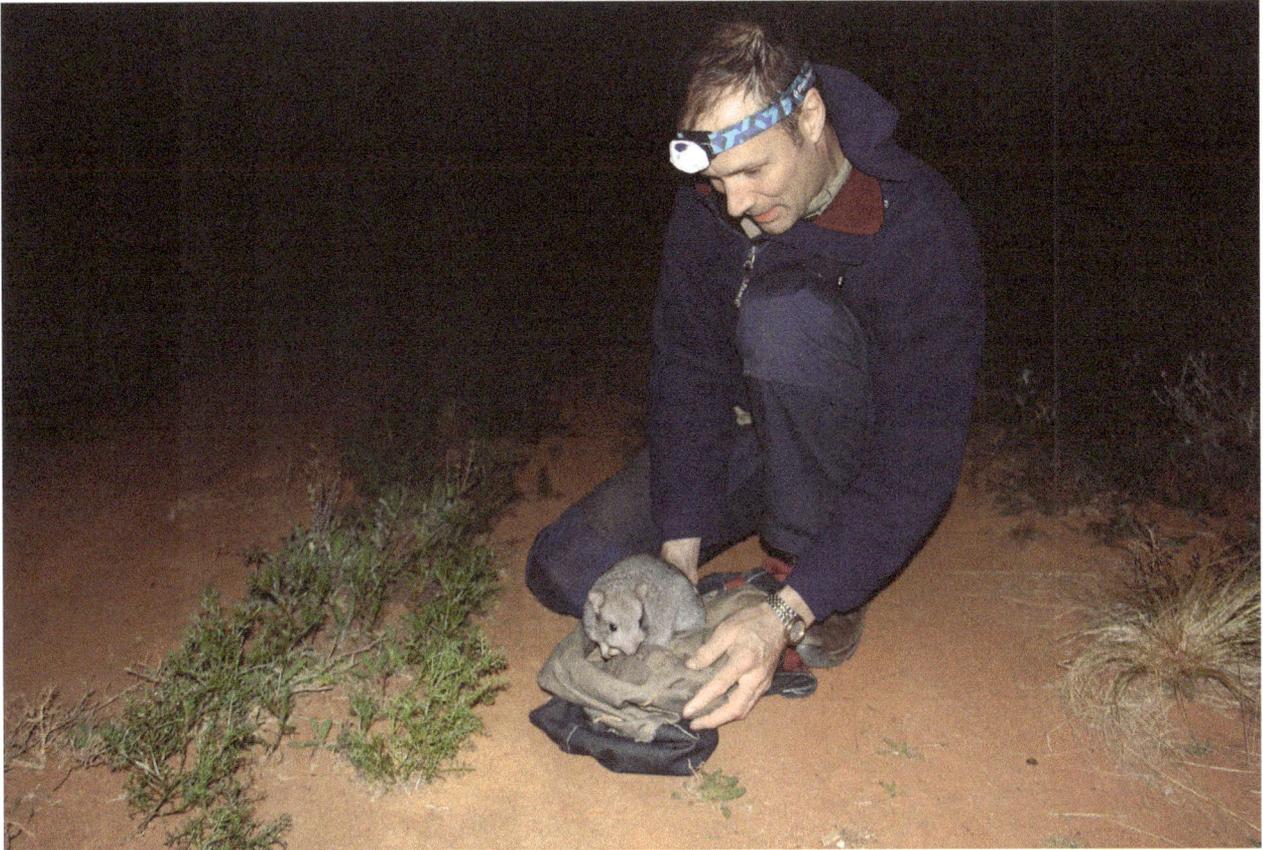

Keith Armstrong
The artist/fieldworker releasing a boodie (burrowing bettong/*Bettongia lesueur*) after check, AWC Scotia Sanctuary, NSW, Australia, *Re-introduction Project*, Photo Document, 2012 © Keith Armstrong

new work. Your collaborative arts-science practice has long involved intensive periods of fieldwork, in collaboration with biological scientists and social scientists, turning these experiences into creative works. How do you engage with the scientific process in the field and in your work as an artist?

Armstrong: Renowned practitioner/arts-science curator Jill Scott speaks about field trips as powerful contexts for creating tacit knowledge and social interaction in a given spatial environment where explicit knowledge is prioritised. I began developing arts-science, creative incubators around ecological fieldwork in 2010 - which have since evolved to include a broad range of projects, that include: landscape-wide conservation (*Re-introduction Project*); flying fox rescue, care and conservation (*The Bat Human Project/Remnant Emergency Artlab, Black Nectar and Uncanny_Intimacy*); anti-uranium mine activism (*Stop Jabiluka!*); marine conservation and climate impacts (*Over Many Horizons*) and (*Eremocene*); and grassroots sustainability projects (*Re-Future/Seven Stage Futures*). Each project has been underpinned by an initial process of discovering what I could practically add to the process within a shared frame of interest. My approaches in the field have ranged from the ethnographic (e.g. joining teams as ascience assistant), to the more speculative (initiating experiments and modelling futuring processes).

In 2011, I decided to pursue a direct engagement with conservationists. This led to an arts-science residency called the *Re-Introduction Project* with the Australian Wildlife Conservancy (AWC), an important, independent, non-profit organisation dedicated to conserving threatened wildlife, and by extension the habitats in which they live. I was acutely aware that Australian policymakers have been unable to reverse the acceleration of mammal extinction, nor arrest the high proportion of surviving animals and plants (over 1,700 species) listed as threatened with extinction. AWC's progressive model for conservation involves acquiring high ecological value land of all biotypes whilst often entering into land management agreements with Indigenous owners, and then actively managing it based upon sound science; ensuring feral animal control, weed eradication and requisite fire management practices. They pursue these methods over their 4.6 million hectares of land, which represents the largest private conservation estate in Australia, specialising in the erection of fenced-in, feral-free areas where they can safely reintroduce endangered species to areas where they had been historically lost, a practice now also referred to as rewilding.

In 2012, supported by the *Synapse* art-science program of the Australian Network for Art and Technology, I engaged with a year long series of high-intensity field trips, at times when different properties were being annually surveyed for fauna. By volunteering practical services to the scientific teams as a survey assistant I experienced rich collaborations within tightly knit teams working together on intensive, remote survey activities. This accelerated my understanding of their techno-scientific processes and methods, and also the cultural specificities or avoidances of this work. My practical contributions to team activities involved processes of clearing pit and cage traps, measuring animals, re-setting, watching and listening for species, describing sightings, mending equipment, baiting traps, digging scientific installations, assisting designing experiments etc. Almost all of the results from this survey process were ultimately reduced to tables of numbers and graphs, in their effort to statistically determine species health and range.

Leimbach: I'm curious about your observations of these scientists and their lived experience as you understand it from having shared time while working in the field and on the frontline of extinction.

Armstrong: I have a brief anecdote that speaks to that… On a hot afternoon, after a pre-dawn mammal survey, the ecology crew were resting in the common room in the rising heat. Needing some air and a break from number crunching, trap fixing, and bait-ball making, I left to walk back to my tent. In the shade, next to an aging tool shed, I came across one of the field ecologists with a table full of tiny objects set out in neat lines. On closer inspection, I saw that these items, dotted with hair and bits of dry vegetation were miniature mammal bones. The ecologist informed me she was analysing owl pellet contents (regurgitated inedible materials) and entering data into another of the many favoured spreadsheets. Kalamurina Station was replete at that time with long-haired rats (Rattus Villosissimus), normally considered an endangered species in that area. The rats had multiplied massively in the boom times after a recent good 'wet' with predators like the owls in question being well fed, as their regurgitations demonstrated. I sat there with the ecologist in the heat of the afternoon

watching her patiently pulling at the pellets, constructing lines of femurs, tibias, pelvis' and parts of skulls, all set in between clumps of fur and other fluid detritus, painstakingly assembling a numerical picture of what those birds of prey had consumed. As she came to the end of her long task, she started to sweep the bones away into a box for disposal, to leave her only with a numerical record of the labour: a classic 'count' process like so many others we had done. As I recall, she didn't even choose to snap a photo since this was such routine.

All that time as she was counting, I couldn't help reflecting that there was something about the strange beauty and intrigue of these microscopic structural elements. Behind them are so many stories of struggles, extinctions, sustenance, structure, endings, and the human, anthropocentric contexts that had propelled much of this in each logically identified and carefully placed item. Could this really be the end of the investigation? Was that all? The only residue some inputs to a graph for future scientific reports? Somehow so many of those other dimensions of the picture had neatly escaped; fugitive narratives erased with the mere sweep of a hand. It struck me, albeit gently, as a powerful metaphor for the place where science chooses to stop, when in reality it was likely these backstories and such experiences that were so compelling to me, and that gave me the fire in the belly to continue to shape my supportive practice accordingly, in ways that might move others to support their work.

I felt compelled to request that I might use them; at least for some further visual experiments that day. Those experiments resulted in little more than some curious photos — collections of strange pearlescent sculptures, mounted upon a portable lighting box I had brought with me — eerie still lifes or memento mori... but the experience left me with a sense of our differences of perspective, outlook, and ways of investigating the ecological conundrum. These thoughts really stuck powerfully with me, and indeed have built over the years and compelled me to consider where arts and sciences, in the shared and urgent context of conservation and its sociopolitical roots, might extend upon each other's capacities and strengths. That clear delineation of what needed to be done, so clearly expressed by the ecologist's actions that day compelled me to imagine what I myself might then be able to 'do'.

Leimbach: An aspect of the work of the Environmental Humanities is to render the lived experience of non-human others. For example, the Extinction Studies Working Group produce vivid reflections across the biological and social world that engage with the lively agency of non-human others, bringing to light all kinds of biosocial relationships. Thom van Dooren writes poignantly about the critically endangered Asian Vulture that is dying in great numbers from organ failure caused by an anti-inflammatory painkiller, Diclofenac. The birds ingest the drug after feeding on cattle carcasses in India. This drug has been given to aging beasts of burden in recent years to prolong their lifespan and productivity. Once dead, these animals are eaten by the carrion as part of the workings of a large multi-species system; and the once abundant vulture is now critically endangered and will soon become extinct without intervention. This situation will cause a number of other problematic disruptions, not least the spread of disease caused by mountains of rotting flesh that would have otherwise been removed by the birds (the number of cattle used for farming in India is massive). Van Dooren's stated objective in writing is to engage and

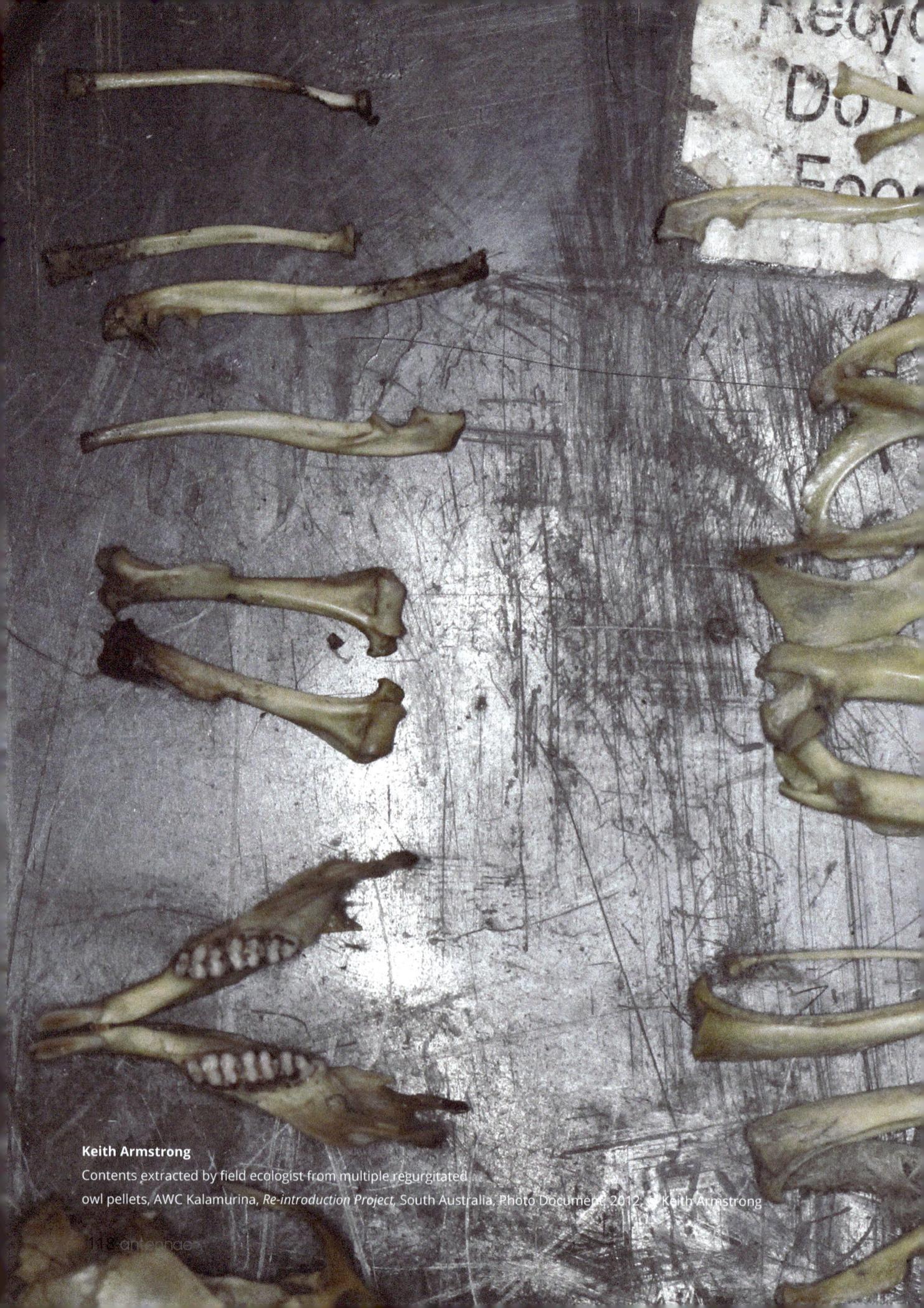

Keith Armstrong
Contents extracted by field ecologist from multiple regurgitated
owl pellets, AWC Kalamurina, *Re-introduction Project*, South Australia, Photo Document, 2012. © Keith Armstrong

Material
ise For
ndling
storage
MADE IN ... NA

Keith Armstrong

Complete regurgitated owl pellet, AWC Kalamurina, South Australia, *Re-introduction Project*, Photo Document, 2012

© Keith Armstrong

empathise with the lived experience of a single creature in the hope to render it ethical and meaningful. He offers it as a counterpoint to the standard scientific representation of loss, for example, what you might find on a data spreadsheet on the IUCN red list. Dooren writes, "In contrast to these more conventional accounts of extinction, this essay takes up the pain of the individuals whose deaths constitute species extinctions; the individuals that are lost, or covered over, both in their deaths and in their suffering, by an exclusive focus on the management and conservation of a species".[6] In your creative practice, can you describe how you harness the potential to critically and/or emotionally engage audiences with the underlying challenges represented in scientific data sets of endangered species?

Armstrong: I am very aware that ecological data 'read' alone by the layperson, without direct experience, often makes limited impact on the senses, and can often fail to convey the multilayered complexity of ecologies under distress or reparation. However, the data clearly does tell a very extraordinary part of the 'story', and thus, used in concert with other media and sensory experiences may be part of the process of encouraging shifts towards public action that we need to subscribe to. Such processes of presenting multi-layered narratives within creatively focused public outcomes can offer quite different

Keith Armstrong

Regenerative (still), from the exhibition *Change Agent*, ISEA, Durban, South Africa, Rendered video still, 2018

© Keith Armstrong

modalities of thinking that can speak to broader cultural dilemmas. The goal must always be to enhance both cultural and biological diversity in ways that acknowledge and negotiate human psychology.

Leimbach: Questions of politics have become integral to both the concerns of creative practitioners and climate scientists. Cultural theorists, Jennifer Gabrys and Kathryn Yusoff suggest that arts-sciences discourse and practices must grapple with how to find the forms of intensive political engagement that climate change calls for, but in the process are returning not to a two-cultures debate, but instead to recognition of the multiple nature-cultures involved in these practices.[7] Do you consider part of your creative process to involve visual re-working, visual analysis and artful communication of scientific findings around climate and related datasets, or is that anathema to your approach to arts-science collaboration?

Today's newly minted robotic machines are capable of flying a range of sensors beyond the ubiquitous camera, offering up a whole range of new approaches to photo and video imaging of the environment, monitoring and acting from the air in ways not previously possible in larger, noisier, bulkier craft.

Armstrong: There is often an 'in-house' hierarchy of arts-science project 'worth', that begins with art as communication, and culminates with the pinnacle — where the artist makes a creative contribution towards or even co-invents scientific knowledge. Whilst we are all curious about how far we may be able to push experimental practices in this arena, i.e. how much the methods of science and arts can be practically interchanged and re-worked, there is probably ample room for a 'biodiverse' set of approaches to the serious relational work that needs to be done (and in record time). I use that principle

Keith Armstrong

Regenerative (still), from the exhibition *Change Agent*, ISEA, Durban, South Africa, Rendered video still, 2018

© Keith Armstrong

of biodiversity — implicit in Naess' call for complexity — to say; yes, the holy grail is desirable, but let's also actively encourage all of the above as differently valid approaches.

Personally, I am less drawn to the data representational approach and more towards areas that the scientists I work with feel less comfortable operating within. This accords with the role of political ecology within my practice, and the need to collaborate towards a more activated and politicised science per se. Climate science is a good case in point because it draws from numerous disciplines — all in a hugely complex conversation — although perhaps not always with the general populace in tow. This takes us back to the value of working in the field, especially because the effects of climate change may not be primarily evident in a 'lab' for example, and are unevenly distributed across the world, at multiple scales. These were concerns raised in the collaborative project *Over Many Horizons (O | M | H)*, where our team of designers, artists, scientists, and philosophers sought to develop a transdisciplinary conversation around the complex problem of coral reef decline; an issue that the collaborating marine biologist passionately brought to us. His expressed fear, that I had heard before from other scientists, was that his reliable, solid, well-researched science seemed to have limited impact upon public opinion; however, he felt unable to resort to more emotive, immersive, political language/tactics that might risk reputational damage. By all spending time together in the field (in this case above and below Sydney Harbour where we snorkeled together on several occasions), we began to embody and qualify the impacts which his science had quantified - fragility, toughness, diversity, and danger — all in that one profoundly interconnected experience.

The aim of that project was to design and build low-cost sustainable buildings and models for living with residents, scientists and international development organisations in South Africa's informal settlements, working with international development workers, architects, and sustainability scientists.

Leimbach: The artist and cultural theorist James Bridle critiques misguided assumptions about technology as neutral, benign or the beneficent fix-all, stating: "We need to stop thinking about technology as a solution to all of our problems, but think of it as a guide to what those problems actually are, so we can start thinking about them properly and start to address them".[8] From what you have said in regard to problematising the 'techno-fix', it seems that you share his perspective. Bridle's view that technology reveals to us our own flaws and as such provides real opportunity to deeply engage with problems, connects us here to an exploration of how 'we' might better use our aerial robots. You have suggested that the investigation of drones is a key cultural challenge of our age, brought to the fore by individuals currently co-inventing drone applications that could play critical roles in redesigning social relations to natural systems. For example, in 2018 a collection of essays were published by MIT exploring the 'good' drone "as an organising narrative not only for technological development but for political projects, governance practices, and social mobilization as it is imagined, legally constituted and deployed".[9] In a sense this text is a manifesto for diverse applications of humanitarian, commercial, environmental and other civilian purposes; with the authors pointing out that drones have now thoroughly been co-opted by conservation science, agro-science and those working with anti-poaching and other animal and biota security concerns. Today's newly minted robotic machines are capable of flying a range of sensors beyond the ubiquitous camera, offering up a whole range of new approaches to photo and video imaging of the environment, monitoring and acting from the air in ways not previously possible in larger, noisier, bulkier craft.

In conservation biology, typical applications include land-use surveys, species monitoring, 3D modelling and thermal imaging useful for anti-poaching activities. What first drew you to UAVs and what are your current interests in drone technology?

Armstrong: During my time at the AWC working closely with scientists in the field, I was often engaged tracking animals fitted with radio transmitting collars on foot using handheld and vehicle mounted analog aerials and receivers, to accurately triangulate their position. I did this work extensively on North Head Conservation Park adjacent to Sydney Harbour to monitor the local protected populations of Bandicoots, and to a lesser extent at other sanctuaries, as a means for calculating the 'home range' and current position of released rare animals such as wolyies, boodies and bilbies. The radio signals and the animal radio collars had a range of technical limitations such as tracking noise, physical breakages and dead batteries. Furthermore, the large scale use of GPS collars to enact landscape-scale monitoring of moving animals was fiscally not feasible, and still in many cases is not. We often spoke of the power of aerial monitoring from planes or helicopters, in an era long before domestic drones were available. My interest was therefore strongly piqued by the cheaper drones that began to emerge on the horizon somewhat later.

Leimbach: Depictions and applications of UAVs have appeared widely in the arts, with some seeing the drone as emblematic of contemporary anxieties about surveillance, privacy, artificial intelligence, and remote warfare, whilst others celebrated what the newly accessible technology afforded. The first two decades of the 21st century often saw artists using the tools and strategies of tactical media — people like Peter Fend, Marko Peljhan, Bureau of Inverse Technology and Trevor Paglen — creating work that both revealed the growing capabilities of aerial technologies, but also using these capabilities to turn attention towards the manufacturers and users, and sometimes actively intervening within systems deemed to be problematic. Many artists continue to critique the use of drones and explore civilian activities and their integration into daily life, including James Bridle, Mariele Neudecker, and Liam Young. Exhibitions such as *Decolonised Sky*, curated in 2014 by Yael Messar and Gilad Reich expand the critique of spatial territory and the possibility of new visual strategies that can activate the political imagination. Returning to earlier comments you made about your central preoccupations and your commitment to a creative practice in support of living ecological systems and non-human others, I'm curious about how you engage with the use of aerial robots within your arts-science collaborations?

Armstrong: My drone experiments began three years ago as part of a project around regenerative futures called *Re-Future* based in South Africa. The aim of that project was to design and build low-cost sustainable buildings and models for living with residents, scientists and international development organisations in South Africa's informal settlements, working with international development workers, architects, and sustainability scientists. Working on the ground with local residents I then assisted them to re-image and re-present that work for new audiences to build understanding, support and critical mass around the work, including a presentation at a series of community festivals (*Seven Stage Futures*, 2017-18). The use of drones in this

Ultimately the objective is to understand how this composite art form might be able to render something as seemingly familiar as an iconic landscape profoundly 'strange', allowing it to be experienced anew via 'sensual realms' that the artwork helps stimulate.

project involved the flying of numerous 'missions' above these settlements and ultimately rendering out creatively manipulated 3D models of those locales (using the drone-based terrestrial mapping process called photogrammetry), further overlaying cultural information as part of the projects' remit to question what future sustainable, grassroots suburbs based upon the local building designs might become.

This experimentation ultimately led to *Uncanny Valley* (2018–) which is currently emerging as a rich collaboration between biological, conservation and agricultural scientists, who together will seek to invent a 3D visual map-making process that exploits the inherent technical weaknesses of drone-based map making software processes. The visible exterior of our ecologically damaged planet is now almost entirely satellite-mapped, and available on demand via Google Earth. Armed with a domestic drone and some high-end scientific 'photogrammetry' software, any smaller part of the earth's skin can be 'captured' and presented as a 'fully-featured', user-navigable 3D model. However, getting that model to mathematically align with original forms means avoiding all sorts of technical pitfalls. The process can result in extraordinarily strange, yet highly evocative 3D imagery — whether of a riverine valley, waterfall or settlement — presenting a new way of envisaging these altered and re-presented landscapes. Much energy and time goes into avoiding these problems (e.g. the 'wrong' time of day, 'incorrect' flight paths, 'indistinct' or 'moving' objects, 'shutter blur' etc.). As one would expect there appears to be little, or maybe no significant investigation into how these errors might lead to the creation of more extraordinary 3D imagery than that close mimic of the landscape these 'scientifically accurate' packages promise. The aim is, therefore, to collaborate with these scientists to build towards an exhibitable VR artwork that enables users to wander within a series of these continuous 'uncanny landscapes'.

Much of our world has been rapidly warped beyond recognition during the Anthropocene. Overall, our attempts to re-badge our error-laden ways of living have failed the planet. Hanging doggedly on to failing systems has left us with little possibility to welcome in the unanticipated, or see and act anew to comprehend root causes. Artists have long been aware that the creative repurposing of mistakes can become powerful triggers for seeing things anew, suggesting possibilities beyond accurate or graphic representations of quantitative data sets. Curiously these early experiments in creating 'landscapes in error' I have found still possess the feel and form of something as immense and unknowable as a riverine valley, a towering waterfall or a village, but their strange bulbous glitchings, unfamiliar stretched shapings, missing or mysterious textures or apparent 'inside out views' confound description and possess a strangely uncanny power. Metaphorically, therefore, re-imaging disparate landscapes through this arts-science partnership offers new potential for seeking to re-image a 'world made strange' through the entwined capacities of science and media art. Ultimately the objective is to understand how this composite art form might be able to render something as seemingly familiar as an iconic landscape profoundly 'strange', allowing it to be experienced anew via 'sensual realms' that the artwork helps stimulate. Collectively this approach speaks to eco-philosopher Timothy Morton's rich idea of the "strange stranger"; something that we are unable to completely comprehend or label, given the more we think we know about it, the stranger it becomes.[10] Joining together immense, strange landscapes via VR imagery I believe will also speak to Morton's concept of 'hyperobjects'; 'things' like landscapes of vast

scale that are far beyond normal human comprehension. Morton suggests if we wish to become sustainable humans, we must work to transform how we see & experience our world, rewiring our 'ecological awareness'. In all these ways I hope that *Uncanny Valley* will create unexpected, strange encounters, both with the artwork & its originating landscapes, as a tactic for de-centring & expanding ecological perception.

Leimbach: The environment (as 'we' generally understand and experience it), largely appears as local and tangible, however the interrelated issues of anthropogenic climate change are global and intangible. This means that in some locations, associated risks are contemporary and very real, while in others — perhaps most — such risks are remote in both time and space and thus only knowable through various representations. It seems that your new project speaks in certain ways to this strange warping of space and time, and the dislocation between the very local and the global. Certainly, the strange and sombre crisis of the biosphere is challenging longstanding accounts of the meaning of human agency and notions of responsibility. We are now very much confronted by the challenge of shifting ethical understandings — of ourselves, communities, social change, and world society — and of rethinking the terms of our relationships between culture, science, nature, technology and 'life itself'. In finishing then, how do you see arts-science projects utilising drone technology to actively transform attitudes, perceptions and modes of participation in relation to this bigger picture?

Armstrong: Obviously these are early steps into these new strange landscapes of aerial possibility; building along the way unexpected 'big picture' experiences that may ultimately make contributions towards the transformation of attitudes, perceptions and modes of participation. Whilst I anticipate a rich arts-science process in the making of these speculative worlds, and outcomes exceeding these preliminary sketches, if they fail to connect with other facets of this struggle then their limited agency is guaranteed. Furthermore, the weight of the problems that we face today refuse easy solutions and require a plethora of actions working in concert — in no small part because we have so often failed to understand the tenor of the landscapes within which those problems are situated. Our designed worlds — limited by their lack of meta-perspective — simply keep on designing, so often in ways quite opposite from those which we would have hoped for. Today we need to urgently re-harness all the creative tools and tactics at our disposal as we build our communities of concern, and ultimately our communities of change — in the search to liberate powerful and transformative ideas and ways of being.

Endnotes

[1] da Costa, B. & Philip, K. *Tactical Biopolitics: Art, Activism and Technoscience*, Cambridge, MA: Leonardo Book Series, MIT Press, 2008.
[2] Naess, A. 'The Shallow and The Deep, Long-Range Ecology Movements' in George Sessions ed. *Deep Ecology for the 21st Century*, Boston: Shambhala, 1995, pp. 151-155.
[3] Williams, R. "Culture" and "Nature" in *Keywords: A Vocabulary of Culture and Society*, Fontana: Glasgow, 1976, pp. 76-82 and 184-189.
[4] Latour, B. & Weibel (eds.), *Making Things Public: Atmospheres of Democracy*, Cambridge, Mass: MIT Press, 2005.
[5] York, R. & Clark, B. 'Critical Materialism: Science, Technology, and Environmental Sustainability' in *Sociological Inquiry*, 2010, vol. 10, no. 3, pp. 475-499.
[6] van Dooren, T. 'Pain of Extinction: The Death of a Vulture' in *Cultural Studies Review*, 2010, vol. 16, no. 2, pp. 271-289.
[7] Gabrys, J. & Yusoff, K. 'Arts, Sciences and Climate Change: Practices and Politics at the Threshold' in *Science as Culture*, 2012, vol. 21, no. 1, pp. 1-24.
[8] Bridle, J. 'The Nightmare Videos of Children's YouTube — and What's Wrong with the Internet Today', TED, 2018, https://www.ted.com/speakers/james_bridle.
[9] Sandvik, K.B. & Jumbert, M.G. *The Good Drone*, London: Routledge, 2018.
[10] Morton, T. *The Ecological Thought*, Cambridge, MA: Harvard University Press, 2010.

Bibliography

Allison G. 'Daniel Pauly and George Monbiot in Conversation about "Shifting Baselines Syndrome"', Oceana International: https://oceana.org/blog/daniel-pauly-and-george-monbiot-conversation-about-shifting-baselines-syndrome, 2017.

Bridle, J. 'The Nightmare Videos of Children's YouTube — and What's Wrong with the Internet Today', TED, 2018, https://www.ted.com/speakers/james_bridle.

da Costa, B. & Philip, K. *Tactical Biopolitics: Art, Activism and Technoscience,* Cambridge, MA: Leonardo Book Series, MIT Press, 2008.

Dreyfus, H.L. 'The Current Relevance of Merleau-Ponty's Phenomenology of Embodiment', *The Electronic Journal of Analytic Philosophy,* 1996, no.4, Spring.

Hoare, P. The Sea Inside, London: Fourth Estate, 2014.

Gabrys, J. & Yusoff, K. 'Arts, Sciences and Climate Change: Practices and Politics at the Threshold' in *Science as Culture,* 2012, vol. 21, no. 1, pp. 1-24.

Gibbs, L. 'Arts-science Collaboration, Embodied Research Methods, and the Politics of Belonging: 'Siteworks' and the Shoalhaven River', *Cultural Geographies,* 2014, vol. 21, no. 2, pp. 207-227.

Latour, B. & Weibel (eds.), *Making Things Public: Atmospheres of Democracy,* Cambridge, Mass: MIT Press, 2005.

Naess, A. 'The Shallow and The Deep, Long-Range Ecology Movements'. In George Sessions ed. *Deep Ecology for the 21st Century,* Boston: Shambhala, 1995, pp. 151-155.

Sandvik, K.B. & Jumbert, M.G. *The Good Drone,* London: Routledge, 2018.

Morton, T. *The Ecological Thought,* Cambridge, MA: Harvard University Press, 2010.

van Dooren, T. 'Pain of Extinction: The Death of a Vulture' in *Cultural Studies Review,* 2010, vol. 16, no. 2, pp. 271-289.

Williams, R. "Culture" and "Nature" in *Keywords: A Vocabulary of Culture and Society,* Fontana: Glasgow, 1976, pp. 76-82 and 184-189.

York, R. & Clark, B. 'Critical Materialism: Science, Technology, and Environmental Sustainability', *Sociological Inquiry,* 2010, vol. 10, no. 3, pp. 475-499.

Tania and Keith would like to thank their numerous collaborators and colleagues, specifically the QUT Creative Lab, the Australia Council for the Arts, ANAT's Synapse Art-Science program (esp. Vicky Sowry) and the Australian Wildlife Conservancy (esp. Shauna Chadlowe, Joe Stephens, Matt Hayward and the ecologists at AWC Scotia).

Keith Armstrong describes his broad practice as a form of 'embodied media', exploring the use of sensory media, specialising in hybrid works with an emphasis on innovative performance forms, site-specific electronic arts, networked interactive installations, public arts practices, and arts-science collaborations. His 23-year practice is foregrounded by a long-standing interest in scientific ecology, focused on the broad conceptual territory of ecological philosophy. www.embodiedmedia.com. **Tania Leimbach** is a social researcher and artist who has worked in collaboration with Keith over the past 8 years on a number of arts-science collaborations. As an academic, Tania's research crosses cultural theory, art and design theory and sustainability studies, interested in the way diverse communication strategies are utilised to engage audiences with ecological understandings and contested political issues. Keith and Tania share interests across ecological science and philosophy, conservation biology and earth system science and more broadly the cultures of science, arts-science collaboration, systems thinking and transdisciplinarity.

LABIOMISTA:
Biology, Art, and Philosophy

"Art and science have the same origin and follow a similar process. Both are inspired by the power of imagination and fuelled by the ever-inquiring mind. Art, like science, is a way to discover new things. Both disciplines imagine the future, both are tasked with advancing society. Art, in a way, is expected to 'tear up the rule book.' It has the ability and the responsibility to trigger innovation - also in science," states Koen Vanmechelen. Biologist and philosopher of science Geerdt Magiels talked to the artist about his work - art that touches upon philosophy, science, and social commitment. Each piece tells a story – a story in which the local and the global interact. A reflection on art, science, culture, and society.

text **Geerdt Magiels**, images **Koen Vanmechelen**

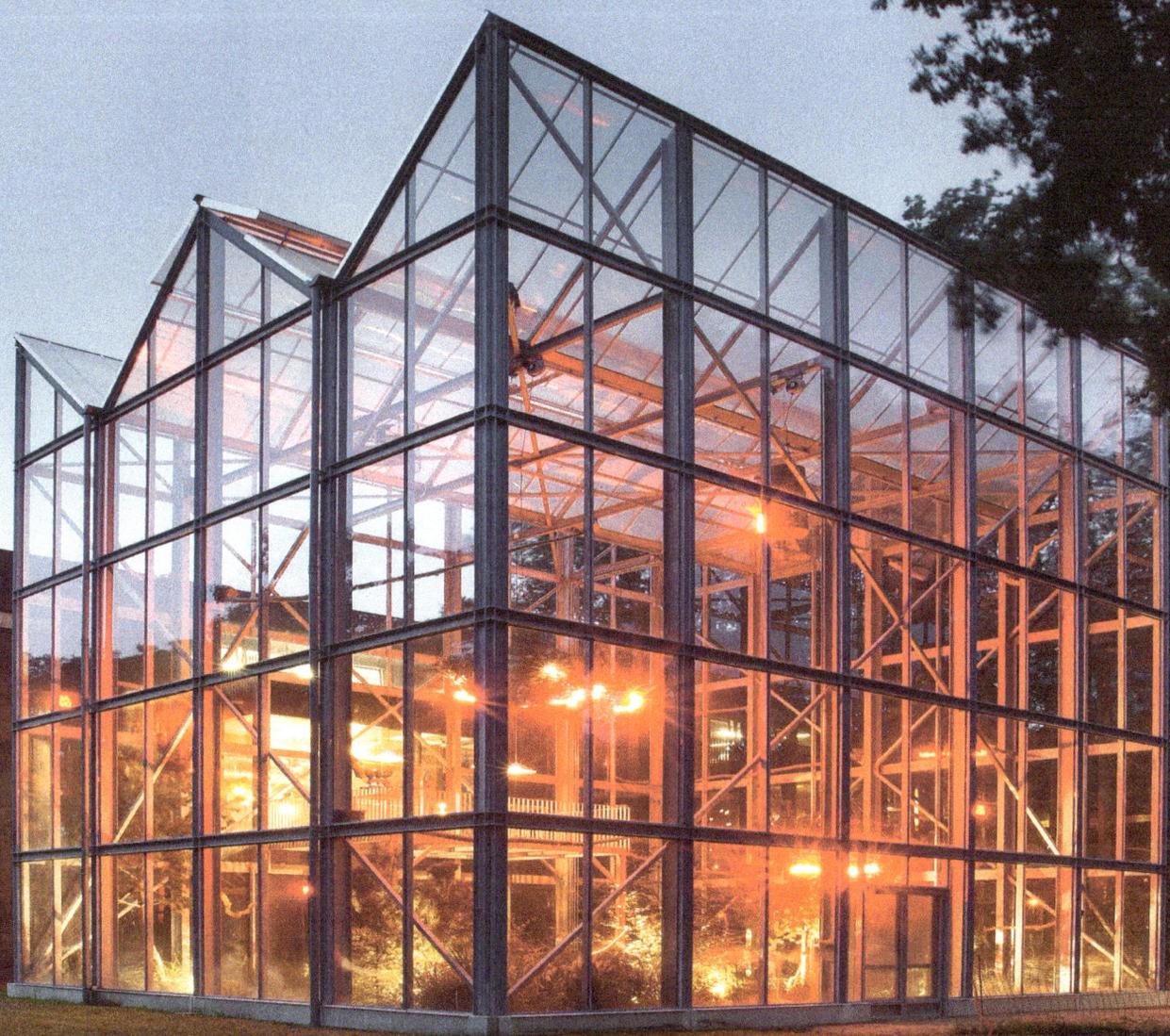

Koen Vanmechelen is an incubator of ideas, which he moulds into various shapes at a rapid pace and with substantial variation. One of the central ideas behind his work is that humanity is part of nature and exists only because of nature; and that nature, therefore, deserves our attention and respect.

That idea is at the heart of his recent project called *LABIOMISTA*, a nature area, animal park, and sculpture garden on the grounds of the former Zwartberg Zoo, adjacent to a large nature reserve. The entrance to the park, with its allotment gardens, exhibition spaces, animals, stables, aviaries, and open-air theatre, is located at the former director's residence of the mine, now renovated and housing various foundations for world development. Next to it is an imposing new building, a sober design by Swiss architect Mario Botta, fully integrating Vanmechelen's fascination with living nature.

The building is dissected by a giant aviary housing Steller's sea eagles. They are part of an international breeding programme for this impressive and endangered raptor species. If and when a chick is born, it will join its counterparts in Kamchatka to replenish the population in the wild. On its western side, the building leads into an equally impressive conservatory. The kitchen and dining room for Vanmechelen, his team and his guests opens onto a balcony that protrudes into this birdcage. Toucans and hornbills sit on the edge of the balustrade. Zebra finches and Java sparrows flit around between giant nests (works of art), seven species of turaco fly among the trees tall as houses, the green junglefowl rummages on the ground, under the cooing of tropical pigeons.

It's no coincidence that it's these birds that are here, in this place in the building. "These fruit and seed eaters come from across six continents. They represent the world. Eagles are meat eaters. We – the omnivores – live and work among the carnivores and frugivores." says Vanmechelen. The birds are an architectural element, a living tableau recounting the story of the evolution of life on earth.

Evident in each of Vanmechelen's works is a tension, between natural evolution propelled by genetic variation on the one hand, and human-engineered development nurtured by playful creativity on the other. In the Flanders of his youth, canary cages, chicken coops, and dovecotes were a common sight.

"As a little boy, I was fascinated by eggs and chicks. Even back then, I was amazed at how one could lead to the other: How does an egg turn into a chicken and then into another egg? Asking questions was and is second nature to me. They guide me in my experimental approach. My growing collection of birds forced me to think about how to give all those animals a healthy and happy life. How do they live in the wild? What is their natural behaviour and how can you let this flourish? With the biology questions came the philosophical ones: If we love something so much, why do we put it in a cage? How do we deal with other species? And what does that say about the place of humans in the bigger picture?"

With his art, Vanmechelen seeks a balance between wild nature (which hardly exists anywhere anymore) and human culture (which manifests itself globally). So it's no coincidence that the chicken, which is both the primordial fowl from the forests of Southeast Asia and the extremely cross-bred industrial chicken of today, is a recurring *motif* in his work. The chicken, whether alive or stuffed, is the best-known aspect of his oeuvre.

The *idea* becomes a *machine* that makes the *art*, Sol LeWitt

The chicken cross-breeding project isn't a scientific experiment designed to test a hypothesis. It starts from an intuitive appreciation of the beauty of (biocultural) diversity.

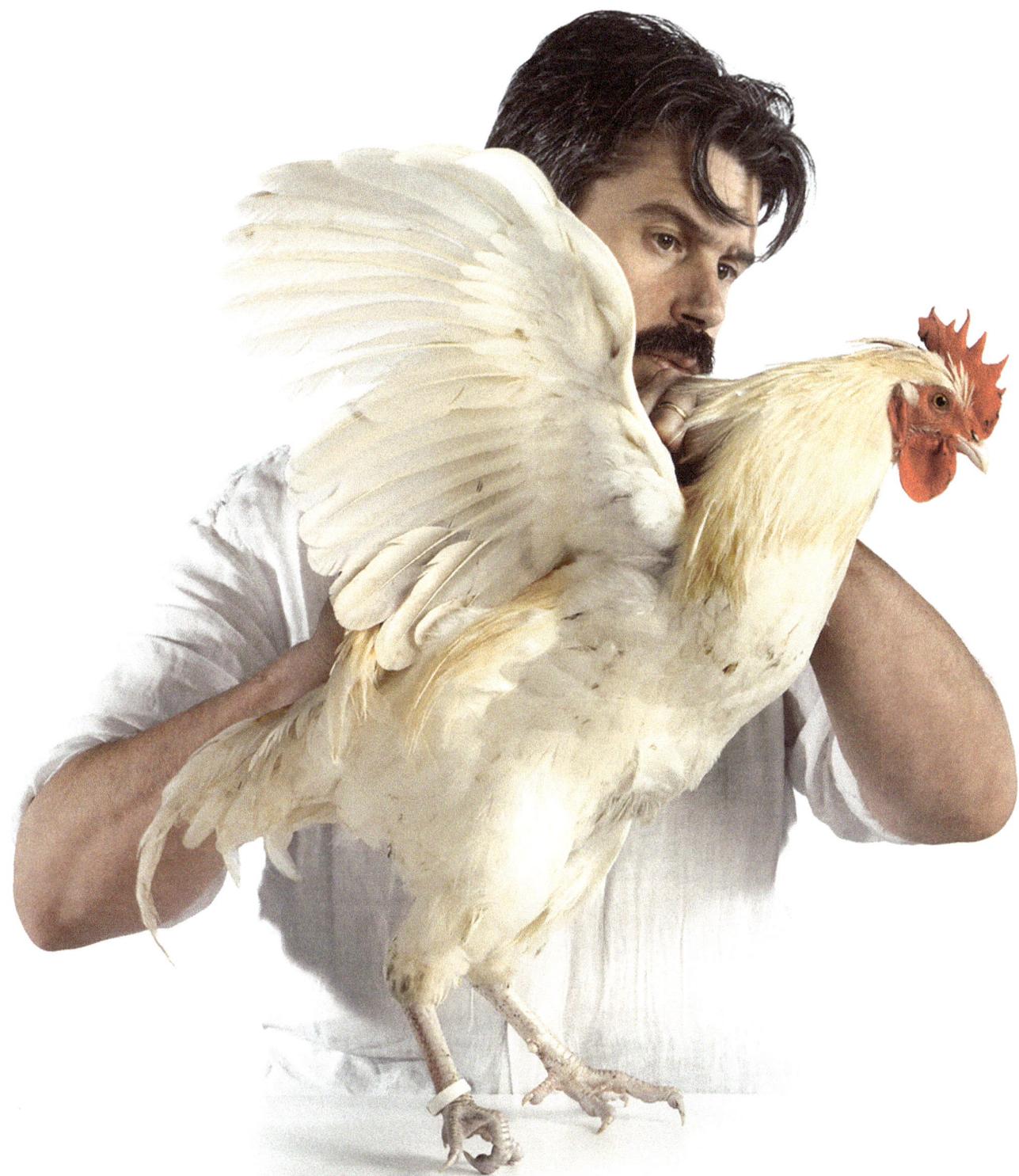

Koen Vanmechelen

Portrait Koen Vanmechelen

© Koen Vanmechelen

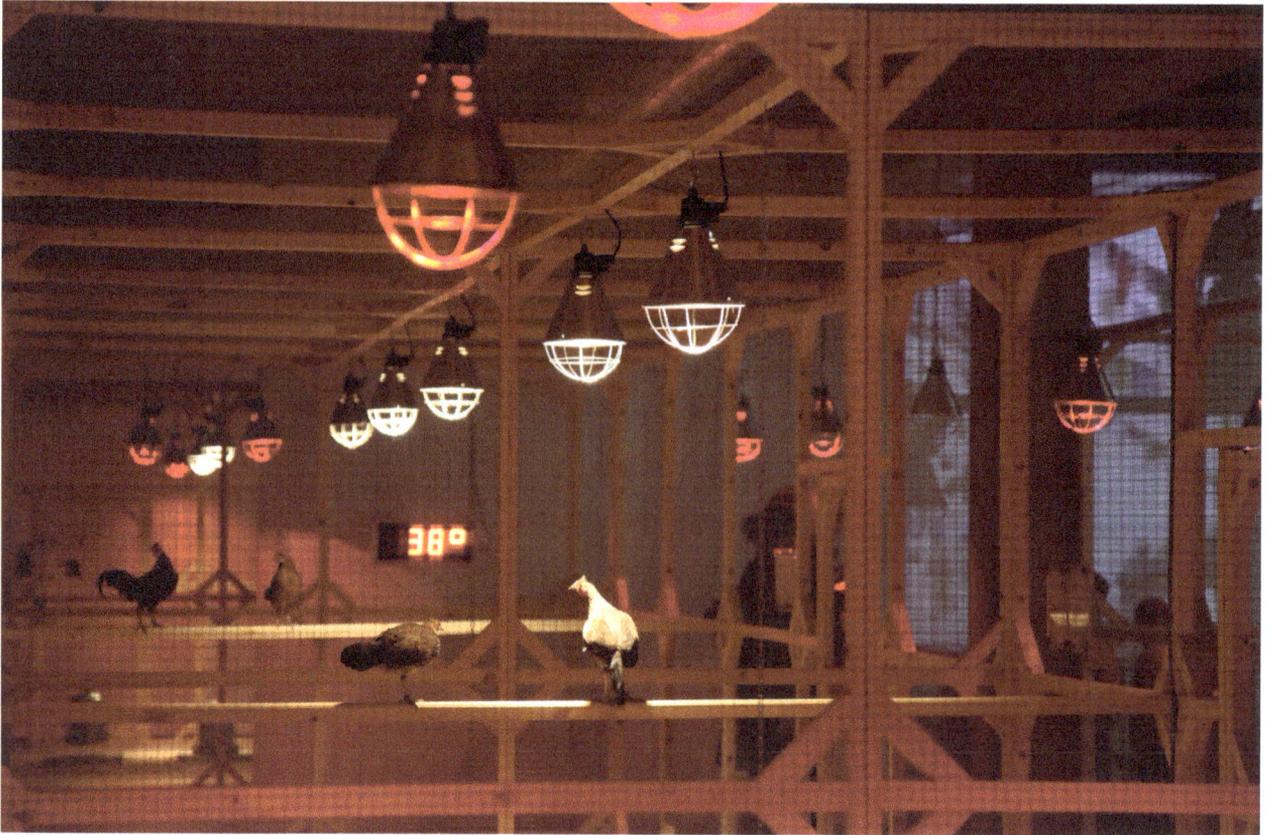

Koen Vanmechelen

Breaking The Cage, C.C.P., IKOB - 2011, Museum für Zeitgenössische Kunst, Eupen (BE), *Installation view*. Photo by Stoffel Hias
© Koen Vanmechelen

wrote in 1967. Vanmechelen detects in the chicken a primal form of bird, and in birds a blueprint of life itself. His fascination with variation and diversity has led to an ever-expanding hybridisation project: he crosses local chicken species in order to create a more universal chicken – genetically more diverse and biologically stronger than today's factory chicken. Vanmechelen's project to create a 'Cosmopolitan Chicken' arose from the (scientifically substantiated) realisation that the chickens scratching around in their pens are not 'ours' (be they Mechelse, Bresse or Finnish chickens), but the living product of millions of years of evolution, selection and adjustment. At the same time, Vanmechelen hybridises biological with cultural diversity. Whenever he returns a diversified chicken to its local community – in Cuba, Ethiopia or Finland – he connects a local culture with the epic of the worldwide spread of these birds; with the 7.7 billion people and 23 billion chickens sharing this planet.

The chicken cross-breeding project isn't a scientific experiment designed to test a hypothesis. It starts from an intuitive appreciation of the beauty of (biocultural)diversity. Over time, Vanmechelen got in touch with geneticists and biologists. For them, it was clear from the beginning that these new chicken breeds did not produce any reliable biological knowledge per se. But it did inspire them to look at chickens differently. As a result, there are now projects ongoing to investigate whether hybridisations like these can lead to more robust chicken varieties. In line with this, Vanmechelen inaugurated a

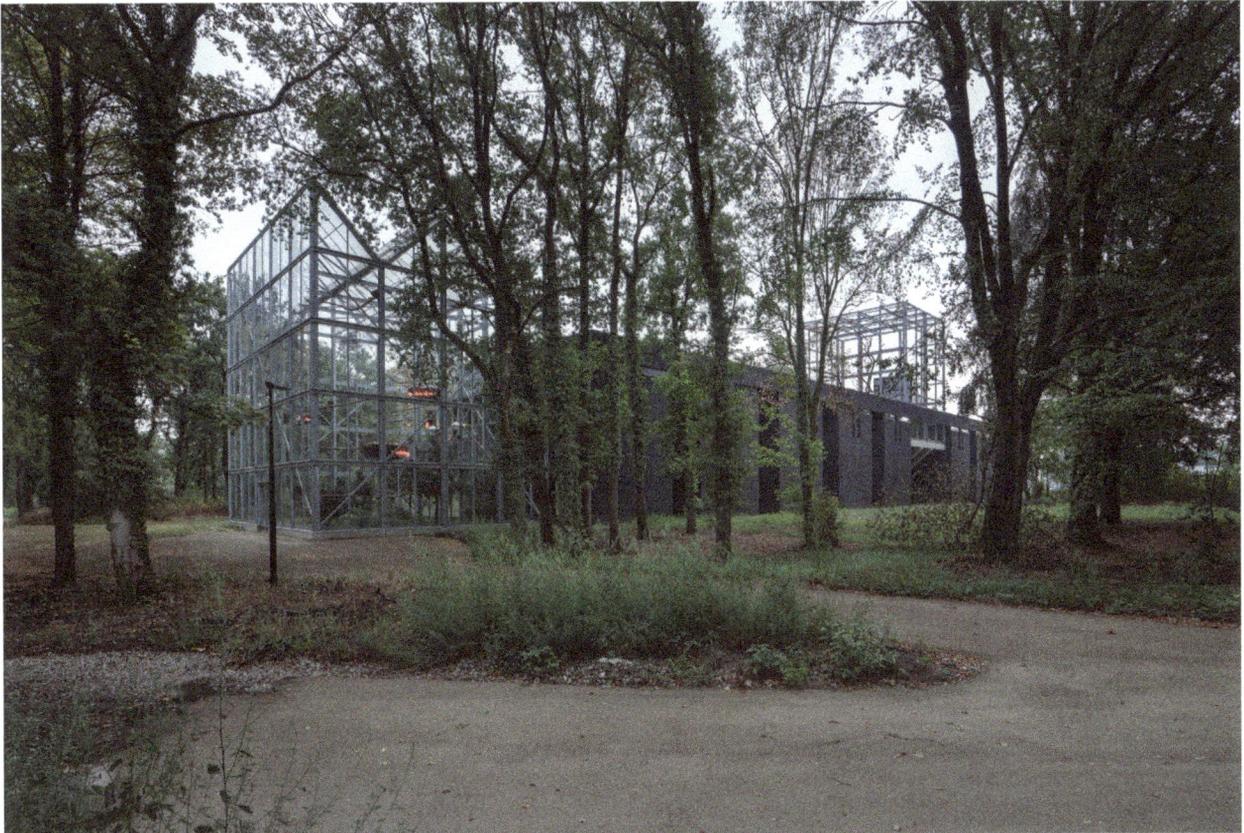

Koen Vanmechelen

The Battery, studio Koen Vanmechelen, exterior view on The Looking Glass (greenhouse installation), LABIOMISTA, Genk (BE)

Photo by Kris Vervaeke © Koen Vanmechelen

new work of art in Addis Ababa, Ethiopia in 2018, which doubles as a research centre in collaboration with the International Livestock Research Institute (ILRI). Here, social and agricultural research is being done into the use of chickens as a source of protein for a population that often teeters on the brink of starvation. The ILRI project is supported by the Bill & Melinda Gates Foundation.

Biology and genetics are always present in the background of Vanmechelen's conceptual art. They substantiate the ideas about diversity that he cherishes and releases into the world as art projects. After their natural death, the roosters and hens from Vanmechelen's transcultural breeding programme end up in works of art and installations, the silent witnesses to the spin-off projects of his art.

His work is the core around which crystallise a number of post-art foundations to further the development and emancipation of people – often women and children – in the poorest parts of the world, from the highlands of Chile to the suburbs of Detroit. His art is the common denominator in projects based on private-public cooperation. These projects are just as hybrid as his artistic creations, which join feathers, skins, eggs or antlers with plexiglass, marble, neon, paint or ink. In a sense, the materials he works with are secondary. It's all about the ideas they express. In fact, the 'material' often isn't even tangible at all, when it comes to the people whom Vanmechelen inspires and unites with their dreams and wishes.

It's striking to see how Vanmechelen's art is able to bring peo-

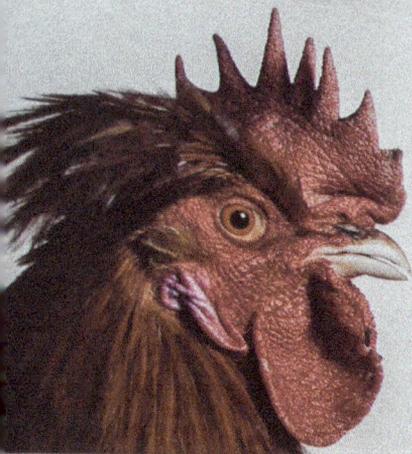
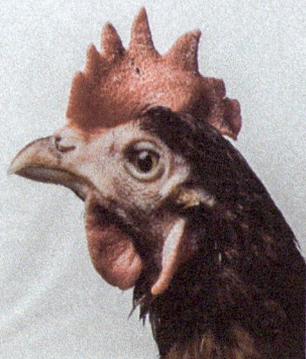
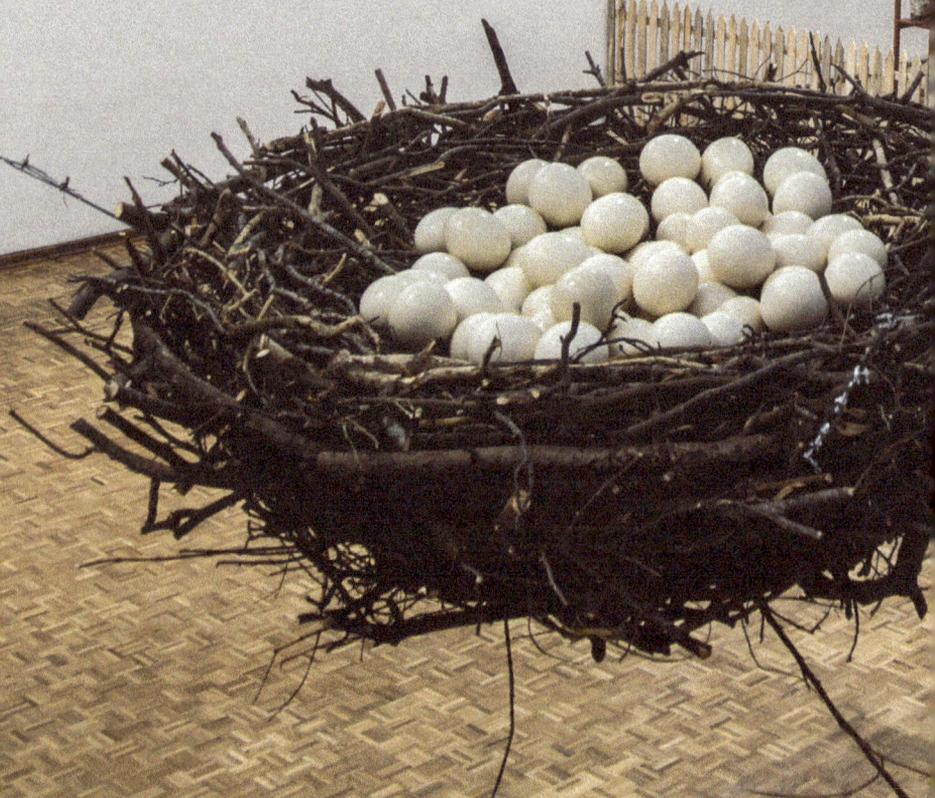

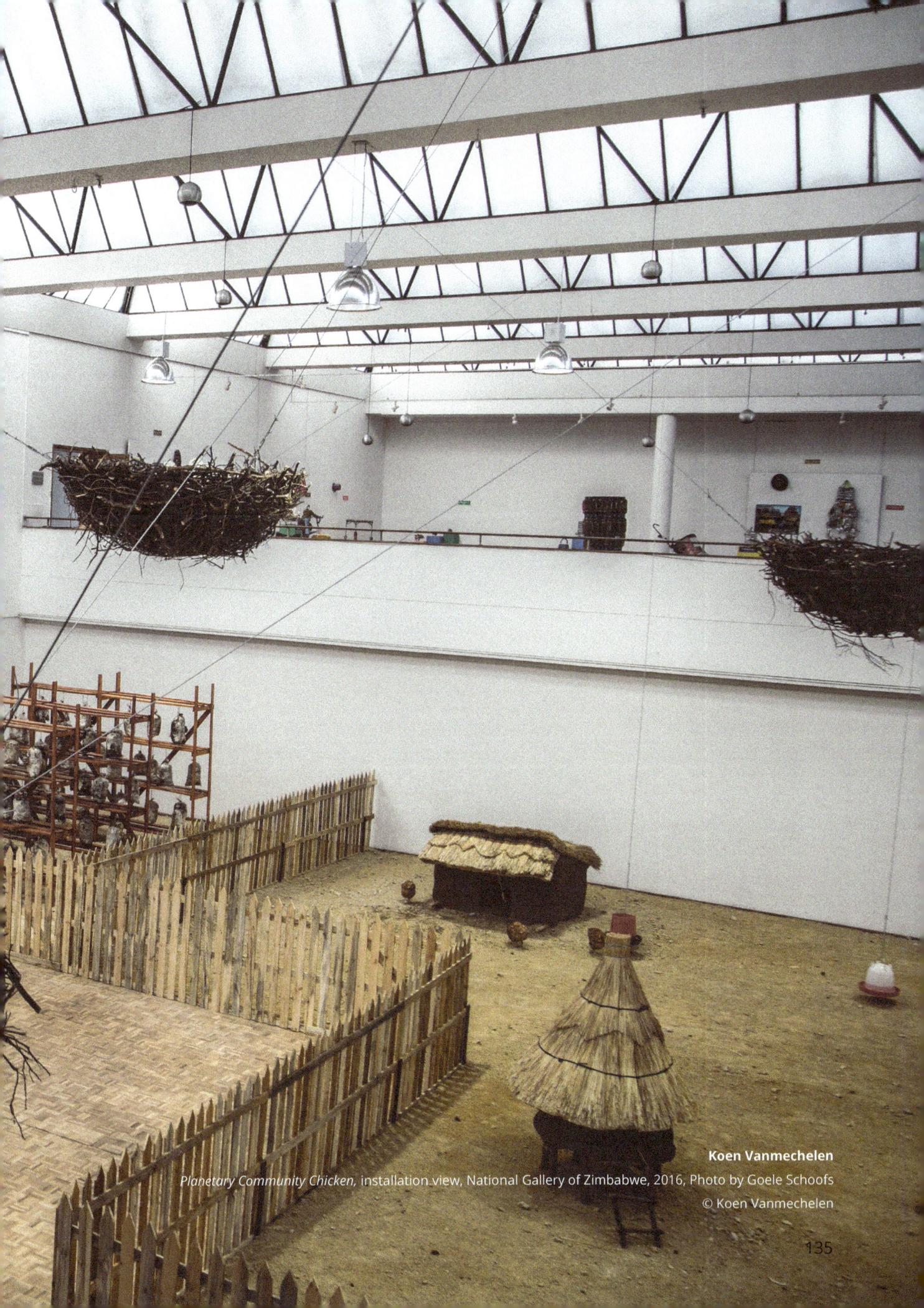

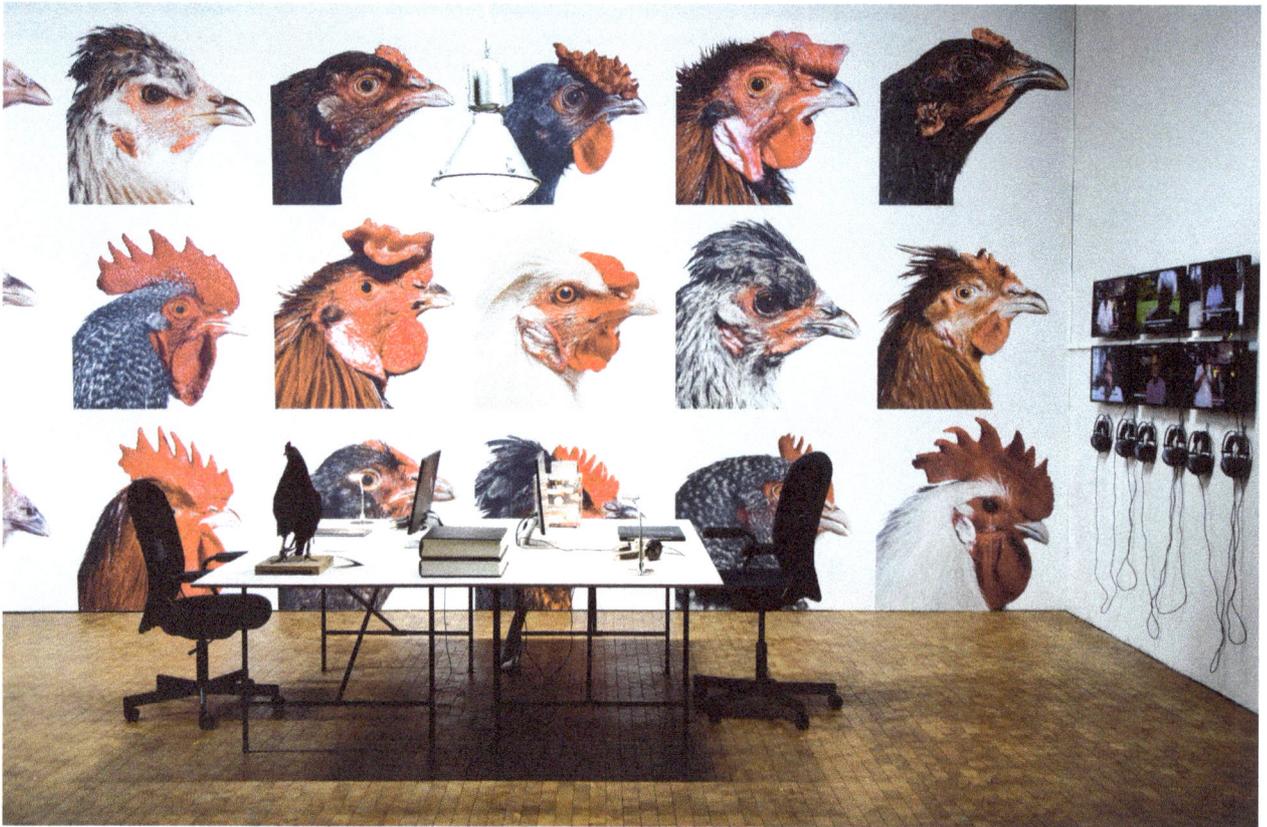

Koen Vanmechelen

LABIOMISTA, Exo-Evolution, installation view, Globale 2015, ZKM | Zentrum für Kunst und Medientechnologie, Karlsruhe, 2015.
Photo by Stoffel Hias © Koen Vanmechelen

ple together. The concepts behind his art transform into stories that enthuse. Wonder, that universally recognisable feeling, is his basic source of inspiration.

"I often ask myself questions, and one question leads to another. About eggs or ova and fertility, about llamas or camels and their wonderfully duplicated immune system, about genetic and phenotypic diversity in poultry and cattle, about women and food security, about children and their rights and dreams: these are the basic ingredients of my work, and they keep coming back, in different forms and materials."

Asking questions is an art. For Vanmechelen, they are the source of his art, and their scientific or philosophical answers inspire him. But he is not a scientist, and knows the difference: "You're right when you say that artistic research is of a very different nature than scientific research. For the latter, reliability, reproducibility and objectivity are required. But these criteria do not apply to art. I do feel related to researchers and that is why I like to talk with them. All research starts with observing reality and wanting to know what you're observing. That's what I do too."

Vanmechelen likes to exchange ideas with the researchers with whom he regularly shares a table. Because all research starts with observing reality and wanting to know what you're observing. That's what Vanmechelen does: on the observation deck in the large aviary, he looks – and looks again. For him, standing face to face with

these strange, yet familiar creatures is a gift. He observes with the aim to learn. Everyone who has a pet knows how interesting animal behaviour can be. And people without pets know the behaviour of the human animal can also be endlessly fascinating. If you look closely, there is so much to see.

Art and science start from the same sense of wonder. The art of critical observation is a basic ingredient of all research: the assessment and analysis of acts, statements or thoughts. The critical mind searches for the limits of what people know or think they know, it examines the scope of available knowledge, and in so doing also calls for modesty: "We still know so little and we struggle with the ethical implications of what we do".

Through his work, Vanmechelen manages to get people to look differently at their own discipline, and at reality per se. In and by his art, Vanmechelen brings together people from various disciplines: from medicine to genetics, from taxidermy to development aid and from human rights to fertility. Art is his way of spreading ideas. Shared insight is improved insight. Vanmechelen generously shares his work with the rest of the world, in particular with the vulnerable and the disadvantaged. Whenever he cross-breeds with 'cosmopolitan chickens' to make local chickens stronger, he also crosses global with local knowledge to make the world of tomorrow more liveable. It's his curiosity and generosity that drives him. His motto: "The global only exists by the generosity of the local."

Art and science start from the same sense of wonder. The art of critical observation is a basic ingredient of all research: the assessment and analysis of acts, statements or thoughts. The critical mind searches for the limits of what people know or think they know, it examines the scope of available knowledge, and in so doing also calls for modesty

Geerdt Magiels is a biologist and philosopher of science. This background and a substantial experience in different fields of science and society enable him to cover a broad range of subjects, from medicine to healthcare, from art to science, from brain physiology to culinaria.

Koen Vanmechelen is an internationally renowned conceptual artist based in Belgium. Across the last decade, Vanmechelen has collaborated with scientists from different disciplines. His research and work earned him an honorary doctorate from the University of Hasselt in 2010, and the Golden Nica Hybrid Art award in 2013. His ongoing investigations, with the support of project partners, led to the creation of the Open University of Diversity, which invites people from different fields of study and practice to engage in a dialogue and new projects that examine ideas of diversity.

Vanmechelen has shown in major institutions across the world, including The National Gallery London, Victoria and Albert Museum (London), Museum Kunst Palast (Düsseldorf), Venice Projects (Venice), Muziekgebouw aan 't IJ (Amsterdam), Museum of Art and Design (New York), Pushkin Museum (Moscow), and across Belgium, including at the Verbeke Foundation, Watou, Museum M and Z33. In 2015, he participated in the Havana Biennale, where his Cosmopolitan Chicken Project was responsible for reintroducing an extinct species of chicken back to Cuba.

HKW, Berlin

Bernd Scherer: Curating the Anthropocene

The Haus der Kulturen der Welt ("House of the World's Cultures") in Berlin is Germany's national centre for the presentation and discussion of international contemporary arts, with a special focus on non-European cultures and societies. It presents art exhibitions, theater and dance performances, concerts, author readings, films and academic conferences on Visual Art and culture. It is one of the institutions which, due to their national and international standing and the quality of their work, receive funding from the federal government as so-called "lighthouses of culture."

interviewee: **Bernd Scherer**

interviewer: **Giovanni Aloi**

Haus der Kulturen der Welt (HKW) creates a forum for the contemporary arts and critical debates. In the midst of profound global and planetary transformation processes, HKW re-explores artistic positions, scientific concepts, and spheres of political activity, asking: How do we grasp the present and its accelerated technological upheavals? What will tomorrow's diversified societies look like? And what responsibilities will the arts and sciences assume in this process?

HKW develops and stages a program that is unique in Europe, blending discourse, exhibitions, concerts and performances, research, education programs and publications. Its projects initiate reflection processes and devise new frames of reference. In its work, HKW understands history as a resource for alternate narratives.

In its extraordinary, modernist congress-hall architecture, HKW enables new forms of encounter and opens up experiential spaces between art and discourse. Together with artists, academics, everyday experts, and partners across the globe, it explores ideas in the making and shares them with Berlin's international audience and the digital public.

*　　*　　*

Giovani Aloi: Haus der Kulturen der Welt in Berlin is Germany's national centre for the presentation and discussion of international contemporary arts, with a special focus on non-European cultures and societies. Its exhibition program is usually challenging, always original, and often ground-breaking. How would you define HKW's curatorial approach?

Bernd Scherer: Because of the history of HKW, our approach is prevalently postcolonial. It consistently reflects upon the power asymmetries we are confronted with all over the world. In recent years we have extended this approach by exploring these same power asymmetries through the concept of the Anthropocene. That does not mean our take on the Anthropocene replaces postcolonial thinking but rather that it adds to the socio-political injustices a critical approach of the material transformation of the planet by new technologies and new forms of turbo-capitalism.

For example, through the working conditions of cobalt miners in Congo, one can see how postcolonial problems are closely linked to the material flows which drive the development of the technological world. Another example would concern people who are forced to leave their homes or regions because of climate change. What was once displacement through colonialism or economic factors is now accelerated by changes in climate

What becomes obvious when one works with the concept of the Anthropocene is that the classical divide between nature and culture collapses. This implies that the classical division of knowledge production between the natural sciences on the one hand, and the social and cultural sciences on the other is no longer adequate for dealing with the problems we are confronted with. The aforementioned example of cobalt mines in the Congo, highlights how human activities and material flows are interconnected not just

Armin Linke

École polytechnique fédérale de Lausanne (EPFL), Alpine model, Lausanne, Switzerland, 2001 © Armin Linke

An analogue model of the Alpine area around Mont Blanc and Lake of Geneva, to demonstrate the movement of clouds.
Since the turn of the century, only digital models have been in use.

locally, but on a planetary scale. Multiple economies are involved between the mining of cobalt in the Congo and our use of smart-phones, which heavily relies on cobalt. Cobalt as a material contributes to not only the transformation into so-called information societies, but it is also an interface for social and economic inequalities. As far as knowledge production is concerned, we need conceptual approaches which are able to articulate the interconnectedness of these phenomena.

A second important aspect of the Anthropocene idea is its implication in the emergence and development of academic disciplines. Normally, establishing a discipline requires time. It takes decades to establish and finetune conceptual frameworks. The disciplinary frameworks that we in Western Europe have inherited from the 18th and 19th centuries are no longer appropriate to reflect the current situation. Today, when new generations of technologies every five to ten year and transform the world we are living in, then this classical concept of disciplines implodes because it needs different timeframes.

In the last years, we have also encountered a shift in the role of knowledge production from producing knowledge about the world to using knowledge to create new worlds. If you look at the founders of tech-companies, they leave the university sometimes without any diploma in order to develop an idea in a start-up. Funding institutions in the academic world direct their funding to projects which have practical applications and less and less to basic research. This shift has important consequences for the role of scientific knowledge in the public discourse of democratic societies: Instead of asking what aims to pursue it seems that to transform knowledge

141

Armin Linke

Greenhouse, El Ejido, Spain, 2013 © Armin Linke

Poniente Almeriense is a region in Almería, Southern Spain, which hosts the most intensive agricultural production in Europe. The strip of land between the Sierra Nevada and the Mediterranean Sea is a single layer of plastic and genetically modified vegetation. Through the presence of large international agribusinesses, plastic factories, and dedicated ports, it is one of the most valuable areas of real estate in Spain.

 Intensive agriculture in the El Ejido area produces vegetables for most of Europe, throughout the year. This greenhouse covers a ground space of about 0.5 km2. An English supermarket company rents the greenhouse and ships young tomato plants from Britain to Spain, where they are grown and harvested, and then shipped back to the British chain.

into technologies and goods becomes an aim in itself and therefore completely defined by business-models of big companies. This process leads to a de-politicization of central processes that affect societies. This is one reason why, more and more, people see themselves as objects and not as subjects of processes. This is an important task for cultural institutions such as the HKW, which define themselves as forums where the transformations of societies are discussed and negotiated—to re-politicize exactly these processes.

And it is in this context that new forms of knowledge production are also emerging. So more specifically, in answer to your question, I would say that at HKW, we are curating "ideas in the making", which means that we are now reflecting on processes rather than focusing on stable objects. Curating means to explore ideas rather than organize objects in the gallery space. And the Anthropocene is an idea that allows you to establish new constellations of knowledge.

Armin Linke and Giulia Bruno

United Nations Climate Change Conference (COP19), Warsaw, Poland, 2013 © Armin Linke and Giulia Bruno

In November 2013, the 19th United Nations Climate Change Conference (COP19 or CMP9) in Warsaw was where delegates met to negotiate a global climate agreement. The conference, which took place in Warsaw's main football stadium, was characterized mainly by disagreements over damage and loss compensation payments by developed countries to developing ones. Here, the temporary architectural structure for the event – including its heating system – can be seen on the stadium's turf.

Aloi: Over the past few years, HKW has been at the forefront of an important art and science revolution that is currently changing the face of contemporary art. Since 2013, an initiative called 'Anthropocene Curriculum' has focused on a deep integration of cross-disciplinary thinking, mutual learning, new modes of research, and civic commitment designed to shape the future of universities, academies, research platforms, and cultural institutions as situated spaces of knowledge production and its dissemination. How did the idea of the 'Anthropocene Curriculum' originate?

Scherer: The idea of the *Anthropocene Curriculum* originated in the context of the opening of *The Anthropocene Project*. We invited directors of different research institutions from Europe and beyond to discuss what type of strategies we could envision in relation to the Anthropocene-related processes that I have just mentioned. The shared vision of this group focused on one major point: When the old academic structures no longer function adequately for our

Armin Linke

United Nations Climate Change Conference (COP19), Warsaw, Poland, 2013 © Armin Linke

Activist and philosopher Farhad Mazhar initiated a local seed-storage facility in Bangladesh, aimed at resisting the industrial standardization by agribusinesses and dedicated to preserving the countless varieties of rice once cultivated in the area.
 This local farmers' association archives about five thousand of the ten thousand traditional Bangladeshi rice-seed types. Recently introduced industrial far ing practices make use of only about ten varieties of rice. The farmers can have rice seeds for free, provided they bring twice the amount taken, after their harvest.

contemporary age, we have to design new ones. There is a need to explore new forms of knowledge production with not only scientists and intellectuals, but also with artists, cultural producers, and social activists.

On the basis of this insight, we developed a "novel curriculum" designed by thinkers and practitioners from different artistic and scientific disciplines to exchange ideas and processes. Another important aspect was to develop a kind of long-term cooperation between different individuals as well as research institutions and non-governmental institutions. For us, this project is a tool to experimentally investigate the changing conditions and creative possibilities of current and future knowledge production and to test new and Anthropocene-adequate forms of knowledge transfer.

Aloi: How did it start?

Scherer: Back in 2013 we invited scientists, designers, and university teachers—many of them belonged to the group of directors that I just mentioned—to collectively create a model curriculum for a 9-day "Anthropocene Campus". You have to think of such a campus as a highly transdisciplinary combination of several courses, like in a summer school but much more experimental, generative and mutual. A very intensive period of time in which you test novel ways of

Armin Linke

Bahar Energy Operating Company Limited, oil platform, Baku, Azerbaijan, 2015 © Armin Linke

Oil exploration began in Baku in 1846, with the first wellbore drilled with percussion tools to a depth of twenty-one meters. Nearly two hundred small refineries operated in the suburbs of Baku by 1884. As a side effect of these early developments, the Absheron Peninsula emerged as the world's "oldest legacy of oil pollution and environmental negligence." In 1878, Ludvig Nobel and his Branobel company "revolutionized oil transportation" by commissioning the first oil tanker and launching it in the Caspian Sea.

co-learning and co-producing knowledge. The first Anthropocene Campus was very much concerned with developing a conceptual framework with which to conceive the Anthropocene through specific lenses. For instance, we focussed on the idea of "modeling wicked problems", or "imaging the Anthropocene". This was important since the concept of the Anthropocene confronts us with new forms of conceiving realities. We have to take into consideration extremely different time-scales, the deep time of Earth history, cultural and social time scales up to the nanoseconds of an electronic stock exchange crash that has repercussions in global markets. All these time frames are interacting "at the same time". Additionally, the Anthropocene concept draws the attention to different spatial scales where local processes are deeply embedded into planetary, or Earth system processes. We need conceptual tools to traverse between these scales and navigate their interconnectedness. The ontologies produced on the bigger scales do not concern objects or phenomena of the mid-sized empirical world that we can tap into or experience, but usually consist of data, models and, even more interesting, data models. We are confronted with deep epistemological problems when it comes to the Anthropocene. The question of transdisciplinarity became also central to the early stages of this project. This is a preoccupation that we continue to productively

cultivate by crafting new aesthetic languages to capture the phenomena that we are only now beginning to grapple with.

The second phase of the project focused on the idea of yet another concept that is closely tied to the Anthropocene: the technosphere. The term was coined or revitalized by Peter Haff, a geologist and civil engineer at Duke University. The idea of the technosphere is that our technologies have amassed to a global system that, much like the biosphere, it has a kernel influence on the material and energetic metabolism of the planet. This system includes all our technical infrastructures but is more than that: it is what drives the human impact on the Earth; our politics, agriculture, cities, etc.

Lately, we have entered a third stage of the project where it becomes more and more important to develop knowledge "topologies" out of the local "topographies" of the Anthropocene. We are now looking how in certain regional contexts the different processes of human intervention, natural development, and technologies are not only producing new realities but also how they are teleconnected to other phenomena and, crucially, what the different cultural traits and modes of grasping and grappling with the Anthropocene are. One major project in this context is a project we have just started together with many local collaborators along the entire Mississippi River—a true model-geography of the Anthropocene.

The Mississippi River is, on one side, a cultural icon which has many representational incarnations in literature, movies, and music. But on the other, beyond its romanticised image, it is a true crucible and product of human development and material interventions and power. It is a highly engineered body of water, maintained by the Army Corps of engineers. There is the vexing history of plantations and slavery in the South which established economic and social segregation, and which is now replaced by the chemical corridor of endless refineries and plants that, amongst others, produces the fertilizers used by the highly industrialized agriculture of the Midwest further north. The fertilizer runoff again flows all the way down to the Gulf of Mexico—together with the corn and soy that is shipped to other continents—and creates the dead zones. Interconnections such as these make this River so emblematic.

From an Anthropocene perspective, it is impossible to distinguish the river from all the human interventions that have occurred over time. In cooperating with different local groups, our aim is not only to highlight human intervention on the local geography but to explore the entanglements of this key landscape in the American heartland with planetary processes.

Aloi: In my opinion, our "Anthropocentric-miseducation", as I have been calling it for a few years, is largely responsible for the current environmental degradation and climate change. Our relationship to what we call 'nature' starts off with a wrong footing from primary school. I believe that "natural studies" and science should lie at the foundation of our learning. Enthusing children and young adults about the natural world should be seen as something essential to the interconnected wellbeing of the individual and ultimately to that of the planet. Instead, we continue to treat nature as a curiosity, a separate and sublime entity—an approach that we carry with us in our adult life.

Art has the ability to change our minds in unique ways. How

From an Anthropocene perspective, it is impossible to distinguish the river from all the human interventions that have occurred over time.

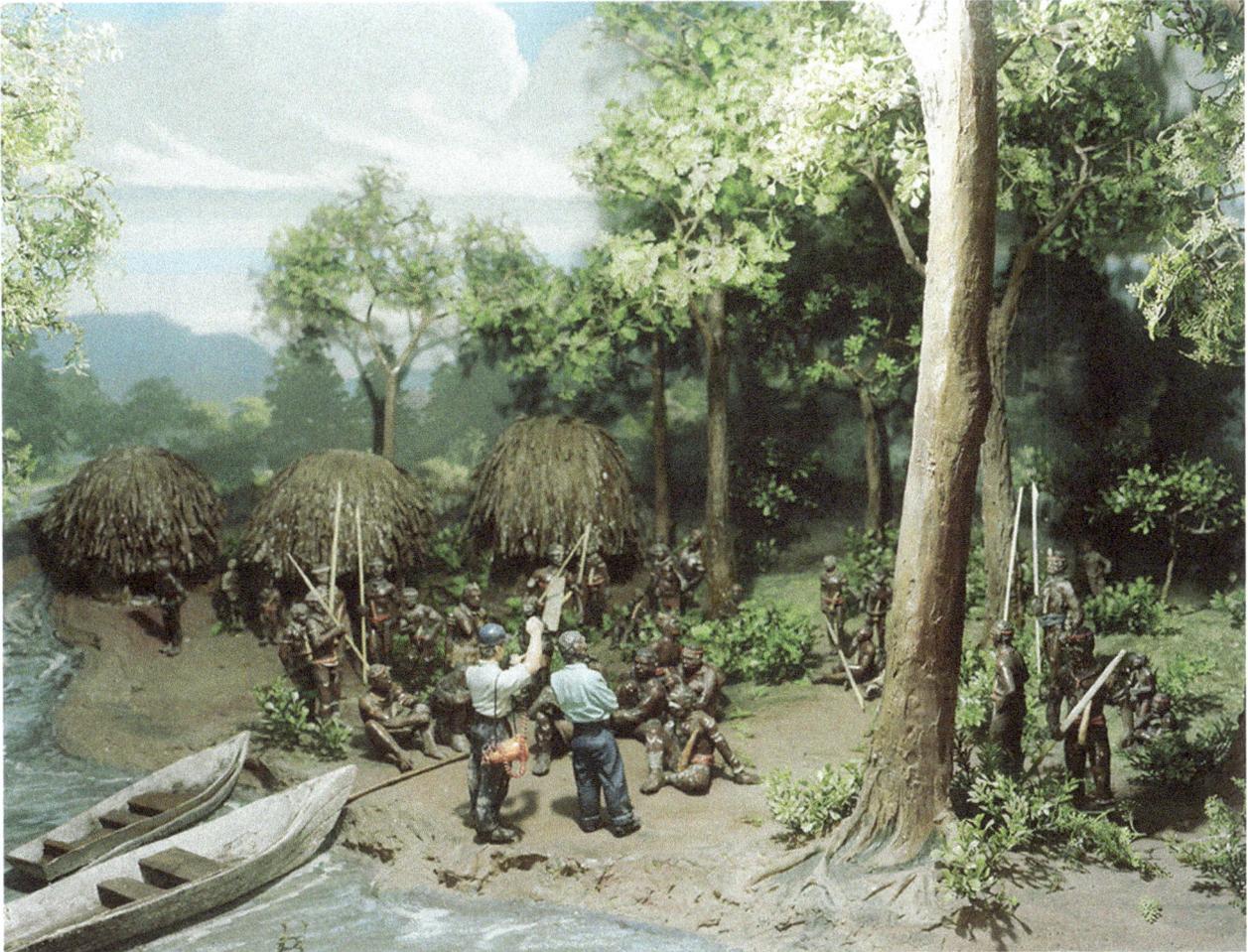

Armin Linke

Taman Mini Indonesia Park, Penerangan Information Museum, Diorama showing "informations officers rendering information to the people in Irian Jaya" Jakarta Indonesia 2016.

can the intersection of art and science help to alter our anthropo-centric-miseducation?

Scherer: What is interesting, and I can only speak from a German educational point of view, is that right from the beginning there is a clear distinction between art education on one side and the natural sciences education on the other. In this context, the natural sciences are attributed more value, and that's where the problem begins. Art education provides maturity—it refines your conceptual and creative abilities. Art established articulation for aesthetic sensibilities and therefore art education should not be treated as separate from the natural sciences—it should be seen as integral to the formation of the individual within a social scope. So, yes, we miseducate our children from the very beginning by teaching them that the natural sciences are concerned with the outside world and that the arts are focused on internal emotions—this is the structure that we need to get rid off.

What we can see in the arts, over the past 15 or 20 years, is

Armin Linke

Firefighters working in the peatland forest, Kecamatan Sungai Sembilan, Kota Dumai, Sumatra, Indonesia, 2016 © Armin Linke

Indonesia has drained many of its peatlands to grow oil palms and other crops, and has seen some of the most devastating peat fires over the past decade. Fires are extremely rare in non-degraded and non-drained peatland, but fires in drained peatlands can last for weeks, sometimes even months, burning right down into the thick layers of peat across large areas. Worldwide, peatlands store massive amounts of carbon in thick blankets of wet organic matter accumulated in the ground over centuries. Though they cover just three to five percent of Earth's land surface, peatlands store a quarter of all soil carbon; thus, the fires that go along with the transition to palm oil plantations constitute one of the world's worst environmental disasters of recent years.

the emergence of new documentary strategies designed to develop new articulations of the phenomena and transformation processes of the Anthropocene. What the arts can provide is an access point with which to experiences of the new world we are in, for new perspectives of seeing, hearing, tasting the world. We have to establish these new aesthetic strategies in order to develop new theoretical approaches. In every project, HKW, therefore, bypasses the classical separation between art and science to produce new kinds of practices in which aesthetics and cognition are intertwined.

Aloi: One of the striking aspects of recent art aiming to draw attention to anthropocenic subjects lies in its approach to, what might be called, a neo-sublime aesthetic of the Anthropocene. I am particularly interested in the desire to devise new poetics capable of envisioning the contextual urgency of the time we live in. My impression is that postmodernism's deliberate disregard and irreverence for pretty much anything have been somewhat reconfigured. In contrast to the "I don't care" of much 1990s art, the current preoccupation seems to lie with aesthetics of care—there's a renewed

sense of appreciation for depth and interconnectedness, materiality and history along with a refusal to engage viewers through shock tactics, or an even more demarcated rejection of classical beauty. Do you see a growing trend in the aesthetics of art addressing the Anthropocene?

Scherer: I agree. There is a new trend, which is deeply related to the anthropocenic perspective, around the concept of „Care", which conceptually is questionning the nature-culture divide and looking into our interrelatedness with animals, plants and object. In sharpening the senses for our embededness in the world it develops new forms of care taking. Related to this development, industrial materials too have become more frequent objects in the arts, and they reflect or articulate the situation we are in. With reference to the natural sublime, which we knew from art history, these aesthetics train the viewers to see the new materiality of our world where "pure" nature does not exist nor can it sublimate a nature which is imbued with human-made materials. In this sense they make us see the new world of the Anthropocene. It is a world in which humans are entangled with material process in various ways and where we have to develop new ways to take care of this entanglement.

In this context, I would like to refer to the work of Armin Linke with whom we developed the 'Anthropocene Observatory' and are part of an exhibit on the Anthropocene at the Triennale in Milano. The aesthetic properties of Armin's images of the Anthropocene, which are quite often concerned with anthropocenic infrastructures as well as landscapes, draw the view of the spectator into the image and then this view, by exploring the different aspects of the image, gets more and more out of balance. For example, one of his photos is dominated by an impressive water dam in China. And only after taking some time with the photo one discovers a few figures at the bottom of the dam. These are fishermen who used to catch fish from boats on the river. Now they can do this simply by hand because the fish are completely stunned by the pressure of the water. Both the fishermen and the fish appear completely lost in this artificial environment. The disorientation of the fish reflects an environment that is completely out of balance. It demonstrates how the anthropocenic infrastructures inscribe themselves into the bodies but also the psyche of animals and humans.

But I would also argue that artistic strategies are sometimes used to deal with anthropocenic ideas without identifying with the concept in a straightforward away. For example, "forensic architecture" currently uses aesthetic strategies to address human rights or environmental violations in areas where either no law is in place or it is misused by the state or other agencies. This is the case when human rights groups explore forms of Arsenic poisoning of landscapes as a modern form of ecological crime or they engage into research of water pollution because of mining practices which threaten the life of people.

All this research engages with the materiality of the Earth in order to uncover violence produced by human interventions into material processes. It is a violence against humans as well as nature. These aesthetic strategies are forms of knowledge production with a clear socio-political agenda. Their aim is to make the invisible visible in order to negotiate responsibilities in public. We encounter the challenge to make the invisible visible, especially in

All this research engages with the materiality of the Earth in order to uncover violence produced by human interventions into material processes. It is a violence against humans as well as nature. These aesthetic strategies are forms of knowledge production with a clear socio-political agenda.

149

anthropocenic violations because these are quite often long-term developments which are mediated by different material processes and human actions.

Aloi: Do you also see recurring aesthetic approaches in the current moment? I am thinking more specifically about materiality and certain aesthetics...

Scherer: What would you say these are?

Aloi: I have noticed a tendency to appropriate the materiality and aesthetics of capitalistic production. I am referring to a specific brand of minimalist-capitalist aesthetic that flaunts steel and plastic, as well as computer circuitry and screens as signifiers of our power over nature. The overall result of these aesthetics seems to revolve around alienation—they capture a disconnect that in a sense is less implicated in the concept of the Anthropocene than it might initially seem.

Scherer: You are hinting at what I would call "aesthetic forms of mimicry". These are works that mirror the surface phenomena of the technological world. With reference to the screens of computers and smartphones, one could say that they are exploiting an aesthetic of flatness. It is an aesthetic of flatness which is exactly not interested in exploring the logics behind the screen and in making the invisible visible. It is an affirmation of what we are supposed to see and not an uncovering of the deeper structures of our new technological worlds. They are symptoms of the alienation we are confronted with, not works which reflect upon the alienation.

Aloi: What roles do inclusivity and audience engagement play in the current curatorial direction taken by HKW? I am thinking of both, your ability to focus on a range of diverse subjects, but also the ability to get across to audiences in Berlin and in Europe more in general.

All this research engages with the materiality of the Earth in order to uncover violence produced by human interventions into material processes. It is a violence against humans as well as nature. These aesthetic strategies are forms of knowledge production with a clear socio-political agenda.

Scherer: On the curatorial level, we are interested in exploring specific social and political instances which lead us to collaborate with a variety of people and institutions across the world. On the programming level, we have different strategies for engagement. We actively strive to include communities and groups that are not directly involved with the academic world in order to develop ideas about agency and non-objectification in the capitalist system. We actively work with different social groups in the city. For example, we are currently collaborating with Fehras Publishing Practices, a group of Syrian social practitioners who started their work on important libraries in Damascus. The work reflected the intellectual crossroads of the Arab World, focusing on translation and the impact the English language has had on the Arabic language. Another group is Eoto, which engages in work with black communities in Berlin and Germany. And finally, we are working together with groups like Tactical Technology Collective who explore strategies at the interface between technology, politics, and society in order to activate knowledge and technics vis a vis new technological developments.

In Berlin, we have hundreds of different groups of people and cultures who constantly explore new perspectives on the current state of affairs. Thereafter, our collaborative work becomes part of a dialogue with other communities in the city. So, we aim

Armin Linke

Palm oil plantation on the way from Kecamatan Batahan to Kabupaten Rokan Hilir, Sumatra, Indonesia, 2016 © Armin Linke

Ecological activists are deploying a drone over controlled field burning of the forests in Sumatra to produce evidence. The forest is set-alight to expand palm oil plantations. The rapid destruction of massive areas of rainforest by largely illegal forest fires is resulting in the elimination of habitats of endangered species and the release of vast amounts of greenhouse gases.

to develop projects that different sections of the city's society can become involved in directly.

Our exhibitions are designed to invite the viewer to explore new perspectives relating developments in the arts to cultural and political processes. We expect a level of engagement and participation; the development of a kind of agency to shape one's own narrative. Our exhibitions deliberately resist easy answers. I consider the HKW as a counter-project to the consumer attitude which is taking over all parts of society including culture. Audiences are no longer challenged to engage, but they now expect to go through an exhibition in no more than half an hour. I think that there is a need for institutions to question this approach by proposing different modes of engagement. We need institutions that provide more than affirmative attitudes to the transformations which we encounter. There is a need to question the underlying worldviews that enable these very trasnformations. In this sense, I also would define the HKW as a forum in which the politics of the ongoing transformations of our societies are discussed.

Aloi: I couldn't agree more—since the very first issue of *Antennae* I rejected the notion of providing separate PDFs of the individual papers we publish because of I believe that there is a pedagogical value in slowing down and digest a sequence of texts over some time. I did not want to comply with the current academic trend which sug-

gests that we should grab and go from an electronic archive without engaging with the casual encounters that a journal format provides. But how sustainable is this approach in relation to a museum?

Scherer: It is challenging, but at the moment especially in the context of Berlin, we see substantial appreciation for this type of political position. I would say that our main audience is university students and in a city like this, you have almost 150,000 to 200,000 students. And beyond university students, there are more people who do not just want to consume, but try to make sense of their life and want to engage in meaningful interactions with others. So that's a good place to be. We don't provide answers to the world we live in, but we actively engage the thinking of our audiences which is rather empowering to them.

Aloi: In 2014, the *Anthropocene Observatory* exhibition at HKW aimed at questioning the implications of the thesis of the Anthropocene. I am impressed by the amount of discussion and attention that the introduction of this term has generated, but I sometimes worry that us, scholars, might lose ourselves in counterproductive politics and tactics. I am specifically referring to recent controversies revolving around the naming of the 'Anthropocene'. From Donna Haraway's Chthulucene to Jussi Parikka's 'Anthrobscene', scholars have contested the 'Anthropocene label' right at the time when the term has begun to gain traction on newspapers and magazines around the world. While scholarly discussion is always welcome, I am somewhat concerned that we might be too swiftly, and too easily, fragmenting the cultural scene with little regard to what audiences beyond academia might think. Ultimately, it seems that addressing climate change and environmental degradation, along with all the sociopolitical issues that generated them, demand the engagement of large numbers of people. What is your take on the use of the term Anthropocene?

Scherer: Yes, this is still a very controversial term. But in Germany, the intellectual world seems to have embraced the term quite unanimously. Last year, in August, even our chancellor gave a speech on the Anthropocene—this was unprecedented, but also very important in assessing the term's validity. And yes, I agree that in the fashionable academic artworld, there is a desire to constantly come up with new buzzwords to attract attention. We focused on the Anthropocene from the very early days and developed projects around it in a very visible way in order to build a shared vocabulary. The basic idea of the Anthropocene is addressing a deep crisis and a burning issue. The dominant model of humans exploitation of the globe creates imbalances in the Earth system. These transformations threaten the survival of many species including humans. These observations have a lot of implications we try to explore, starting from asking who the historical agents in this process are, up to what strategies are driving it, what categorical changes are taking place and what can be done to renegotiate agency. I think that the number of people finding this term useful and stimulating is growing despite the controversies around it. In fact, we have quite a few projects lined up for 2020 and 2021 at HKW in which the term Anthropocene will return to play a central role in our programming.

Aloi: I am personally concerned with an ethical sense of respon-

sibility in this case. It is visible that academic presses reward the coining of new and catchy idioms. Ideas are being packaged in neat books where a new term encapsulates, most often too many ideas. I am concerned that we are experiencing a commercialization of academic knowledge, similar to what you have described earlier in relation to exhibitions, and I am afraid that this race to the trendiest idiom can be seriously counterproductive, especially in relation to non-academic audiences who need a new and shared language to discuss topics involving art and science like the Anthropocene. I think that quibbling too much over the legitimacy of a term, which is by the way geological in essence and not coined by the humanities upon cultural grounds bears some ethical implications us scholars should reflect upon. Do we want to communicate to the non-academic work or are we constantly isolated in ivory towers talking to ourselves? I equally find highly problmeatic the current use of entirely made up labels like "plantocene" or "plantationcene" which are simply symptomatic manifestations of how scholars tend to take the real importance of terminology today. Not everything should become a hashtag.

When I think about the term Anthropocene, what I really care about is its ability to mobilize; the uses that this concept can have as a tool. That's a pragmatic attitude, but that's what really matters. The term's ability to cross the boundaries of the sciences and the humanities and to establish multidisciplinary communication and discussion is what we should really focus on.

Scherer: Yes, you're right. When we started our project, I was fascinated by the fact that the term originated from natural sciences, from research and observation. Yet, the natural sciences could have never anticipated that it would have been so well co-opted by the humanities and the arts to become part of a broader political and social project. When I think about the term Anthropocene, what I really care about is its ability to mobilize; the uses that this concept can have as a tool. That's a pragmatic attitude, but that's what really matters. The term's ability to cross the boundaries of the sciences and the humanities and to establish multidisciplinary communication and discussion is what we should really focus on. That's what makes it so powerful. It becomes an effective access-point to a complex framework, and it is capable of changing sedimented perspectives. It is charged with agency, and we need this agency to address the crisis I described earlier.

Aloi: Which recent texts and authors have informed the philosophical outlook of KHW?

Scherer: There are quite a few! Ana Tsing's work has been pretty influential to my own work. And even if she has been skeptical about the term Anthropocene, Donna Haraway is another very important reference point in what we do. Her concept of "situated knowledge" has been very important for us. Dipesh Chakrabarty's work has also been very important to us because of the postcolonial discourse and its entanglements with the Anthropocene. Of course, the Anthropocene Working Group, Jan Zalasiewicz, Colin Waters, and Marin J. Head have also been an influence. Bruno Latour... of course. And James Scott's latest book *Against the Grain: A Deep History of the Earliest States*. Scott's book provides a very interesting take on re-reading pre-history. And of course, Eyal Weizman's *Forensic Architecture at the Threshold of Detectability*, in which the author theorizes a practice devised to understand the situation we are in. This is an approach that has also characterized what we do here, at HKW, in that we do not produce knowledge out of theories but out of practices like developing exhibitions or through other forms

of cultural engagement. This relation between theoretical reflection and practices is a very important one for us.

Aloi: Where will HKW be in five years?

Scherer: It's a good question... we have a curatorial workshop coming up in two days and I am just now preparing HKW's mission for that. HKW has pursued three lines of inquiry over the past eight years. One is the Anthropocenic discourse with all its implications involving the revisioning of the scientific framework through which knowledge is produced. But we also developed a number of projects around the question of the Western artistic canon in the visual arts. And simultaneously we have also explored the implication of sound/music production in relation to the current economic and technological infrastructures. That means that we are in the process of reflecting on the larger conceptual frameworks of cultural production in the 20th century, academic disciplines, canons, and infrastructures in order to question if they are still relevant and in which way we have to build up new frameworks. We will continue to develop these lines of inquiry over the next three to four years. At the end of this process, we will pause to reflect on what has been accomplished and how discourses have changed since the beginning of our journey. Then, I think, we will be ready to question our processes again, most likely to craft new ones.

Dr. Bernd Scherer has been Director of the Haus der Kulturen der Welt (HKW), Berlin, since 2006 and has held an honorary professorship at the Institute for European Ethnology at the Humboldt University of Berlin since 2011. His central areas of work lie in philosophy, semiotics, aesthetics and intercultural questions. He has initiated and headed a series of international cultural projects, including *Über Lebenskunst* (2010–2011), an initiative project of the German Federal Cultural Foundation in cooperation with HKW.

Since 2012, Scherer has headed *The Anthropocene Project* and, since 2014, the project *100 Years of Now*, both at HKW. He is curating the *Dictionary of Now* as part of the latter project. Parallel to this, he is overseeing the conceptual development of HKW's third large-scale project, *The New Alphabet*. In his tenure at HKW, Scherer has guided its conceptual development from an institution that presented non-European cultures into one dedicated to the "curating of ideas in the making," in a world that is changing not only globally, but also in planetary terms. Publications: coeditor together with Katrin Klingan, Ashkan Sepahvand, Christoph Rosol of : *Textures of the Anthropocene. Grain Vapor Ray*. MIT Press 2014; co-editor of *Das Anthropozän. Zum Stand der Dinge*. Berlin 2015; editor of the series: *Bibliothek 100 Jahre Gegenwart*. Berlin 2016-2019.

Embodied Objects

Laura Splan's Embodied Objects *series uses biosensors to produce data-driven forms and patterns for objects and images. The series includes digitally fabricated sculptures, weavings and works on paper created using electromyography (EMG) data from Splan's own body. The project examines the potential for objects to embody human experience and to materialize the intangible. The narrative implications of process and form are mined for their potential to explore how technology, data, and cultural artifacts mediate our understanding of the human body.* Embodied Objects *was recently presented in Splan's solo exhibition at Occurrence (Montréal, QC).*

text and images by **Laura Splan**

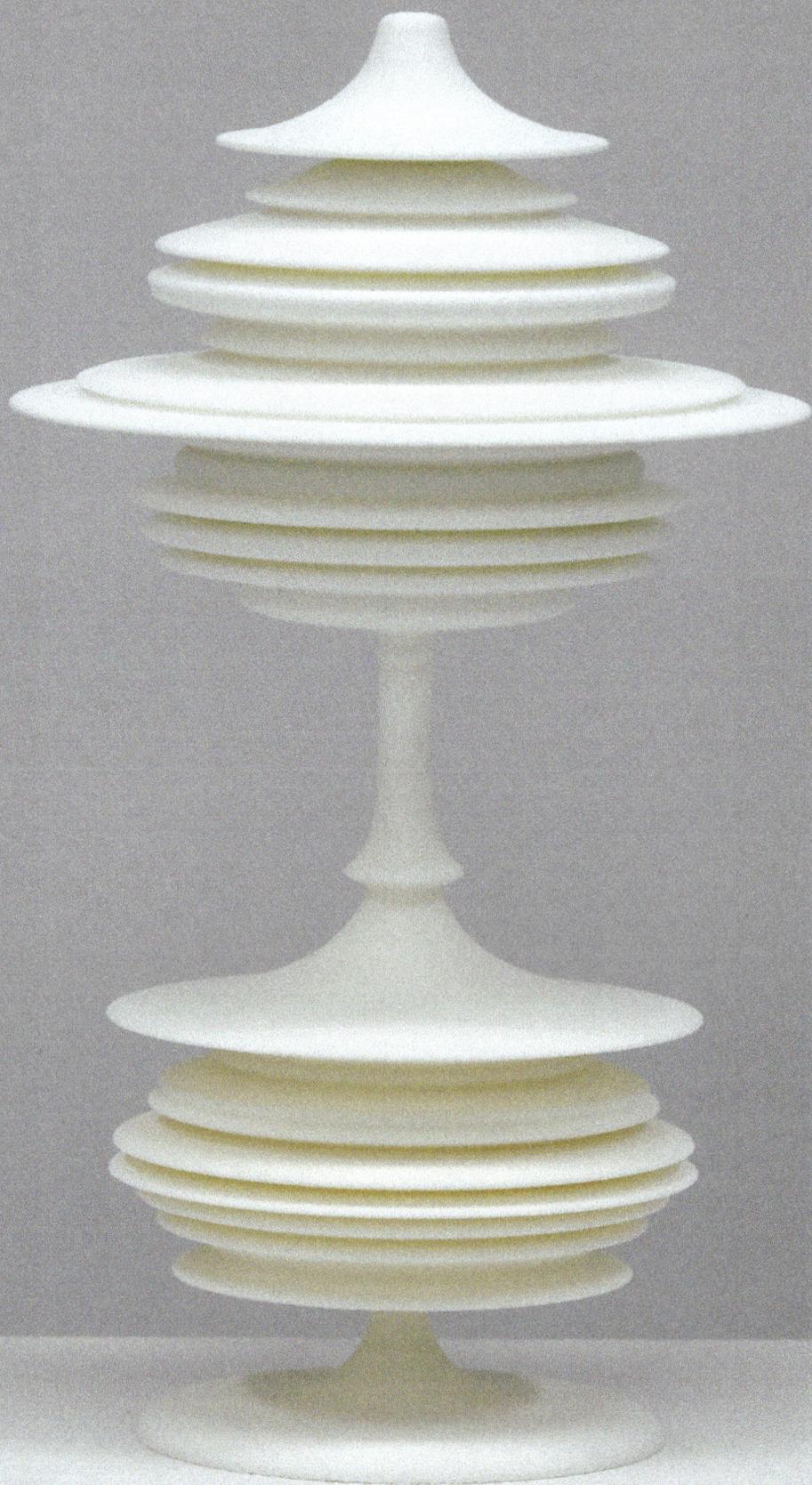

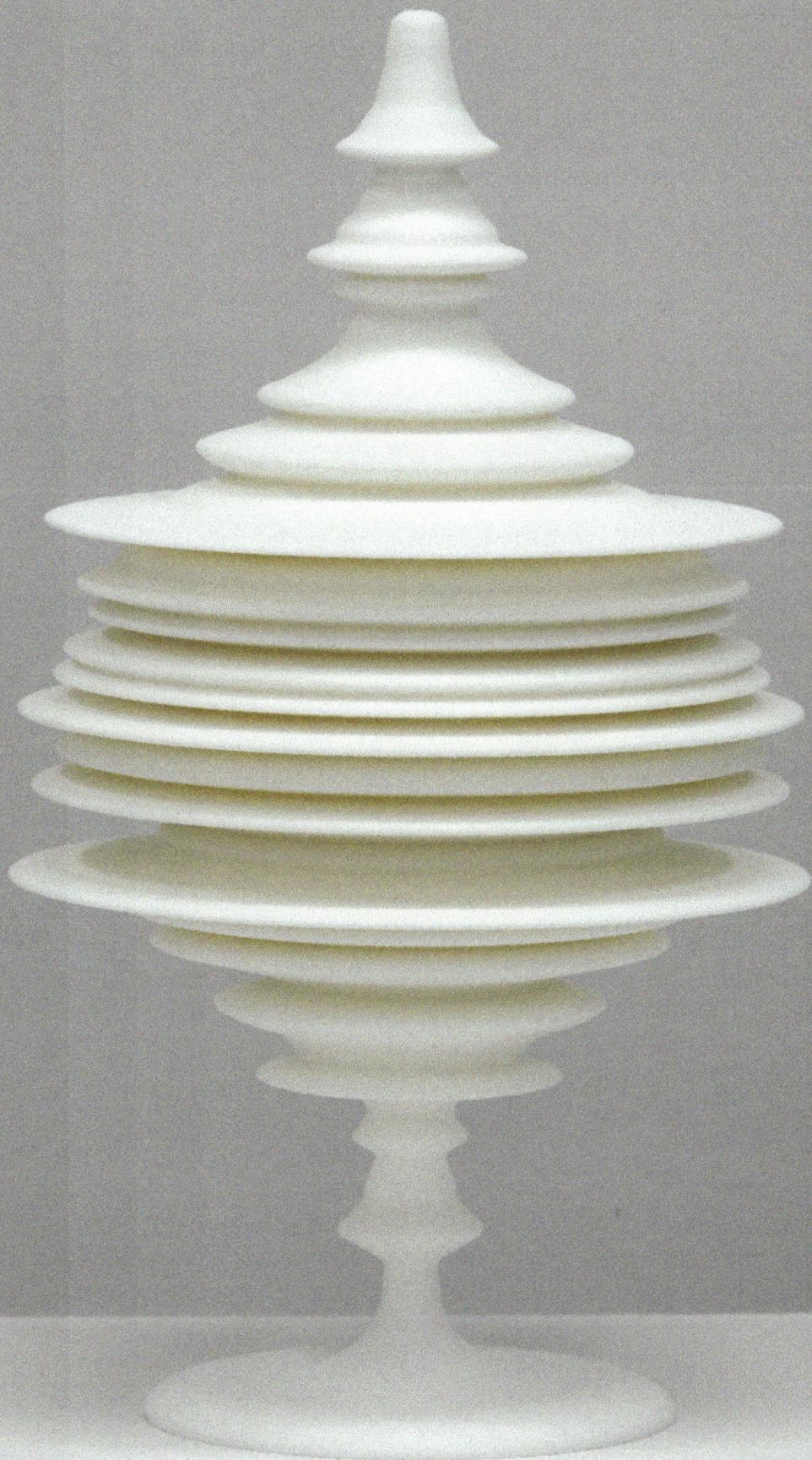

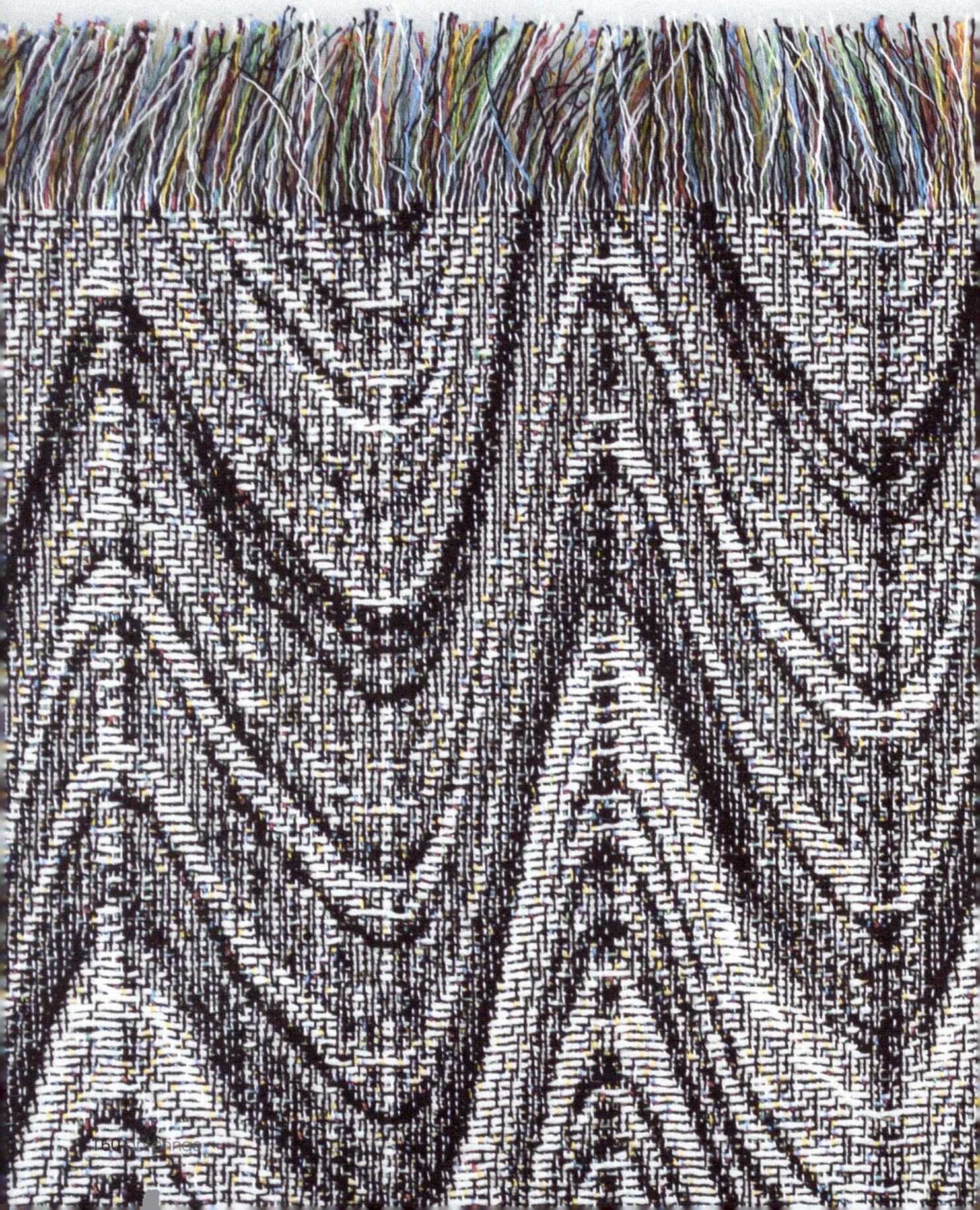

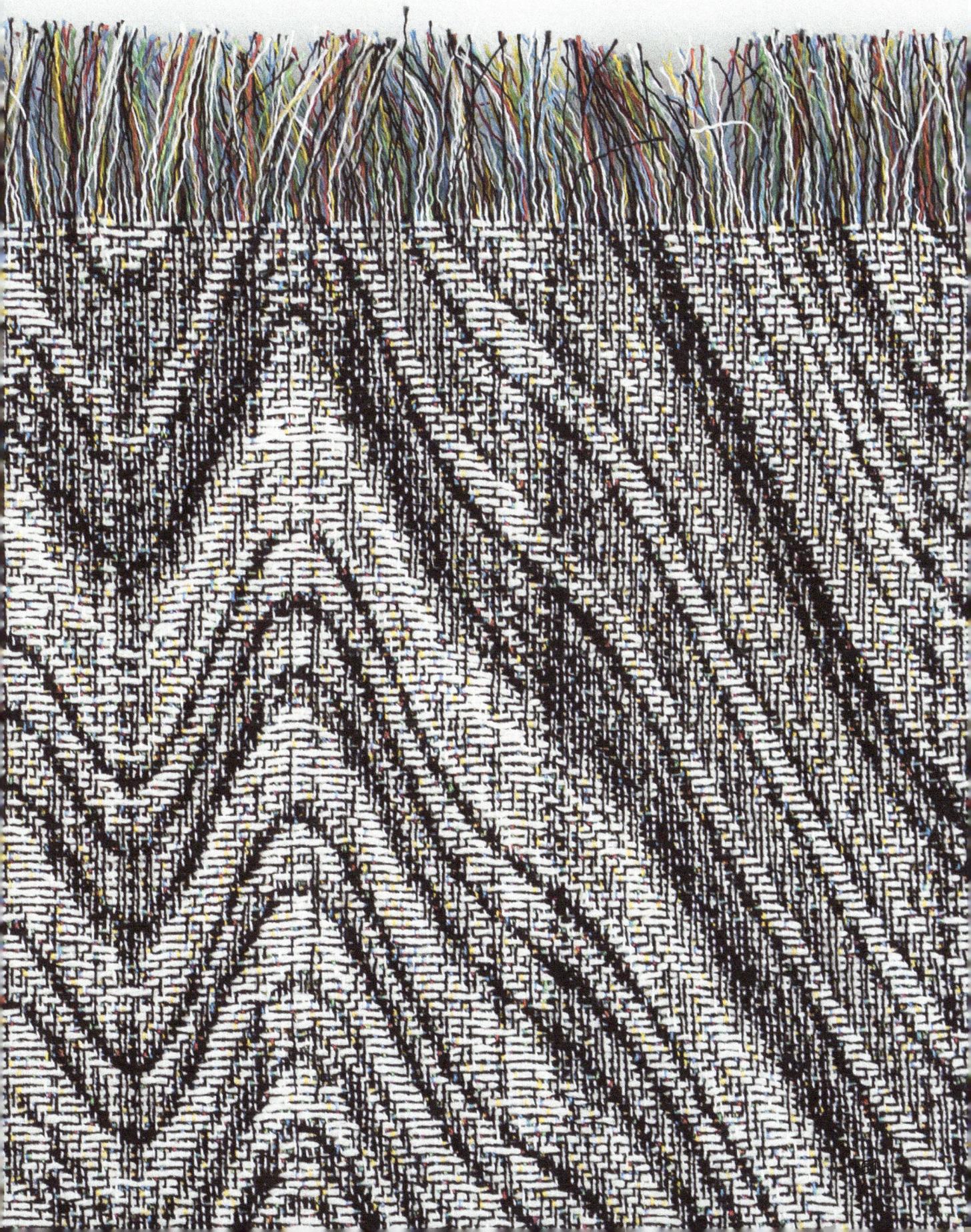

Laura Splan's *Embodied Objects* uses biosensors to produce data-driven forms and patterns for objects and images. The series includes digitally fabricated sculptures, weavings, and works on paper created using electromyography (EMG) data from Splan's own body.

Manifest is a series of sculptures based on EMG readings that measured fluctuating levels of electricity in facial muscles. Neuromuscular activities associated with experiences of wonder were performed as facial expressions and bodily movements (i.e. smiling in delight, blinking twice in disbelief). Each activity produced unique data that was translated into a curve using custom software written by the artist. Each curve served as a profile for a different 3D printed sculpture. EMG data was also used to generate the frenetic imagery in the *Embodied Objects* weavings and *Recursive Expressions* prints. The imagery was generated by software programmed to repeat, rotate, and randomly colorize the waveforms in order to create "woven" patterns for computerized Jacquard tapestries and archival pigment prints. The computer-generated patterns "weave" the waveforms together in both directions—*warp and weft.* While the overall image of the print has a geometric, unified, and even tidy form, upon close inspection one can see that the chaotic structure of each end of each waveform has been altered "by hand". Using a stylus pen, the beginning and end of each vector line were teased out and reshaped by the artist to create thread-like details along the edge of the image.

As a whole, the project examines the potential for objects to embody human experience and to materialize the intangible. The narrative implications of process and form are mined for their potential to explore how technology, data, and cultural artifacts mediate our understanding of the human body. The title, Manifest playfully refers to an examination of the mutable meaning of the forms themselves. *Manifest*, is a nuanced word that offers a variety of interpretations. As an adjective, it refers to the way the sculptures render obvious the unique neurophysiological phenomenon of each performed movement (i.e. blinking, smiling). As a verb, it refers to the emotional significance that performed movements communicate (i.e. surprise, happiness). As a noun, it objectifies the body as a vessel whose contents are cataloged in detail. Splan's process draws inspiration from Charles Darwin's facial feedback hypothesis in which he posited, "Even the simulation of an emotion tends to arouse it in our minds." His theory published in *The Expression of the Emotions in Man and Animals* in 1872 suggests that physiological changes caused by an emotion not only express that emotion but also enhance it: we can manifest feelings by performing their expression. The series of digitally fabricated Jacquard weavings draws from the shared histories of computers and textiles in considering Babbage's analytical engine, which was based on Jacquard's loom technology. Splan's work often implicates the viewer in the narrative meaning of her work. Her *Recursive Expressions* series invites close inspection and perhaps even a squinting gesture in an attempt to bring into focus its intricate detail. The viewer is compelled to perform the very gesture used to produce the image itself creating an experience where understanding and embodiment are intertwined.

Laura Splan

p. 151: *Manifest,* installation view, laser sintered polyamide nylon, 2015 © Laura Splan

p.152-153: *Manifest (Blink Twice),* laser sintered polyamide nylon, 2015 and *Manifest (Smile)* laser sintered polyamide nylon, 2015 © Laura Splan

p.154-155: *Embodied Objects (Undo),* computerized Jacquard loom woven cotton, 2016 © Laura Splan

p.156-157: *Embodied Objects (Undo),* detail, computerized Jacquard loom woven cotton, 2016 © Laura Splan

Right: *Recursive Expressions (Squint #1),* detail, archival pigment print on hot press cotton rag, 2016 © Laura Splan

p.160-161: *Recursive Expressions (Squint #1 and #2),* 2016/17, archival pigment print on hot press cotton rag © Laura Splan

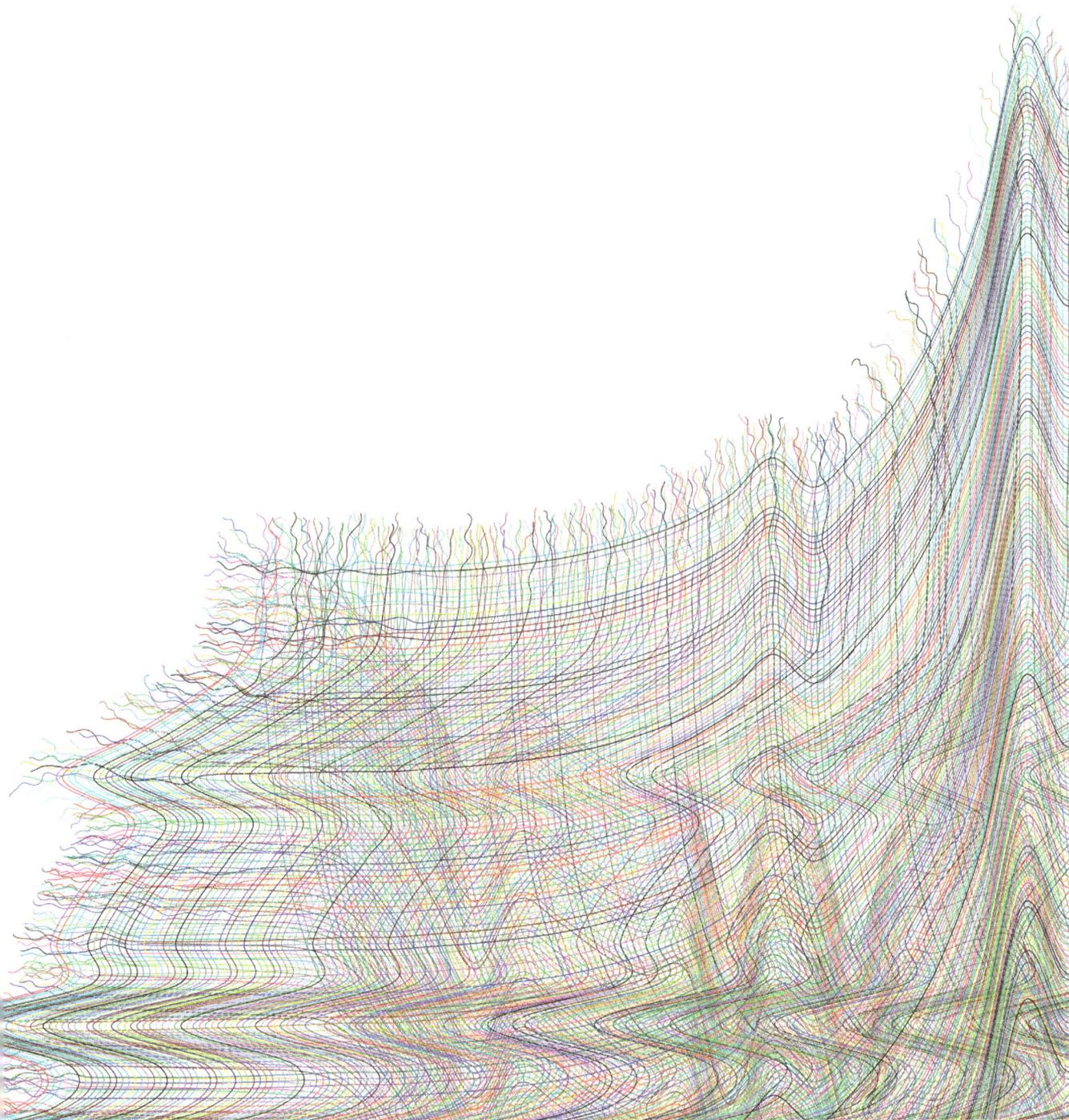

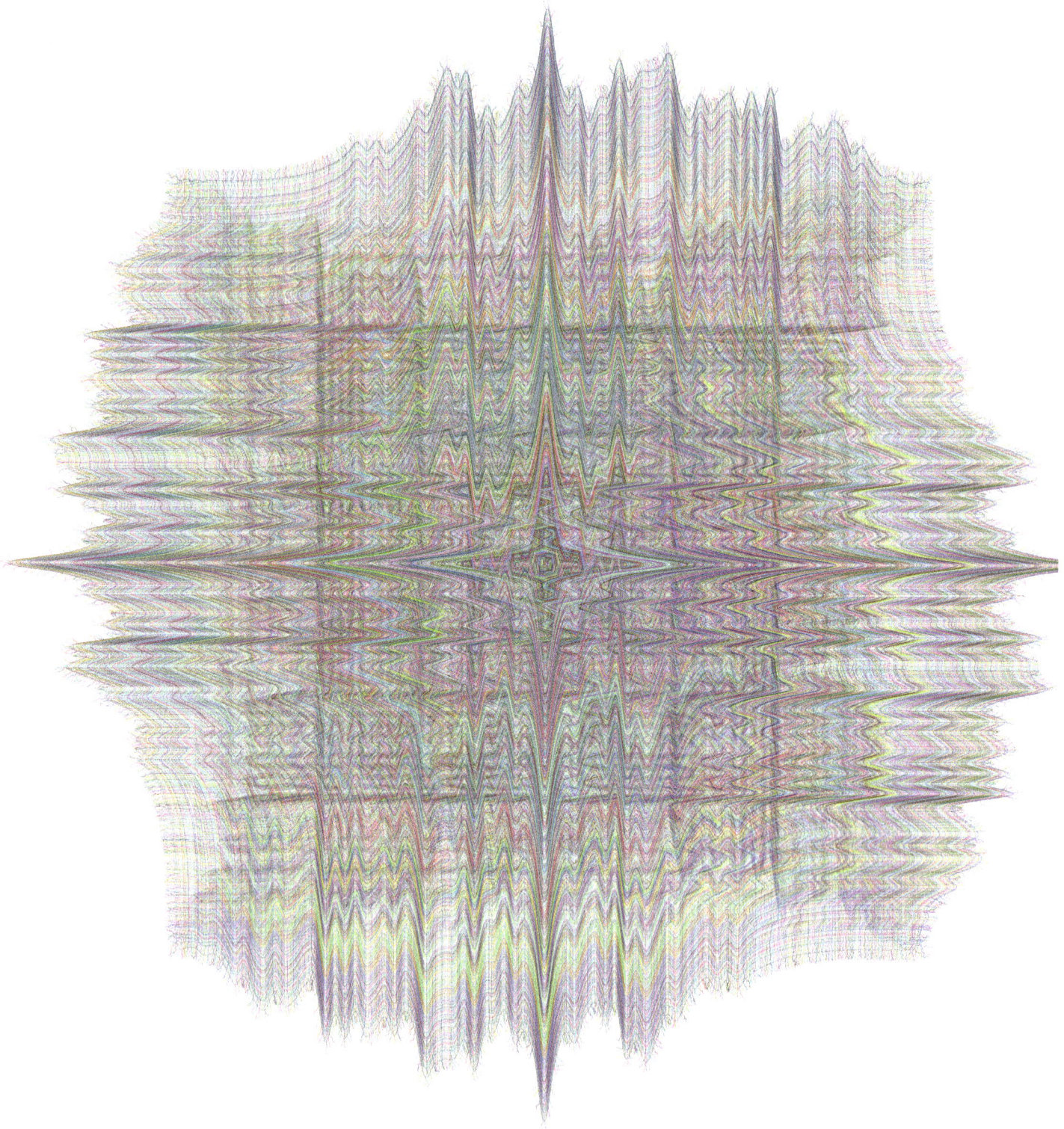

Laura Splan's work explores intersections of art, science, and technology. Her conceptually based projects examine the material manifestations of our mutable relationship with the human creative production and question notions of agency and chance in aesthetics. Splan's interdisciplinary work has been exhibited at venues including the Museum of Arts & Design and Beall Cen Foundation. She is currently a Fellow in AS220's Digital Arts Program supported by the National Endowment for the Arts. The Esther Klein Gallery will host a solo exhibition of her work in Fall 2

eptions and representations of the corporeal with a range of traditional and new media techniques. Her frequent combinations of textiles with technology challenge values of "the hand" in

r work is in the collections of the Thoma Foundation and NYU's Langone Art Collection. Her research and residencies have been supported by the Jerome Foundation and the Pollock-Krasner

Let Yourself Be a Mirror

The film *Do we feel with our brain and think with our heart?* is a performative interview between visual/theatre artist Jan Fabre and neurophysiologist Giacomo Rizzolatti, who discovered the mirror neurons. It is explored as an image of consilience between art and neurophysiology by the metaphor of a landscape theatre of the brain, based on the performer-spectator relationship approached through the mirror as agent of imitation and empathy (as in mirror neurons), of symmetry, repetition and imagination (as in Fabre's art) and of intersubjectivity (as in Merleau-Ponty's philosophy). As consilience results from transformation through the mirror of the other, Fabre takes from Rizzolatti a model for his theatre and Rizzolatti takes from Fabre an image for brain function

text by **Sylvia Solakidi**

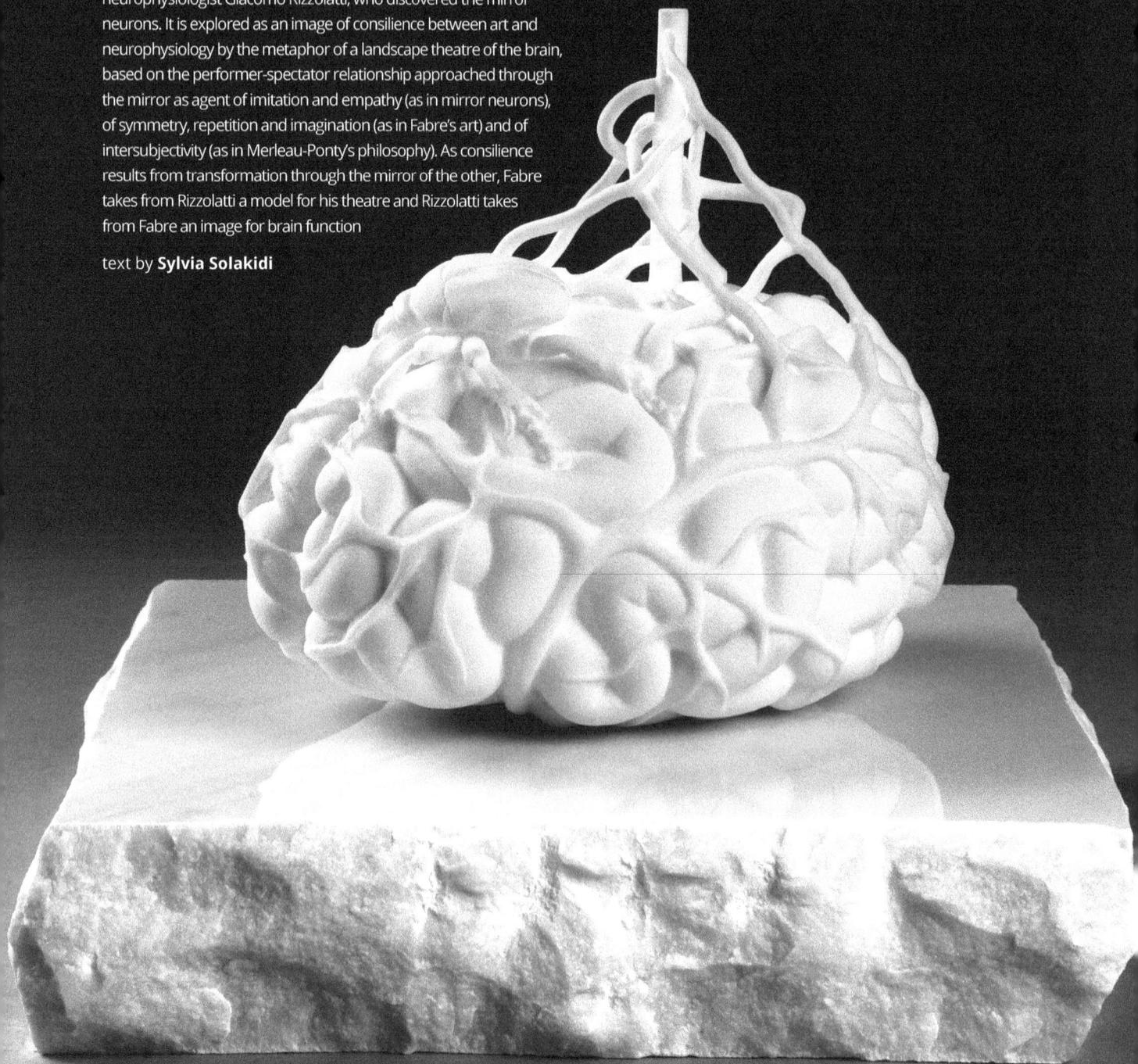

Jan Fabre
The Artist's Brain measuring his own Mirror Neurons, marble 17.8 X 18.6 X 14.8 cm – base 6 X 27 X 27 cm, 2014, photographer: Pat Verbruggen © Angelos/Jan Fabre bvba

A man with white hair[1], wearing glasses, a dark blue suit, a white shirt, an orange tie, having an electrode like an antenna on his head and sitting on a high rolling chair, takes a peanut from the table in front of him and feeds a second man, with white hair, wearing glasses, the same dark blue suit, the same white shirt, the same orange tie, who has an identical electrode on his head and sits on an identical high rolling chair opposite him at the same side of the table. This second man eats and takes a fruit from the table, cuts a piece and offers it to the first man; the first man eats it greedy.

The background is gradually lit and an amphitheatric lecture hall emerges. The first man remains seated at the table where fruits and peanuts are placed instead of a lecturer's papers, and looks towards the seating rows. The second man jumps over the rows of the empty lecture hall, takes the seat at the table and observes the first man jumping over the seats and the rows of the empty lecture hall.

Both men are sitting at the table opposite each other. The second man asks: 'Is the brain a beautiful object?'; 'Are we ever going to feel our own neurons?'; 'Is failure to imitate the beginning of something original?' 'No'; 'No'; 'No', replies the first man.
No?

Mirror neurons measured – mirror neurons dancing

The lecture hall is in the Sector of Human Physiology of the Faculty of Medicine at the University of Parma, where the first man, Professor Emeritus of Human Physiology, Giacomo Rizzolatti teaches. This is where the second man, Belgian visual artist, theatre director and choreographer Jan Fabre, visited him on November 29, 2012 and their conversation in the lecture hall was filmed. By May 22, 2013, Fabre completed editing a 15-minute HD film piece entitled *Do we feel with our brain and think with our heart?* (Fabre, 'Stigmata' 610, 614).

Giacomo Rizzolatti and his research team discovered in monkeys (1992) and in humans (1996) (Rizzolatti and Gnoli 94), a subset of motor neurons which are activated both when a specific action is performed and when someone is observed performing it (89). The same neurons are activated both when someone is in pain and when someone is observed feeling pain (Ramachandran). As a result, the pain of the other is felt as if its cause had been applied to the body of the observer. In both cases, this subset of motor neurons demonstrating a relationship between vision and action-movement are named 'mirror neurons'. These groundbreaking findings have been regarded as the physiological background of imitation, a cognitive ability potentially related to learning, and empathy, the emotional state of feeling what the others feel (Rizzolatti and Gnoli 108). Since imitation and empathy are fundamental elements of communication and sociality, mirror neurons have been regarded as the physiological background of human culture (107).

When Jan Fabre had to undergo a brain CT scan because of a neurological problem, he was fascinated by the images of the brain (Chardon). Since then, he has made drawings and sculptures in Carrara marble or in silicone bearing the form of the human brain. His first works were *The Brains of my Mother and my Father* (2006) (Fabre, 'Ma Nation' 49). In subsequent pieces, the gyri (ridges) and sulci (grooves) and the symmetrical organization of the brain in hemispheres, were combined with symbols of mortality and sexuality. While Rizzolatti is interested in the physiological mechanisms of brain function, Fabre approaches the brain as a terra incognita

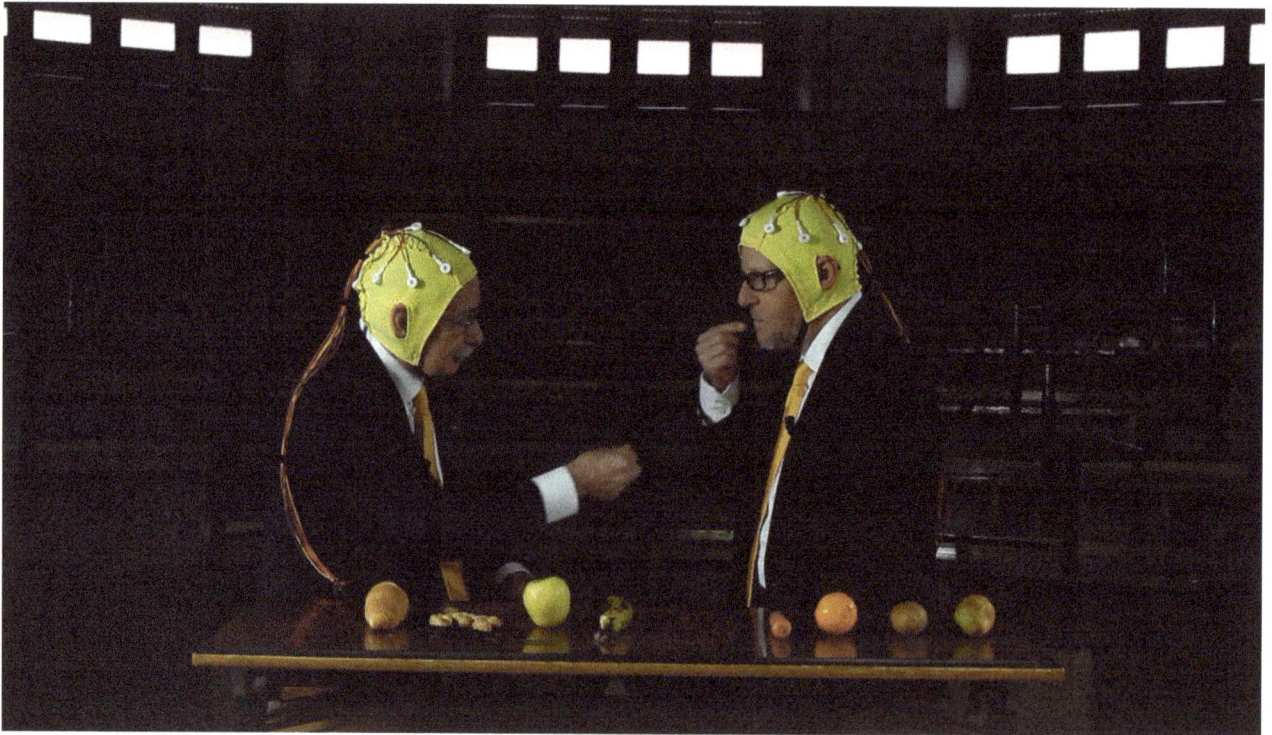

Jan Fabre

Do we feel with our Brain and think with our Heart?, HD film 14´09", 2013 © Angelos/Jan Fabre bvba

within his own body, as the physical counterpart of the mind which governs imagination (Angelos website). The brain is a part of his ongoing research on the body and its potentiality, which is crucial for his solo performances as well as for his work in theatre and dance and for the development of his 'guidelines' for performers, entitled 'From Act to Acting' (Cassiers et al). In 2009, Fabre was invited by Rizzolatti at a neurophysiology conference to talk about his work on repetition (Chardon), which is the fundamental dimension of his theatricality, and they have made other public discussions on their views on creativity, beauty, instinct and imagination ever since (Alfieri). Fabre's exhibition *Pietàs*, organized as a parallel event of the Venice Biennial in 2011, was inspired by his relationship with Rizzolatti (Fabre, 'Ma Nation' 23). Works inspired by their ongoing collaboration, and particularly by their 2012 conversation transformed into the film piece of 2013, are dedicated to Rizzolatti and have been presented in exhibitions at various venues under the titles *Do we feel with our brain and think with our heart?* (Fabre 'Do we feel') and *My only nation is imagination* (Fabre 'Ma Nation').

The conversation with Rizzolatti had the structure of an interview, with Fabre asking all the questions. The discursive element, though, was not the only aspect of this interview. The neurophysiologist and the artist, dressed alike, mirrored each other's movements in the lecture hall, as they fed each other. They also attempted to develop a special kind of empathy, not only with each other through imitation and discussion, but also with the laboratory animals, the monkeys with which Rizzolatti conducts his experiments. Thus, they wore electrodes and they used props (fruits,

peanuts etc). As they renounced their status of sovereign humans, they became their own laboratory animals, they acted like monkeys in men suits, and were ready to experiment with their own selves.

Thanks to this attempt for imitation and empathy not only with each other, but also with the laboratory animals, the atmosphere of the interview became playful, although very serious scientific issues were addressed. The answers offered by the neurophysiologist were reworked by Fabre in inventive ways, like the three suggestions regarding the brain as an object, the ability to feel one's own neurons and failure as a prerequisite for originality. The neurophysiologist may have answered 'no', but speech was not the only way to reply to questions. Indeed, the playful atmosphere of the interview was reprised during the editing of the footage. Thanks to editing, some questions by Fabre were answered by movement in the lecture hall or by scenes showing Rizzolatti and Fabre feeding each other. Therefore, this interview was not just a tool for gathering information, but it enacted its topic, namely imitation and empathy.

Enactment of imitation and empathy between humans and between humans and laboratory animals, results in an interdisciplinary relationship between neurophysiology and art, regarding the particular topic of experimentation, the brain, so that the two disciplines may negotiate the status of the ethnographic 'other' they hold against each other. The interview becomes 'simultaneously a site for conversation and a communicative format', 'a vehicle producing performance texts' of imitation and empathy, as it happens with the reflexive or performative interview exploring identities of the self and other in the ethnographic context (Denzin 24, 27). As a result, it functions as a hybrid piece of interview and performance. Like the ethnographic performative interview, it acts as 'a simulacrum, a perfectly coherent world of its own right', and 'it stands in an interpretive relationship to the world it creates' (25, 30). Since the conversation does not take place in front of a live audience but is conducted exclusively to be recorded, the edited film is the medium of the performative interview, with decoupage and montage being the tools that interrelate questions, answers, speech, movement and the use of props. Thus, the performative interview becomes an ideal format for the 'production of knowledge for the cinematic society' (27), which is characterized by mediated knowledge.

The production of knowledge in performative ways is a recurrent practice in Fabre's work. For example, the sculptures of brains that he creates in silicone by adding other materials, are referred to as 'thinking models', which for Fabre correspond to 'works of 'collage and bricolage' ('Journal II' 34). Such works are constructed manually by selecting from a diverse range of available materials. For Fabre, 'thinking is not the execution of a spiritual dance', but a 'street fight' (62). Since doing is not opposed to thinking, both activities coincide in the structure of the thinking model. This object aims to perform thinking as doing and doing as thinking. Diversity of doing and thinking is not denied, but the subversive effect of the thinking model lies in overcoming the thinking-doing duality.

Fabre's vivid interest in entomology and animals, reflected in incorporation of jewel beetles in his art pieces, and in the fact that a number of exercises he proposes for the training of performers are inspired by animals like cat, tiger, lizard or insect (Cassiers et al), has led him to conduct analogous performative interviews in the past. He concluded his residency in the Natural History Museum in

London with the filmed performance *A consilience* (2000), in which scientists were dressed like the animals they research (Fabre, 'Stigmata' 518-525), in another attempt to help them empathize with the object of their studies. He also conducted a performative interview with Edward O. Wilson in 2007, entitled *Is the brain the sexiest part of the body?* (Fabre, 'Stigmata' 571-581), in which the corporeal aspect of the brain and its role as a site for imagination were stressed.

Wilson is the entomologist who elaborated on the largely forgotten term 'consilience', in his 1998 book with the same title. The term was introduced by Whewell in 1840 (Wilson 8-9), as a way of achieving the unity of knowledge by transferring knowledge from one discipline to another, without privileging any of them. Although the examples discussed in the book come mainly from science, Fabre has collaborated with Wilson and has developed this idea into a paradigm for his work that is usually characterized by critics as either multidisciplinary or interdisciplinary. Consilience overcomes the problem of simply adding knowledge from different disciplines, implied in the term 'multidisciplinarity' and specifies the interactions taking place in an interdisciplinary project, while Fabre's practical engagement with the concept offers a paradigm for carrying out research engaged with multiple disciplines. The performative interviews are particularly interesting because consilience is enacted by two researchers, a scientist and an artist, who choose to experiment through their interaction as embodied subjects.

The aim of this text is to explore the interaction between neurophysiology and art in the performative interview between Fabre and Rizzolatti, as a paradigm for consilience, by following the way stories about measurements of mirror neurons, provided by Rizzolatti, are being transformed by Fabre, whose mirror neurons 'are floating and dancing', as he writes in his diary in the night after the performative interview with Rizzolatti (Fabre, 'Stigmata' 610). As it is the case with the performative interview, this writing piece proceeds through the elaboration of the mirror both as a concept and as a method. As a result, it demonstrates the role that imitation and empathy (which are the scientific meaning of the mirror in the name of mirror neurons) have in consilience, by employing different points of view, like mirrors reflecting them. The mirror is a storied concept with rich symbolism involving duplication, representation, and introspection. The mirror has also been an important tool in the history of painting. In this writing piece, the mirror is approached as a methodology of creating and recreating images and transforming imitation and empathy into an image of consilience. This image results from multiple scatters on the following four mirrors:

The three suggestions by Fabre that Rizzolatti seems to deny, namely the brain as a beautiful object, the ability to feel one's own neurons and failure as a condition for originality, function as the first mirror scattering the research question of consilience. Works of visual art that Fabre created after the interview with Rizzolatti, as well as his theatre pieces on imitation, entitled *The Emperor of Loss* (final version 2003) and *The King of Plagiarism* (final version 2005), function as the second methodological mirror. The titles of exhibitions of works of visual art inspired by and dedicated to Rizzolatti, function as the third mirror. Both titles, *Do we feel with our brain and think with our heart?* and *My only nation is imagination*, focus on the role of the brain in pre-reflective activity and its role

The relationship between seeing and seen points out to the participation of the body and the world in the flesh of the world, instead of relating as a container and a contained object.

as a site for imagination and feelings, rather than a site for reason. This pre-reflective activity is approached mainly through imagination as a force of creating images. The term 'reflection' points out to both mirroring and thinking, which stresses the fact that all creative forces of the brain, both discursive (questions and answers) and pre-discursive (movement and use of props) are at play in this performative, reflexive-reflective interview. The fourth mirror is the one present in the philosophy of the French phenomenologist Maurice Merleau-Ponty. Rizzolatti has been reading philosophy since his school years (Rizzolatti and Gnoli 23), which has had a direct influence on his ideas about the body-mind divide and the brain. Merleau-Ponty's ontology is even referenced in his research papers (Rizzolatti and Craighero 179).

Merleau-Ponty's ontology is based on the notion of being-in-the-world (Merleau-Ponty, 'Phenomenology' lxxvii), according to which the world solicits the embodied subject that responds through its affordances and solicits the world back (137-139). Since the embodied subject is situated in the world, its view is always perspectival. By pointing out that 'the body is a thing of the world' (Merleau-Ponty, 'Visible' 10) he reassesses all experiences and dualisms between body and world.

Being-in-the-world refers to a pre-reflective perspective on the world and is related to the notion of 'operative intentionality', which differs from the thetic, conscious intentionality of the 'I think' and is the pre-thetic intentionality of the 'I can' (Merleau-Ponty, 'Phenomenology' 453). For Merleau-Ponty, perception is the pre-reflective way of being-in-the-world and it is already an expression, since 'all action... every human use of the body is already primordial expression' (Merleau-Ponty, 'Eye' 104). The primacy of the role of expression in Merleau-Ponty's philosophy is emphasized by its open-ended character and its relationship with action (Landes 2-4). 'Expression is experienced as an embodied act' and is related to an open trajectory of sense not as thetic meaning but as direction (10), which is reprised through coherent deformation, a way of repeating differently (Merleau-Ponty, 'Visible' 147), 'a deformation of a dimension provoked by the emergence of new sense, which does not just deform, but also reforms the dimension (Yahata 162).

Being-in-the-world also foreshadows the notion of reversibility in Merleau-Ponty's late ontology (Merleau-Ponty, 'Visible' 155). Since the body is an agent exploring the world while being also *of* the world, it is the site of chiasm between sensing and the sensed, activity and passivity. Merleau-Ponty argues that when 'I touch myself touching, my body accomplishes a sort of reflection' (Merleau-Ponty, 'Signs' 166). The relationship between seeing and seen points out to the participation of the body and the world in the flesh of the world, instead of relating as a container and a contained object. The flesh is the ontological 'element' that guarantees the being-in-the-world and *of* the world and allows reversible relationships as sensing-sensed, which never lead to fusion of the two poles, since there is always a divergence between them (Merleau-Ponty, 'Visible' 135). The reversible relationship between the body and itself, as well as between the body and the world, guarantees the opening up towards the world, as a 'primordial intercorporeality', 'prior to the distinctions of self and other' (Merleau-Ponty, 'Visible' 142). The same reversibility is possible with all senses. Regarding vision, since the only way to see myself seeing, 'to glimpse my living gaze',

Jan Fabre

Let yourself be a Mirror, drawing 24 X 30.5 cm, 2014, photographer: Pat Verbruggen © Angelos/Jan Fabre bvba

is the use of a mirror (Merleau-Ponty, 'Phenomenology' 94), the mirror image in Merleau-Ponty's philosophy is not regarded as a fake reflection, but as a way to achieve reversibility, and as a foundation for intersubjectivity as intercoroporeality. Vision is 'the gaze gearing into the world and this is the reason why another person's gaze can exist for me' (367), while the experience of the gaze transforms 'myself into another, and another into myself', as Merleau-Ponty points out in his essay on painting *The Eye and the Mind* (129-130). Therefore, painting and visual arts in general, become the expression of this reversibility, which for the pair of seeing and seen is called visibility. Reversibility can never be completely accomplished, since a divergence always exists. For Merleau-Ponty this is the condition for Being to appear as the invisible of the visible (Merleau-Ponty, 'Visible' 135). In this writing piece, the unavoidable condition of the divergence is approached as the space where consilience between neurophysiology and art is being developed as the result of the four aforementioned mirrors, occupying this space of divergence.

The mirror, the agent for imitation and empathy, is approached as an agent for consilience. Adopting multiple points of view, namely 'mirrors', upon the research aim, does not just add perspectives, but is the crucial element that creates the intertwining structure in the image of consilience. The mirror becomes an invitation to consilience, as on the title of one of Fabre's drawings made in 2014 after the interview with Rizzolatti: *Let yourself be a mirror.*

The writer of this paper accepts this invitation and she becomes a mirror. Her experience as a spectator of the interview becomes the 'fifth' mirror that scatters the image of consilience, as she looks at the amphitheatric lecture hall and she sees 'a palace of mirrors', as Fabre describes theatre in his monologue-theatre manifest *The Emperor of Loss* (73), not only because Fabre and Rizzolatti are both performers and each other's spectators, but also because she has walked among Fabre's brain sculptures in gallery spaces, where 'the brain... is a character' (Fabre 'Maeght' 38). As a result, the writer develops a theatrical metaphor while exploring the image of consilience. For the spectator that the writer is, the image of consilience is a theatre image. As shown in the final section of this writing piece, this point of view on the performative interview suggests the interactions developed between neurophysiology and art, namely the kind of consilience between them.

How does this theatre image look like? How do mirror images look like?

The Beauty of the Vulnerable Brain

The neurophysiologist may have replied negatively, but the artist has already conceived it (Fabre, 'Do we feel' 3): the brain is 'a beautiful object'. Indeed, this can be seen in his drawings and sculptures focusing on the brain's form. In all these works the brain is depicted 'nude', isolated from the rest of the body and without the protection of cranial bones and skin (Fabre, 'Ma Nation' 38). As a result, the brain, which cannot be seen unless through imaging techniques or intracranial operations, becomes palpable and is exposed as a vulnerable object. The stress does not fall on its power of reason that is supposed to manage the world, but on its corporeality, which is vulnerable, since everything made of human flesh is promised to death. This corporeality is emphasized even more in works like *Brain-legs* and *'The Heart-brain*.

In the first (2010), legs are made of 'nude' brain tissue, pointing to how mirror neurons could actually dance: the brain is not only the site of reason, of 'I think', but also of movement, of 'I can', which is Merleau-Ponty's operative intentionality. This 'I can' initiates a movement not only of legs, but also of meaning, since a different direction may be searched and found through it. In French, the language in which Merleau-Ponty wrote, 'sens' means also 'direction' and is used as a kind of pre-reflective meaning. In the second piece (2015), two marble brains are arranged in a symmetrical way in order to form a heart (which is also a symmetrical organ) crossed by an arrow. The way the brain is transformed into heart points to how it can be possible to 'think with our heart' and refers again to the pre-reflective abilities of the brain. As it is the case with the works depicting brains, the symmetry in *The Heart-brain* is achieved neither through a wall that separates, nor by fusion of the two parts. There is a mirror in the divergence between them, as there is a mirror between the brain and the heart, pointing to a reversibility between the two organs, analogous to Merleau-Ponty's reversibility between sensing and the sensed. Since both organs participate in the flesh of the world, Fabre seems to suggest a chiasm not thought by the philosopher, a chiasm that through the imitation of the symmetry of the heart by the arrangement of the two brains, leads to a connection of the vulnerability of corporeality to feeling, namely to empathy. Fabre seems to show how 'empathy with the brain' that

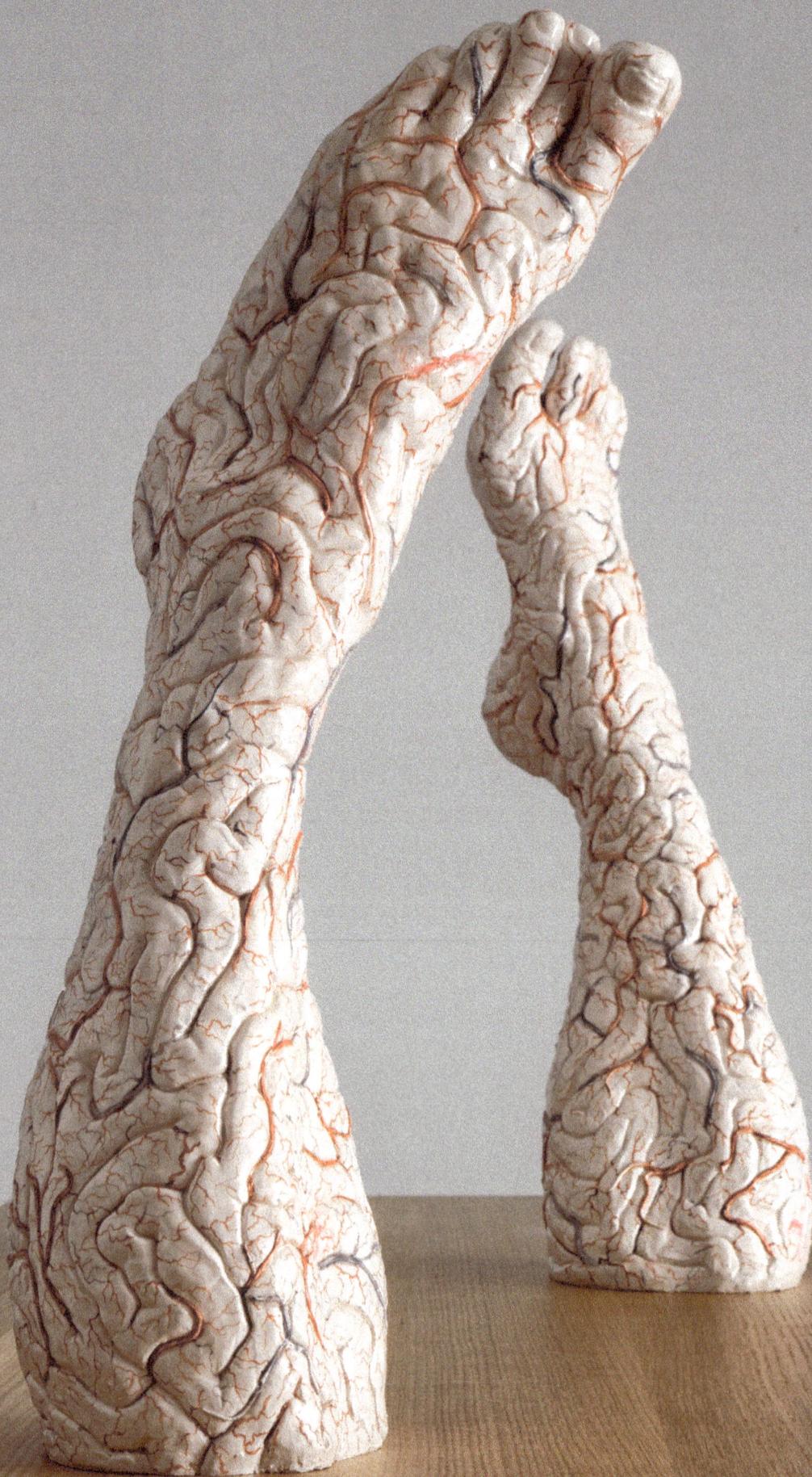

Jan Fabre
Brain Legs, silicone and painting 52 X 16 X 14 cm (left leg) 48.5 X 15 X 14 cm (right leg), 2010, photographer: Pat Verbruggen
© Angelos/Jan Fabre bvba

Rizzolatti does not seem to have, can be possible. This is empathy not only with the brain, but with the vulnerability of existence as well. For Fabre, beauty, the driving force of his artistic work, is both an aesthetic and an ethical principle, vulnerable like a butterfly when handled in a clumsy way, but also bearing the potential for transformation that a butterfly embodies (Fabre, 'In your face!'). The artist calls himself 'a warrior of beauty' (Fabre, 'Journal I' 204), who aims at defending the vulnerability of beauty, which is also the vulnerability of existence. Acquiring empathy with this vulnerability, which in this case is the vulnerability of the brain, namely acknowledging and accepting it as a condition of existence, is a way to defend its beauty, in this case the beauty of the brain as a palpable object.

In all these works, the palpable brain summarizes human corporeality, the body that according to Merleau-Ponty is the agent that explores the world. Its freedom is situated (Merleau-Ponty, 'Phenomenology' 467) because its vulnerable corporeality is a condition for this freedom, but it seems that this condition is rather an asset than a restriction. Another sculpture in silicone (2014) shows the brain's red and blue gyri and sulci intertwining like threads and shaping a structure that comprises the words: 'my', 'only' 'nation', 'imagination'. Imagination is another function of the brain that becomes as palpable as the images it creates. Indeed, Merleau-Ponty disagrees with Sartre that imagination is 'a nihilation of the world in favour of non-being' and reworks the concept of imagination as 'attention to the imminent, latent, hidden or repressed hollows of the world', in other words, to the invisible of the visible (Johnson 32). Since a fundamental reversibility for Merleau-Ponty exists between the visible and the invisible, imagination allows perception not of what does not exist, but of what cannot be readily seen. The functions of the brain are part of the invisible, but are made possible through the structure of the brain. The intertwining between structure and function is transformed by Fabre into the intertwining of the visible and the invisible, which for Merleau-Ponty, as already mentioned, is enacted as visibility by visual arts. As a result, Fabre's images of imagination restore the intertwining of structure and function, and make it visible.

Fabre's work of 2012 in silicone *Brain of Janus (brown eyes)* shows a perfectly symmetrical brain with one eye on each hemisphere, gazing at the spectator. 'The things gaze upon me. I gaze upon myself (through the eyes of things)' (Morris 141), as Merleau-Ponty claims to be the 'me-world chiasm' in an until recently unpublished working note from his unfinished work *The Visible and the Invisible*. Thus, imagination is not just a characteristic of the spectator, it is not just a characteristic of the writer-spectator, who uses her own imagination for interacting with the agency of Fabre's brains in marble and silicone when she walks among them, but Merleau-Ponty also 'locates it in the being itself' (140). The visual artist depicts 'this active role of things' (138) and activates 'the metamorphic force of images' (Dufourcq 718), the one that is present in Fabre's images of 'becoming'. Fabre's brain images of the imagination make sense of the brain by initiating a new direction of research, namely an empathetic exploration of the brain. Imagination makes up for the conditions of situated freedom and transforms it into the potentiality towards empathetic, pre-reflective knowledge. Imagination allows the writer-spectator to belong to the same 'nation' as the artist and the neurophysiologist.

Fabre's brain images of the imagination make sense of the brain by initiating a new direction of research, namely an empathetic exploration of the brain. Imagination makes up for the conditions of situated freedom and transforms it into the potentiality towards empathetic, pre-reflective knowledge.

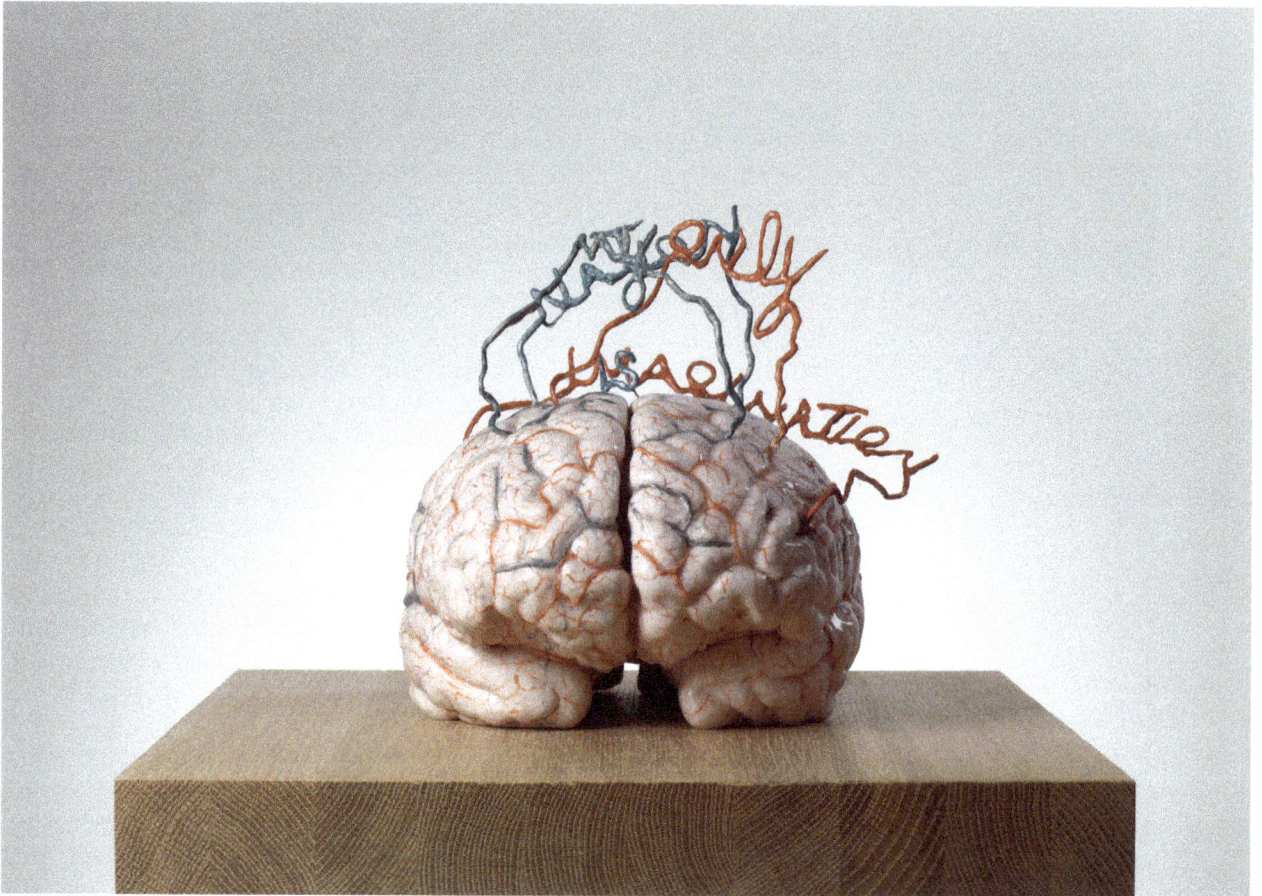

Jan Fabre

My only Nation is Imagination, silicone, wood, wire, painting 27 X 28.5 X 30.9 cm, 2014, photographer: Lieven Herrreman
© Angelos/Jan Fabre bvba

Fabre approaches the brain as 'terra incognita'. His 2008 installation *In the trenches of the brain as an artist-lilliputian*) shows a small sculptural portrait of him attempting, like 'an archaeologist', to expose and explore a huge brain in order to find answers about its function (Fabre, 'Ma Nation' 167). The brain becomes a landscape of palpable functions to be explored. This is the landscape researched by both Rizzolatti and Fabre 'in the palace of mirrors' during the performative interview. Their interaction is transformed into the images of the film, thanks to Fabre's editing. It could be the landscape of a dream, stressing once again the power of vulnerable mortality, since dreaming landscapes are made possible thanks to the fact that mortals need sleep in order to survive. Indeed, the editing of acceleration and deceleration that characterizes the film has been compared to the way dreams unfold (Fabre, 'Do we feel' 4). Alternatively, it could be the landscape of experimentation in the performative interview, which, as already mentioned, 'produces knowledge for the cinematic society'.

Editing is the mirror that creates the image of the performative interview in the medium of film. It imitates the way Rizzolatti and Fabre interact in the lecture hall, by alternating speech with movement. The interaction in the lecture hall could be approached as the neurophysiological experiment, which in Fabre's theatrical laboratorium corresponds to improvisation during rehearsals (van

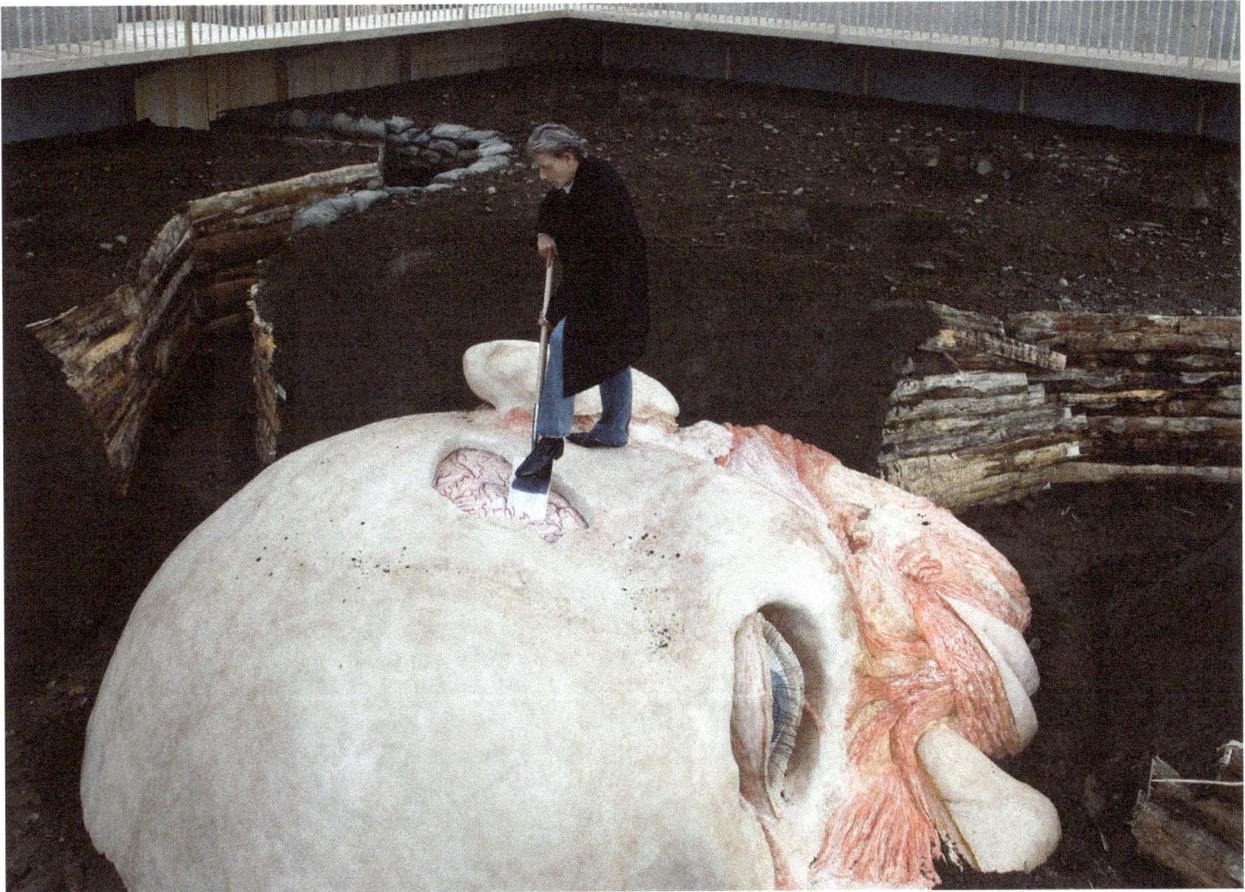

Jan Fabre

In the Trenches of the Brain as an Artist-lilliputian, Installation view: wood, earth, polyester, wax, silicon, leather, cloth, human hair, Kunsthaus Bregenz 3rd Floor, 2008, photographer: Markus Tretter © Angelos/Jan Fabre bvba

den Dries 315). The footage becomes the neurophysiological experimental data or the themes that Fabre extracts from improvisations in order to use them in his theatre pieces, and the film is a way to make sense of the process. If it had been made by Rizzolatti, probably it would have corresponded to the discussion section of a scientific paper. But the editing is by Fabre, and in his hands it becomes a tool that transforms the footage into dramaturgy. Dramaturgy in Fabre's theatre pieces is non-linear and resembles a cinematic modular narrative[2] proceeding through shifting among different directions, rather through an 'I can' than an 'I think'. The editing process leads to an image in which discursive parts of questions and answers alternate with movement and imitation of laboratory monkeys, while some questions are either interrupted or answered through movement. As a result, the film reflecting the performative interview resembles Fabre's thinking models, in which thinking and doing intertwine and all capacities of the human brain, both reflective and pre-reflective are at play. The same as Fabre's installation *In The Trenches of The Brain as an Artist-lilliputian*, editing makes the brain visible as a landscape to be explored. 'The power of manipulation of editing' that Fabre mentions in his diary in 2013 (Fabre, 'Stigmata' 614), transforms the invisible landscape of functions and relations explored by the neurophysiologist and the artist by speech and movement, into a visible image. The dramaturgy of

the film corresponds to this landscape. Landscape is a term that refers to painting and not to nature and is a 'theatricalization of the world' (Fuchs and Chaudhuri 12), a theatricalizing point of view on nature. Based on the theory and practice of landscape painting, Gertrude Stein developed the idea of a landscape theatre in which 'the stage can be a ground where landscapes of words can be arranged and put in motion' (5). In Fabre's dramaturgy the discursive part of the interview is put in motion when edited in alternate with silent scenes showing movement. The film image becomes the dramaturgical analogue of the trenches of the brain.

Consilience happens in this dramaturgical context. Art has offered the images of imagination to both neuroscientist and the writer-spectator, who has walked in the landscape of the brain in gallery spaces and has chosen to approach the dramaturgy of the film through the theatrical metaphor of the landscape theatre. Images and imagination are as vulnerable as beauty and existence because of their corporeal foundations. The same happens with consilience, which is made possible thanks to their dramaturgy. The brain is a beautiful-vulnerable object in the images of Fabre's visual art, as well as in the images of the film of the performative interview. Imagination, though, is not completely free. Its freedom is conditioned by the fact that 'what you imagine about the brain, comes from the brain' (Fabre, 'Ma Nation 97). How does this condition transform the landscape theatre of the brain?

The Spectator reflected in the Arnolfini Mirror

The neurophysiologist may have replied negatively, but the artist has already conceived it: how could we 'feel our own neurons'? Fabre has attempted to show this empathy with the brain in his visual art pieces. In his 2007 silicone sculpture *The Artist Who Tries to Drive His Own Brain Forward* a sculptural self-portrait of Fabre drives his oversized brain as if it had been a carriage with horses. This piece, which is inspired by a drawing by Félicien Rops, whose works have had a major influence on Fabre (Fabre, 'Ma Nation 39), imitates the need of the researcher to be in control of the object of his research. This object, though, becomes 'a metonymy of the individual' (39). It is impossible to drive the brain as a sovereign individual since the brain *is* the individual and, as a result, the brain is driven by the brain. The landscape theatre of the brain is not played outside the brain, the same as Merleau-Ponty's embodied subjectivity is an agent in the world because it is situated within the world and neither does it have a complete, god-eye view on it, nor is it deprived of agency. Thanks to this existential condition, the artist's research of the brain proceeds through overcoming the subject (artist)-object (brain) divide.

This approach to research becomes more evident in the 2014 marble sculptures *The artist's brain measures his own mirror neurons* and *The scientist's brain measures his own mirror neurons*, which imitate measurements of mirror neurons carried out with electrodes. These electrodes, though, are directly applied to 'nude' brains and gyri and sulci are wrapped around them with the help of an insect. Insects are for Fabre symbols of death and resurrection, capable of transformation thanks to their life cycle which includes metamorphosis, the analogue to the 'metamorphic force of images' created by imagination. For Merleau-Ponty, this self-reflective approach to research, which is undertaken rather pre-

> *It is impossible to drive the brain as a sovereign individual since the brain is the individual and, as a result, the brain is driven by the brain.*

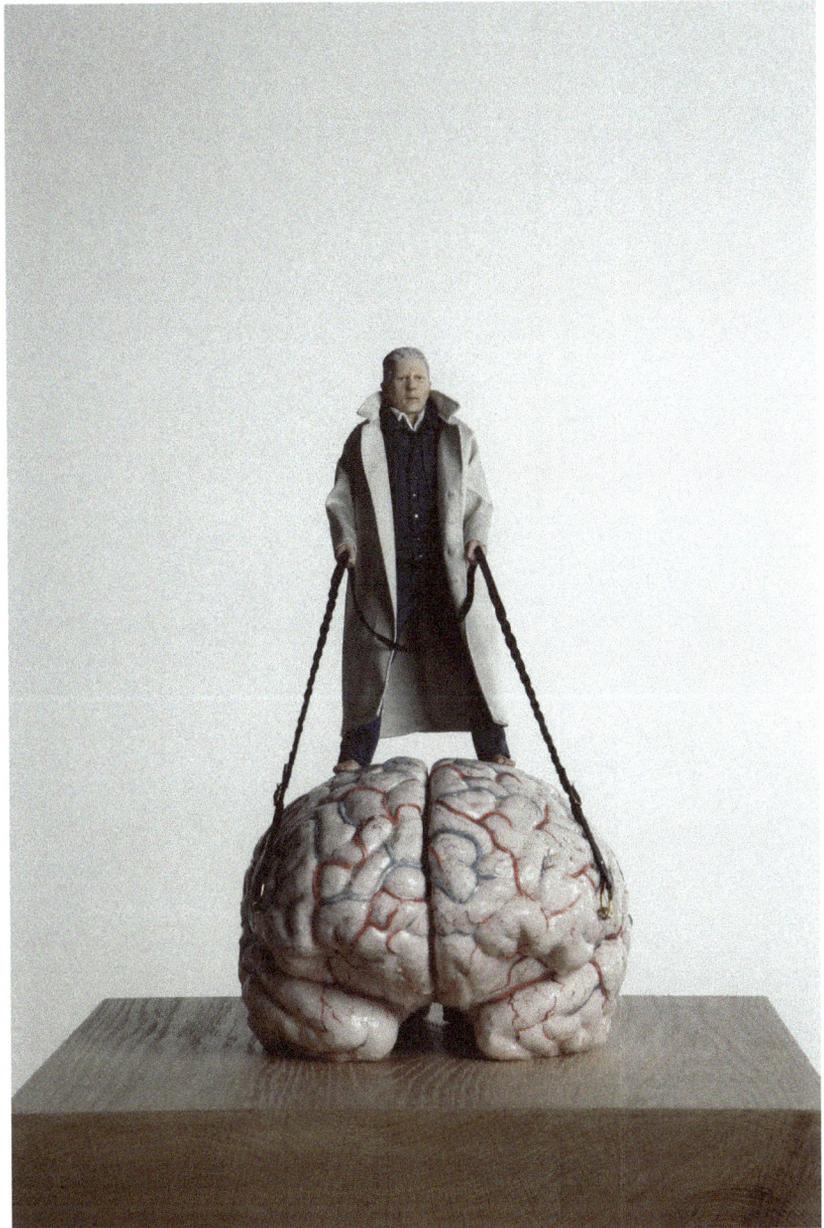

Jan Fabre

The Artist who tries to drive his own Brain forward, silicone, textile, oak and painting 23 X 32 X 43.5, 2007, photographer: Pat Verbruggen © Angelos/Jan Fabre bvba

reflectively, corresponds to self-affection, which is articulated through temporality (Merleau-Ponty, 'Phenomenology' 448-450). It refers to the subject's relationship with time as a relationship between affecting and the affected, which is not one of causality, is never fully accomplished and is summarized in a together-and-apart movement. As a result of this enactment, subjectivity does not remain isolated in self-affection, but opens up towards the world, since, 'in each present moment of my experience, I am on the watch for something else' (Marratto 162). Research becomes empathetic with its own topic, since this is a condition for opening up towards the world. The landscape theatre of the brain is to be explored through self-affection and empathy, before theatre can be played

179

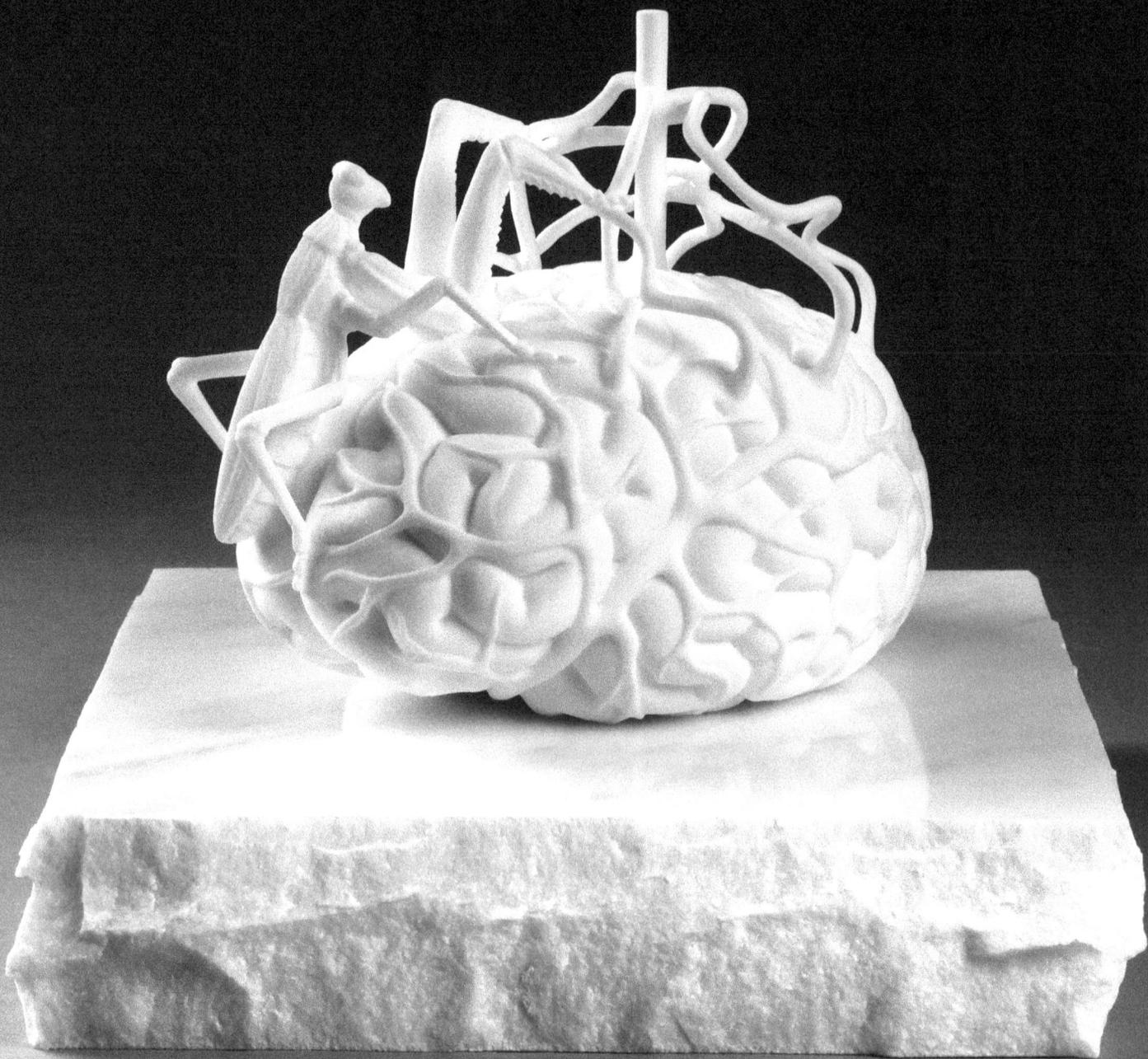

Jan Fabre

The Scientist's Brain measuring his own Mirror Neurons, marble18 X 21.2 X 15.2 cm – base 6 X 27 X 27 cm, 2014

© Angelos/Jan Fabre bvba

with others. Indeed, in the lecture theatre Fabre plays this theatre with Rizzolatti and becomes his spectator. When editing the film, though, he has to be the spectator of the interaction between Rizzolatti and himself. As a result, self-reflection as self-affection has an important role in the film and refers to the second term used to describe the performative interview, as a reflexive one.

Fabre has put the body at the core of his theatre 'as subject and object of research' (van den Dries 337). The corporeal brain approached as a metonymy of the embodied subjectivity becomes subject and object of research in his brain drawings, sculptures and performative interviews with Wilson and Rizzolatti. It is possible that scientists aiming to produce knowledge by conquering their object of research, may forget that the brain is both their subject and object of research, that they use their own brains as parts of their own bodies in order to explore it. Even scientists like Rizzolatti, who has stated his connection to the ontology of Merleau-Ponty, tend to forget this – even Merleau-Ponty admitted that himself as a philosopher who was a writer and did not create pre-reflective work, was at risk of forgetting it. In an attempt to overcome this danger, he tried to adapt Cézanne's way of painting into a writing method. It seems that through his interest in art and philosophy and the acceptance of Fabre's invitation to the performative interview, Rizzolatti is also trying to overcome this risk.

Corresponding to what happens in Fabre's marble sculptures, the accomplishment of self-affection during the performative interview is made possible thanks to help, but not from an insect. In 2014 Fabre made the drawing *Jan van Fabre Eyck: Portrait of Rizzolatti Arnolfini*, in which a knife cuts the brain symmetrically where, as already mentioned, there is a mirror for Fabre and not an impermeable wall. References to Flemish Masters are frequent in Fabre's art. Jan van Eyck's *Arnolfini Portrait* is a painting of 1434 depicting a man and a woman, most probably at their wedding and comprising, among others, a mirror at the back, where two figures are reflected. Above the mirror there is the inscription 'Johannes van Eyck fuit hic', meaning 'Jan van Eyck was here' and identifying one of the figures in the mirror as the painter himself.

Why was it important for the artist to state he was present? Erwin Panofsky provided an answer, though not a definite one. Recent research has identified the couple as Giovanni di Arrigo Arnolfini and his first wife Helene, and attributed the fact that the man holds the woman's right hand in his left and not the right hand, as a gesture corresponding to 'a secular marriage with a bride of lower social rank' that the painter witnessed (Binstock 119). On the other hand, the reflection and the signature of the painter is supposed to have turned this wedding portrait into 'the first modern painting' (109), created from an individual's point of view. It seems, therefore, that this artwork 'reflects on its own production' (122) and the reason van Eyck was 'here' was not just to witness the wedding, but also in order to paint the subjectivity of the painter.

Fabre takes up van Eyck's gesture. As it happens in the drawing, he creates for the film a double portrait, which is cut in two symmetrical halves not with a knife, but by the act of decoupage, which makes editing possible. Indeed, Fabre himself refers to symmetry as an important aspect of his editing (Fabre, 'Stigmata' 614). In the film, he creates a portrait of Rizzolatti, which corresponds to a portrait of the function of mirror neurons discovered by him, since their func-

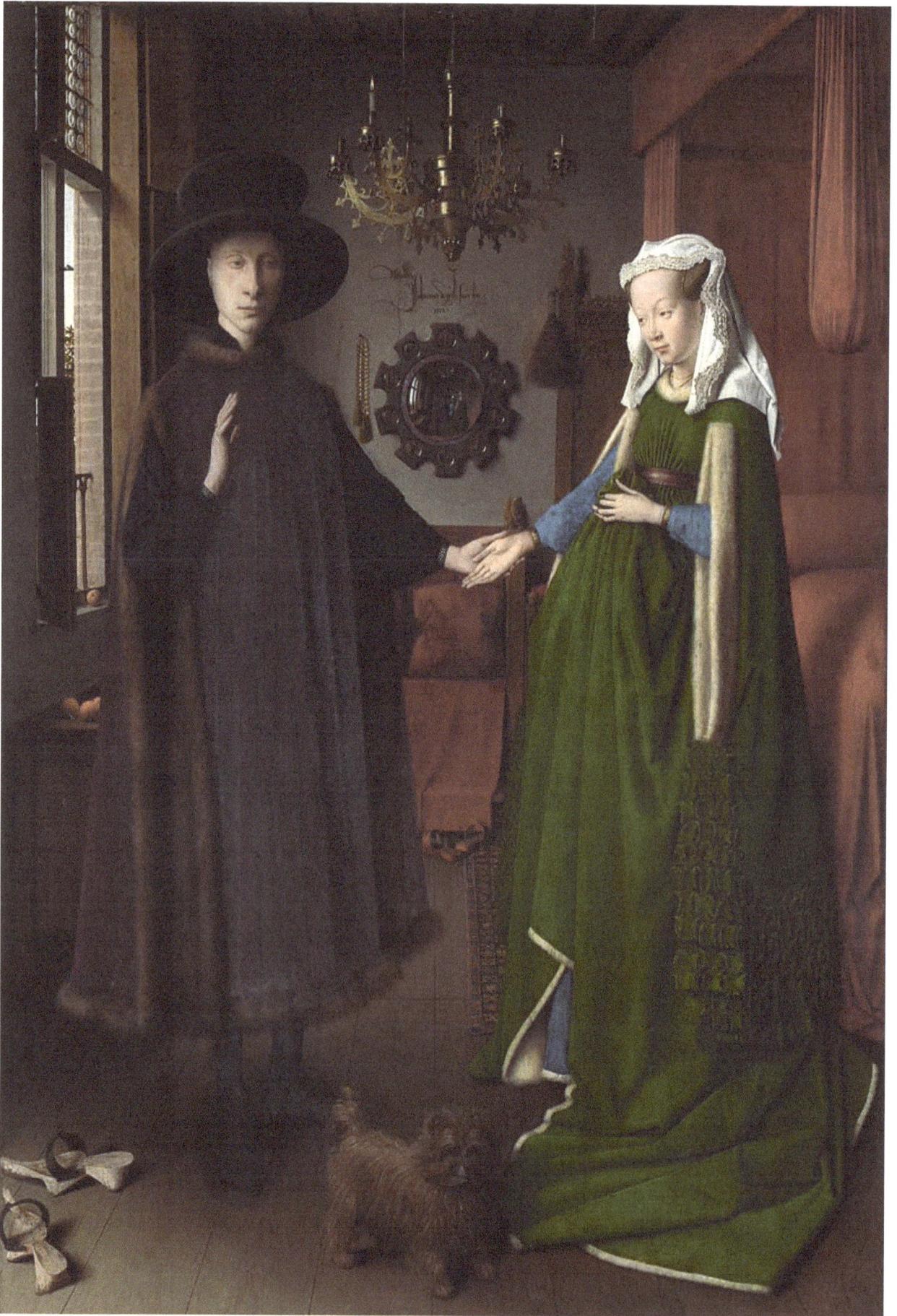

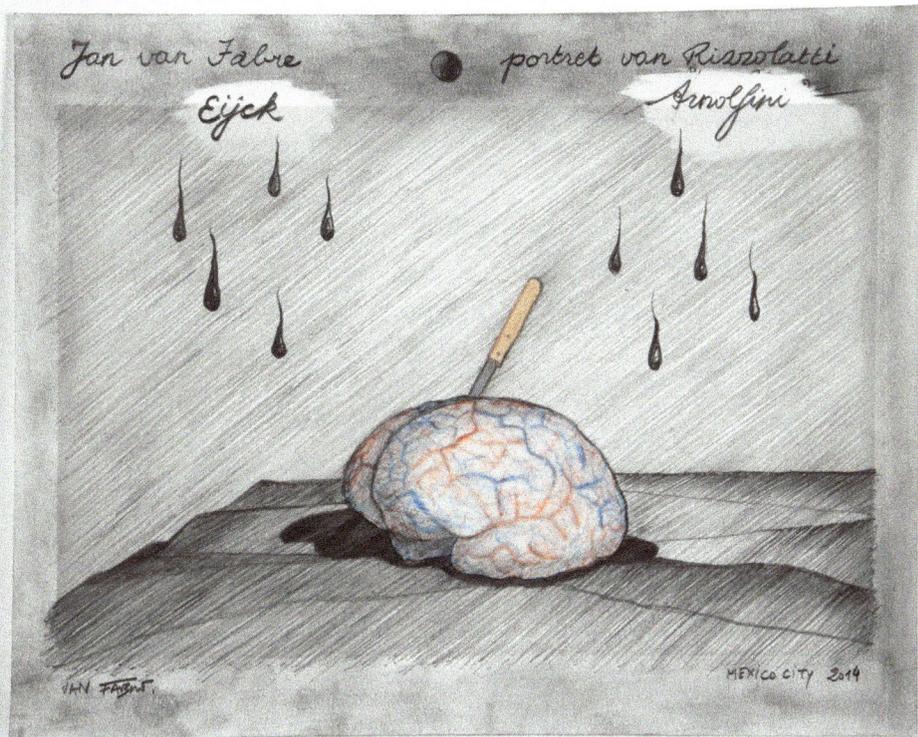

Jan Fabre
Jan van Fabre Eyck: Portrait of Rizzolatti Arnolfini, drawing 24 X 30.5 cm, 2014 © Angelos/Jan Fabre bvba

Through Fabre's method it is suggested that his concept of imagination may be the catalyst transforming Merleau-Ponty's theory of reversibility and intersubjectivity into a theory of empathy. Merleau-Ponty's writings on the mirror suggest that the understanding of the other does not take place through a fusion into the other but as 'a scattering of the self into a myriad of sparkling reflections and images'.

Jan van Eyck
The Arnolfini Portrait, oil on oak, 82.2 X 60 cm, 1434
© National Gallery London

tion is enacted during the performative interview. Fabre, though, 'fuit hic'. 'Here' is both at the site of the performative interview (as van Eyck was in the same room with Giovanni Arnolfini), since he is in the portrait of Rizzolatti, and at the site of editing (as van Eyck was in his painting studio), since at the same time he is the one who makes this portrait as a way to approach the subjectivities of the neurophysiologist and the artist.

Although van Eyck painted self-portraits, he chose in this painting to portray himself together with his rich and powerful commissioner, as if connecting his reputation and social status with that of Arnolfini. By taking up this gesture, Fabre, although he is a performance artist who has created a considerable number of solo performances, chooses to portray himself through the portrait of Rizzolatti. For Fabre, each performance is a metamorphosis, a way of reinventing himself (Fabre, 'Stigmata' 515). This time, though, he attempts to make sense of himself through the portrait of someone else, by becoming Rizzolatti's spectator and letting himself be reflected on his mirror.

For his 2017 theatre piece *Belgian Rules / Belgium Rules*, Fabre creates his modular dramaturgy around Belgian painters[3]. In the Chapter referring to van Eyck, a mirror is hung at the background of the stage, facing the audience. This mirror reflects the audience, including himself, who usually watches the performances of his own works from the sound control. The performative characteristics of

The Arnolfini Portrait discussed by Panofsky are taken further by Fabre in this scene of the theatre performance, as well as in the performative interview. Fabre's guidelines for performers are summarized in 'visceral acting', a way for performers to react to physical or imaginative stimuli and work on the transformative effects on their bodies (Cassiers et al 277, 280), rather than identify themselves psychologically with a character. For example, performers perform exercises by empathizing with animals. Imagination has a decisive role in this visceral acting[4], since they have to imagine the animal and its actions and use their imagination in order to embody them.

As already mentioned, imagination has also a corporeal aspect, since its site is the corporeal brain. It has been suggested that Merleau-Ponty's 'intertwining between the imaginary and the perceived is strengthened with his study of intersubjectivity' and especially with his writings on Lacan's Mirror Stage (Dufourcq 712). In Fabre's theatre, audience responds to the physical stimulus of the performers' physicality through a 'visceral act of spectatorship' (Cassiers et al 286), which also involves imagination. This is the way that spectators empathize with performers, since, as Fabre claims, 'seeing is feeling' (Fabre, 'Maeght'). Merleau-Ponty has not formulated a concise theory of affect or empathy. Through Fabre's method it is suggested that his concept of imagination may be the catalyst transforming his theory of reversibility and intersubjectivity into a theory of empathy. Merleau-Ponty's writings on the mirror suggest that the understanding of the other does not take place through a fusion into the other but as 'a scattering of the self into a myriad of sparkling reflections and images'. (Dufourcq 712).

Instead of making his own self-portrait, Fabre cuts Rizzolatti's portrait into two halves and creates a double portrait of himself and Rizzolatti, of himself and himself reflected through Rizzolatti, achieving self-affection through intersubjectivity, which thanks to imagination becomes empathy. Self-affection is the condition for the neurophysiologist and the artist to open up towards each other and enact empathy as Merleau-Ponty's reversibility. They help each other accomplish self-affection as a condition of their opening up towards each other. This is a non-hierarchical way of interaction, since it is based on overcoming the subject-object divide. Both of them are visceral performers empathizing with laboratory animals and at the same time visceral spectators empathizing with each other. The distance at which they sit at the table is the necessary divergence for their interaction to take place, without any fusion of themselves, their ideas and their respective disciplines. The theatrical metaphor of the landscape theatre of the brain is taken further by this reversible, empathetic relationship between performer and spectator. Neither Rizzolatti nor Fabre are alone 'in the trenches of the brain', trying to explore their object-subject of research. They help each other, their disciplines help each other. Consilience taking place during their visceral acting and visceral spectatorship with imagination having a decisive role, is as vulnerable as the images created by their corporeal imagination. By becoming herself a mirror, the writer-spectator participates in this empathetic relationship and takes it further in this writing piece. How does a spectator look like when reflected in the mirror of Rizzolatti Arnolfini?

The transformative potential of the spherical mirror
The neurophysiologist may have replied negatively, but the artist

Intersubjectivity is a non-hierarchical way of interaction, since it is based on overcoming the subject-object divide. Rizzolati and Faber are visceral performers empathizing with laboratory animals and at the same time visceral spectators empathizing with each other.

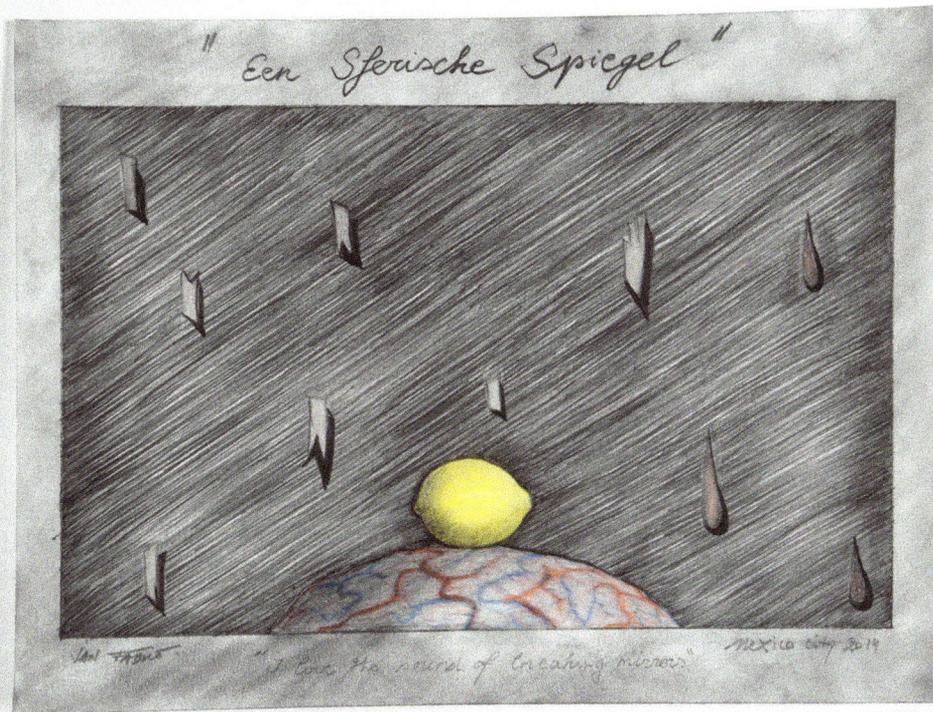

Jan Fabre

A spherical Mirror (I love the sound of breaking Mirrors), drawing 24 X 30.5 cm, 2014,

photographer: Pat Verbruggen © Angelos/Jan Fabre bvba

has already conceived it: 'failure to imitate' initiates originality. In Fabre's theatre, failure refers to the impossibility of imitation as cloning and identical repetition, and becomes a creative force, a condition that brings transformation. In his diaries, repetition is a metonymy of rehearsals. It is described as 'a terrible tissue of diversity' and the paradox is stressed that although it is 'mimetic', it is impossible to happen 'because of a primary force of change' (Fabre, 'Journal I' 135-136).

The Arnolfini mirror bears the same transformative potential, because it is spherical. During the temporary exhibition *Reflections: van Eyck and the Pre-Raphaelites*, organized at the National Gallery of London (02.10.2017-02.10.2018), the Arnolfini portrait was exhibited not only alongside works by Pre-Raphaelites but also in the same room with spherical, Arnolfini-like mirrors, used by the Pre-Raphaelites as props for their paintings. These mirrors reflected the gallery rooms and the visitors by slightly deforming them. It was made obvious to the spectator that one of the main influences of the Arnolfini portrait was its potential for the deformation-transformation of experience. Fabre's 2014 drawing *A spherical mirror (I love the sound of breaking mirrors)*, showing a lemon at the top of the curved surface of a 'nude' brain, could also refer to the Arnolfini portrait. The deforming effect of the spherical mirror, like failure in Fabre's theatre, are charged neither negatively nor positively, but are conditions for transformation, namely for opening up towards unpredictable dimensions of experience.

Such an unpredictable dimension of experience is the kind of consilience performed during the performative interview. Its editing corresponds to a spherical mirror, that 'manipulates' it, as Fabre writes in his diary (Fabre, 'Stigmata' 614). As it is the case with the spherical mirror, Fabre's agency through editing deforms, or to use Merleau-Ponty's term, coherently deforms experience: the seen-performer becomes for the seer-spectator not just a perspective on the world, but 'the world itself with a certain coherent deformation' (Merleau-Ponty, 'Visible' 262). Thanks to this deformation, expression becomes possible. No definite answers are provided in the performative interview. Even the title of the film is another question. Merleau-Ponty has introduced interrogation as a method of philosophical writing, which is inspired by the painting practice of Cézanne (Merleau-Ponty, 'Eye' 149). The philosopher admits that intellectual adequacy is impossible and reason alone cannot drive research. Interrogation questions meaning from various perspectives rather than offering positive answers, and leads to a non-rigid elaboration of concepts. Merleau-Ponty describes interrogation as an 'art' and 'an inspired exegesis' (Merleau-Ponty, 'Visible' 133).

The importance of imitation leading to transformation in Fabre's theatre is highlighted in his monologue-theatrical manifest *The Emperor of Loss*, an expression he also uses during the performative interview in order to characterize the artist for whom experimentation never ends. *The Emperor of Loss*, 'desires to play failures with mirrors' (Fabre, 'Empereur' 53), with 'a disguised mirror' of dreams and with 'tarnished mirrors' (58-59) and he deforms experience coherently, without end. He is even 'disguised as a mirror' (67), since his heart and his brain are symmetrical. These organs are double, with a mirror and not a wall reflecting their two halves. In the theatre, 'in the palace of mirrors' (73), he tries to reflect himself on the spectators and by that way become double, like his organs. The mirrors of spectators are 'deforming' (77) and he occasionally feels 'the pleasure of metamorphosis' (99). It is then that he really exists, not as a half, but as a double. It is only then that he feels complete, when his game of 'failures' releases its potential for transformation.

The art of the *Emperor of Loss* is the art which admits that the self is not original, but half, and the art which looks for ways to make oneself complete and original by coherently deforming experience through mirroring oneself on others. It is the art that searches for relationships by enacting the reversibility of the mirror. It is the art that searches for consilience and the transformative potential of the spherical mirror is the agent of consilience. As it is the case with the *Emperor of Loss*, it is the transformative potential of editing that allowed Fabre to make the film and thus a double portrait, in which Rizzolatti and himself empathize with each other thanks to imitating each other's gestures and mirroring each other. In the landscape theatre of the brain, in this 'palace of mirrors', they coherently deform each other's experience, they become each other's other half and they perform consilience through an experimentation that never ends. Each mirror interrogates existence anew. The path of imitation remains open since the experience of the other is coherently deformed without end. By becoming herself a mirror, the writer-spectator of this piece participates in the interrogation along this open path of imitation, as her point of view on the film through the development of a theatrical metaphor coherently deforms in writing

It is an image of doing and feeling, taking further the image of doing and thinking of Fabre's thinking models. The relationship of consilience is bidirectional, therefore it is not important whether neurophysiology or art is the first discipline mentioned in this 'through'-kind of relationship.

the image of consilience presented in the film. The inability of identical repetition is for Fabre the source of originality, since as he states in the last line of his other monologue-theatrical manifest entitled *The Kind of Plagiarism*, 'you-are-unique-when-you-want-to-imitate-the-others-and-you-cannot-make-it' (Fabre, 'Roi' 158). Consilience taking place during this endless research is powerful thanks to its vulnerability to transformation through deforming mirrors, which have the potential to keep open the path towards expression.

'The chatty monkeys' looking at the mirror

In the landscape theatre of the brain, the neurophysiologist and the artist, as individuals and as disciplines, let themselves be each other's mirrors and play their parts in the exploration of the brain by becoming each other's spectators, by acting as the two halves of a double portrait, in which they are imitating and empathizing with each other through reflecting each other in a deformed way, revealing that mirroring and imitation are not synonyms for identical cloning, but for repetition as transformation. The theatrical metaphor developed by the writer-spectator while exploring Fabre's three suggestions to Rizzolatti, which received 'no' for an answer, gives rise to the image of consilience as the result of multiple scatters in the mirrors of Fabre's visual and performing arts, of the titles of Fabre's exhibitions inspired by and dedicated to Rizzolatti and of Merleau-Ponty. In this performative interview consilience is mirrored in intersubjectivity, it is enacted as intersubjectivity, which, thanks to imagination, leads to empathy. Mirror neurons measured are reflected in this image through mirror neurons dancing and vice versa. The connector defining the kind of consilience between neurophysiology and art is not 'and', it is not even 'with', but 'through', since consilience is achieved as a transformation through the deforming mirror of the other. It is not a relationship proceeding as a synthesis (an 'and' or a 'with'), but it is directly related to the topic of consilience, namely the way a mirror reflects and creates an image. The image of consilience is not the sum of its parts. Theatre, which is based on the relationship between performers and spectators, is about making sense through others. Making sense through others, is about making sense through their deforming mirrors, the way they reflect differently. It is about finding a direction, without offering definite answers. This writing piece does not offer any definite answer either. The writer-spectator who let herself be a mirror, develops the theatrical metaphor in order to make sense of the interactions achieving consilience between neurophysiology and art. Through her spectatorship, she empathizes with the neurophysiologist and the artist and mirrors their exploration of the brain in her writing by coherently deforming the image of consilience into a theatre image, the image of the landscape theatre of the brain. This is the image of Fabre's theatre of repetition which is always in-the-making, and is taken up by audience. It is an image of doing and feeling, taking further the image of doing and thinking of Fabre's thinking models. The relationship of consilience is bidirectional, therefore it is not important whether neurophysiology or art is the first discipline mentioned in this 'through'-kind of relationship. The 'through' element does not correspond to a reactant but to the catalyst over the bidirectional arrow demonstrating a chemical reaction, which leads to an equilibrium, where both reactants (whose order is not important because there is no hierarchy in the chemical reac-

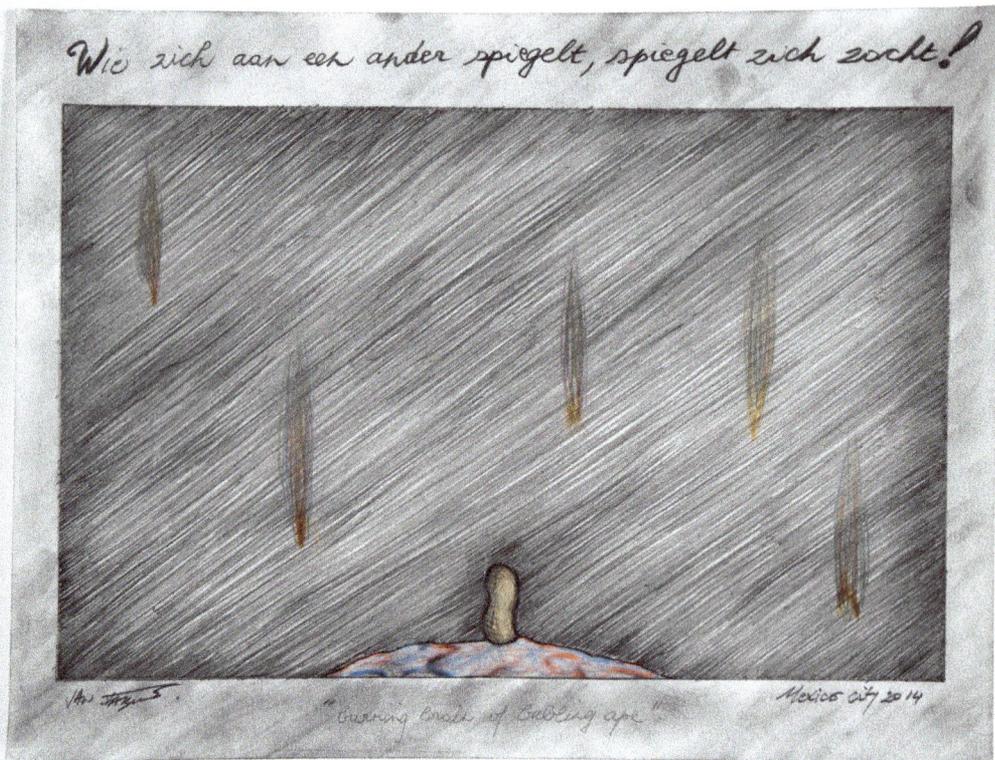

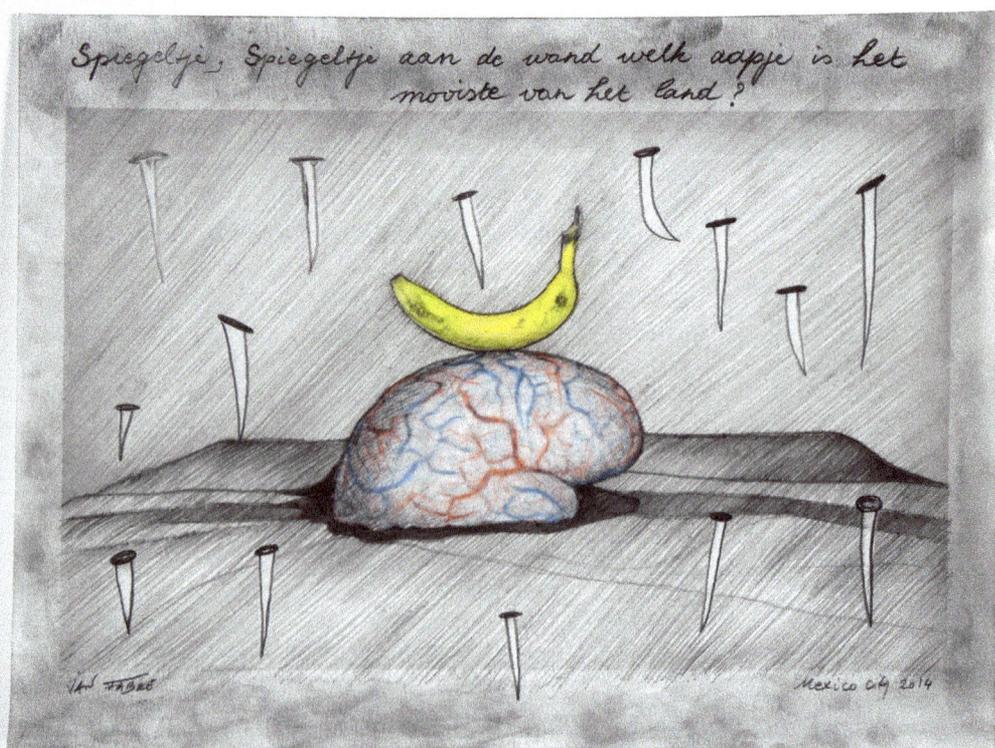

Jan Fabre

He who sees his reflection in another is reflected gently!, drawing 24 X 30.5 cm, 2014, photographer: Pat Verbruggen © Angelos/Jan Fabre

Mirror Mirror on the Wall, which little Monkey is the most beautiful in the Land? drawing 24 X 30.5 cm, 2014,

photographer: Pat Verbruggen © Angelos/Jan Fabre bvba

tion) co-exist with the reaction products. This catalyst is the mirror. The reactants, the reflections of neurophysiology and reflections of art, do not cease to exist, since they are not fused with each other, but they co-exist with their reflections in the image of consilience, the same as Rizzolatti and Fabre are two embodied subjectivities in the image of the film.

One of Fabre's 2014 drawings showing a peanut on a "nude" brain, bears the title *He who sees his reflection in another is reflected gently!* Although the system of the mirror neurons provides a natural pre-disposition to communication and society, as Rizzolatti claims (Rizzolatti and Gnoli 104), intersubjectivity and consilience are vulnerable not only because of the corporeality of the brain, but mainly because there is resistance in their 'through'-kind of interaction. According to Merleau-Ponty, an essential element of reversibility is encroachment (Merleau-Ponty, 'Visible' 123), a certain transgression, a reference to the violent aspect of the positive term of communication when intersubjectivity takes place. Indeed, consilience as intersubjectivity is not easy, which is made obvious by the three 'no' that Rizzolatti replied to Fabre's suggestions. The choice of the term 'performative or reflexive interview' that comes from an ethnographical context in which the approach of the other has a crucial role, demonstrates the difficulty of intersubjective relations, since despite natural predisposition, otherness exists in culture. Encroachment ensures that there is no fusion between the two participants and the two disciplines. Although not easy, consilience is rewarding since the mirror of the other shows more than one can see with one's own eyes. The existential condition of being-in-the-world offers the embodied subject only situated freedom, a partial, conditioned point of view upon the world, which, as already mentioned, is enriched through the gaze of others, as well as through the gaze of things, thanks to an intertwining of perception and imagination. Thanks to otherness, the 'half' can become 'double' and complete.

What makes up for the encroachment is the playful atmosphere of the interview, a mirroring like a game, whose rules and regulations are followed willingly, in order to do 'gaia scienza' (Fabre, 'Maeght'). The neurophysiologist may have replied negatively, but the artist has already conceived them and the neurophysiologist listens to his suggestions. Fabre takes from Rizzolatti a model for imitation and empathy that he tests in his theatre and Rizzolatti takes from Fabre the image of the brain function. The three 'no' may not persist, though. In a subsequent interview (Rizzolatti and Gnoli 180-181), Rizzolatti referred to Fabre's idea of his artistic originality based on copying the great masters, which as already mentioned Fabre has summarized in the line: 'you-are-unique-when-you-want-to-imitate-the-others-and-you-cannot-make-it' (Fabre, 'Roi' 158). Indeed, interrogation leaves the trajectory of sense open towards diverse ways of expression, like the spherical mirror that opens experience towards unexpected directions. And this trajectory is playful, a fairytale whose heroes are the laboratory monkeys with which 'the chatty monkeys who organize encounters in the theatre' (107) empathize, reflecting each other's stories of beauty as vulnerability of existence and wishing to explore them without end. By searching for answers about mirror neurons through mirrors, they play in the fairytale of the mirror that speaks and reveals secrets; the landscape theatre is the one of a fairytale: *Mirror Mirror on the wall, which little monkey is the most beautiful in the land?* – this is the title of another 2014 drawing by Fabre.

Sylvia Solakidi receives funding from the TECHNE AHRC Doctoral Training Partnership. She would like to thank Angelos/Jan Fabre bvba for granting permission to use images of Jan Fabre's works.

Notes

[1] The description and the quotes from the film *Do we feel with our brain and think with our heart?* are based on my notes while watching it in the Museum of Contemporary Art in Lyon, on September 30, 2016, during Jan Fabre's exhibition *Stigmata: Actions and Performances (1976-2016)*

[2] A detailed discussion of Jan Fabre's modular dramaturgy alongside cinematic modular narratives is included in my upcoming research paper in *Performance Matters*, elaborating on spectatorship and temporality in the 24-hour piece *Mount Olympus* (2015)

[3] The description from the theatrical piece *Belgian Rules / Belgium Rules* (2017) is based on my notes while watching the performance of July 20, 2017 in Volkstheater, Vienna

[4] Although the element of imagination is not explicitly mentioned in the research papers published on Fabre's method, Professor Luk van den Dries from the University of Antwerp who is working on an upcoming book on the topic, made this addition during his presentation of the method at the 1st EASTAP Conference in Paris, October 25-27, 2018

Bibliography

Alfieri, Andrea. "Tra Arte E Neuroscienze: Jan Fabre, Giacomo Rizzolati E Il Fascino Del Cervello | Eventi." Krapp's Last Post. November 15, 2011. Accessed November 05, 2018. http://www.klpteatro.it/jean-fabre-giacomo-rizzolati-convegno-parma.

Binstock, Benjamin. "Why Was Jan Van Eyck Here." *Venezia Arti* 26 (2017): 109-36. doi:DOI 10.14277/2385-2720/VA-26-17-7.

Cassiers, Edith, Jonas Rutgeerts, Luk Van Den Dries, Charlotte De Somviele, Jan Gielen, Ann Hallemans, Annouk Van Moorsel, and Nathalie A. Roussel. "Physiological Performing Exercises by Jan Fabre: An Additional Training Method for Contemporary Performers." *Theatre, Dance and Performance Training* 6, no. 3 (2015): 273-90. doi:10.1080/19443927.2015.1084846.

Chardon, Elisabeth. "Jan Fabre: «Le Cerveau Est La Partie La plus Sexy Du Corps Humain»." Le Temps. November 11, 2015. Accessed November 05, 2018. https://www.letemps.ch/culture/jan-fabre-cerveau-partie-plus-sexy-corps-humain.

Denzin, Norman K. "The Reflexive Interview and a Performative Social Science." *Qualitative Research* 1, no. 1 (2001): 23-46. doi:10.1177/146879410100100102.

Dufourcq, Annabelle. "The Ontological Imaginary: Dehiscence, Sorcery and Creativity in Merleau-Ponty's Philosophy." *Filozofia* 69, no. 8 (2014): 708-18.

Fabre, Jan. " L'Empereur de la Perte ". In *L'histoire des Larmes ; L'Empereur de la Perte ; Le Roi du Plagiat ; Une Tribu, Voilà ce que Je Suis ; Je suis une Erreur*. Paris: LArche, 2005.

------------ " Le Roi du Plagiat ". In *L'histoire des Larmes ; L'empereur de la Perte ; Le Roi du Plagiat ; Une Tribu, Voilà ce que Je Suis ; Je suis une Erreur*. Paris: LArche, 2005.

------------ *Journal De Nuit I: 1978-1984*. Translated by Michèle Deghilage. L'Arche, 2012.

------------ *Stigmata; Actions & Performances 1976-2013*. Milano: Skira, 2014.

------------ *Do We Feel with Our Brain and Think with Our Heart?* Brussels: Galerie Daniel Templon, 2015.

------------ *Journal De Nuit II: 1985-1991*. Translated by Daniel Cunin. L'Arche, 2016.

------------ *Ma Nation, L'Imagination*. Paris: Gallimard, 2018.

------------ Jan Fabre - Fondation Maeght. Accessed November 05, 2018. https://www.facebook.com/17340030609/videos/10156536149100610/.

Fuchs, Elinor, and Una Chaudhuri. *Land scape theater*. Ann Arbor (Mich.): University of Michigan Press, 2002.

"In Your Face!: Jan Fabre." YouTube. May 28, 2012. Accessed November 05, 2018. https://www.youtube.com/watch?v=kwAmgTjHox8.

"Jan Fabre / Angelos." Jan Fabre / Angelos. Accessed November 05, 2018. http://www.angelos.be/.

Johnson, Galen A. *The Merleau-Ponty Aesthetics Reader: Philosophy and Painting*. Evanston, IL: Northwestern University Press, 1996.

Landes, Donald A. *Merleau-Ponty and the Paradoxes of Expression*. London: Continuum, 2013.

Marratto, Scott L. *Intercorporeal Self: Merleau-ponty on Subjectivity*. Place of Publication Not Identified: State Univ Of New York Pr, 2013.

Merleau-Ponty, Maurice. "Eye and Mind." In *The Merleau-Ponty Aesthetics Reader: Philosophy and Painting*, 121-63. Evanston, IL: Northwestern University Press, 1993.

------------*Signs*. Evanston, IL: Northwestern University Press, 1995.

------------*The Visible and the Invisible: Followed by Working Notes*. Evanston: Northwestern University Press, 2000.

--------------*Phenomenology of Perception*. Translated by Donald A. Landes. Routledge, 2014.

Morris, David. "Reversibility and Ereignis." *Philosophy Today* 52, no. 9999 (2008): 135-43. doi:10.5840/philtoday200852supplement62.

Panofsky, Erwin. "Jan Van Eyck's Arnolfini Portrait." *The Burlington Magazine for Connoisseurs* 64, no. 372 (1934): 117-27.

Ramachandran, Vilayanur. "Mirror Neurons and Creativity – Is There a Relationship?" November 21, 2010. Accessed November 05, 2018. http://www.creativityland.ca/mirror-neurons-and-creativity-is-there-a-relationship/.

Rizzolatti, Giacomo, and Laila Craighero. "The Mirror-Neuron System." *Annual Review of Neuroscience* 27, no. 1 (2004): 169-92. doi:10.1146/annurev.neuro.27.070203.144230.

Rizzolatti, Giacomo, and Antonio Gnoli. *In Te Mi Specchio: Per Una Scienza Dellempatia*. Milano: Rizzoli, 2016.

The National Gallery, London. "Reflections: Van Eyck and the Pre-Raphaelites." The National Gallery. Accessed November 05, 2018. https://www.nationalgallery.org.uk/whats-on/exhibitions/past/reflections-van-eyck-and-the-pre-raphaelites.

Van den Dries, Luk. *Corpus Jan Fabre: Observations of a Creative Process*. Gent: Imschoot, 2006.

Wilson, Edward Osborne. *Consilience: The Unity of Knowledge*. London: Abacus, 2010.

Yahata, Keiichi. *La Problématique De Lexpression Dans La Philosophie De Maurice Merleau-Ponty*. PhD diss., Reproduction De: Thèse De Doctorat: Philosophie: Toulouse 2, 2012. 2008.

Translations from French and Italian sources have been made by the author.

Sylvia Solakidi has a background in visual and performing arts (BA Art Theory and Art History, Athens School of Fine Arts; MA Theatre and Performance Studies, King's College London) and is at the third year of a TECHNE-funded PhD (University of Surrey) in Performance Philosophy, which focuses on temporal experiences in durational theatre and performance explored through the concepts of contemporaneity and presence and the writings of Maurice Merleau-Ponty. She also holds a BSc in Biology and until 2015 she worked as a biologist in research and diagnostic laboratories. Publications: "I am a Magician of Soap: Alchemical Transformations in the Biomedical Politics of the HIV-Infection through Embodiment of Illness and Dance in Jan Fabre's *Drugs kept me alive* (2012)" – Platform Postgraduate Journal (12(2):49-64, 2018); Research Papers on Fabre's theatre pieces *Mount Olympus and Belgian Rules, Belgium Rules* have been invited to future issues of *Performance Matters* and *Performance Research*, respectively.

Dana Simmons: Micrographs

To most people, the brain is a mystery, but Dana Simmons is trying to change that through the engaging power of art. As a neuroscientist, Dana studied how autism affects the cerebellum, a brain region that supports our balance and posture, and helps us learn new movements. Specifically, she studied neurons called Purkinje neurons -- they are the most branched neurons in the brain, reminiscent of trees, lightning, coral, and many of the other branched structures found in nature. Dana collected images of these neurons in the lab using a high-powered microscope and manipulated laser light and color filters to create these intriguing neuron portraits.

text and images by **Dana Simmons**

Dana Simmons

Cygnet, Micrograph, 2017 © Dana Simmons

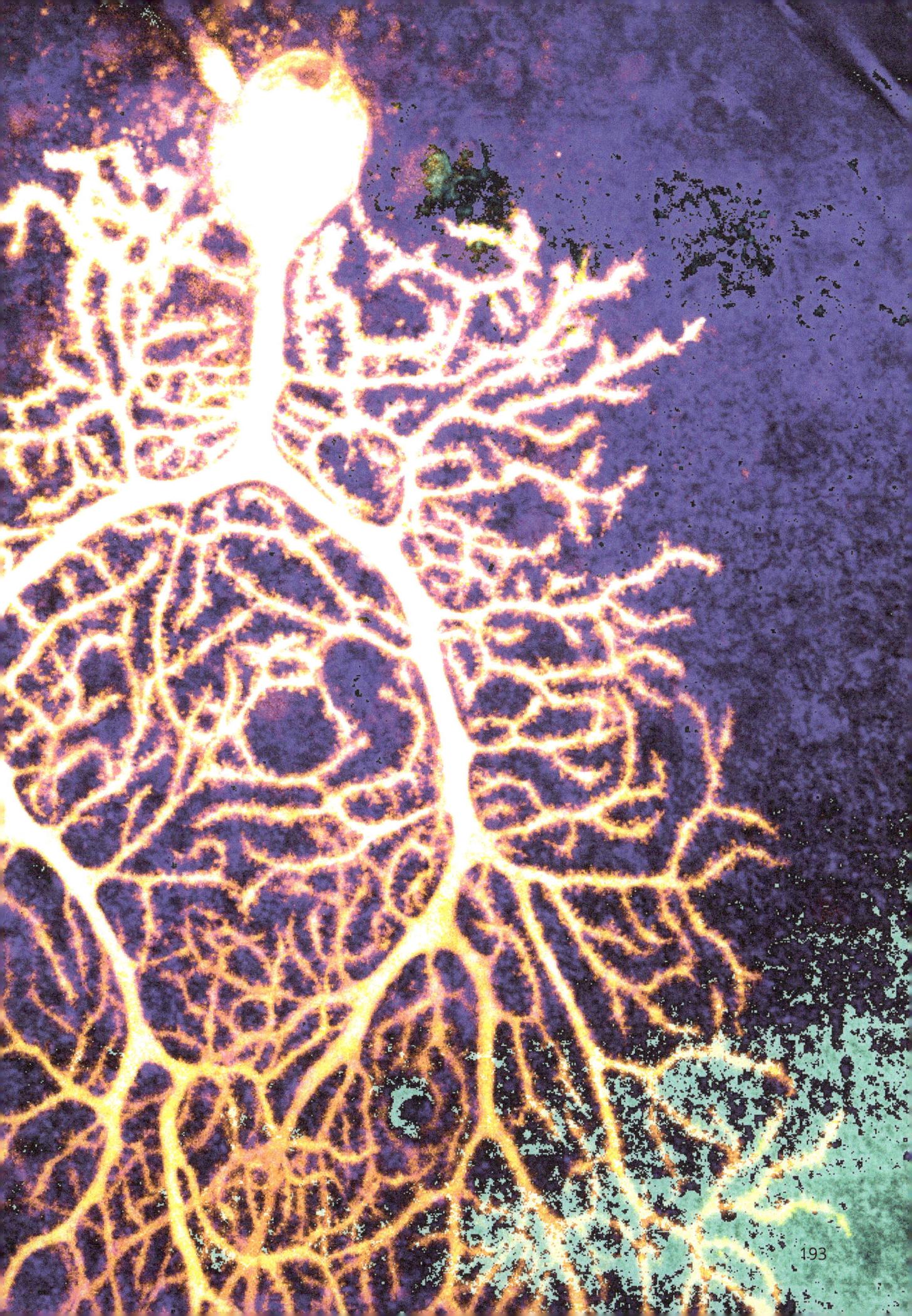

From the outside, the human brain looks like nothing more than a soft, wrinkly mass. But a peek inside reveals a dense, woven network of billions of neurons and other cells, constantly chatting with each other, endowing us with the power of movement, emotion, and thought. The brain contains many different types of neurons, but by far, one of the most unique in its form is the Purkinje neuron.

These neurons reside in the cerebellum, the region that sits in the back of the brain, behind the brainstem. From there, they support our motor learning, helping us walk, move our eyes, balance, and move our mouths to form words.

The cerebellum is critically important. Although it only accounts for a tenth of the brain's volume, it contains over half of its neurons, which play an important role in helping us navigate our world: when we trip on a crack in the sidewalk and become unbalanced, it helps us stay upright. When dust is flying towards our eyes, it helps us close them in time to protect them. When we are feeling around for a light switch in the dark in a new house, it helps us remember where to reach the next time. All of these functions require very fast processing speed—and that's where Purkinje neurons come in.

Purkinje neurons communicate with their neighbors using chemical and electrical signals. Similar to a tree gathering sunlight through its leaves, Purkinje neurons collect chemical information from other cells through their dendrites—little branches that extend out of the neuron's body. The dendrites on each individual Purkinje neuron make tens of thousands of connections with its partners, helping it collect lots of information in a very short amount of time and make split-second "decisions" about what message it will pass along. Once this calculation is made, a Purkinje neuron sends its data through the form of an electrical signal down through the round cell body and out along a wiry extension called an axon, where, at its end, the process starts all over again with another neuron. And another. Until the right message eventually makes its way to other brain areas and our muscles.

When I was a doctoral student in neuroscience at the University of Chicago, I studied Purkinje neurons because I wanted to understand the cerebellum's role in autism. When most people think of autism, they think of deficits in social and communicative skills. But a majority of people with autism also experience motor deficits, too, such as impaired or unbalanced walking abilities and abnormal eye contact. Researchers have demonstrated that many of these motor deficits involve changes in how the cerebellum works, which is where Purkinje neurons come in.

I studied the electrical activity of Purkinje neurons by observing how "loudly" they spoke to their neighboring neurons. When a neuron "talks", a puff of ions flows through it. I studied the differences in this interneuronal communication by examining the way calcium ions flowed through Purkinje neurons from autistic vs neurotypical individuals. To accomplish this feat, I stuck a tiny straw-like, glass tube into the round portion of a Purkinje neuron and filled the neuron with a fluorescent dye that made the calcium glitter in green under laser light.

During these experiments, as soon as I turned down the overhead lights and turned up the lasers, the beauty within the brain would emerge: a solitary, glowing Purkinje neuron, its dendrites glowing like lightning in a night sky. The dendrites reminded me of branches on a tree (the term "dendrite" even comes from the Latin word for "branch"). I also saw the branches of lightning, coral, antlers, and veins on a leaf reflected in the shape of the dendritic network. I realized I was looking at a pattern that appears all over nature, and in this case, it was in the microscopic environment of the cerebellum.

My photographs display what I saw under the microscope: a Purkinje neuron's cell body and its dendrites. But I also explored the limits of the microscope by adding lights and color filters to give each Purkinje neuron's portrait its own texture and dimension. The colors come from computer manipulation and sometimes correspond with the amount of fluorescent dye in each branch. The bands of color in some of my pictures come from changing the microscope settings in real-time while it acquired the image. Finally, for some of my images, I left the background light on, which reveals the texture of the brain slice in which the neuron resides.

With my art, my goal is to demonstrate that the brain is not just a squishy, wrinkled blob whose deepest mysteries are only accessible to researchers, but rather, that it is actually beautiful in the intricacy of its architecture and the familiarity of its form. I want these neurons prompt viewers to ask questions about what these strange, yet recognizable, structures are, how they work, and why they matter. For me, turning the brain into art introduces my discipline to a broader audience in an instantly engaging way, which in turn, helps me connect with new people. At the nexus of science and art is where I find inspiration and engaging, innovative conversations. As humans, we all have similar brains enhanced by our multitude of varied experiences, ideas, and interests. Don't you think it's time we get together and see what's in there?

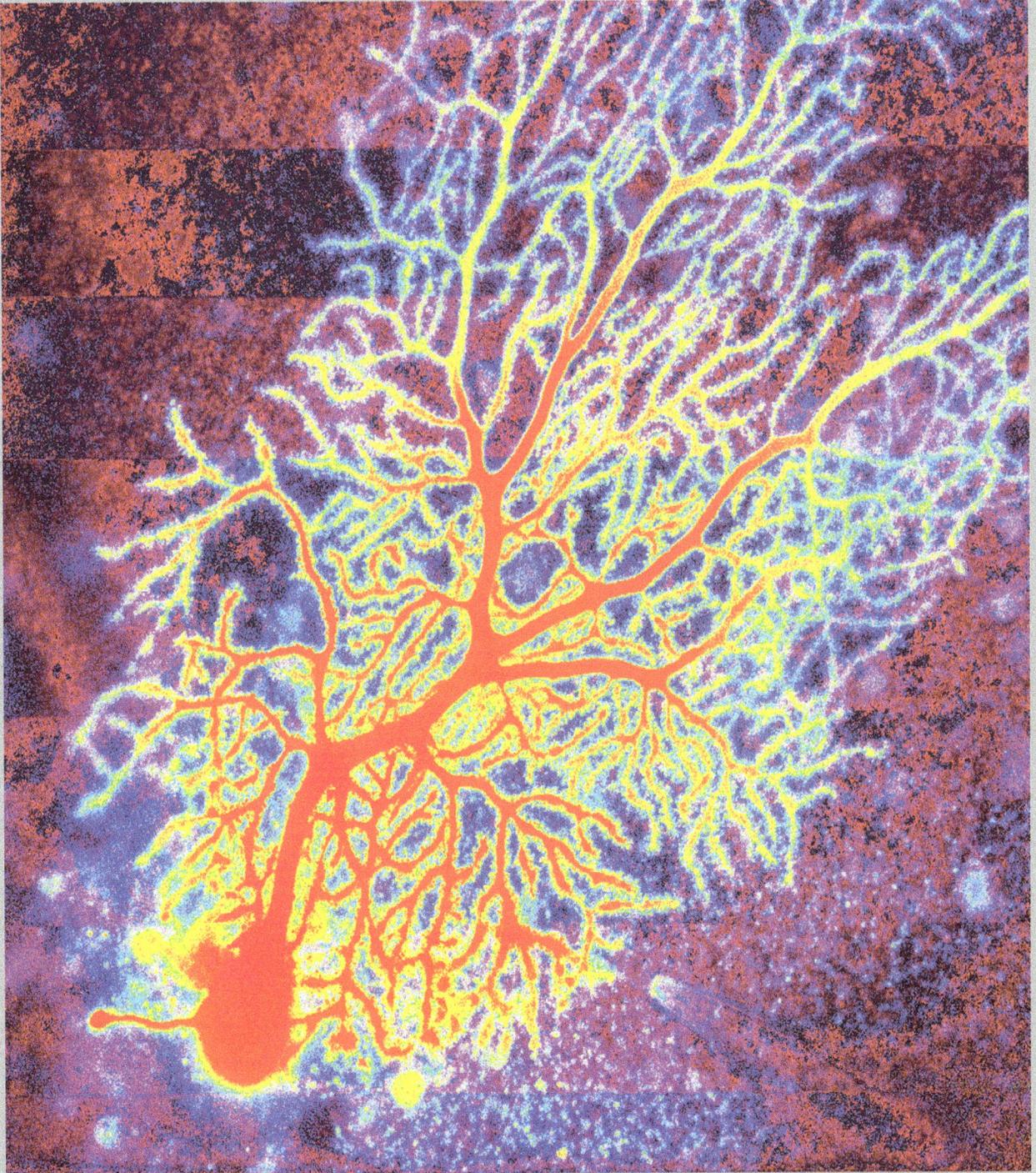

Dana Simmons

Axon, Micrograph, 2016 © Dana Simmons

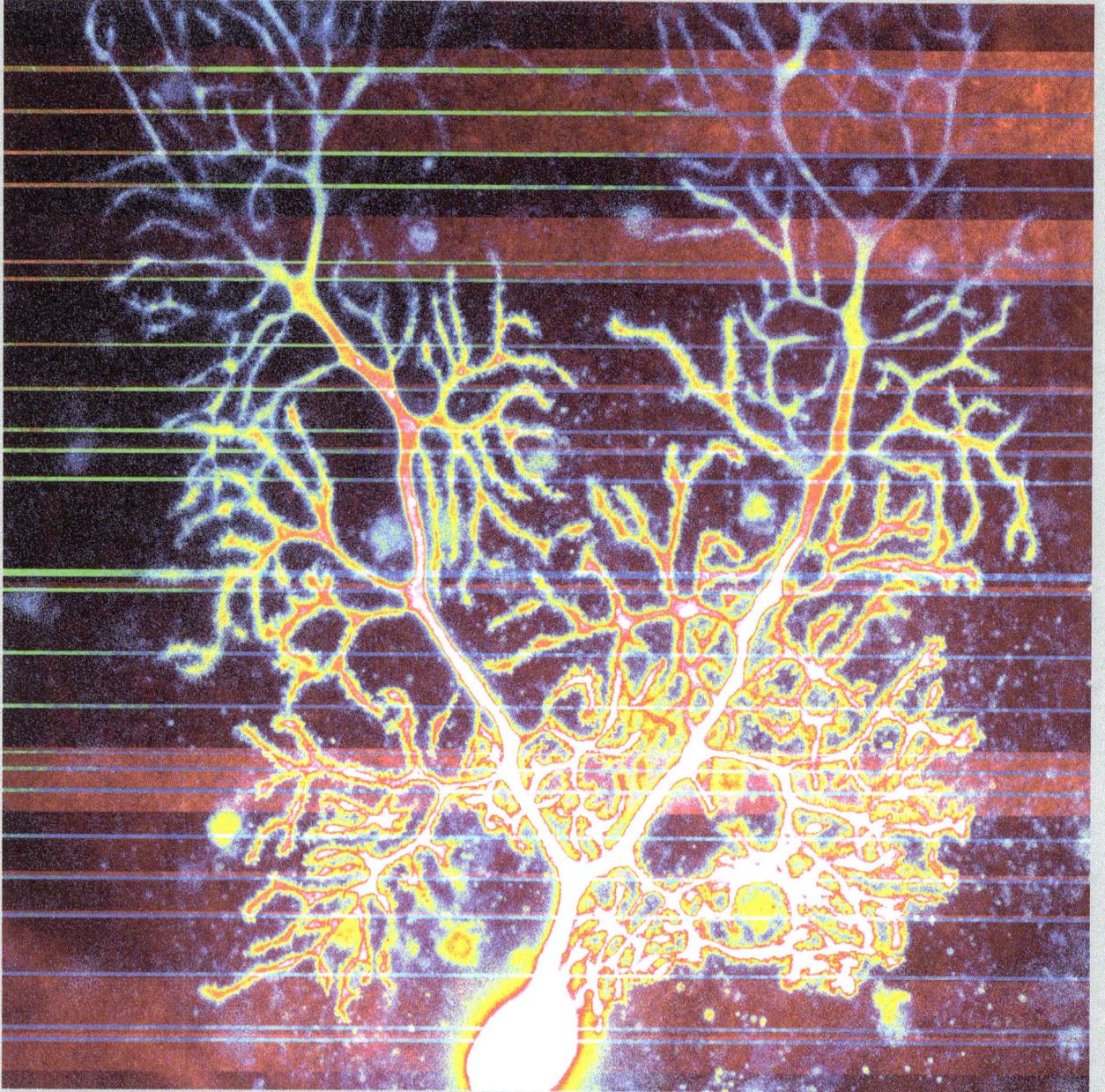

Dana Simmons

Beams, Micrograph, 2016 © Dana Simmons

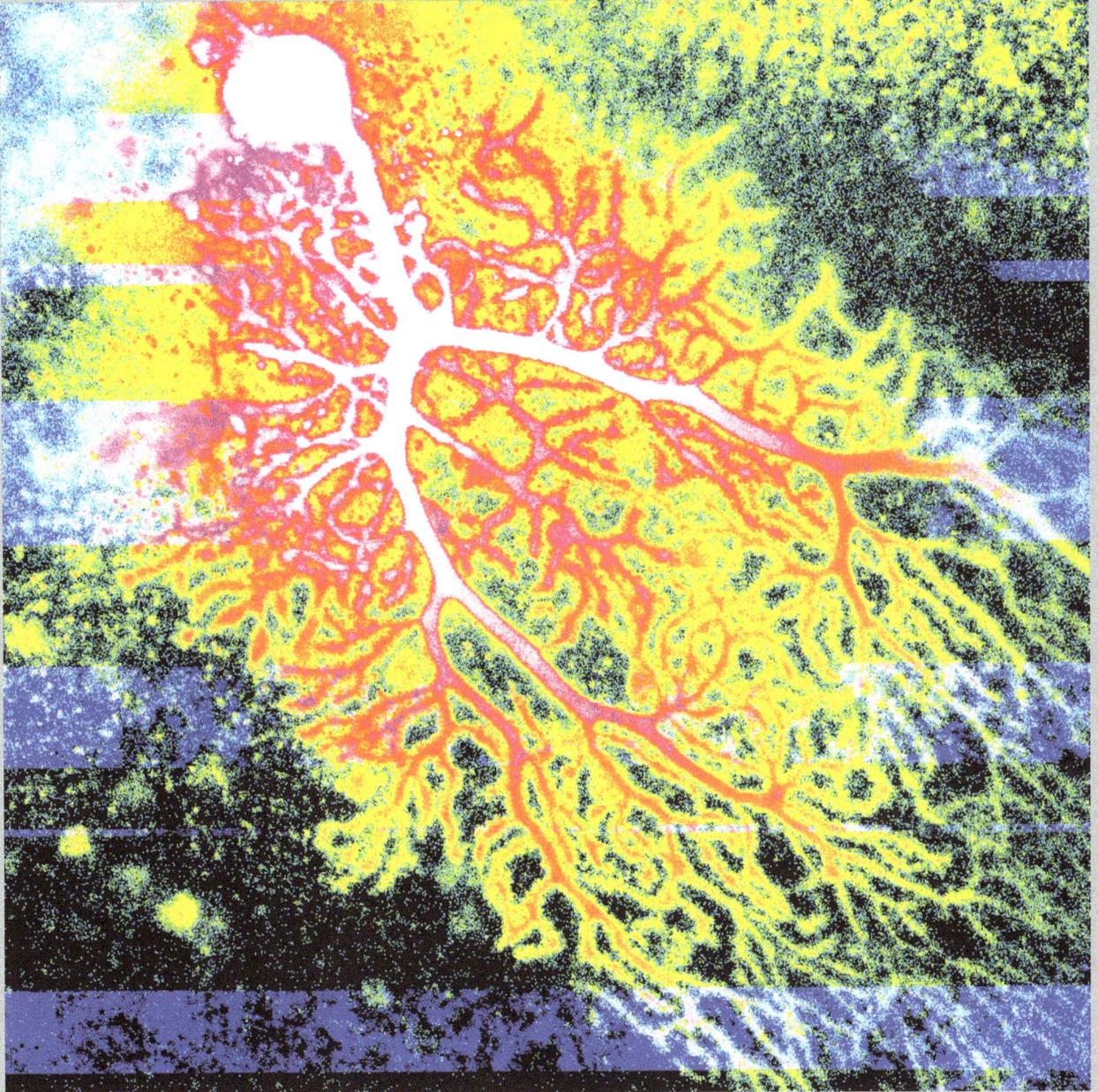

Dana Simmons

Branching Out, Micrograph, 2016 © Dana Simmons

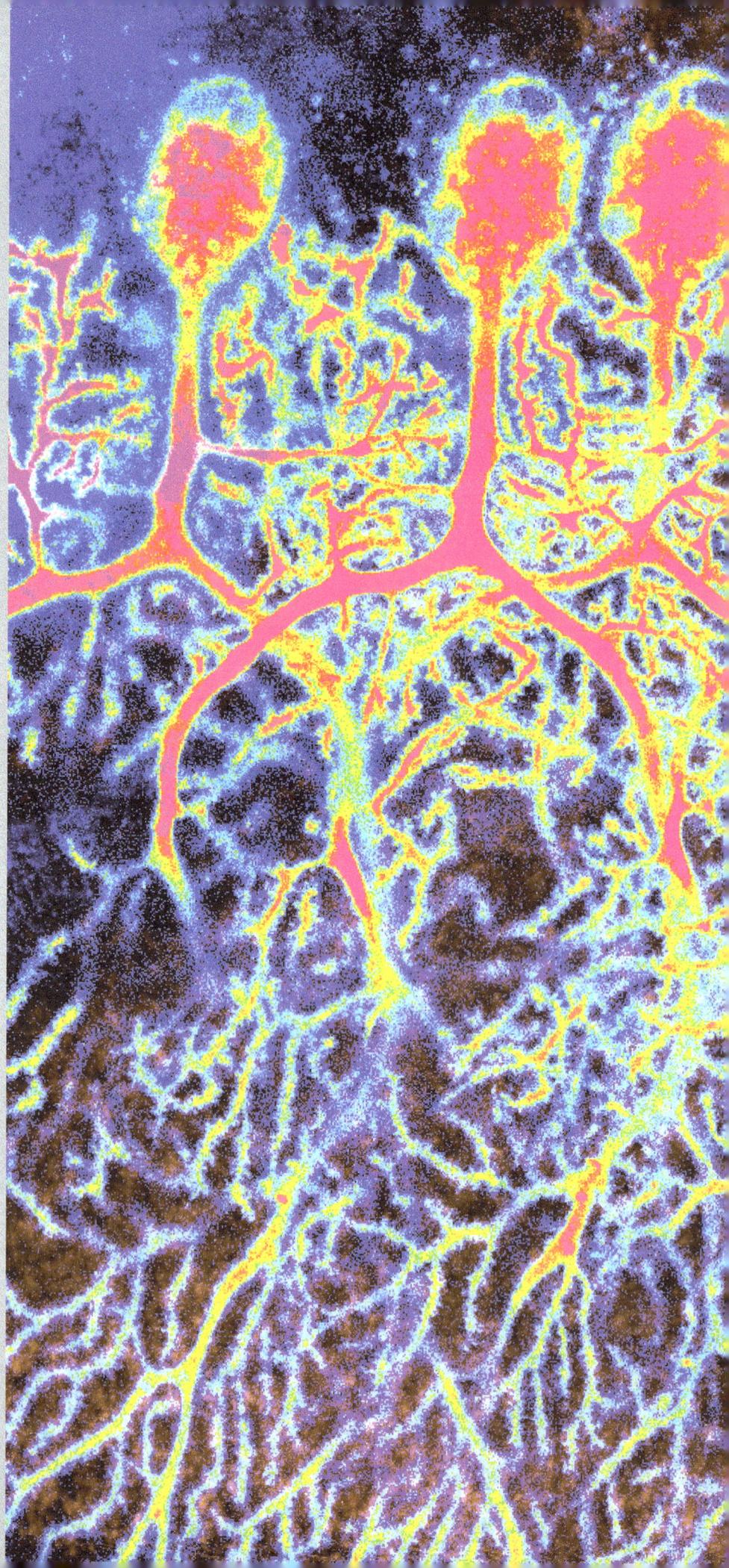

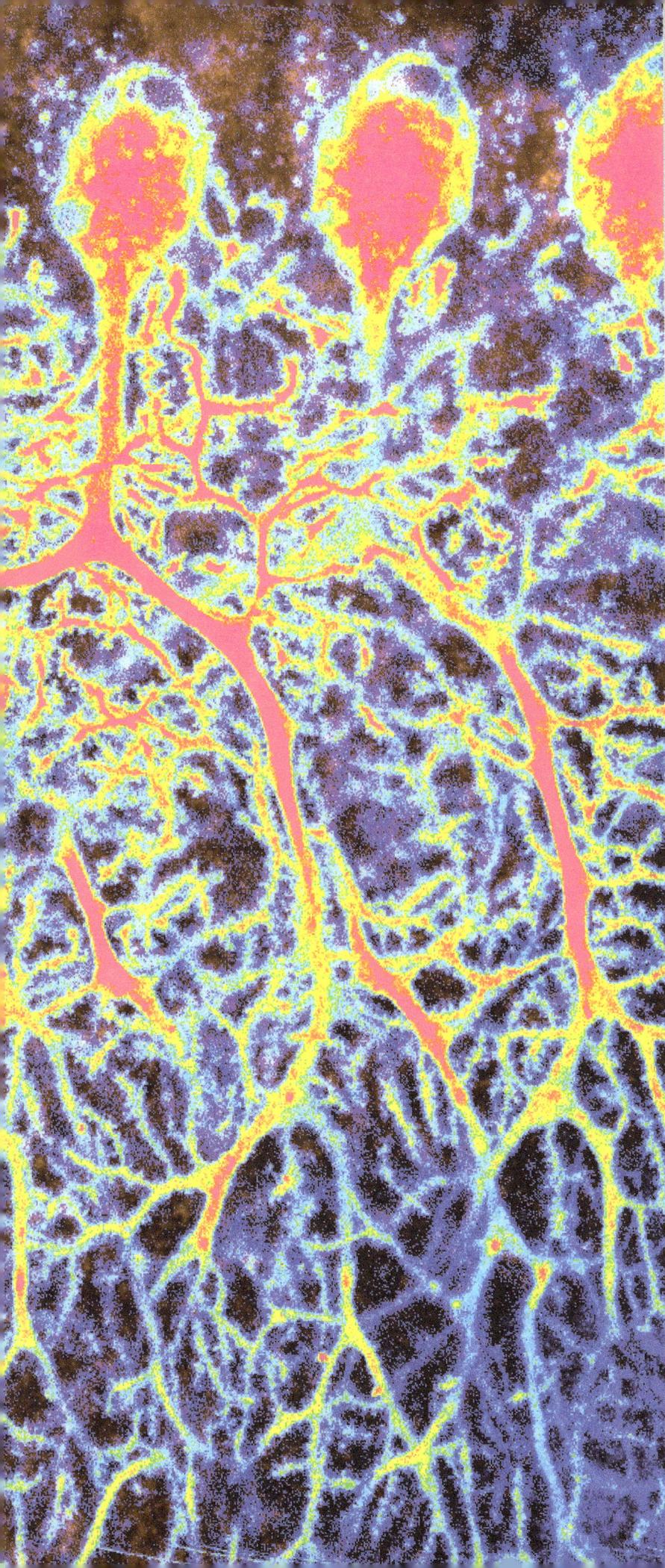

Dana Simmons

Dana Simmons h, 2017 © Dana Simmons

Cygnes, Micrograph, 2017

© Dana Simmons

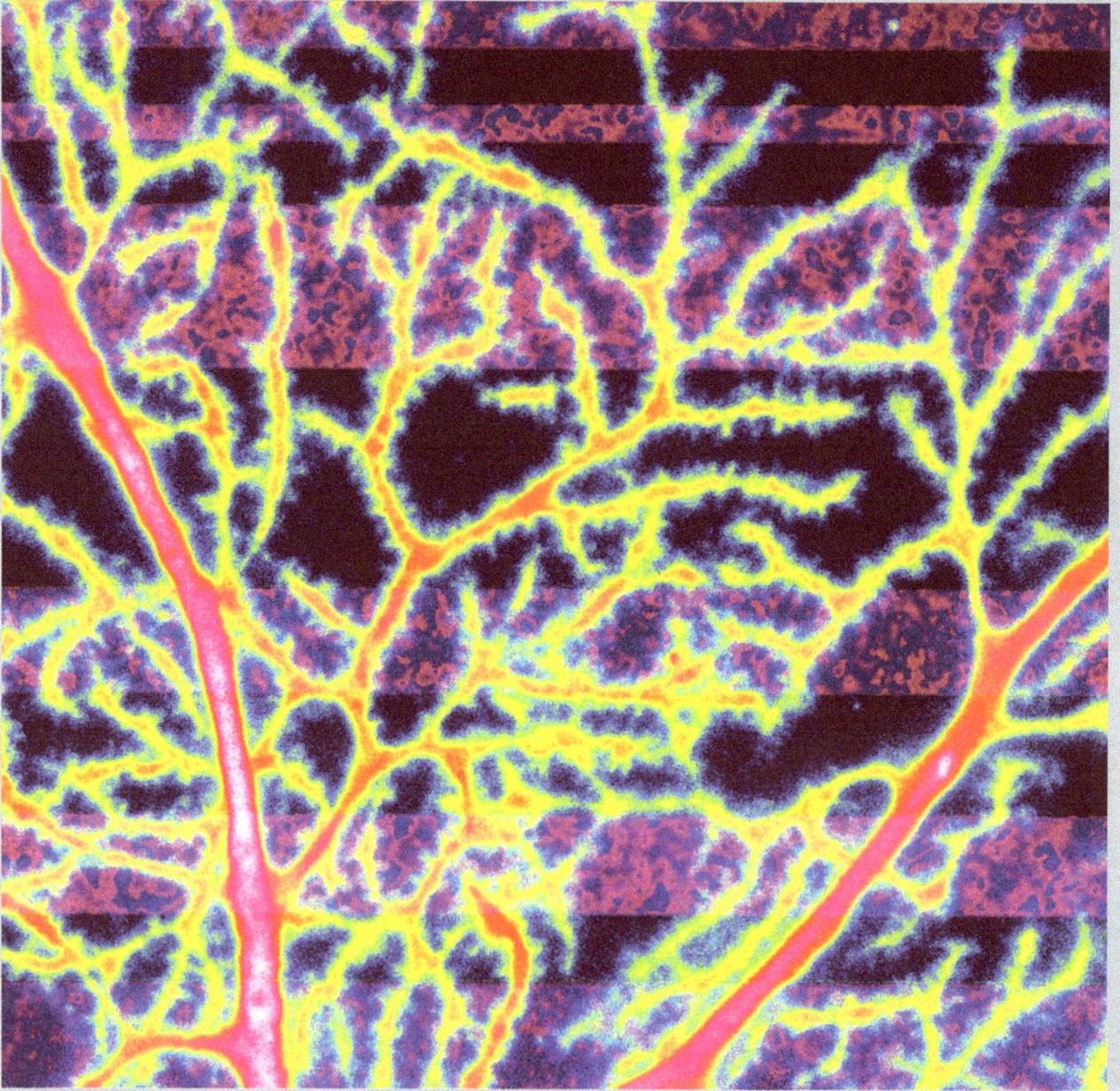

Dana Simmons

Dendrites, Micrograph, 2016 © Dana Simmons

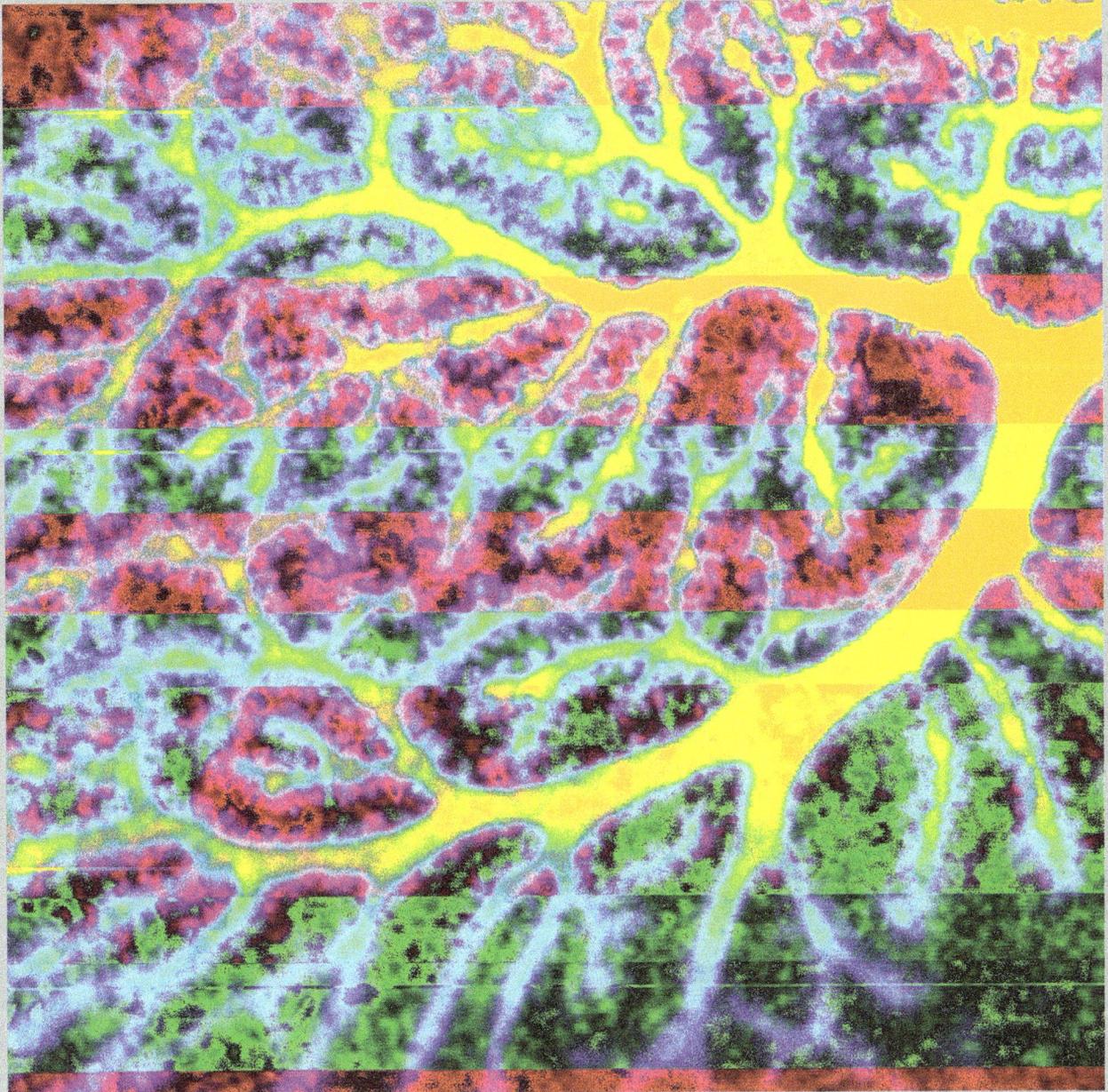

Dana Simmons

Voltaic, Micrograph, 2017 © Dana Simmons

Dana Simmons is a neuroscientist, internationally recognized award-winning science-artist, and medical writer in Chicago. She holds a Ph.D. in neurobiology from the University of Chicago, where she researched the cerebellum and autism. While at the university, Dana transformed Purkinje neurons into art by stretching the limits of her microscope's capabilities to infuse neurons with color and light. Dana has exhibited her artwork in Chicago, New York, Vancouver, and the Netherlands; her artwork has been featured in *Nature, Cell,* and *The Scientist;* and she was part of the inaugural group of Bridge Residents for the SciArt Center of New York. She received the Passion in Science Award for Arts & Creativity from the New England Biolabs in 2016. Dana volunteers as Co-Editor-in-Chief of *Science Unsealed,* the Illinois Science Council's blog, which aims to inspire curiosity and start conversations about science.

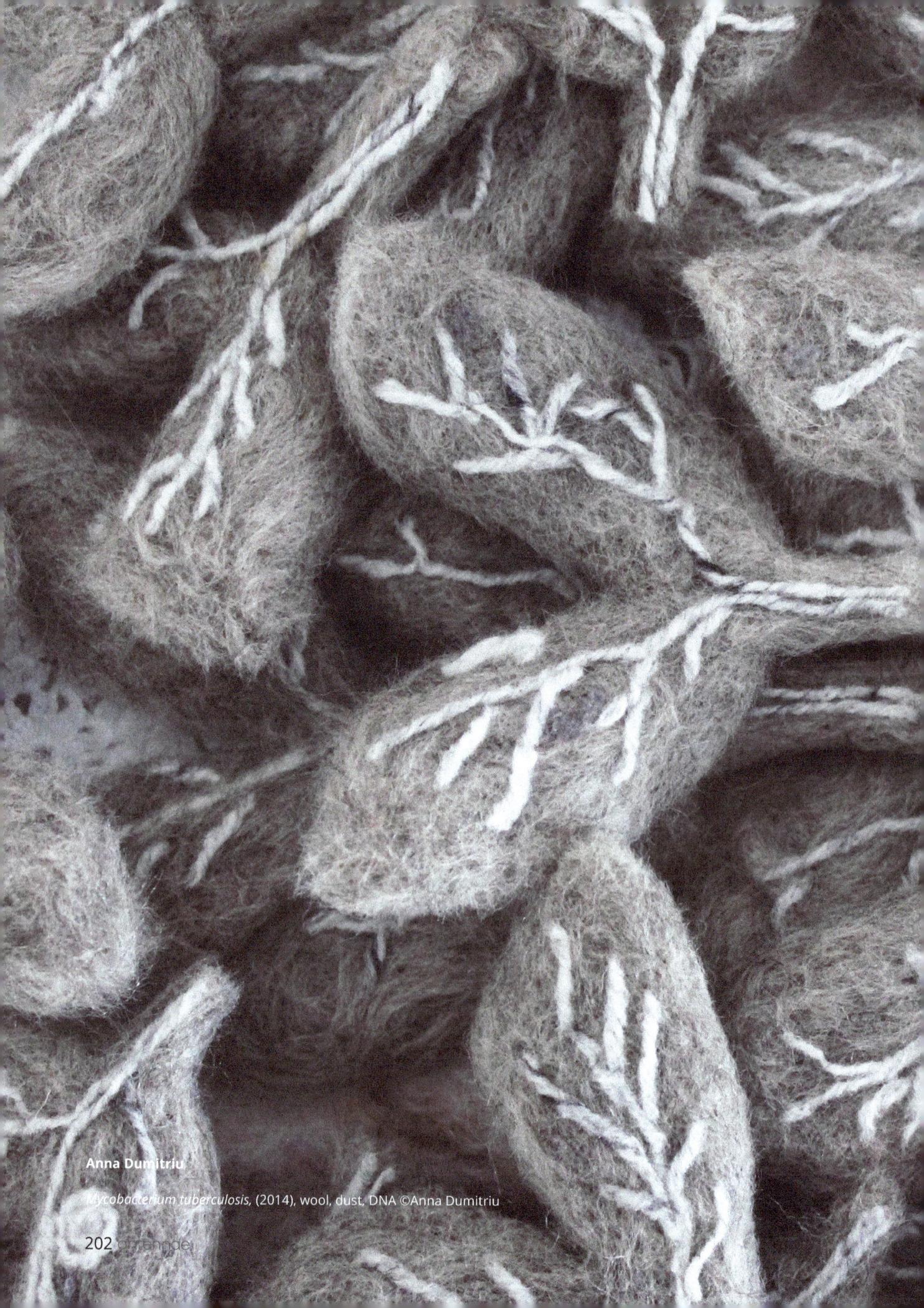

Anna Dumitriu

Mycobacterium tuberculosis, (2014), wool, dust, DNA ©Anna Dumitriu

Contemporary Relics: Threads Across Time in Bio Art

This article explores the ways in which I incorporate relics of some of the most sublime bacteria to have ever existed in my artworks. It considers the health and safety challenges that my collaborators and I face in producing and exhibiting these artworks, which take the form of sculptural objects or installations and incorporate diverse materials such as altered historical objects or textiles combined with bacteria and DNA. In my artworks I make links between the history of science or medicine and cutting-edge research in synthetic biology and genomics. I aim for the objects I make to become affecting relics of the sublime processes I undertake in the lab, as I work deeply embedded in biomedical research settings using new and emerging technologies. I am inspired by historic stories of infection and contagion as well as contemporary research and aim to make objects that enable me to question our relationship to scientific knowledge, exploring how beliefs and ideas evolve, drawing threads across time.

text by and images **Anna Dumitriu**

In my artistic practice I explore the aesthetic, cultural and societal impacts of some of the most sublime bacteria to have existed and incorporate relics of these organisms within my artworks. I am frequently faced with complex health and safety challenges to produce and exhibit my artworks which take the form of sculptural objects or installations because for me it is necessary to incorporate diverse materials such as altered historical objects or textiles grown with bacteria or impregnated with DNA. (Dumitriu, 2018) The presence of these 'real' organisms, albeit in a safe form, is very important to me and this text attempts to explain why.

The Bacterial Sublime
I often talk about the idea 'the bacterial sublime' which I first started to consider and define around 15 years ago. It has always seemed to me, that this idea is very important to our relationship with bacteria and this is why the objects I make must contain contemporary relics of the laboratory process. From the start, I was greatly inspired by Edmund Burke's *A Philosophical Enquiry into the Origins of Ideas of the Sublime and Beautiful*, which was first published in 1757, when the author had reached the age of 27. Burke had commenced work on the book at least 10 years prior, at just 17 years of age, whilst studying at Trinity College in Dublin. For this reason, it bears the trademarks of the work of a young writer. It is full of passion and drama but the themes laid out in the text reverberate through aesthetic theory, right up until the present day. "The passion caused by the great and sublime...is that state of the soul, in which all its motions are suspended, with some degrees of horror" (Burke 1757, 57).

In his writing, Burke insists that the sublime is dependent on qualities that can be found in objects (in contradiction to later philosophers such as Kant who see the sublime as something created in the mind of the experiencer) but that it seems to allow space for an examination of the potential psychological and physiological causes of aesthetic pleasure. His text became one of the most important 18th Century works of aesthetic theory, built on the effects of the emotions and founded on an analysis of terror. It appears that, like Wordsworth, Burke was attracted to "that beauty... that hath terror in it". (Wordsworth 1888, Book 13). I love the idea, that an experience of the sublime can be captured in an object and these remnants of my process, collected in the lab become like relics of contagion, genetic modification and pain from our insufficient attempts to extend human knowledge.

We owe the theorization of the value of terror as an aesthetic pleasure in art and nature to Burke's enquiry. The opposition of pain and pleasure is central to Burke's whole system. He sees pain as the basis for the sublime and pleasure as being the basis for beauty. Earlier theorists had suggested that pain and pleasure were caused by the effects of ugliness and beauty, but Burke differs in his reading, being fascinated in the way that pain can be a source of pleasure, if judged aesthetically. In opening up the nature of aesthetic judgment in this way, and showing pain to be the foundation of the sublime, he allowed room for many aspects of art that could not have previously been viewed as a source of aesthetic pleasure.

An important quality for Burke's notion of the sublime is obscurity; he seems fixated on the non-rational aspects of art: "It is one thing to make an image clear, and another to make it affecting

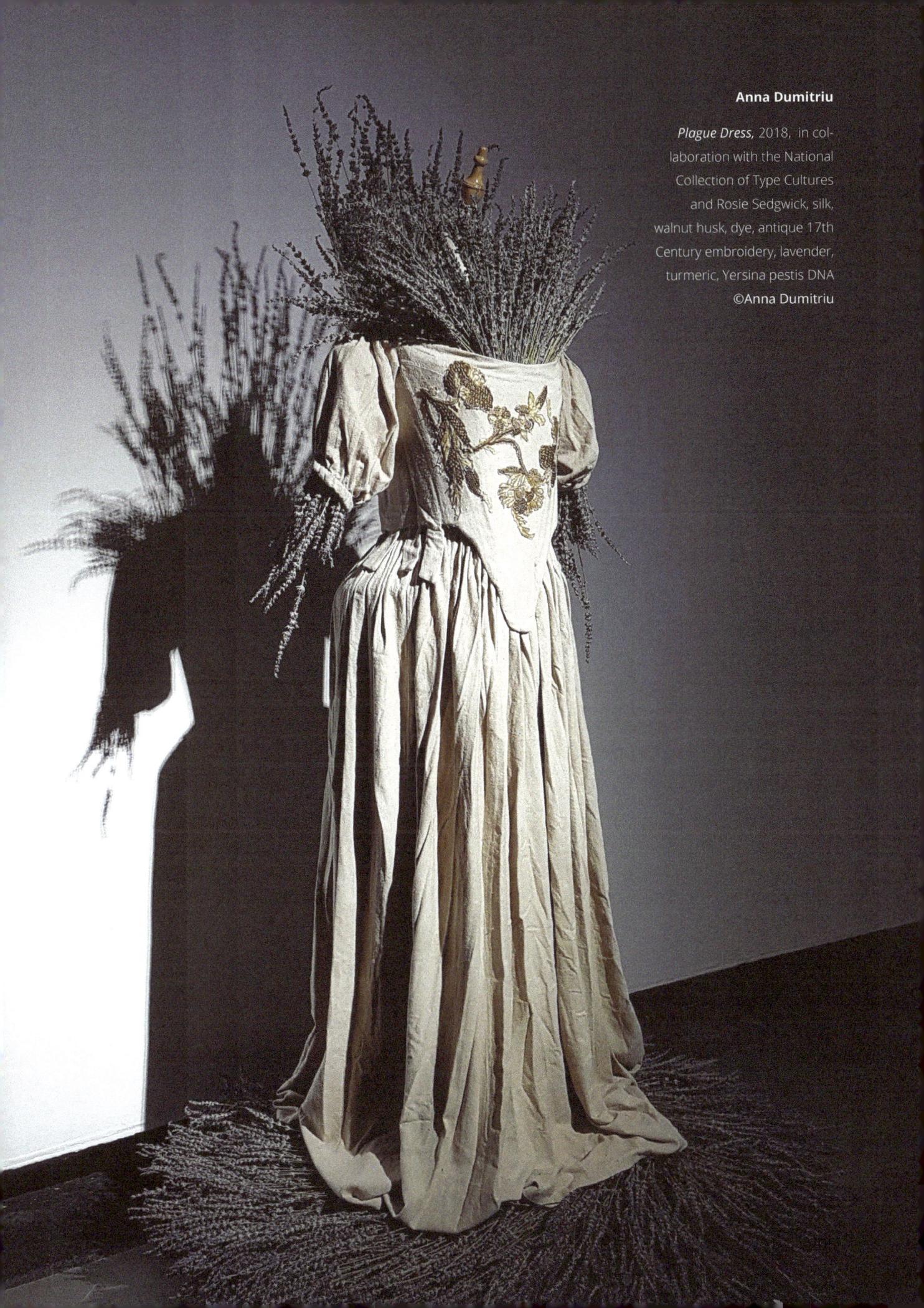

Anna Dumitriu

Plague Dress, 2018, in collaboration with the National Collection of Type Cultures and Rosie Sedgwick, silk, walnut husk, dye, antique 17th Century embroidery, lavender, turmeric, Yersina pestis DNA
©Anna Dumitriu

to the imagination". (Burke 1757, 55) Burke goes on to explain the effects of these ideas, which he sees as possessing sublime qualities through psychology and physiology, in order to work out the "efficient cause" of the sublime. He uses an analytical, empirical method that has strong relations to contemporary psychology, which is made clear by his assertion: "When we go but one step beyond the immediate, sensible qualities of things, we go out of our depth" (Burke 1757, 117). This sums up our ongoing attempts in science to create new tools that throw our ideas into question and shift paradigms. Methods like whole genome sequencing and synthetic biology are opening up our understanding whilst simultaneously revealing how much more we have to learn. This is combined with our ongoing 'battle' with infectious diseases caused by bacteria and viruses, some of which have had such significant impacts on humanity that they have effectively changed the world.

Plague Dress

One of the most sublime organisms is the bacterium *Yersinia pestis* which causes the dreaded disease known as *the plague*. There have been three major outbreaks of the plague (so far) (Rasmussen 2015, 571), starting with the first pandemic known as the Plague of Justinian in the 6th and 7th centuries which is estimated to have killed half the population of Europe. The second pandemic is believed to have originated in or near China and spread along the Silk Road or by ship and succeeded in reducing the global population by between 75-100 million by 1400. During the time of the 'Black Death' (1347-1351) 75-200 million people in Europe and Asia perished, dramatically changing the social structure. The prospect of impending death led to a widespread sense of morbidity that led people to live hedonistically. It also led to the creation of public health regulations and local government systems as cities tried to create strategies to ameliorate the hygiene. Many of these structures and rules continue in some form today.

The second pandemic reoccurred until the late 19th Century but the most dramatic story of this for me is the one I grew up being told about over and over again: The Great Plague of London. Thanks to the diarist Samuel Pepys we have a fantastic record of daily life in London before and during the Great Plague of London in 1665 and then the Great Fire of London in 1666 which led to much destruction in the City of London. London was much smaller in those days. We studied this era or history for weeks at the age of 8. At school we were told what people had believed for centuries, that the fire, which started in a baker's in Pudding Lane, had killed all the rats that played host to the plague carrying fleas. But this is not the case, in fact plague epidemics tend to rage for a while and die out as the susceptible population is extinguished and the survivors resist or recover (and produce antibodies to the disease). This happened in many other cities in Europe without the occurrence of a citywide fire. But the Great Plague and the Great Fire of London make for a great story. One which terrified me as a child as I still feared another outbreak. The most striking thing about reading *The Diary of Samuel Pepys* is just how normal and everyday things sound. We sometimes feel that the 17th Century is ancient history but actually very little has changed in what people feel and even do. Pepys's everyday concerns with taking riverboats to visit his mistress and worries about coughing captains, or if his favourite coffee

shop would be closed (and anyway would it be too risky to go there) and worries that he couldn't get any new clothes as the silk merchants and cloth workers were most dramatically affected. Life goes on even during a period as dramatic as the Great Plague and we can look now to stories around contemporary epidemics such as recent significant outbreaks of Ebola and a kind of contemporary viral sublime as we deal with the invisible and unseen harbingers of disease.

My fears, as an 8-year-old, of a return of the plague were certainly not relieved by my teacher's choice of story book for her class: at the end of the day she would read to us from *Dracula* by Bram Stoker, and my child's mind did not struggle to make connections between the spread of the plague and the idea of vampirism. In fact, both plague and tuberculosis have been blamed on vampires in the past as victims of the diseases as their families sought to make sense of these contagions. Additionally, minority groups were also incorrectly persecuted and blamed for the plague in a way not dissimilar to the present-day blame assigned to immigrant groups for modern economic problems. My continuing attempt to unravel the dramatic impact of these lessons on my young self have been quite central to my life's work in many ways.

Through my long-term work as an artist embedded in the field of microbiology working with Modernising Medical Microbiology at the University of Oxford, with whom I have been artist in residence since 2011, and with numerous other laboratories in the UK and internationally, I have gained extensive laboratory experience working with human disease-causing organisms known as pathogens. With my long-term collaborator Professor John Paul, I was able, in early 2012, to confront plague at first hand, through the support of Novel and Dangerous Pathogens Training at what was then known as HPA Porton, one of the highest security microbiology labs in the UK. I learned to handle the *bacterium*, visually identify it, and stain it to look at it under the microscope.

My *Plague Dress* (2018) is based on a 1665 style gown made from raw silk, which I hand-dyed with walnut husks. I was inspired by famous 17th Century herbalist Nicholas Culpeper (Culpeper's Complete Herbal 2018) who recommended a great many (not particularly useful) treatments for plague including walnuts. I used the husks, the outer parts that surround the shell, which are famous as dyes, and built on my past works which focussed on the relationship of dye and microbiology with a focus on antimicrobial dyes. You have to cook up a huge pot of walnut husks to make a treacle coloured dye which smells almost exactly like the disinfectant used today in hospitals, and then you must steep the cloth for at least 24 hours. I am obsessed with the history of dye and its relationship to microbiology which has so many connections, from the early natural dyes used as medicines, such as madder root, woad, saffron or turmeric to more modern uses of chemical dyes such as the early bacteriostatic drug Prontosil which was based on Paul Ehrlich's idea of the 'magic bullet' and brought to market by Bayer in 1935, before Penicillin which soon replaced it.

The *Plague Dress* is appliqued with original 17th century embroideries accompanied by a description of its provenance, which I sourced many years ago from an auction house. The piece of embroidery included metallic thread and was decayed so much it was barely held together between the embroidered sections. I repurposed these forgotten and unwanted relics of the great plague era,

I am obsessed with the history of dye and its relationship to microbiology which has so many connections, from the early natural dyes used as medicines, such as madder root, woad, saffron or turmeric to more modern uses of chemical dyes such as the early bacteriostatic drug Prontosil which was based on Paul Ehrlich's idea of the 'magic bullet' and brought to market by Bayer in 1935, before Penicillin which soon replaced it.

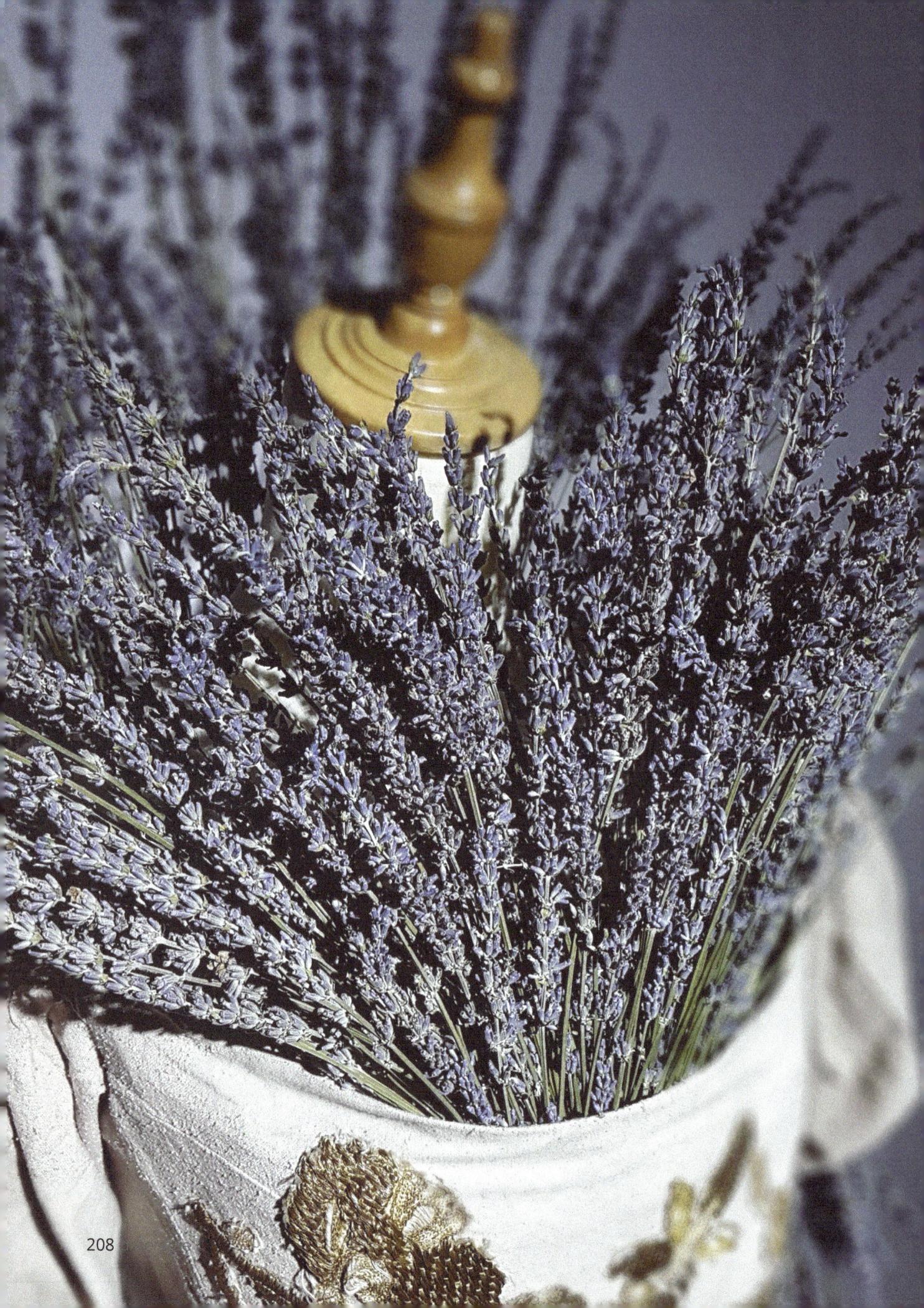

and gave them new life within my artwork.

I am now artist in residence in the laboratory of the National Collection of Type Cultures (NCTC) at Public Health England. The NCTC is the oldest and most historical collection of pathogenic bacteria in the world. NCTC supplies reference bacterial cultures of medical, scientific and veterinary importance worldwide. The cultures include many type strains (these are the organisms to which other strains are compared with to know whether they belong to that same species or not). NCTC strains support academic, health, food and veterinary institutions and are used in microbiology laboratories in a range of different sectors and in research institutes worldwide. Founded in 1920, NCTC is the longest-established collection of its type anywhere in the world, and also serves as a United Nations Educational, Scientific and Cultural Organization (UNESCO) Microbial Resource Centre (MIRCEN). The certified collection comprises over 5,000 bacterial cultures, all of which are available in a freeze-dried format. The NCTC have a large-scale project called NCTC 3000 which will produce complete genome sequences of 3000 Type and reference bacterial strains and 500 viruses from the PHE Culture Collections as the foundation for biomedical research and discovery (Public Health England, 2018). Through this work they know how to safely extract the DNA from many different species in a completely safe way so that they can be studied using whole genome sequencing technologies. I was able to benefit from this expertise and built on my previous works made with sterilised tuberculosis DNA, to extract the DNA from killed samples of Yersinia pestis in the lab, under strict supervision, in order to incorporate the sterile DNA in new artworks (Public Health England 2018).

For me the incorporation of actual traces of the sublime organisms somehow in my work is very important, be it the idea of the remnants on antique medical devices or books bought online, or growing live bacteria into cloth, these remains become relics of the processes and ideas behind the work. To use DNA as a medium is very important to me. It is wholly sterile and safe to exhibit and work with pure DNA, based on extensive lab protocols at the highest level, but it is the 'instruction book' of life of whatever organism I am working with.

The *Plague Dress* is impregnated with samples of DNA from killed *Yesinia pestis*. The dress is also stuffed with bunches of lavender which were historically carried under people's noses during the Great Plague of London to cover the stench of infection, and prevent the disease, which was believed to be caused by 'bad air' or 'miasmas'. The roll, a piece of padding typically worn under the skirt to puff it out, contains a pungent mixture of herbs and spices that would have been stuffed into beak-like masks of plague doctors.

The silk that the dress is made from references the Silk Road link, but also the fact that the first and worst affected tradespeople to suffer in the Great Plague of London were the cloth workers who received the imported fine silks and linen. Almost everyone in that period knew of stories of plague entering communities by cloth, especially light-coloured fabric, a famous example being the 'plague village' of Eyam in Derbyshire, UK, where the pestilence arrived via the village tailor on a bundle of flea infested cloth from London.

The *Plague Dress* premiered in Guangzhou in China as part of the 6th Guangzhou Triennial. It is particularly relevant to connect Guangzhou (formerly known as Canton) to London as both cities

The Plague Dress is impregnated with samples of DNA from killed Yesinia pestis. The dress is also stuffed with bunches of lavender which were historically carried under people's noses during the Great Plague of London to cover the stench of infection, and prevent the disease, which was believed to be caused by 'bad air' or 'miasmas'.

have suffered extensively from plague. Guangzhou was a key trade port on the maritime Silk Road which is thought to be an important vector for the spread of the disease and much later, during the third plague pandemic, the disease killed 60,000 people in Guangzhou in just a few weeks beginning in March 1894. This plague biovar known as *Orientalis* persists even today with an average of 4000 cases reported per year, it is endemic in the rodent population in places including the USA, but one of the most significant foci for this disease today is Madagascar, where in 2017 there was a serious outbreak of bubonic and pneumonic plague (Vincent 2015, 8).

Plague is a disease of poverty. The lack of proper infrastructure, sanitation and clean water in Madagascar exacerbates the situation alongside a lack of healthcare resources leading to an average mortality rate of 30%. It is important to consider that even a disease as 'medieval sounding' as plague is still with us and that, even today, we only are a few steps away from the possibility of another pandemic. In fact, the increasing world-wide phenomenon of antibiotic resistance is significant even with the plague. Two multidrug-resistant strains of *Yersinia pestis*, one resistant to all of the antimicrobial agents recommended for treatment and prophylaxis of plague and the other resistant to a smaller array of drugs have been isolated in Madagascar as far back as 1995 (Galimand 2006, 3234).

This ability of bacteria to evolve rapidly makes them particularly dangerous as pathogens. Recent research from 2015 now shows evidence that *Yersinia pestis* bacterial infection in humans actually emerged around the beginning of the Bronze Age suggests that plague may have even caused major population declines that are believed to have taken place in the late 4th and early 3rd millennium BCE. Researchers studied the genomes of plague isolated from the teeth of 7 Bronze Age adults, the oldest of whom died 5,783 years ago (the earliest evidence of plague) and found that in six out of the seven samples the disease lacked two key genes that allowed the bacterium to survive in the guts of fleas or to spread across different kinds of tissues outside of the lungs. These mutations are believed to have occurred around 1000 BCE and enabled the plague to take its bubonic form and spread rapidly via fleas. In many ways the fleas that carry the disease and their hosts, the rats, take the blame for the plague. But we must remember that they are as much victims as the human sufferers. One of the mutations that prevents *Yesinia pestis* from being destroyed by the toxins in flea guts, enables it to multiply and block the flea's digestive tract, thereby causing the starving flea to go on a crazed spree of biting before it too dies. (Rasmussen 2015, 571). Researchers look at this historical plague DNA evidence to understand how the plague, and other diseases might evolve in the future and how the sublime plague shaped world history.

Clean Linen

A related work exploring the DNA of deadly pathogens is *Clean Linen* (2018). This piece takes the form of an antique French nightgown that I embroidered with images of the bacteria that cause plague, tuberculosis, scarlet fever and diphtheria and where highly prevalent in the era of the Great Plague of London. It is also invisibly impregnated with the extracted DNA of those sublime organisms. In past centuries it was not common practice to wash the body as people believed washing their linen clothes was sufficient (an idea

Plague is a disease of poverty. The lack of proper infrastructure, sanitation and clean water in Madagascar exacerbates the situation alongside a lack of healthcare resources leading to an average mortality rate of 30%.

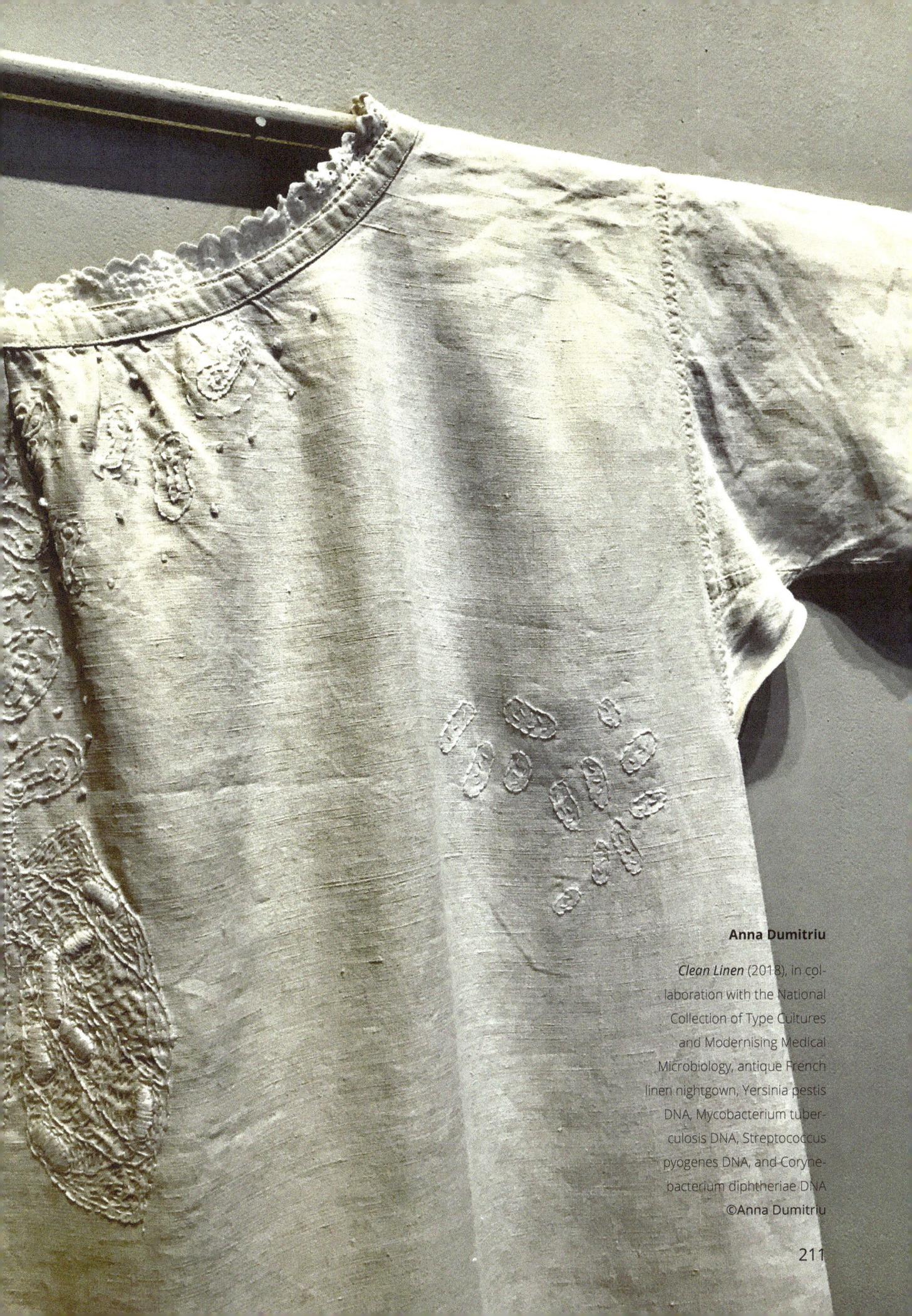

Anna Dumitriu

Clean Linen (2018), in collaboration with the National Collection of Type Cultures and Modernising Medical Microbiology, antique French linen nightgown, Yersinia pestis DNA, Mycobacterium tuberculosis DNA, Streptococcus pyogenes DNA, and Corynebacterium diphtheriae DNA ©Anna Dumitriu

211

that seems to have originated in France) and that "linen washed the skin through humoral regulation" (Dolan 2015, 35). This was related to the belief that clothing spread disease, which arose around the time of the Great Plague due the high death rate of clothworkers. Having clean linen was specifically used to express cleanliness and respectability, even for poorer people who rarely washed their bodies. Linen fibres become stronger when wet and are not damaged by washing, unlike silk and wool. The gown is impregnated with the DNA of *Yersinia pestis* (plague), *Mycobacterium tuberculosis* (TB), *Corynebacterium diphtheriae* (diphtheria) and *Streptococcus pyogenes* (scarlet fever) DNA, which my collaborators and I in the lab as part of the process of whole genome sequencing the organisms.

As I mentioned before, we think of these infections as 'diseases of the past' but I have already shown that we would do well not to be so complacent. Currently a quarter of the global population are infected with TB. In 2017, 10 million people around the world became sick with the disease and there were 1.3 million TB-related deaths worldwide. It is the leading killer of HIV positive patients (Centers for Disease Control and Prevention 2018).

The history of TB, like plague, is also closely linked to the history of the human race and is the earliest disease to have so far been found in ancient remains as far back as 9000 years ago in the Neolithic era, and later in Egyptian mummies, including the mummified body of Akhenaton (the father of Tutankhamen). It is a form of Mycobacterium, similar to *Mycobacterium leprae*, which causes Hansen's disease (previously known as Leprosy) and Mycobacterium vaccae, a soil bacterium now thought by some scientists to act as an antidepressant.

The vampire folklore tradition is also consistent with modern knowledge of the transmission of tuberculosis. Many of the historic accounts indicate that family members living in close association became infected with the disease before or soon after the death of the "vampire."

The Romantic Disease

TB, popularly known as 'Consumption' in the past (because the body appears to be literally consumed from within) was described as 'the romantic disease' and believed to be a cause of extreme creativity in the form of the *Spes Phthisica*, a form of euphoria brought about by the latter stages of pulmonary disease, leading the poet Byron to declare: "I should like to die of a consumption". The controversial "genius germ hypothesis" published in 2009 continues to argue a similar point: that infectious agents may be involved in the chain of causation of schizophrenia—a disease characterized by abnormal lipid metabolism in the brain and increased creativity. Manipulation of host-lipid pathways represents a significant mechanism for *Mycobacterium tuberculosis* and *Mycobacterium leprae* to cause and sustain infection. Leprosy and tuberculosis epidemics endemic to Europe but not to Asia are therefore speculated to positively select for schizotypal genes or alteration of the lipid metabolism phenotype in this population resulting in "evolutionary disproportionate" increases in cerebro-diversity and cognition beyond the threshold required to affect scientific or technological paradigm change—as occurred in the Renaissance and during the Industrial Revolution (Apte, 2009).

Throughout the ages, a diverse number of causes have been blamed for TB from demonic dogs (whose barking could be heard in the coughs of sufferers) to vampires, with ritually buried corpses being found in New England, USA from as late as the 19th Century. The New England vampire belief is based on a folk interpretation of the physical appearance of the tuberculosis victim and the transmission of tuberculosis. As the name "consumption" im-

Anna Dumitriu

Pneumothorax Machine (2014), carved and engraved antique Pneumothorax Machine, wood and metal © Anna Dumitriu

plies, the disease caused sufferers to "waste away" and "lose flesh," despite the fact that they remained active, desirous of sustenance, and maintained a fierce will to live (Brown, 1941). This dichotomy of desire and "wasting away" is reflected in the vampire folk belief: The vampire's desire for "food" forces it to feed off living relatives, who suffer a similar "wasting away." The vampire folklore tradition is also consistent with modern knowledge of the transmission of tuberculosis. Many of the historic accounts indicate that family members living in close association became infected with the disease before or soon after the death of the "vampire." (Sledzik and Bellantoni, 1994)

In fact, throughout history the folk myth of the vampire has been a popular explanation of disease and to stop an epidemic, "vampires" might be sought out and "killed" by various methods (Perkowski, 1989). So, the wasting diseases, which infected many romantic poets and gothic novelists, may have also been their inspiration, such as in John Keat's "Lamia". Even Bram Stoker, the writer of "Dracula" is suspected to have died of Syphilis, another bacterial infection, which also produces 'vampire-like' symptoms, such as swollen gums, causing prominent teeth, sensitivity to light and a pale complexion (Krumm, 1995).

I voraciously collect relics both of TB history and of contemporary research processes, many of which I have worked with myself in the lab. The laboratory items are of course sterilised to the highest level and present no risks to visitors. I incorporate both

213

Anna Dumitriu

Rest, Rest, Rest!, 2014, metal, cotton, madder root dye, walnut husk, dye, safflower dye, and Mycobacterium tuberculosis DNA
© Anna Dumitriu

these kinds of relics into artworks my artworks and have many more saved in my studio to become incorporated into future planned works. I particularly enjoy a copy of a book from the 1930s in my collection, which advises the reader on how to clean up after a patient has either recovered from or succumbed to TB and recommends that the pages of books read by the patient should be sunned for three weeks and kept out of circulation for 1 month, unless obviously soiled. Now we know that this method is both not particularly useful in killing the germs, nor is it necessary. TB cannot be spread by books.

My mother who was born in 1929 told me a sad story that she took her only doll with her to the hospital when she was sick as a child (not with TB) and that the nurses would not let her take the doll home after, presumably under a similar logic. I also have in my collection plates and doorknobs marked with the two bar 'Cross of Lorraine' which was widely used as a symbol as the 'crusade against TB' notably by the American Lung Association. I am currently developing a sculptural work with the doorknob. Another document in my collection provides advice from the British Society for the Prevention of Consumption in 1902, saying "where there's dust there's danger". Of course, it was a mistake to believe that TB could be caught from dust and it fascinates me how these ideas are catego-

Anna Dumitriu
Blue Henry, 2014, antique sputum bottle, metal and glass © Anna Dumitriu

rically stated with complete faith. It makes me reflect on where we are today and wonder which other medical 'facts' will be proved wrong in the future.

Blue Henry

In my search for TB relics, I found a strangely beautiful 'Blue Henry', a sputum flask carried by TB patients in order to collect infected sputum coughed up from their lungs, rather than spit it out. The Blue Henry "a pocket bottle for coughers" was designed by Dr Peter Dettweiler, a former TB sufferer, and pioneer of the Sanatorium movement. The idea was that a patient could spit directly into the top of the flask, which has a spring-loaded lid. The funnel inside prevents spillage and the screw cap on the bottom makes for easy cleaning. The main benefit of the device was that patients would cough into the receptacle rather than into the faces of healthy people, though most people were embarrassed to use it publicly.

The *Blue Henry* was sold at the Davos sanatorium in Switzerland, where Thomas Mann set his famous novel *The Magic Mountain* (1924). The main character in the book, Hans Castorp, is introduced to the device by his cousin: "Most of us here have one; it even has a nickname, very jolly." Then later as another character excuses himself from the dinner table, Frau Stöhr remarks: "Poor thing. He'll

soon be drawing his last breath. Once more he has to go out for a meeting with Blue Henry."

 I altered the lid of the Blue Henry by engraving a diagram of a transmission network of tuberculosis patients revealed through new research by the Modernising Medical Microbiology Project using whole genome sequencing. A collection of TB samples taken from patients from the English Midlands between 1994 and 2011 was sequenced and the method revealed many previously unrecognised links between patients. By identifying minor changes in the bacteria's genome, as it moves between people, it has become possible to reveal who passed the disease to whom. This engraved diagram shows the possible occurrence of what is known as a 'super spreader', numbered '1', who caught the disease from patient '0' and proceeded to spread it widely. Patient 1 was involved with drugs and was therefore a member of a recognised high-risk group for TB. When I first received the Blue Henry purchased from a dealer in blue glass, I tried to work out how to open it, not realising it had a spring-loaded lid. When I finally triggered the lid, it burst open and a cloud of dust came out. At that point, I was very glad to know that TB is not spread by dust, as previously believed.

References

Dumitriu, Anna. 2018. "Anna Dumitriu: BioArt and Bacteria" http://annadumitriu.co.uk

Burke, Edmund. 1757. *A Philosophical Enquiry Into the Origin of Our Ideas of the Sublime and Beautiful.* Oxford: Oxford University Press.

Wordsworth, William. 1888. *The Complete Poetical Works The Prelude, Book 13.* London: Macmillan and Co.

Morelli, Giovanna, Yajun Song, Camila J. Mazzoni, Mark Eppinger, Philippe Roumagnac, David M Wagner, and Mirjam Feldkamp. 2010-12. "Yersinia pestis genome sequencing identifies patterns of global phylogenetic diversity." *Nature genetics*, 42, No 12: 1140

Rasmussen, Simon, Morten Erik Allentoft, Kasper Nielsen, Ludovic Orlando, Martin Sikora, Karl-Goran Sjogren, and Anders Gorm Pedersen. 2015. "Early Divergent Strains of *Yersinia pestis* in Eurasia 5,000 Years Ago." *Cell*, 163, No 3: 571-582. DOI: 10.1016/j.cell.2015.10.009

Culpeper's Complete Herbal. 2018. "Index of Herbal Remedies" http://www.complete-herbal.com/culpepper/walnuts.htm

Public Health England. 2018. "National Collection of Type Cultures NCTC 3000 Project" https://www.phe-culturecollections.org.uk/collections/nctc-3000-project.aspx

Richard, Vincent, Julia M. Riehm, Perlinot Herindrainy, Rahelinirina Soanandrasana, Maherisoa Ratsitoharina, Fanjasoa Rakotomanana, Samuel Andrianalimanana, Holger C. Scholz, and Minoarisoa Rajerison. 2015. "Pneumonic plague outbreak, Northern Madagascar, 2011." *Emerging Infectious Diseases* 21 No 1: 8-15. DOI: 10.3201/eid2101.131828

Galimand, Marc, Elisabeth Carniel, and Patrice Courvalin. 2006. "Resistance of *Yersinia pestis* to Antimicrobial Agents." *Antimicrobial Agents and Chemotherapy* 50, No 10: 3233-3236. DOI: 10.1128/AAC.00306-06

Dolan, Alice. 2015. *The Fabric of Life: Linen and Life Cycle in England, 1678-1810*, Hatfield, University of Hertfordshire

Centers for Disease Control and Prevention. 2018. "TB Data and Statistics" https://www.cdc.gov/tb/statistics/default.htm

Apte, Shireesh P. 2009. "The 'Genius Germs' Hypothesis: Were epidemics of leprosy and tuberculosis responsible in part for the great divergence?" *Hypothesis* 7, No. 1.

Sledzik, Paul S. and Nicholas Bellantoni. 1994. "Bioarchaeological and Biocultural Evidence for the New England Vampire Folk Belief." *The American Journal of Physical Anthropology,* 94, No. 2: 269-274. DOI 10.1002/ajpa.1330940210

Krumm, Pascale. 1995. "Metamorphosis as Metaphor in Bram Stoker's Dracula." *Victorian Newsletter*, Fall: 5-11.

Austin Alchon, Suzanne. 2003. *A pest in the land: new world epidemics in a global perspective.* Albuquerque: University of New Mexico Press.

Fawcett, Nicola J., and Anna Dumitriu. 2018. "Bacteria on display—can we, and should we? Artistically exploring the ethics of public engagement with science in microbiology." *FEMS Microbiology Letters*, 365, No. 11. DOI: 10.1093/femsle/fny101

Anna Dumitriu is a British artist who works with BioArt, sculpture, installation, and digital media to explore our relationship to infectious diseases, synthetic biology and technology. She has an extensive international exhibition profile including ZKM, Ars Electronica, BOZAR, The Picasso Museum, The V & A Museum, Philadelphia Science Center, MOCA Taipei, LABoral, Art Laboratory Berlin, and The Museum of the History of Science Oxford. She was the 2018 President of the Science and the Arts section of the British Science Association and holds visiting research fellowships at the University of Hertfordshire, Brighton and Sussex Medical School, and Waag Society, as well as artist-in-residence roles with the Modernising Medical Microbiology Project at the University of Oxford, and with the National Collection of Type Cultures at Public Health England. Her work has featured in many significant publications including *Artforum International Magazine, Leonardo Journal, The Art Newspaper, Nature* and *The Lancet.* http://www.annadumitriu.co.uk

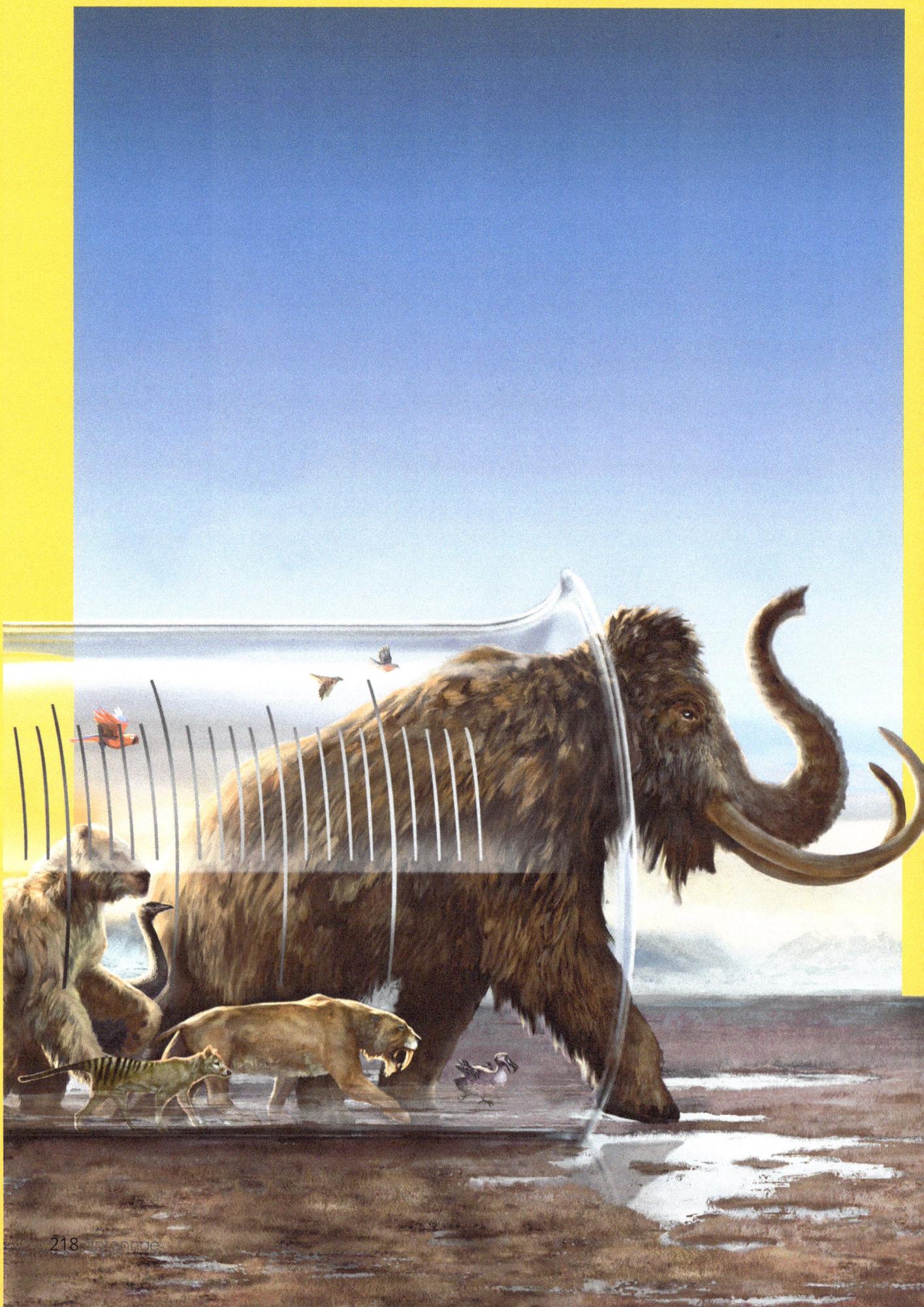

Regenesis Aesthetics:

Visualizing the Woolly Mammoth in De-Extinction Science

Pursuing an iconographical analysis of the de-extinction of the woolly mammoth, this essay explores how the (re)production of the visual image intersects with the creative and variable processes of species revivalism. The art of de-extinction science (or what this essay describes as 'regenesis aesthetics') mobilizes the fossil image in order to generate manifold copies of revived species like the woolly mammoth. The proliferation of these images, in turn, creates new and disruptive potentials for interpreting prehistoric natures and speculative futures.

text by **Sarah Bezan**

*D*e-extinction science begins with the image. Setting the scene for the revival of the woolly mammoth, more often than not, commences with an image of a carcass—a set of ivory tusks emerging from a tract of melting permafrost, a tuft of ginger-tinged fur in a cryogenically stabilized display case, or a vial of ancient blood, along with a news headline that proclaims that soon, scientists will restore the woolly mammoth to its rightful place on the mammoth steppe.

In the spring of 2013, the liquid blood of a woolly mammoth found in Siberia's Lyakhovsy Islands by a team of Russian researchers became the lede in a number of reports. Following the necroscopy, the researchers announced that the blood, while devoid of intact cells, contained a cold-resistant hemoglobin that functioned as a kind of "anti-freeze." The woolly mammoth may have been dead for 40,000 years, but the blood was, paradoxically, frozen in time.

Along with red ochre, charcoal, manganese dioxide, and other coloured mineral pigments, blood may also have been implemented as a binding agent in mixtures of prehistoric paint[1] by Upper Palaeolithic humans and utilized in their depictions of woolly mammoths at sites such as Rouffignac (the Cave of the Hundred Mammoths), Chauvet, and Lascaux. In these prehistoric cultures, blood was a supernatural substance[2] that, according to Georges Bataille, ritualistically "rendered present" animal figures "through a direct and very powerful appeal to the imagination."[3] Whether directly applied to a limestone cave wall or blended with other pigments, blood was an original element that was both materially appropriated and symbolically represented in the mimetic (re) creation of copies.

For de-extinction scientists, the blood of the woolly mammoth is, likewise, a kind of biotechnographic ink: a medium through which a copy is composed. Accompanied by the preserved tissues and bones of the mammoth, blood is both the matter and means for species revivalism, exemplifying the way in which biological images are doubly endowed with reproductive potential. If the expired

Jon Foster

Cover Art for National Geographic,
oil painting, 2013 © Jon Foster

woolly mammoth is itself a biological copy of its ancestors, and the material and symbolic blood of the mammoth is the medium through which new copies are produced in prehistoric art, then the art of de-extinction science draws out the liquid imaginaries of the fossil record, expanding the prehistories of extinct species into an unknown and speculative future.

Much like the ancient blood recovered by researchers in 2013, the propagation of contemporary images of the revived woolly mammoth makes the fossil record *proximate* and *tangible*, foreshortening the human timescale of prehistoric natures (in tens or hundreds of thousands of years) into an intimate lived experience that transports us back and forth — and forward — in time. From photographs of woolly mammoths in news media to naturalistic and hyper-realistic images of mammoths breaking through the permafrost or spilling out of laboratory beakers, the persistence of this visual record demonstrates W.J.T. Mitchell's claim that "the destruction of species is not necessarily the destruction of its image."[4] As Mitchell suggests, "the fossil record is a material and pictorial record, a vast iconic and indexical archive of species" that is "reversed by resurrection and reanimation in the paleontological imagination."[5]

Mitchell's insights set the stage for an examination of what I have termed *regenesis aesthetics*. In calling upon the title of Harvard geneticist George Church's co-authored book, *Regenesis: How Synthetic Biology Will Reinvent Nature and Ourselves*,[6] regenesis aesthetics explores the jointly scientific and artistic remaking of the beginning and end of species in the paleontological imagination. Through an iconographical analysis of hyper-realistic digital images, naturalistic paintings, and speculative exhibitions by artists Chris Buzelli, Raúl Martín, Lisel Ashlock, and the artist collective at The Centre for Genomic Gastronomy, I hope to illuminate the creativity and variability of de-extinction science itself, which inspires the reanimation of the woolly mammoth in pictures and (ostensibly in the near future) in the flesh.

Regenesis aesthetics is founded upon a principle of co-existence (the shared time and space of prehistoric human and nonhuman animals) that responds to the perennial problems of climate change and species extinction.[7] However, regenesis aesthetics also reveals the extent to which images of de-extinction display and disrupt chronoscapes,[8] create "deep copies,"[9] and foster connections between prehistoric and contemporary human(ities) in an era of unprecedented declines in species biodiversity. Addressing a constellation of "unnatural histories"[10] that have arisen in the wake of the sixth mass extinction (which has itself been shaped by anthropogenic changes under the regimes of biocapitalism[11] and cryopower[12]), the art of de-extinction operates on the basis of eco-fantasy — a morally redemptive desire[13] to restore environments to their "original" state — first through the visual image, and then through the body.

But in its production of "deep copies" or hybridized proxies[14] that build upon and enhance the prototypal woolly mammoth through the editing of genes sourced from the modern Asian elephant, the Woolly Mammoth Revival Project (led by George Church)[15] could be properly classified as a speculative endeavor that generates new insights for speculative aesthetics and philosophy. If, as Mark Fisher argues, extinction incites a "speculative and cognitive challenge" for speculative aesthetics,[16] then what is the value of the speculative arts in forecasting the habitats and environments imagined by de-

Regenesis aesthetics is founded upon a principle of co-existence (the shared time and space of prehistoric human and nonhu- man animals) that responds to the perennial problems of climate change and species extinction.

extinction scientists? Following Giovanni Aloi, who describes the speculative arts as a set of contemporary visual images that develop their own tools for "questioning our modes of perceiving, constructing, and consuming animals,"[17] I pursue a reading of de-extinction images that accounts for its speculative potentials.

An analysis of regenesis aesthetics in the case of the woolly mammoth elucidates how these potential mediations and values of representation are shaped by institutional knowledges of the laboratory, museum, and "frozen" zoological gardens like Pleistocene Park, which take on the image of the woolly mammoth as a "flagship species" for rewilding entire ecosystems. Given that the woolly mammoth has been deemed "history's most iconic extinct creature,"[18] I propose that images of revived woolly mammoths help us to critique the narrative of human exceptionalism that often lies at the heart of de-extinction programs, and which also perpetuates a cult of "cool" candidates for de-extinction according to a rubric of conservation iconology.[19] Through these images, we can better understand how and why the convergence of artistic and scientific practices on the subject of species revivalism ultimately coheres around the iconographic charisma of necrofauna[20] like the woolly mammoth.

The Mammoth Metapicture

Chris Buzelli's "Long Live the Mammoth" reanimates the woolly mammoth as it steps in (and symbolically through) the natural history museum diorama. As a commissioned piece for the cover of an article by Beth Shapiro, an evolutionary biologist at The University of California, Santa Cruz who works with "ancient DNA,"[21] Buzelli's artwork is meant to capture the observations Shapiro makes about the uses of scientific tools for de-extinction. But as an image that signals a time *both before and after extinction*, the painting also visualizes the interconnections between Ice Age and Anthropocene extinctions alongside the future of species revivalism.

In "Long Live the Mammoth," the museum space becomes a backdrop for enacting the politics of the "chronoscape" — a figuration of multi-temporality that is premised, as Jussi Parikka suggests, upon the fact that "ecocrisis is not just a present dilemma but a future that acts on the now."[22] The sixth mass extinction hovers at the periphery of Buzelli's rendering of the revived woolly mammoth, just as the past Ice Age extinction lies embedded within the frame of the natural history museum diorama. This arguably functions as a metapicture (an image "nested" within another image).[23] As a metapicture capable of staging "self-knowledge,"[24] Buzelli's painting adopts a self-reflexive stance that makes manifest the shifting contexts and fragmenting temporalities that characterize visual cultures of the woolly mammoth from prehistory to the present.

Through the use of foregrounding and backgrounding, shadowing, multiple framing techniques, and geometrical perspective (the level of the viewer's eye, coupled with the 3/4 turn of the mammoth, who meets our gaze), Buzelli constructs a visual image that comments on the histories and futures of natural representation. The first order of representation, foregrounded by the depiction of the museum diorama upon a stationary wall (and signed by the artist on the bottom left-hand corner), portrays a pastoral scene of grazing megafauna accompanied by what appears to be a cave lion stalking its prey. However, the shaded area beneath the diorama, along with tattered pieces of the breached wall, signals the dissolution of this

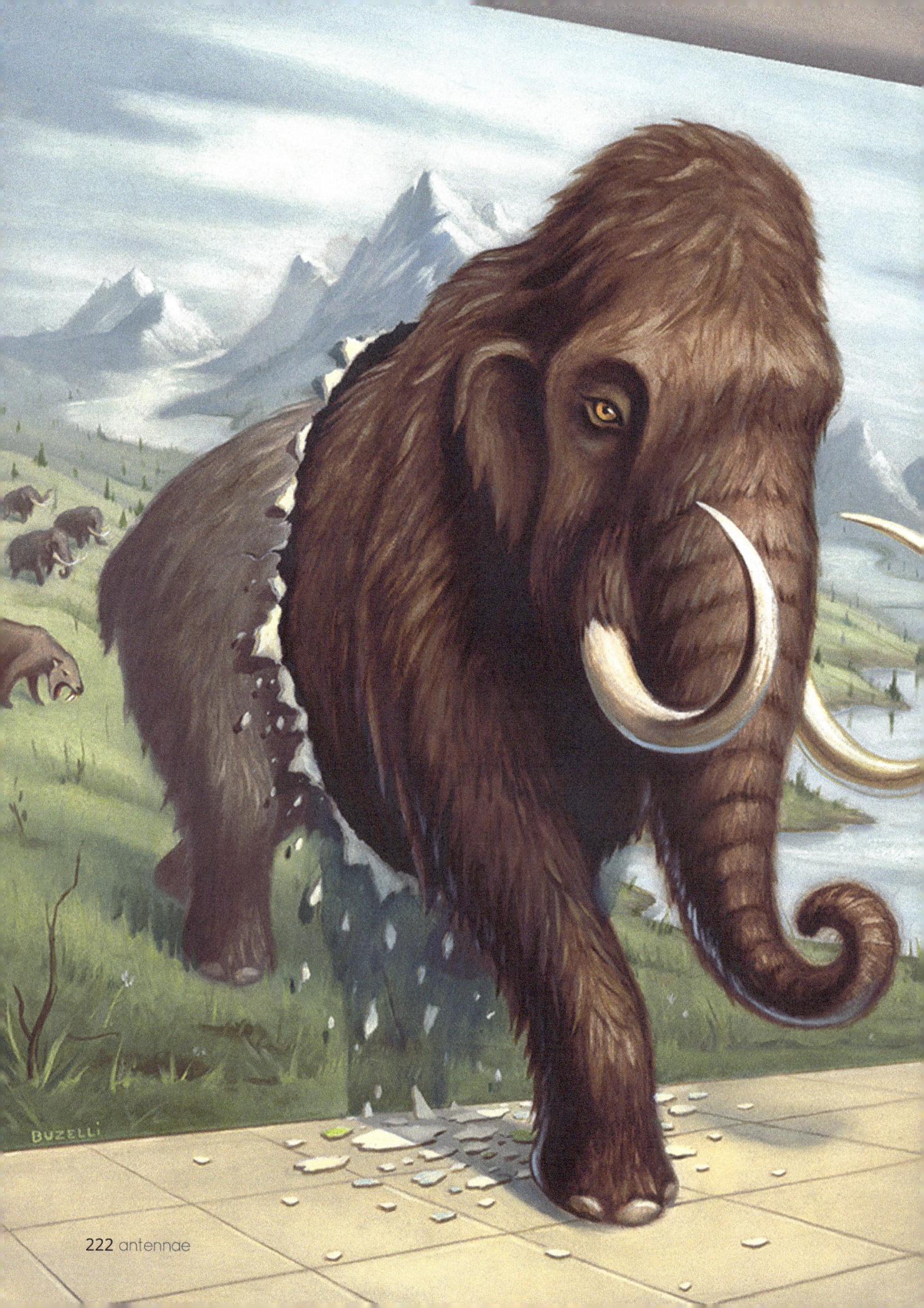

first order by a revived mammoth that steps both backward and forward in time.

This fissure in time and space positions us, as viewers, to acknowledge the infinite regression, and progression, of the image of the woolly mammoth. The fossil and the clone are conjured here as "endpoint species" in Mitchell's analysis of the paleontological imagination. Exhibiting how the fossil and the clone serve as "a 'missing link' in the evolutionary record of… strange, phantasmatic likenesses and apparitions,"[25] Mitchell explains that the freezing and melting of the image (from life to death and back again) operates as a play on the trope of destruction and creation. This trope is, of course, central to the process of de-extinction, but is integral to image-making itself.

From prehistoric painting to digital reproductions, the successive representation of images also exposes how the proliferation of "copies" of the woolly mammoth are shaped by its continually shifting contexts. This is exemplified by the parietal art at the Cave of the Hundred Mammoths, along with other portable objects (such as engravings of mammoths on tusks of ivory),[26] which were in many cases characterized by the use of *pentimenti* — signs or traces of alterations in artistic objects[27] that archive the creation and destruction of images over long periods of time. Much like an evolutionary process of mutation and re-creation, parietal and portable art records the (re)animations of the woolly mammoth. These modifications are activated by artists, but they are also, intriguingly, set in motion by changing environments like the cave. Calcitic deposits, fungi and mould, and the formation of stalagmites, along with settling sediments that lie upon the convex and concave surfaces of the cave wall, can alter images. For example, essayist Elizabeth Dodd, who came upon a red-ochre painting of a mammoth during her visit to the caves at Chauvet in 2006, writes that

> the back half of the mammoth has vanished into a veil of new calcite, which might, in time, overtake the shoulder, the head, the leg, the trunk. The painting long predated the decline and disappearance of the mammoths from this European landscape, but to the contemporary viewer, for whom the animals live only through depictions and imagination, the slow obliteration seems symbolic.[28]

The foreground and background of Dodd's description, as with Buzelli's metapicture, illustrates the intersection of the image's (re)creation in new and shifting contexts. While Dodd was unable to anticipate the promise of de-extinction, her essay speaks to the way in which the medium of paint upon a cave wall can, over time, transform the matter of the image and the terms of its representation.

An awareness of the shifting contexts and intersecting temporalities of the image leads to the kind of self-knowledge that Buzelli's mammoth metapicture proposes. This is because beyond the frame of the revived mammoth stepping into the foreground, we are faced with human-influenced acceleration of species loss, coupled with de-extinction projects purposefully designed by scientists to combat climate change (a significant contributing factor in mass extinctions).[29] Indeed, trapped between our "fossils" and our "clones," as Jean Baudrillard asserts, is the human.[30] But what self-knowledge

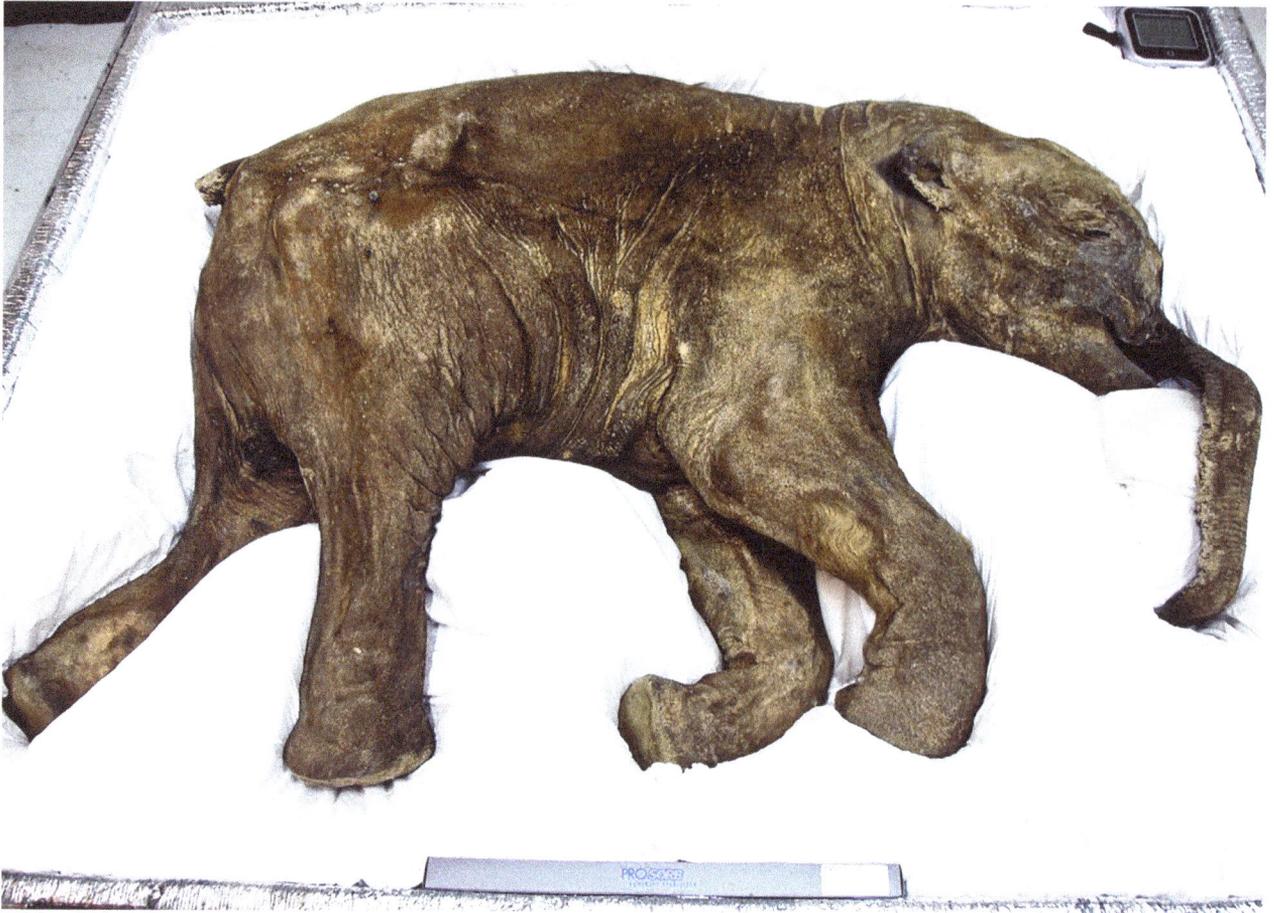

Michael McArthur

Lyuba, a 40,000 year old mammoth calf. 2016 © Michael McArthur

is produced through the nature of the metapicture, and moreover, as a result of the penetrating gaze of Buzelli's mammoth? While Charles R. Knight's well-known naturalistic watercolour paintings of mammoths and other prehistoric species offer no self-referential framing for its depiction of prehistoric nature, Buzelli's artwork has a heightened awareness of the extent to which human intervention mediates both animal images and animal bodies. At a time when the human is often hubristically figured as the "saviour" of species facing mass extinction, Buzelli's image invites us to evaluate how this disruption of time and place also infers a critique of what it means to look at animals that exist not only for themselves but also for us (again).

The mammoth metapicture references the sliding spatiotemporal logics of extinction through the apparitional reappearance of the "fossil" and its "clones" (as per Mitchell's analysis), but the shifting mediums of these mammoth images throughout history also suggest the unravelling of these anthropocentric frameworks. Beyond the use of mammoth images for the natural history diorama, which shortens evolutionary history into short, static tableaus that supposedly reflect the "reality" or "truth" of prehistoric natures, the appearance of the mammoth in visual images of de-extinction gestures to its entanglement with other species. In Buzelli's work, we might see these dissolving temporal and spatial frames as a representation of

what Deborah Bird Rose deems "multispecies knots of time," which both precede and succeed extinction proper.[31] Given that extinction is never the purview of a single individual or a single species, but rather a component of broader ecosystems, we ought to see the mammoth metapicture as self-reflexive about time and space, but also about the inter-species relationships it reveals and conceals within its frames.

Eco-Fantasy and Exhibition Value

In the same way that "Long Live the Mammoth" steps both backward and forward in time and space, it also encourages us to consider how the iconography of the woolly mammoth signals the problem of absence and presence in de-extinction images. For if developing technology to bring back a mammoth will also benefit the gastric brooding frog, heath hen, and other recently-extinct and endangered species facing extinction today, then it is safe to say that de-extinction is, conceivably, a response to extinction in the past, present, and future, and to animals both absent and present.

Playing on these animal absences and presences, the promise of de-extinction science cultivates a new set of values for representation. In a time of biotechnological reproduction, regenesis aesthetics produces a fantasy of ecological restoration that fosters a newfound (or renewed) proximity with de-extinct species, confronts ecocrisis, elevates the human, and amplifies the visual appeal of biotechnology through the composition of idyllic and unspoiled scenes of moral redemption. It is in eco-fantastical images of de-extinction science that we apprehend the role of the human observer and the roles of the *image-maker* — both of which are represented in the forms of the artist and de-extinction scientist.

In Jon Foster's cover art for *National Geographic*, we witness the plodding advance of extinct creatures like the giant sloth, Cuban red macaw, New Zealand giant moa, thylacine, saber-toothed cat, passenger pigeon, dodo, and woolly mammoth. Each individual animal represented functions as a synecdoche — a stand-in for the whole of its species. Like the biblical imagery of the ark before the deluge, the artist similarly sets the scene for this revival of species amidst the current environmental catastrophe. However, the ark in Foster's image does not contain and preserve animals but rather spills them out in an assembly line, each one trudging onto a softly-muted landscape awash with dawning light and staged with drying puddles. This is the beginning after the end: regenesis.

In a new narrative of reversed creation, this line-up of revived species parading towards a postlapsarian habitat encapsulates the bleeding of a boundary between cult value and exhibition value. In Walter Benjamin's now-familiar essay on the work of art ("The Work of Art in the Age of Mechanical Reproduction," 1935), cult value is illustrated by the image of a prehistoric animal (i.e. an elk) upon the cave wall, which functions as an "instrument of magic" that was "meant for the spirits."[32] Benjamin further argues that cult value is displaced by exhibition value in an age of mechanical reproduction (the mechanics of film, photography, and other accelerated processes of mass production and distribution). As art that was meant to be seen only by the gods, according to Benjamin, prehistoric cave paintings gave way, to art that was meant to be seen widely. Cult value (that is, art that is *present*, but not *seen*) therefore anticipates the advent of exhibition value (art depicting animals

In a new narrative of reversed creation, this line-up of revived species parading towards a post-lapsarian habitat encapsulates the bleeding of a boundary between cult value and exhibition value.

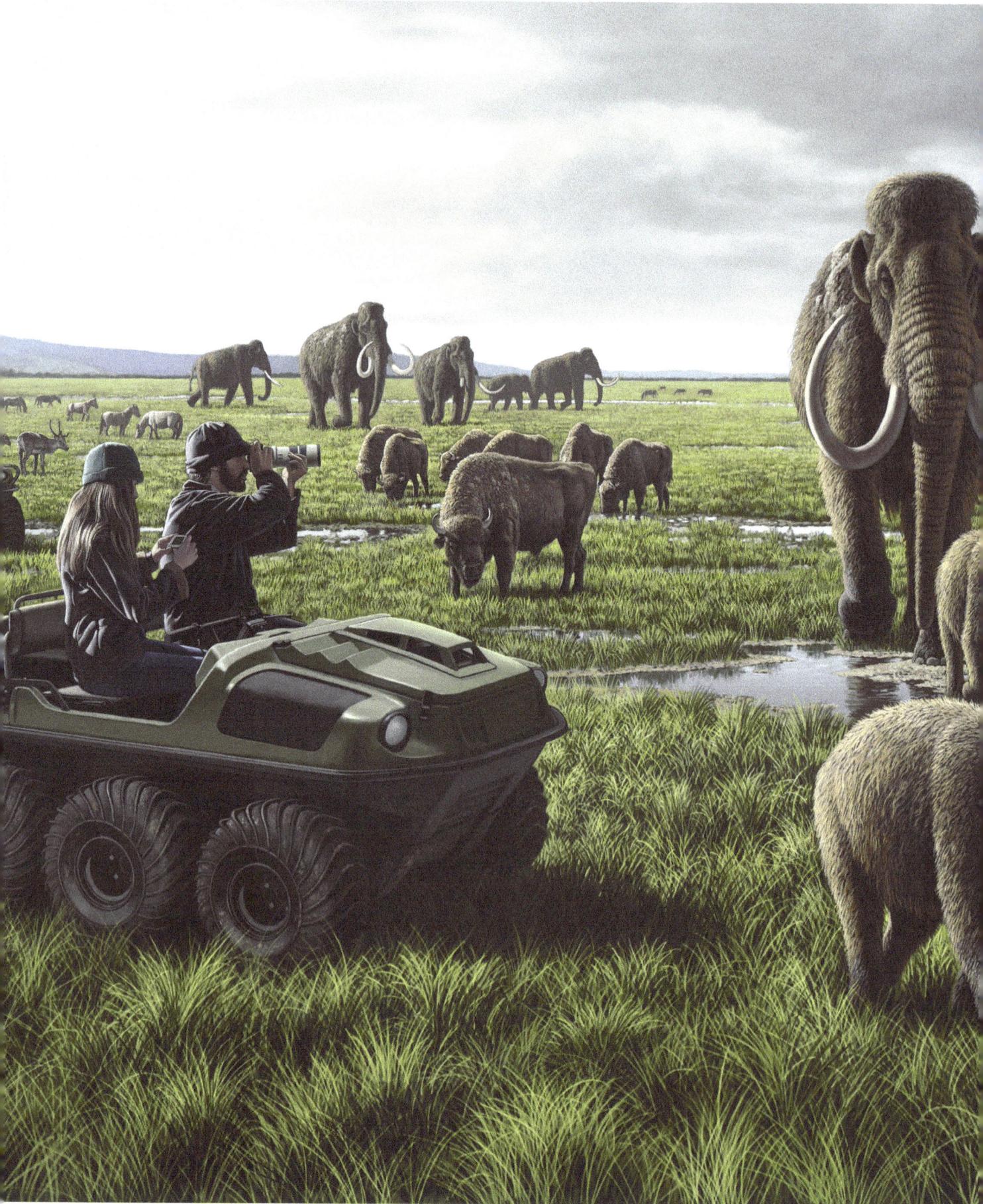

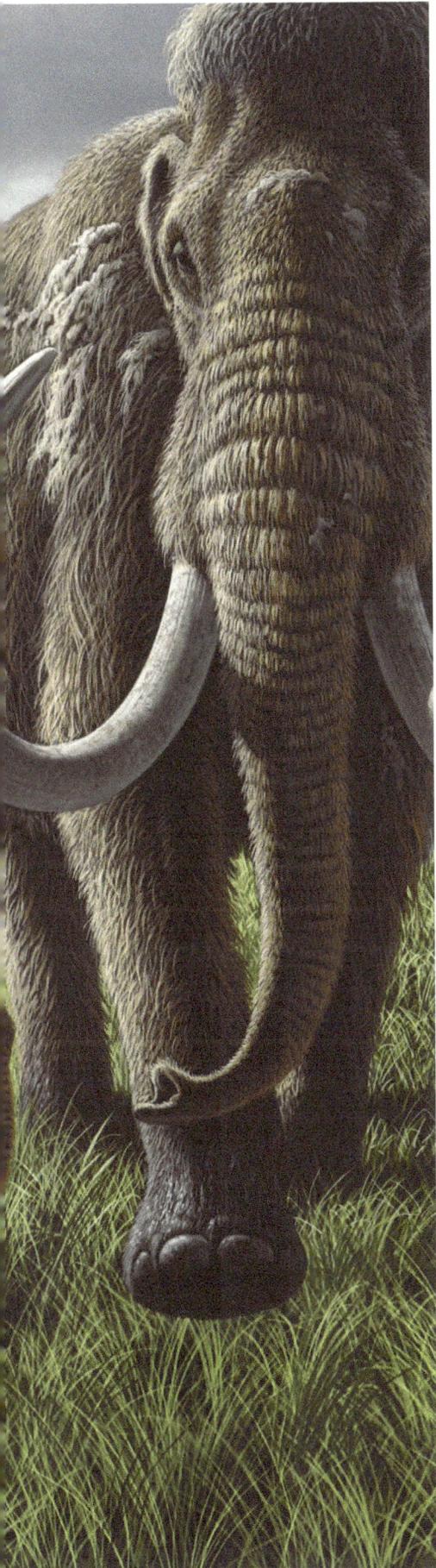

Raúl Martín

Pleistocene Park, digital painting, 2013

© Raúl Martín

WOOLLY MAMMOTH CUT CHART

A. Topside	G. Rear Foot	M. Thin Rib	S. Front Foot
B. Silverside	H. Sirloin	N. Thick Rib	T. Head
C. Rump	I. Flank	O. Neck	U. Trunk
D. Thick Flank	J. Belly	P. Brisket	V. Trunk Tip
E. Tail	K. Fore Rib	Q. Shank	
F. Rear Leg	L. Chuck	R. Knee	

The Centre for Genomic Gastronomy

"Woolly Mammoth Cut Chart, De-Extinction Deli, 2013 © The Centre for Genomic Gastronomy

which are no longer *and* not yet present, but seen).

In this shift to exhibition value, we witness the human exalted as creator. The trailer for Christian Frei's documentary film on mammoth-hunting in Siberia, *Genesis 2.0*, upholds this view: reflecting the corrective moralism that is a classic refrain for de-extinction scientists, we hear a scientist proclaim that "God's word is still imperfect, but if we work together we can make God perfect."[33] As a new creator, the de-extinction scientist aims not only to re-create extinct species, but to perfect them, and to imagine a renewed proximity between woolly mammoths and humans. Thus, instead of posing a critique of human mediations of animal life, the quasi-theological imagery of the laboratory-beaker-as-ark validates

human intervention as a predestined program for the rehabilitation of Ice Age megafauna to the Siberian tundra.

By representing ecocrisis as a passing affair — one supplanted by the recreation of perfect forms and images — the cover of *National Geographic* places the de-extinction scientist on par with the gods. But as another example of this eco-fantasy, Raúl Martín's "Pleistocene Park" imagines this Edenic return as an opportunity for heightened voyeurism and visual pleasure. We see in Martín's hyper-realistic digital art that de-extinct mammoths are drawn intimately near as visual objects in a restored natural order. The high horizon line of the image places the verdantly green tundra on the level of the viewer, while the human figures (aboard eight-wheeled all-terrain vehicles, or ATVs) are equipped with high-powered binoculars. The scale and scope of the image references the kind of ethological vision one would expect of a de-extinction exhibit such as this: everything, both near and far, is within the purview of the tourist or biologist.

Accentuated through a vivid colour palette and hyper-realistic details, the scenery of "Pleistocene Park" is designed for scopic satisfaction; it is a wonderland akin to Jurassic Park. Martín's image, however, is punctuated by an odd use of perspective. What is it that we imagine is being made visible through the lens of the viewer's high-powered binoculars (bottom-left in the image), given that a mammoth is no more than ten feet away, and already depicted as somewhat larger than they were, purportedly, in life? The heightened spectacle of this image reflects an aesthetics of co-existence (one as old as prehistoric painting) but also presents a particular kind of voyeurism and spectacularization of prehistoric life that is characteristic of ethological science. The nuclear family of woolly mammoths that forage for food and produce young exhibits behaviours, for example, that one would expect to see on a nature program. As a vivid depiction of the natural realism that subtends regenesis aesthetics, Martín's digital painting imagines a relationship between the human and bioengineered mammoth that is grounded in a newfound proximity.

The viewers depicted in Martín's work are *in* the image, but are themselves *producing* images through the means of binocular vision. The doubled ocularcentrism of "Pleistocene Park" plays with this principle of proximity with prehistoric life, but it also allows us to consider the role of the image-maker, who is both the artist and the de-extinction scientist. In tracing the shift from art that is present but not seen (cult value) to animals no longer *and* not yet present, but seen (exhibition value), we can begin to comprehend how regenesis aesthetics functions as eco-fantasy, made manifest through the interface of science and spectacle. Reproductive potential, which is attributed not only to the making of visual art but to the making of biological organisms brought back from extinction, is ultimately fuelled by a creative desire that is a feature of the human and the driving mechanism of evolutionary progress itself. But this desire, which stands apart from a whole constellation of ethical and political questions that arise from the prospect of de-extinction, is, in fact, an overlooked aspect of scientific progress: in the murky middle-space between real and representational forms of extinction, desire commits us to an ordered visual narrative that in turn prompts support, or garners criticism, for this kind of biotechnological intervention. It is at this junction that a new set of representative values is introduced.

Reproductive potential, which is attributed not only to the making of visual art but to the making of biological organisms brought back from extinction, is ultimately fuelled by a creative desire that is a feature of the human and the driving mechanism of evolutionary progress itself.

Speculative Futures

Speculative values emerge in regenesis aesthetics as a result of a critique of the desire to restore extinct species. Wielding a circumspect view of de-extinction science and its biocapitalist disposition, the artist collective housed at The Centre for Genomic Gastronomy (a think-tank that examines the biotechnologies and biodiversity of human food systems) foments a distinctly speculative engagement with de-extinction science. As Cathrine Kramer and Zack Denfeld (the founders of the Centre for Genomic Gastronomy) explain in an interview with *Experimental Emerging Art Journal*, the purpose of the *De-Extinction Deli* exhibit is to showcase the discordant and unsettling histories and futures of biotechnologies, extinction, and in-vitro meat consumption. By reviving species that we "ate to death the first time around,"[34] the project as a whole reflects on how digital remediations of extinct animals might be materially rendered from strands of DNA in a laboratory to cuts of meat on the plate.

The explicit focus of the project is on the speculative aesthetics of de-extinction and on the material practice of eating extinct animals. The *De-Extinction Deli* exhibit includes, according to their website, "butcher paper infographic take-aways, representations of extinct animal habitats, a grow-your-own-cell kit, and an ongoing poll in which visitors answer a series of questions regarding de-extinction." Part interactive museum exhibit, part speculative performance, and part communal dinner, *De-Extinction Deli* began in 2013 as a collective project by artists affiliated with The Centre for Genomic Gastronomy. The exhibit has since traveled to the Victoria and Albert Museum in London, United Kingdom (2016), the Science Gallery Dublin, Ireland (2018), and at the Museum Marta Herford, Germany (2018/19), among other venues. In each iteration of the museum exhibit/performance/dinner, visitors are invited to write postcards to George Church and other leaders of the de-extinction movement like Stewart Brand (of the Long Now Foundation) and to respond to a series of polls regarding the plausibility of de-extinction science.

As the world's first "fantastical market stand" for "contemplating the emerging technologies, risks, and outcomes of the growing movement to revive (and possibly eat) extinct species,"[35] the exhibit is predicated on the digital aesthetics of DNA editing and the technologies of digital and biotechnological mediation that work to re-animate long-dead animals. But through their graphic-designed menus, postcards, and plated "fantasy" dinners of extinct species, *De-Extinction Deli* plays on the doubled animation of DNA codes, the ethical investments of cryopolitical consumption, and the biopolitics of rendering animal bodies.[36] Moreover, as a critique of the eco-fantastical desire to image/imagine the revival of extinct species, the project presents us with speculative value — the meaning attributed to art that depicts a reality beyond our own lived experience.[37] In short, the *De-Extinction Deli* project illuminates the potential of speculative value in an age of biotechnological reproduction.

The mammoth, as we have seen, is an image materialized out of the fossil record, becoming legible first as flesh and then as a technographic archive: a genome unlocked and depicted on a screen as a digital picture of extinct DNA. In *De-Extinction Deli*, this genome turns the mammoth back into flesh — a foodstuff for culinary artists. The project uses the image of the woolly mammoth cut chart to link the past relationship with mammoths (which may or may not have led to the destruction of the woolly mammoth through a combi-

Lisel Ashlock

Back From the Dead, 2013, acrylic painting on birch board © Lisel Ashlock

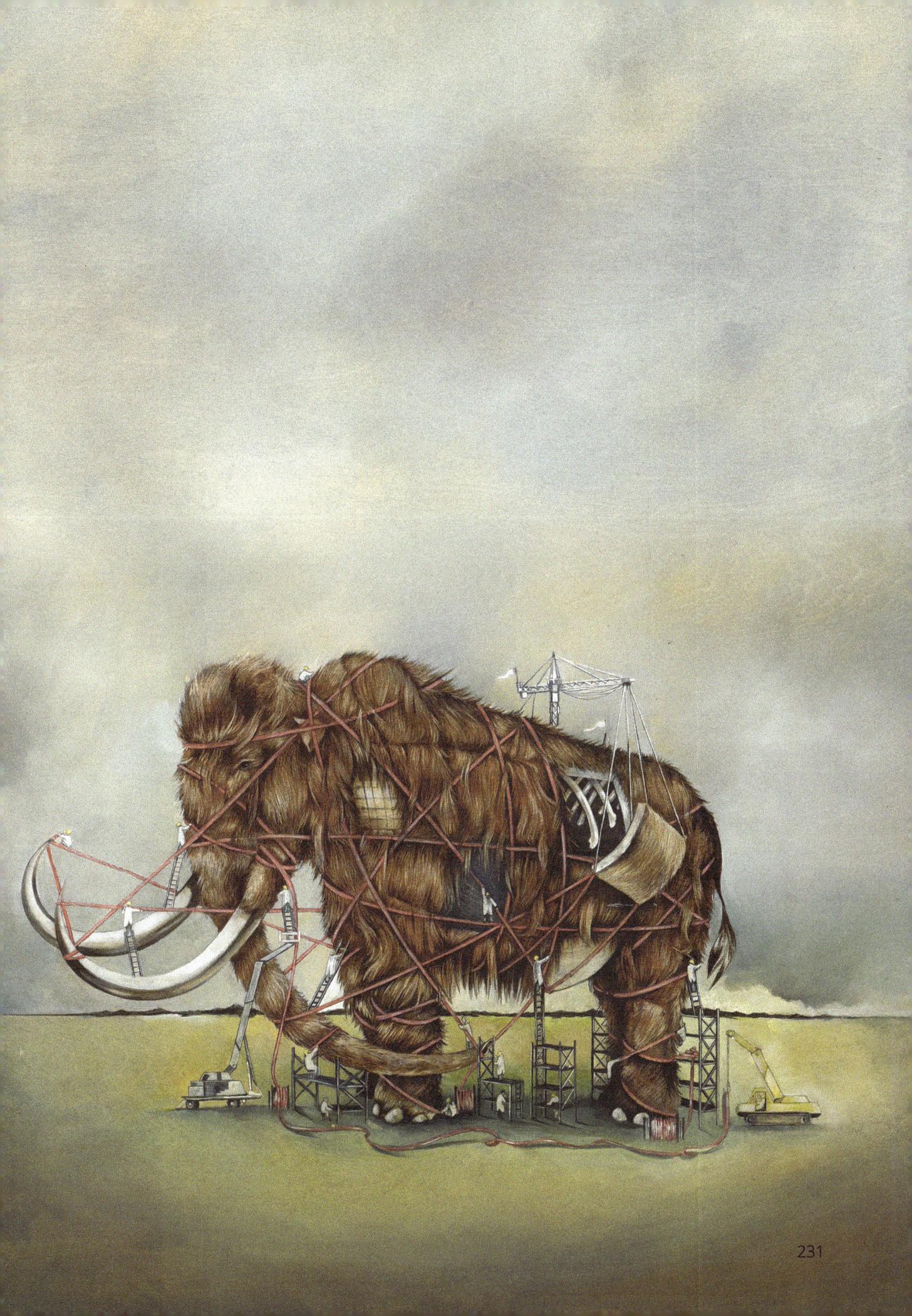

"I lay all this while, as the reader may believe, in great uneasiness." —*Page* 8.

Hilary Jane Morgan

Gulliver held prisoner and tied hand, foot and hair by the people from Lilliput during his voyage there. From *Gullivers Travels* by Dean Swift, published c.1880. Image in public domain.

nation of climate change and overhunting on the part of palaeolithic humans), in turn demonstrating a lingering desire to re-create and consume its flesh. While the mammoth, in particular, has remained with contemporary humans as an image (as a vial of ancient blood or a red-ochre cave painting), this fantasy of destruction and reproduction exposes the paradoxical absence and presence of the image in de-extinction science, and calls diners at the deli to ruminate on a vision of the past and future of human-animal relationships in a way that is palpable, and in this case, palatable. Ruminating on conceptions of consumption and visibility, *De-Extinction Deli* is an exhibit designed to unsettle the economy of desire that motivates the paleontological imagination.

This circumspect approach to de-extinction can also be discerned in Lisel Ashlock's acrylic painting, *Back From the Dead*, which appears on the cover of the autumn 2013 issue of *Earth Island Journal.* The piece imaginatively depicts the reconstruction of the woolly mammoth with a series of levers, ladders, scaffolds, cranes, and red rope by lab-coated scientists. Unlike Martín's slightly oversized mammoths from "Pleistocene Park," these manipulations of the woolly mammoth body are captured in exaggerated scale, with miniaturized humans climbing ladders and fastening ropes and pulleys. Distinct from the cover of *National Geographic* (which came out around the same time and highlighted a tool of de-extinction science — the beaker), Ashlock's cover image highlights the power relationships that serve as the underbelly of de-extinction work.

Signaling a shift in iconographic traditions of the woolly mammoth, the cover image bears a peculiar resemblance to the nineteenth-century illustration of *Gulliver's Travels* by Jonathan Swift. In a scene with the Lilliputians, the protagonist of Swift's novel, Lemuel Gulliver, finds himself subject to arrest after urinating on a fire to extinguish it. Despite solving the problem, Gulliver must flee the land of Lilliput and leave the Lilliputians to their own devices. Through a similarly muted and moody palette of hues and a representation of oversized and undersized figures, Ashlock seems to reference this story and its underlying themes of moral reason. Ashlock's representation of the mammoth restrained and put asunder by human domination (however small) indicates a speculative stance that critiques the potential outcomes of technological mediation. If Swift's novel serves as a commentary on human political systems and the nature of moral reason, then Ashlock's similarly-muted and moody palette of hues calls attention to the moral problems that lie embedded in the prospect of biotechnological innovations.

The mediation of the mammoth body in Ashlock's image does not reflect an indulgence in the eco-fantastical view that would elevate the human about nonhuman animal life. If anything, Ashlock's "Back from the Dead" decries the manipulation of animal bodies as a form of oppression. But it is also clear from Ashlock's depiction of de-extinction that species revivalism can, and should, be represented as a process with uncertain outcomes. As a representation of the cross-pollination between art and science, species revivalism is only possible through the use of a range of biotechnological tools, from cloning to back breeding and gene editing, all of which lead to creative copies, rather than true resurrections.

From *De-Extinction Deli* to Ashlock's restrained mammoth, speculative images oscillate between a hubristic championing of biotechnological innovation and an uncertainty about the scale and scope of these projects.[38] As a result, these projects produce a vastly different set of speculative values that reflect on the image-making process as the work of artists but also the practice of de-extinction scientists. As we have seen from the earliest palaeolithic cave painting of the woolly mammoth to recent images of mammoths fabricated as a solution to climate change, our relationship with prehistoric life is reflective of our own (often anthropocentric) view of past, present, and future extinctions. Beyond the treatment of prehistoric nature as a flat prototype that can be endlessly replicated and reproduced, de-extinction science itself is highly creative and variable, conveying a sense of the sensuous proximity, and the vast temporal distance, that attends animal prehistories and de-extinction futures.

Notes

[1] "Prehistoric Colour Palette," *Encyclopedia of Fine Art*, http://www.visual-arts-cork.com/artist-paints/prehistoric-colour-palette.htm (accessed 1 October 2018). Other binding agents included eggs, animal fat, saliva, and water.

[2] David S. Whitely, *Introduction to Rock Art Research, Second Edition* (London: Routledge, 2011), p. 43.

[3] George Bataille, *The Cradle of Humanity: Prehistoric Art and Culture*, Ed. Stuart Kendall, Trans. Michelle Kendall and Stuart Kendall (New York: Zone Books, 2005), p. 50.

[4] W.J.T. Mitchell, *Image Science* (Chicago: The University of Chicago Press, 2015), p. 23.

[5] Mitchell, *Image Science* (above, n. 4), pp. 35-36.

[6] George Church and Ed Regis, *Regenesis: How Synthetic Biology Will Reinvent Nature and Ourselves* (New York: Basic Books, 2012).

[7] Climate change and species extinction were arguably an ongoing concern for Upper Palaeolithic hunters. See Kieran D. O'Hara, *Cave Art and Climate Change* (Bloomington, IN: Archway, 2014).

[8] The term "chronoscape" is credited to Sarah Sharma, *In the Meantime: Temporality and Cultural Politics* (Durham, N.C.: Duke University Press, 2014). In the context of extinction, Jussi Parikka applies Sharma's term in order to consider the multiple temporalities of extinction. See Jussi Parikka, "Planetary Memories: After Extinction, the Imagined Future," in *After Extinction*, edited by Richard Grusin (Minneapolis, MN: The University of Minnesota Press, 2018), pp. 27-50.

[9] Mitchell, *Image Science* (above, n. 4), p. 52.

[10] Elizabeth Kolbert, *The Sixth Extinction: An Unnatural History* (London: Bloomsbury, 2014).

[11] Ashley Dawson, "Biocapitalism and De-Extinction." In *After Extinction*, edited by Richard Grusin (Minneapolis, MN: The University of Minnesota Press, 2018), pp. 173-200.

[12] Cryopolitics, as with the operation of biopower in Foucault's analysis, proceeds from a 'make live and let die' mandate. But as Matthew Chrulew argues, cryopolitics "strives to secure life against *living itself*" by holding organic life in a state of "suspended animation" through cryogenic freezing at institutions like the Frozen Zoo (p. 299). From what we know of George Church's work in the realm of "longevity science," this directive also applies to the Woolly Mammoth Revival Project, which will purportedly support the extension of life through synthetic biology. Chrulew, "Freezing the Ark: The Cryopolitics of Endangered Species Preservation," in *Cryopolitics: Frozen Life in a Melting World*, edited by Joanna Radin and Emma Kowal (Cambridge: MIT Press, 2017), pp. 283-305. See also George Church and Ed Regis, *Regenesis* (above, n. 6), pp. 203-224.

[13] Stefan Skrimshire, "Re-Writing Mortality: A Theological Critique of Geoengineering and De-Extinction," in *Theological and Ethical Perspectives on Climate Engineering*, edited by Forrest Clingerman and Kevin J. O'Brien (Lanham: Lexington Books, 2016), pp. 103-126.

[14] Beth Shapiro clarifies the misconception that de-extinction involves producing a carbon copy of an extinct animal. Instead, she says, synthetic biology generates a "proxy" that utilizes the mammoth genome in order to bioengineer modern elephants to withstand the freezing temperatures of the Siberian tundra. Beth Shapiro, *How To Clone a Mammoth: The Science of De-Extinction* (Princeton, N.J.: Princeton University Press, 2015), p. 165.

[15] To learn more about the Woolly Mammoth Revival Project or the suite of de-extinction projects created by the Revive and Restore Network, visit https://reviverestore.org/projects/woolly-mammoth/.

[16] Mark Fisher, "Practical Eliminativism: Getting Out of the Face, Again," in *Speculative Aesthetics*, edited by Robin Mackay, Luke Pendrell, James Trafford (Falmouth, UK: 2014), pp. 91-94.

[17] Giovanni Aloi, *Speculative Taxidermy: Natural History, Animal Surfaces, and Art in the Anthropocene* (New York, N.Y.: Columbia University Press, 2018), p. 34.

[18] Ben Mezrich's nonfiction book follows the progress of George Church's Woolly Mammoth Revival Project, and proclaims that the woolly mammoth is a visual icon for de-extinction science. See Mezrich, *Woolly: The True Story of the Quest to Revive History's Most Iconic Extinct Creature*. New York, NY: Atria, 2017.

[19] I explore the function of conservation iconology in a forthcoming essay on the Galápagos tortoise. See Sarah Bezan, "Endling Taxidermy: Lonesome George, Global Genomics, and the Iconographies of Extinction" (*Configurations: A Journal of Literature, Science, and Technology*, special issue on "Taxidermic Forms and Fictions" co-edited by Sarah Bezan and Susan McHugh, Vol. 27, No. 1, 2019).

[20] Britt Wray's book (which includes a foreword by George Church) bears the image of two mammoths, one fossilized, and the other enfleshed, facing opposite one another. The woolly mammoth looms large in Wray's consideration of necrofauna, a word that plays on futurist Alex Steffen's description of "charismatic megafauna" as the defining characteristic of candidate species for de-extinction (xi). Britt Wray, *Rise of the Necrofauna: The Science, Ethics, and Risks of De-Extinction* (Vancouver, B.C.: Greystone Books, 2017).

[21] Beth Shapiro, "Long Live the Mammoth" (*Popular Science*, 19 May 2015, https://www.popsci.com/de-extinction-long-live-mammoth#page-6). Accessed 23 October 2018.

[22] Parikka, "Planetary Memories" (above, n. 8), p. 38.

[23] Mitchell, *Image Science* (above, n. 4), p. 18.

[24] W.J.T. Mitchell, *Picture Theory: Essays on Verbal and Visual Representation* (Chicago: The University of Chicago Press, 1994).

[25] Mitchell, *Image Science* (above, n. 4), p. 37.

[26] One of the most important archaeological discoveries from the Ice Age occurred in 1864, when a ten-inch piece of ivory was excavated from a rock-shelter in Southwestern France. Alexander Marshack writes that this finding, along with evidence at Chauvet and other sites, illustrated the practice of renewing and reusing artistic mediums "by scraping and engraving outlines" of prehistoric animal figures (p. 34). See Marshack, "Images of the Ice Age," (*Archaeology*, Vol. 48, No. 4, July/August 1995), pp. 28-39.

[27] "Pentimento." *Oxford English Dictionary* (http://www.oed.com/view/Entry/140353?redirectedFrom=pentimenti#eid).

[28] Elizabeth Dodd, "Here the Animal," (*Southwest Review*, Vol. 91, No. 3, 2006): pp. 415-427.

[29] We read on the website of the Revive and Restore Network that the de-extinction of the woolly mammoth is supposed to reverse the effects of climate change by restoring herds of megafauna to the Siberian tundra. The herds, they write, will compact and scrape away layers of snow, allowing the extreme winter cold to penetrate the layers beneath. This, in turn, will slow the "the melting of the permafrost and the release of greenhouse gases that have been trapped for millennia." *Revive and Restore Network*, "Project Goals," http://reviverestore.org/projects/woolly-mammoth/ (accessed 23 October 2018). See also Scott Pelley, "Siberia's Pleistocene Park: Bringing Back Pieces of the Ice Age to Combat Climate Change," *60 Minutes*, Mar. 31 2019. https://www.cbsnews.com/news/siberia-pleistocene-park-bringing-back-pieces-of-the-ice-age-to-combat-climate-change-60-minutes/ Accessed May 10th, 2019.

[30] Jean Baudrillard, *Fragments: Cool Memories III (1990-1995)*, trans. Emily Agar (New York: Verso, 1997), p. 138.

[31] Deborah Bird Rose, quoted in Michelle Bastian, "Encountering Leatherbacks in Multispecies Knots of Time," in *Extinction Studies* (above, n. 23): pp. 149-186; p. 151. In Bastian's interpretation of Rose's conception of the temporality of extinction, she suggests that "multispecies knots of time" are "fraying, threatening the functional extinction that precedes the actual" (151).

[32] Walter Benjamin, "The Work of Art in the Age of Mechanical Reproduction," in *Illuminations*, edited by Hannah Arendt, translated by Harry Zohn, from the 1935 essay (New York: Schocken Books, 1969). http://web.mit.edu/allanmc/www/benjamin.pdf (accessed 1 November 2018).

[33] Trailer for *Genesis 2.0*, 2018. Dir. Christian Frei, Co-Dir. Maxim Arbugaev, https://www.genesis-two-point-zero.com (accessed 1 November 2018).

[34] Zane Cerpina, "Feeding Dangerous Ideas: An Interview with Cathrine Kramer and Zack Denfeld" (*Experimental Emerging Art #3, Interviews*, June 2017). http://eejournal.no/home/2018/3/2/feeding-dangerous-ideas-cathrine-kramer-and-zack-denfeld (accessed 21 October 2018).

[35] "De-Extinction Deli," http://genomicgastronomy.com/work/2013-2/deli/ (accessed 21 October 2018).

[36] Nicole Shukin, *Animal Capital* (Minnesota, M.N.: The University of Minnesota Press, 2009).

[37] I want to qualify this claim by acknowledging that while eating mammoth meat is an experience quite beyond most of us, there are rare cases in which scientists have tasted defrosted mammoth tissues in the field or in the laboratory.

[38] Rosie Ibbotson contends that de-extinction images "bear the representational burden of what cannot be seen, either because it is too microscopic or concealed, or because it is no longer around." See Ibbotson, "Making Sense?: Visual Cultures of De-Extinction and the Anthropocentric Archive." *Animal Studies Journal* Vol. 6, Iss. 1 (2017), pp. 80-103, p. 84.

Bibliography

Aloi, Giovanni. *Speculative Taxidermy: Natural History, Animal Surfaces, and Art in the Anthropocene* (New York, N.Y.: Columbia University Press, 2018).

Bataille, George. *The Cradle of Humanity: Prehistoric Art and Culture*, Ed. Stuart Kendall, Trans. Michelle Kendall and Stuart Kendall (New York: Zone Books, 2005).

Baudrillard, Jean. *Fragments: Cool Memories III (1990-1995)*, trans. Emily Agar (New York: Verso, 1997).

Benjamin, Walter. "The Work of Art in the Age of Mechanical Reproduction," in *Illuminations*, edited by Hannah Arendt, translated by Harry Zohn, from the 1935 essay (New York: Schocken Books, 1969). http://web.mit.edu/allanmc/www/benjamin.pdf (accessed 1 November 2018).

Bezan, Sarah. "Endling Taxidermy: Lonesome George, Global Genomics, and the Iconographies of Extinction" (*Configurations: A Journal of Literature, Science, and Technology*, special issue on "Taxidermic Forms and Fictions" co-edited by Sarah Bezan and Susan McHugh, Vol. 27, No. 1, 2019), pp. 211-238.

Cerpina, Zane. "Feeding Dangerous Ideas: An Interview with Cathrine Kramer and Zack Denfeld" (*Experimental Emerging Art #3, Interviews*, June 2017). http://eejournal.no/home/2018/3/2/feeding-dangerous-ideas-cathrine-kramer-and-zack-denfeld (accessed 21 October 2018).

Church, George and Regis, Ed. *Regenesis: How Synthetic Biology Will Reinvent Nature and Ourselves* (New York: Basic Books, 2012).

Chrulew, Matthew. "Freezing the Ark: The Cryopolitics of Endangered Species Preservation," in *Cryopolitics: Frozen Life in a Melting World*, edited by Joanna Radin and Emma Kowal (Cambridge: MIT Press, 2017), pp. 283-305.

Dawson, Ashley. "Biocapitalism and De-Extinction." In *After Extinction*, edited by Richard Grusin (Minneapolis, MN: The University of Minnesota Press, 2018), pp. 173-200.

"De-Extinction Deli," http://genomicgastronomy.com/work/2013-2/deli/ (accessed 21 October 2018).

Dodd, Elizabeth. "Here the Animal," (*Southwest Review*, Vol. 91, No. 3, 2006), pp. 415-427.

Fisher, Mark. "Practical Eliminativism: Getting Out of the Face, Again," in *Speculative Aesthetics*, edited by Robin Mackay, Luke Pendrell, James Trafford (Falmouth, UK: 2014), pp. 91-94.

Ibbotson, Rosie. "Making Sense?: Visual Cultures of De-Extinction and the Anthropocentric Archive." *Animal Studies Journal* Vol. 6, Iss. 1 (2017), pp. 80-103.

Marshack, Alexander. "Images of the Ice Age." (*Archaeology*, Vol. 48, No. 4, July/August 1995), pp. 28-39.

Genesis 2.0, 2018. Dir. Christian Frei, Co-Dir. Maxim Arbugaev, https://www.genesis-two-point-zero.com (accessed 1 November 2018).

Kolbert, Elizabeth. *The Sixth Extinction: An Unnatural History* (London: Bloomsbury, 2014).

Mezrich, Ben. *Woolly: The True Story of the Quest to Revive History's Most Iconic Extinct Creature.* New York, NY: Atria, 2017.

Mitchell, W.J.T. *Picture Theory: Essays on Verbal and Visual Representation* (Chicago: The University of Chicago Press, 1994).

Mitchell, W.J.T. *Image Science* (Chicago: The University of Chicago Press, 2015).

O'Hara, Kieran D. *Cave Art and Climate Change* (Bloomington, IN: Archway, 2014).

Parikka, Jussi. "Planetary Memories: After Extinction, the Imagined Future," in *After Extinction*, edited by Richard Grusin (Minneapolis, MN: The University of Minnesota Press, 2018), pp. 27-50.

Pelley, Scott. "Siberia's Pleistocene Park: Bringing Back Pieces of the Ice Age to Combat Climate Change," *60 Minutes*, Mar. 31 2019. https://www.cbsnews.com/news/siberia-pleistocene-park-

bringing-back-pieces-of-the-ice-age-to-combat-climate-change-60-minutes/ Accessed May 10th, 2019.

"Pentimento." *Oxford English Dictionary* (http://www.oed.com/view/Entry/140353?redirectedFrom=pentimenti#eid).

"Prehistoric Colour Palette," *Encyclopedia of Fine Art*, http://www.visual-arts-cork.com/artist-paints/prehistoric-colour-palette.htm (accessed 1 October 2018).

Revive and Restore Network, "Project Goals," http://reviverestore.org/projects/woolly-mammoth/ (accessed 23 October 2018).

Rose, Deborah Bird, quoted in Michelle Bastian, "Encountering Leatherbacks in Multispecies Knots of Time," in *Extinction Studies* (above, n. 23): pp. 149-186.

Shapiro, Beth. *How To Clone a Mammoth: The Science of De-Extinction* (Princeton, N.J.: Princeton University Press, 2015).

Shapiro, Beth. "Long Live the Mammoth" (*Popular Science*, 19 May 2015, https://www.popsci.com/de-extinction-long-live-mammoth#page-6). Accessed 23 October 2018.

Sharma, Sarah. *In the Meantime: Temporality and Cultural Politics* (Durham, N.C.: Duke University Press, 2014).

Shukin, Nicole. *Animal Capital* (Minnesota, M.N.: The University of Minnesota Press, 2009).

Skrimshire, Stefan. "Re-Writing Mortality: A Theological Critique of Geoengineering and De-Extinction," in *Theological and Ethical Perspectives on Climate Engineering*, edited by Forrest Clingerman and Kevin J. O'Brien (Lanham: Lexington Books, 2016), pp. 103-126.

Whitely, David S. *Introduction to Rock Art Research. Second Edition* (London: Routledge, 2011).

Wray, Britt. *Rise of the Necrofauna: The Science, Ethics, and Risks of De-Extinction* (Vancouver, B.C.: Greystone Books, 2017).

Sarah Bezan is a Newton International Fellow (British Academy) at The University of Sheffield Animal Studies Research Centre, where she researches visual cultures of de-extinction. Sarah's work has appeared in a wide range of venues, including a forthcoming special issue on "Taxidermic Forms and Fictions" (co-edited with Susan McHugh) for *Configurations: A Journal of Literature, Science, and Technology.* Her co-edited book, *Seeing Animals After Derrida*, was recently published in the *Lexington Books Ecocritical Theory and Practice* series. To view a full list of publications, visit sarahbezan.com

Lightning Source UK Ltd.
Milton Keynes UK
UKHW020944100223
416742UK00002B/7

9 780795 659652